THE ENGLISH RENAISSANCE
MINIATURE

ROY STRONG

THE ENGLISH RENAISSANCE MINIATURE

with 255 illustrations, 8 in colour

REVISED EDITION

THAMES AND HUDSON

For A. L. Rowse

Filmset by Tameside Filmsetting Ltd,
Ashton-under-Lyne, Lancashire.
Printed and bound in Japan by Dai Nippon

CONTENTS

PREFACE

England's greatest contribution to the art of painting during the Renaissance was the portrait miniature. It is a subject which I have touched upon often over the years but it was only after 1974, when I became Director of the Victoria & Albert Museum, that I was able to make a detailed examination, under strict laboratory conditions, of the surviving miniatures. I had the benefit of working with Jim Murrell, Deputy Keeper in Conservation, who has pioneered the technical analysis of them, and over the decade that this work has slowly progressed I owe an incalculable debt to him for our endless conversations on the subject of miniatures.

I do not claim to have produced a mass of new documentary material. That aspect has been more than adequately dealt with during the last thirty years, first in the pioneering work of Noel Blakiston and the late Erna Auerbach and latterly in that of Mary Edmond. There are some vital new facts, for example those that shed light on the enigma of Isaac Oliver, but my main concern has been with reinterpreting the known ones and throwing them into a broader historical context than hitherto. My aim has been to restore the balance and above all to look at the miniatures against the background of their creators' work in other media. In some instances I am aware that I have made suggestions that are speculative but this is essential in order to get the study of English painting out of the art-historical straitjacket into which a certain type of historian would so conveniently like to lace it.

In addition to acknowledging the public and private collections whose miniatures we have been able to study out of their frames at the V & A, I should like to thank the innumerable friends and colleagues who over the years have helped with particular queries. In particular, I would like to record my debt to the late Dr Sylvia England for vital scouring of manuscript sources. Garth Hall and Stephen Calloway have supplied me with endless books and articles as well as assisting in the bringing of miniatures to the museum. The project has been closely associated with the planning of the exhibition *Artists of the Tudor Court, The Portrait Miniature Rediscovered, 1520–1620* for the V & A in 1983, and with the preparation of the catalogue for that exhibition.

Victoria & Albert Museum, November 1982 *Roy Strong*

The miniatures are reproduced at their original size except where otherwise indicated.

THE TREE OF LIMNING

Edward Norgate's *Miniatura or The Art of Limning* was written in London at the close of the Civil War and dedicated to that exiled Maecenas of the arts, Thomas Howard, Earl of Arundel. Norgate, who was a herald and clerk of the signet besides being a negotiator on behalf of Arundel and Charles I for works of art in the Low Countries, Italy and the Levant, writes that he was reworking an earlier version of the same treatise. The latter had been compiled at the behest of Sir Theodore de Mayerne, but had 'broke forth and bene a wanderer and some imperfect copies have appeared under anothers name without knowledge or consent'.[1] With the earlier version we are back therefore into the early 1620s, when Norgate taught the Earl's children writing and drawing. James I was still on the throne; Nicholas Hilliard would have been dead about three years, Isaac Oliver about five. As we read his text on the practical processes of painting that peculiar phenomenon of the English Renaissance, a portrait miniature, we are made acutely aware the whole time of being presented with pieces of a jigsaw puzzle, sections of which fall quickly into place, others of which can easily be deduced, while some sections remain wrapped in obscurity and will clearly have to be filled in by some other means. Perhaps an apter metaphor would be a tree, the tree of limning of which he was a branch that bore leaf in the age of Charles I along with two other branches, Peter Oliver and John Hoskins. We catch this sense of being presented with parts of something bigger in phrases such as 'this later was Mr. Hilliards way'; 'much used by Mr. Hillyard'; 'as I had it from old Mr. Hillyard'; 'Mr. Hillyard and his rare disciple, Mr. Isaac Oliver' or 'that rare Lymner my late Deare Cousin Mr. Isaac Oliver'.[2] These are the tricks of the trade as passed from master to pupil and Norgate by such references effortlessly takes us back from the middle of the seventeenth century to the reign of Edward VI, for Hilliard was born in the year of the boy king's accession and his father's death. Norgate has already sketched in for us a line of descent that stretches back over a century and the connection is not one of style but of techniques that made up the art of limning, secret processes and skills, transmitted in the inner sanctum of the studio. And it is this that gives us the framework whereby to unravel the lives and works of the limners of Tudor and Stuart England as a single coherent story.

Limning should be conceived as a family tree, a technical dynasty with its branches spreading ever upwards. It begins in England with the establishment by 1496 of an atelier to service the Tudor Royal Library, a venture that necessitated the recruitment of illuminators from the domain of the Dukes of Burgundy by Henry VII. Thirty years on his son, a far more munificent patron

of the arts, achieved what in his eyes was a much greater *coup* than even his subsequent employment of Holbein, namely the securing of the services of the entire Hornebolte family, court painters to the Regent of the Netherlands and the foremost exponents of the Ghent–Bruges School of illuminators. It was to be Lucas Hornebolte, in his role as King's Painter, who was almost to invent the portrait miniature. He was, however, for twenty years a dominant figure in the arts of the Henrician court and his employment by the King was prompted by the need not only to maintain a workshop capable of producing sumptuously illuminated manuscripts and, as a side line, portrait miniatures, but probably to produce a whole range of other artefacts for the court.

One of the fundamental conclusions to be drawn from the study of limning, indeed, is that its practitioners were often only incidentally miniaturists. What we are in fact dealing with is a sequence of artists who worked in England within the tradition of the late medieval and Renaissance workshop. They were artist–craftsmen who could paint panel portraits, design and often make jewels and plate, execute designs for tapestries and stained glass, supervise the décor and costumes for court fêtes, provide drawings for engravers or illuminate official documents. Virtually all of them turned their hands to a wide range of activities. There was no such thing as only a miniaturist or a limner in Tudor or Jacobean England. There were artists who exercised that skill along with many others. Specialization set in only after about 1620. Our failure to recognize or face up to the consequences of this has led to a total distortion of the limning story before that date. Although the journey along the trunk and branches of the tree is the central theme of this study I shall attempt for the first time to throw the work of these artists into this wider context.

Hornebolte is the test case, for we can now establish, from both the stylistic and technical evidence, that his workshop produced illuminated manuscripts. The lavishly adorned *Liber Niger* or Black Book of the Order of the Garter, in which the activities of this royal chivalrous order are recorded, contains portraits of Henry VIII and his courtiers from the hand of Lucas and his workshop. But I am also going to suggest that his workshop might be the source for a large group of pictures from the late 1520s and 1530s which up until now have been conveniently categorized, thanks to a common stylistic idiosyncrasy, as by the Cast Shadow Master.

We have no hesitation when it comes to Holbein because his polymathic activity has come down to us fully documented. When he entered the service of the Crown some time just before 1536 his range fell short of that of Hornebolte in only one particular, the skill to paint a portrait miniature, an ability he sought to acquire almost at once. Surprisingly neither Hornebolte nor Holbein seems to have taught any other painter, so that with their deaths in 1543 and 1544 respectively one branch of the tree came to an abrupt end. To sustain the art Henry VIII had to return to the roots and entice over from the Netherlands Levina Teerlinc, daughter of Simon Benninck, the other principal exponent of the Ghent–Bruges School. With her arrival in 1546 we ascend along a branch which will lead to Nicholas Hilliard, whom she may have instructed, and thence to Laurence Hilliard, Rowland Lockey and Isaac Oliver, all pupils of Nicholas. And Oliver, in his turn, was to instruct his son, Peter.

Limning emerges therefore as a technical skill and craft full of covert tricks and recipes passed secretly from master to pupil. Even in his *Treatise* Hilliard

never actually divulged all his processes. This secrecy must have added to its exclusivity and hence its appeal. But there is another reason why it was to have such a potency in Tudor England. From the start its origins were rarefied and royal. The portrait miniature began as the prerogative of the ruling dynasty, and throughout its early history a salient feature was its use as a vehicle for the cult of the monarchy, expressed in the bestowal of these objects as the ultimate gesture of favour. The number of royal portraits multiplies most significantly in the Jacobean age, when the Crown articulated unashamedly the doctrine of Divine Right. Far more miniatures survive of James I than of Elizabeth.

As the portrait miniature became an aesthetic expression of the ruling house, so by extension it was adopted as a medium by the ruling classes of Elizabethan England. After 1570 the taste for them spread to include the nobility and gentry and eventually even the wives of the worthy citizens of London. The portrait miniature responded to and assimilated the cult of emblems and *imprese*, and extended its social significance by being adopted into the patterns of contemporary courtship. It underwent the stresses and strains of the great aesthetic revolution that was shattering the Elizabethan icon and bringing England to terms with the principles of Renaissance optics as applied to painting. All this can be traced in the history of the Tudor and Jacobean limners, but this is irrelevant to the central question, which is, why after 350 years do these tiny images still exert such a compulsive hold over us? Having examined in laboratory conditions most of the few hundred that survive I would reply to that question with an answer which has all the simplicity of the obvious: these objects present the men and women of their age as they really were. That they do so sprang from the accident of their technical tradition.[3] Miniaturists actually only ever paint what they see before them. An elementary fact this may be, but it accounts for the extreme power of these portraits which is only matched in their sense of revelation by early photography. The limner did no preparatory drawings; we see the fruits of an immediate encounter between a painter and his sitter placed only a few feet away from him. This must account for the sparkling spontaneity and vivacity of so many of them, as though their subjects were caught mid-stream in conversation – which must often have been the case. Norgate was perfectly well aware of this:

> In this sitting you shall doe well to bend your observations upon what conduces most to the Likenes . . . The party sitting is by occasion of Discourse to be sometimes in motion, and to regard you with a merry, Joviall, and frindly aspect, wherein you must bee ready and suddaine to catch at and steale your observations, and to expresse them with a quick and constant hand . . .[4]

So important to this study is this fact of immediacy that we should pause and grasp the essentials of the art. Both Nicholas Hilliard and even more the late Caroline exponent, Edward Norgate, describe these exactly. Although one source dates from about 1600 and the other from the 1620s, the technical evidence indicates that what they did was no different from what Lucas Hornebolte had done eighty to a hundred years before. A portrait miniature required three sittings of uneven length, the longest being the second lasting up to as much as six hours. The first and last were much shorter but far more important. In the former the painter established composition and likeness, in the latter he concentrated on those bravura touches that brought the whole to life.

We can demonstrate this very simply at the outset by looking at three miniatures abandoned after only a first or second sitting. The first is by Isaac Oliver. Shortly after 1596 Oliver, then but newly returned from Italy, painted Elizabeth's last favourite, Robert Devereux, 2nd Earl of Essex.[5] This was an important sitting by a great aristocrat bent upon eclipsing his rival Robert Cecil as first minister to the Queen. The miniature survives as it was left after just one sitting, because from the outset it was destined to be kept in the studio so that Oliver could produce finished versions of it for the Earl to present to his followers. In this gesture he was emulating the Queen. Although it has been cut to an oval shape at a later date the miniature would have started rectangular made up of vellum glued to card, usually a playing card. Onto this we can see how Oliver began by drawing in graphite the essential lines of the composition and the encompassing oval. Two passages in the drawing of the dress still remain uncertain at the ruff and collar where more than one line is visible. He has also hatched in a cast shadow. Painting began with the laying in of what the limners referred to as the 'carnation', that is the underlying ground colour that made up the flesh tint. 'When you begin your pictures,' Hilliard writes, 'choose your carnations too fair, for in working you may make it as brown as you will, but being chosen too brown you shall never work it fair.' As for the delineation of form, that was achieved by 'little light touches with colour very thin, and like hatches as we call it with the pen'. The rapidity with which Oliver has recorded Essex is reflected in the broad brushstrokes delineating the hair. In finished versions, manufactured from this initial encounter, the treatment is much tighter.

Essex is the result of a single sitting aimed at obtaining a studio pattern and is the only surviving example of what a miniature must have looked like at that stage. Two other miniatures are among a number that record what such a portrait looked like after the second encounter. One is a lady by Nicholas Hilliard painted about 1575–80[6] and another is a second miniature by Oliver executed in Venice in 1596.[7] The latter is a rare survival because it still remains untrimmed on its original rectangular card. Of the two the one by Hilliard appears less finished because the dress is only indicated with a few lines of brown and black over the graphite outlines. Onto the carnation of her flesh tints he has hatched in red and brown the features but it is still incomplete. The same is true of her hair which he has begun to define by means of washes of transparent yellow over the carnation. The blue background of the pigment bice has been floated on, a complicated process to ensure absolute evenness of tone, and the ruff, begun with a white ground at the first sitting, has been worked up with transparent grey with the lace embossed in thick white paint. The gentleman by Oliver looks far more complete as even the gold outline has been put in, but in fact it is not. Although the features have begun to be hatched in they too are unfinished. The ear, for instance, has only just been begun and the lace collar and dress are purely schematic. In both cases the final explosion that was to bring the brilliance and the sparkle – including the shimmering highlights of gold and silver – was yet to come in the final sitting.

These three miniatures capture at once the essential divide that separates them from the large-scale painting of the period. There is also an additional fact. Oil painting was not only a long process, much of which was done away from the sitter in between sittings, often by studio assistants, but its results,

1 A miniature after one sitting. Oliver's portrait of Robert Devereux, 2nd Earl of Essex, *c*.1596, was designed to be kept in the studio as a pattern.

2 A miniature after two sittings. Hilliard's portrait of an unknown lady, *c*.1575–80, lacks the completion of the dress and the addition of the highlights.

3 A miniature after two sittings on an as yet uncut rectangular card. Oliver's miniature of an unknown man, 1596, painted in Venice, in which the dress and areas of the features still remain schematic

painted on wood, have suffered appallingly over the centuries so that we are lucky in the case of the majority of Elizabethan portraits if we have as much as sixty per cent of the original surface left. In sharp contrast most miniatures, in spite of a degree of repainting, flaking, fading and oxidizing of the silver highlights to black, survive down to our own age as they left the studio. What we contemplate are the results of three sittings of a few hours with perhaps the dress and jewels lent and worked on in between. Not until the time of Van Dyck was that quality of liveliness to be transferred from the miniature onto the canvas of large-scale paintings.

But to return to where we began, with Norgate: Thomas Fuller writes in his *Worthies of England* that 'He [Norgate] became the best illuminer or limner of our age, employed generally to make initial letters in the patents of peers, and commissions of ambassadors, having left few heirs to his kind, none to the degree of his art therein.'[8] In this simple statement made at the close of the limning tradition, amidst the catastrophe of Civil War, we are given by this branch of the tree the vital clue as to its roots. The portrait miniature was the solitary descendant into the age of the printed book of the medieval art of manuscript illumination, in particular as it had been revived by Henry VII in the workshops which serviced the Royal Library he created at Richmond Palace. It is therefore in the aftermath of an earlier civil war, that of York and Lancaster, and with the establishment of a new court culture that we must begin.

SCIENCE AND EXPERIENCE: *Lucas Hornebolte*

In spite of all the reinterpretations of Tudor England during the last few decades, the Battle of Bosworth on 22 August 1485 is still accepted as a turning-point. No one in that year, however, could have foreseen that an obscure magnate of Welsh descent was to establish successfully a new dynasty whose rule was to last over a century. Henry VII was to make good the Lancastrian claim to the throne, marry the Yorkist heiress, defeat the remnants of the rival party, lay the foundations of Tudor policy both at home and abroad and achieve ultimate recognition in the marriage of his eldest son to the King of Spain's daughter. This was to be the climax of the King's twenty-five years' reign, during which also occurred something else of extreme importance, the establishment of a new court culture. The latter was created not only by deliberate policy but as a result of the maintenance of peace and of the careful husbanding of financial resources. And the pattern that the culture was to take, whether expressed in building, interior decoration, gardens, dress, literature, pageantry or the visual arts, had its roots inevitably in the style set by the most sumptuous and prestigious of all the northern European courts, that of the Dukes of Burgundy. It is no surprise, therefore, to find that the origins of the portrait miniatures of Hilliard and Oliver reside in the workshops of the illuminators of the Ghent–Bruges School and in the efforts by Henry VII and his son Henry VIII to imitate a rival court.

The Burgundian Renaissance in England

Early Tudor court culture was built on meagre foundations, in the main picking up threads from Edward IV, who had spent years in exile at the Burgundian court.[1] Two events quickened the aesthetic pulse. The first was the signing of the marriage treaty with Spain in 1496–7 and the second was the burning of the old royal Palace of Sheen in 1497. After a decade of rule Henry VII now set out to create a court worthy of the bride. A new palace arose, based on the red-brick châteaux of Bruges, on the banks of the Thames. It overlaid the courtyard–castle style with the elegance of Burgundy, its skyline a forest of towers and pinnacles, its new-fangled gardens enclosed by galleries. So splendid was it that Henry christened it Richmond both after his own title before his accession and also as reflecting the 'Rich Mount' of England that his reign had brought. Besides being splendidly decorated it housed in addition a significant innovation, the first Royal Library, and along with it an atelier of illuminators recruited in the Low Countries.

This library was stuffed with romances, chronicles, Latin classics and histories in Burgundian prose. Its history predated the new palace and went back to Edward IV's exile, much of which had been passed in the house of the

bibliophile Lord of Gruuthuse, Louis of Bruges.[2] On his return as king in 1471, Edward began to assemble a library of elaborately illuminated histories and romances, many of which were sent by that lavish patron of the Bruges scriptoria, his sister, Margaret of York, Duchess of Burgundy, wife of Charles the Bold. Under Henry VII this purchasing escalated with the guidance of skilled bibliographers headed by William Caxton, whose printed books deliberately imitated as closely as possible the products of the Bruges scriptoria.[3] Caxton's death in 1491 deprived the court of its main source of books and directly precipitated a major new appointment, the first Royal Librarian, a Fleming called Quentin Poulet, who entered the King's service in April 1492. Poulet's task was to preside over the atelier soon to be established at Richmond Palace; it was modelled on that of David Aubert which provided the Duke of Burgundy with his manuscripts.

There is no study of the atelier, although a great number of its products are among the Royal Manuscripts in the British Library. We only need to discuss a few examples, however, to establish the links with the Horneboltes and thence with the portrait miniature. We must imagine a small group of Flemings recruited in the Low Countries working in Richmond Palace producing manuscripts illuminated in an inferior version of a style whose prime exponent was the Master of Mary of Burgundy.[4] The demands that the picture plane be treated as an imaginary space were met by laying the page out with the border as a vehicle for still life which acted as a frame for an illumination that differed from a panel painting only in medium and size. An illumination from a book 4 executed around 1495 containing poems by Charles d'Orléans is an example. In the border there are Tudor emblems and arms forming an archway into which has been set an awkward attempt at an elegant courtly scene, in which richly clad courtiers parade in a garden with a splendid fountain.

Another of Poulet's artists was much superior and his illumination to the court poet Bernard André's *Grace entière sur le fait du gouvernment d'un prince* has a far more accomplished border with scrolling and naturalistic flowers and Tudor roses. More important is the scene in which Prince Arthur, Henry VII's 5 eldest son, receives a paper while, in the background, he kneels at Mass. These are clearly portraits and the whole must initially have been observed from life, so that in this illumination we already have a portrait miniature although it is still part of a book. Quentin Poulet disappeared from the scene in 1506 and was succeeded by a second Fleming, Giles Duwes, on the accession of Henry VIII. Under his aegis the atelier continued to produce manuscripts along the lines of the Ghent–Bruges School as exemplified now by the work of the two leading families, the Bennincks and the Horneboltes. An essential feature of this style was the border scattered with naturalistic flowers and insects and other objects, including precious stones. John Skelton's *Garland of Laurel*, published in 1523, describes the illuminations in the Queen of Fame's book of remembrance as follows:

> *With that, of the book loosened were the clasps*
> *The margent was illuminated all with golden rails*
> *And byse, empictured with gressops and wasps,*
> *With butterflies and fresh peacocks tails,*
> *Enflored with flowers and slimy snails;*
> *Envived pictures well touched and quickly . . .*

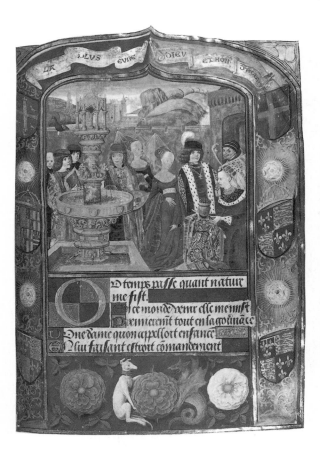

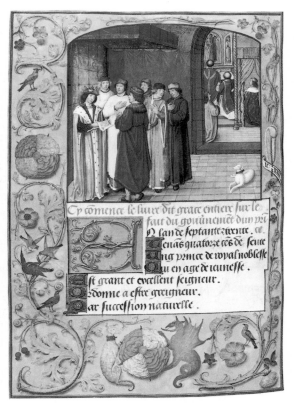

4 Anonymous Flemish artist, *Courtiers in a Garden*, *c*.1495. An illumination from the scriptorium established by Henry VII with borders adorned with Tudor emblems and arms

5 Anonymous Flemish artist, *Bernard André, the blind poet, presents Prince Arthur with a manuscript*, *c*.1500. In the background the Prince hears Mass.

6 Anonymous Flemish artist, *Illumination from a Bible for Henry VIII and Katherine of Aragon*, *c*.1509. Illuminated within the royal scriptorium but with the script by Peter Meghen

> *With balasses and carbuncles the borders did shine;*
> *With* aurum musaicum *every other line*
> *Was written.*[5]

By that date we are fourteen years into the new reign and the manuscripts Skelton is celebrating were those like the Bible for Henry VIII and Katherine of Aragon now at Hatfield House, which was executed about 1509.[6] The text is now in a humanist script by a scribe from Brabant called Peter Meghen, who moved in the circle of Erasmus, Colet, Warham and More. The border matches Skelton's lines, its 'butterflies' and 'flowers and slimy snails' married with the emblems and arms of the new king and queen: H and K, a fleur-de-lis, a portcullis and Tudor roses. It is clearly the work of a Flemish artist of considerable talent which is reflected also in the inset scene of St Luke seated at a table.

It is against this background that the arrival of the Hornebolte family in 1525 must be seen, for one of the reasons they were brought over was to continue running a manuscript scriptorium for the Royal Library. Their sudden advent has never been satisfactorily explained and I cannot pretend to offer more than a series of hypotheses. In the first instance, it is probable that by the middle of the 1520s the illuminators who had been recruited by Poulet and Duwes were either dead or extremely old. They had to be replaced, for the production of richly illuminated books was still a necessary aspect of regal magnificence.

14

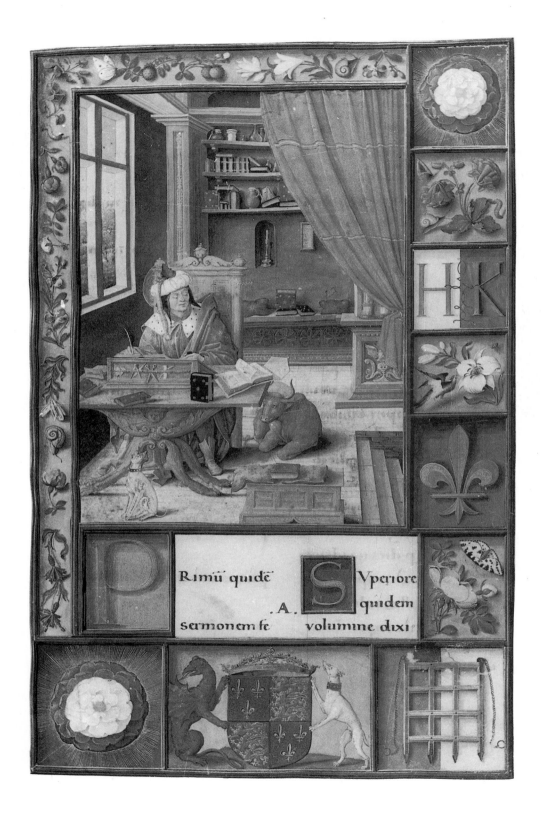

Rimū quidē Superiore
 .A. quidem
sermonem se volumine dixi

Secondly, it is possible that Cardinal Wolsey took a hand, as the Horneboltes certainly worked for him directly on their arrival as well as for the King. In contrast to Henry VIII, who expended his energies on ephemeral neo-Burgundian court fêtes projecting himself as the Tenth Worthy, Wolsey was seriously involved in a massive patronage of the arts in emulation of the Cardinal d'Amboise and as a fitting setting for his ambition. Hampton Court arose under his guidance from 1515 onwards, the first major secular building since Richmond in the 1490s. The Tuscan sculptors Benedetto da Rovezzano and Giovanni da Maiano were employed by him and his tomb was to have been of astonishing splendour. In the middle of the 1520s he was increasing his patronage with the establishment of his colleges at Oxford and Ipswich. He also built palaces at Esher and in London, the latter York House, later to be taken over by the King and renamed Whitehall. All this might suggest that Wolsey, who reached the apogee of his power in 1527, would have been willing and able to have become involved.

COLOUR PLATES

I Lucas Hornebolte, *Henry VIII*, 1525–6 (ill. 14).
This miniature of Henry VIII is one of the earliest, if not the earliest, portrait miniature by Hornebolte of the King. Enlargement reveals his technique of delineating the features by hatching in red and grey paint over the pink carnation ground. The hair and costume are rendered in the same way by lines over other opaque ground colours. In the case of the doublet, which was once silver-grey, oxidization has blackened the pigments. Hornebolte's lettering is generally awkwardly placed and the whole composition is always contained within a gold border.

II Hans Holbein, *Anne of Cleves*, 1539 (ill. 45).
Holbein was sent to paint Anne of Cleves in 1539 and one of the two portraits that he painted was this miniature. As a medium it allowed the artist to produce a likeness with extreme rapidity. Holbein's carnation ground is more opaque than Hornebolte's and his use of line far more structural and precise, aiming at defining contours. As Holbein was left-handed the brushstrokes go in the opposite direction. No detail of the dress is left undefined, evidence not only of exact observation but of a remarkable visual memory.

III Nicholas Hilliard, *Unknown Lady*, c.1585–90 (ill. 108).
An instance of Hilliard's close-up portrait formula from the late 1580s in which very little of the background is visible and the sitter is not seen in silhouettes. Hilliard's carnation ground is paler than Hornebolte's but the technique of hatching in the features in red, grey, brown and blue is the same. The vigorous, thrusting painting of the ringleted hair is typical of his early manner and the highlights of the pearls in the headdress have been painted with gold instead of silver to stress the warm reflections of the hair. The ruff is built up over an opaque grey ground with thick white paint applied to give an embossed effect.

IV Nicholas Hilliard, *Robert Devereux, 2nd Earl of Essex*, c.1593–5 (ill. 127).
A detail from an important miniature which would suggest collaboration between Hilliard and his pupil Rowland Lockey. The figure of the cavorting horse and squire with the distant landscape is far more impressionistic than Hilliard. Lockey was noted at the time for painting 'perspectives'. The miniature commemorates Essex's appearance at an Accession Day tournament and the detail shows the Queen's glove tied to his right arm. The squire tending the horse is attired in Elizabeth's colours of black and white and the horse is elaborately caparisoned. The panorama of tents, artillery and soldiers is purely emblematic, referring to the Earl's role as a military commander.

V Nicholas Hilliard, *Unknown Lady*, 1602 (ill. 137).
Hilliard could always respond to a female sitter and this one, painted when he was fifty-five, clearly enchanted him. She is a girl of the middle classes wearing the high crowned hat of a citizen's wife. She has very few jewels but the thick impasto of the painting of the ruff and bodice has been enlivened by the insertion of flowers. Technically the only change is in the painting of the hair which, after 1593, Hilliard rendered in the tight manner of Oliver.

VI Isaac Oliver, *Unknown Man*, c.1590–95 (ill. 196).
The earliest of Oliver's cabinet miniatures depicting a young man in the attitude of melancholy with a broad-brimmed hat and folded arms. The method of building up the portrait is by stipple as well as line and, unlike Hilliard, the figure is definitely lit with one side of the face cast into shadow. Unlike Hilliard also, the view of the garden and house is an exercise in correct perspective, the lines converging through the central arch of the pergola.

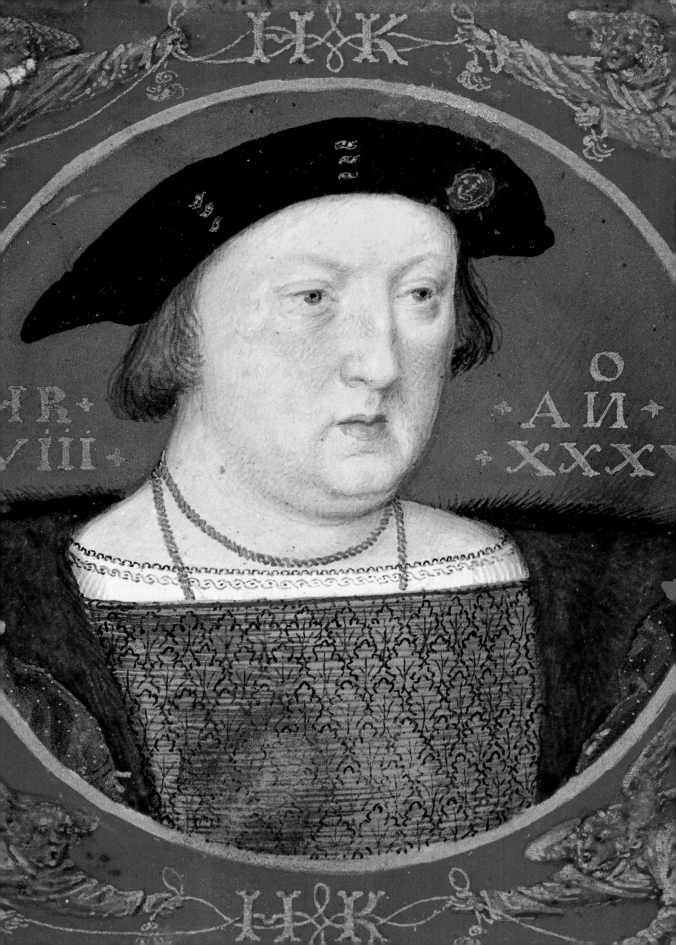

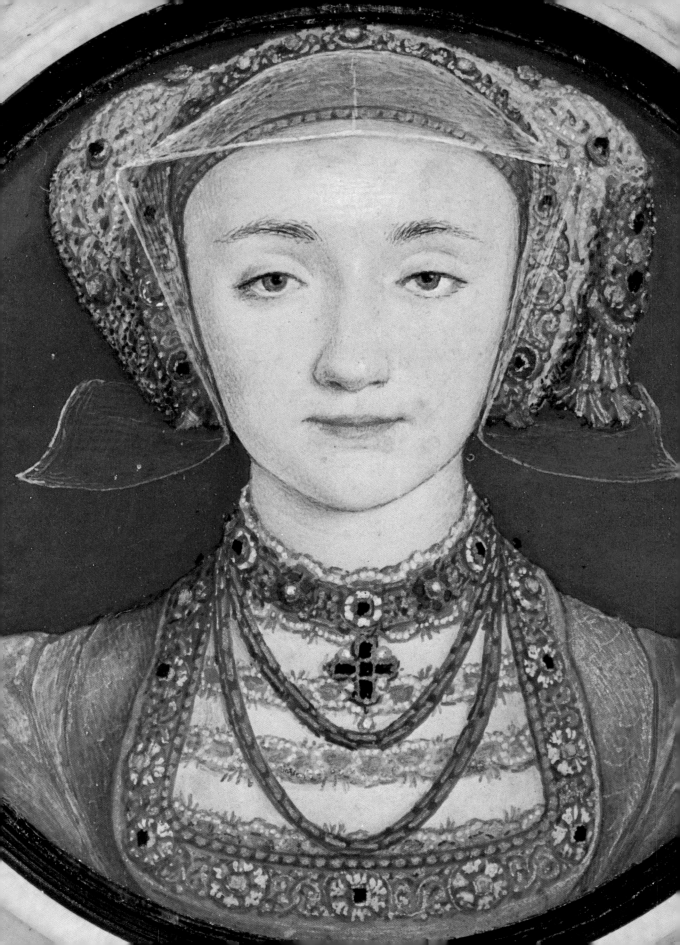

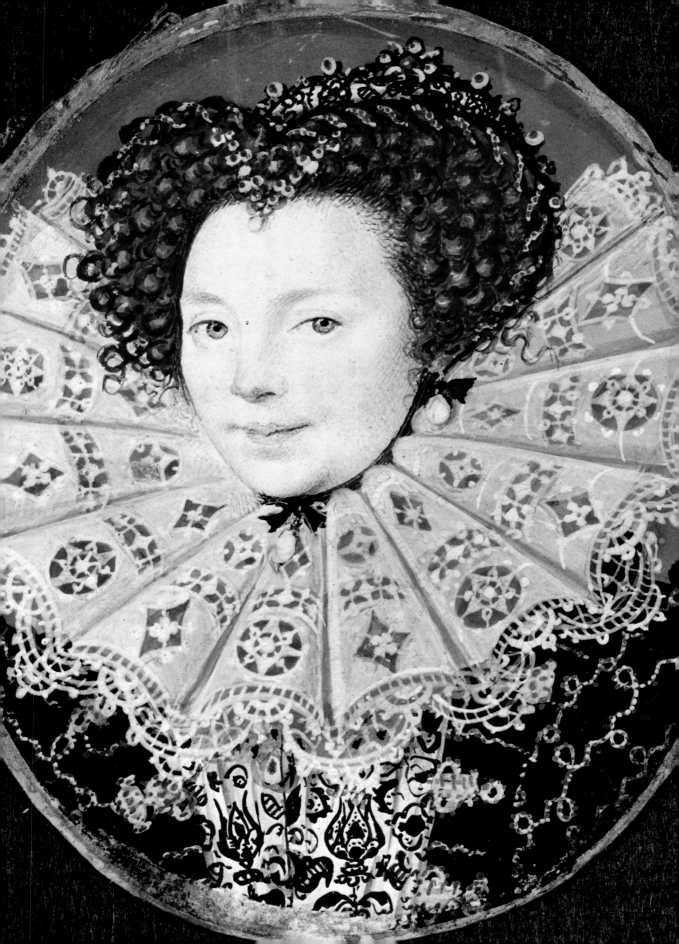

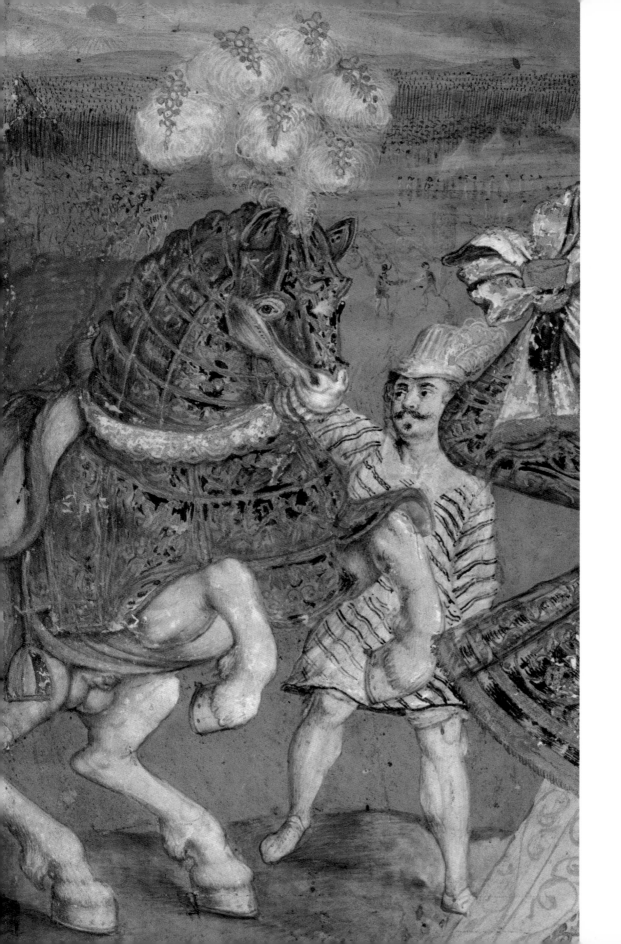

VII Isaac Oliver, *Henry, Prince of Wales*, c.1612 (ill. 223). This miniature of Henry, Prince of Wales, is Oliver's greatest royal portrait. The enlargement emphasizes the total mastery of his chiaroscuro stipple and line technique, which he uses in the foreground and the background in two different ways. The portrait and costume are exact and tight in their brushwork, rendering every detail with precision. In sharp contrast the same brushwork is used in a loose manner in the background to achieve a flickering, hallucinatory effect for the inset scene of warriors *à l'antique*, a revival of Ancient British chivalry similar to those in which the Prince appeared in the court masques.

VIII Isaac Oliver, *Lady Masque, probably in Jonson's 'Masque of Queens'*, 1609 (ill. 234). The sitter is attired for a court masque with a complicated headdress of scrolled goldsmith's work, pearls and a floating veil. The gold breastplate is military in its allusions and the style of the dress is such that it relates closely to those designed by Inigo Jones for the 'Masque of Queens' in 1609. By that date Oliver rarely made use of a blue background but used other colours such as the sombre hue here which serves to emphasize both the mystery and splendour of the sitter.

Early Tudor royal portraiture: the search for a court painter

7 Michel Sittow, *Henry VII*, 1505

In addition there was a third possible factor. By the middle of the 1520s the type of artist that was needed for the court was a very different one from hitherto. There is no indication that the royal manuscript atelier had previously produced anything but manuscripts. The range of the Horneboltes would suggest that the search this time in the Low Countries was not only for illuminators of the highest quality but also for a man capable of maintaining a workshop which would cover a much wider field. And there was one particular area in which it was essential for him to excel, the new-fangled art of portraiture.

What Lucas Hornebolte painted immediately on arrival in 1525 was *ad vivum* portraits. We can deduce that this is likely to have been the main motivation for his employment, and that his advent probably represented the successful conclusion of a quest for a particular type of court artist. The series of miniatures which we can now certainly associate with Lucas Hornebolte are the earliest surviving portraits from life of members of the Tudor family, apart from Michael Sittow's celebrated likeness of Henry VII painted in 1505. In order to understand the sudden emergence of these miniatures we have to place

them, therefore, into the broader context of the history of portraiture under the Tudors. Up until comparatively recently this has been a highly speculative area of study, bedevilled by the condition of the paintings, often damaged and overpainted, and by the existence of so many copies made at uncertain dates. Two factors, however, have begun to clarify this: the systematic cleaning and restoration of many of the pictures and, more importantly, the science of dendrochronology, the dating of panel pictures by an analysis of the ring growth of the tree.[7] From this evidence a context can be established which explains why an artist like Hornebolte would have had a special appeal to the Tudor court.

Portraiture as it emerged under the Tudors was exclusively royal portraiture. The usual incentives for the production of pictures were that they were needed in marriage negotiations – such as Sittow's *Henry VII*, painted when marriage of the King to Margaret of Savoy was under consideration[8] – and that portraits of the monarch and his forebears were required as sets for use in the interior decoration of the royal palaces. Although Richmond Palace contained a series of wall-paintings depicting Henry VII and his ancestors, both actual and mythical,[9] there is no evidence that the familiar format of the sets of royal portraits on panel existed at that period. Isolated likenesses there must have been which later became the basis upon which these series drew, but what used to be advanced as the late fifteenth-century examples of a set in the Royal Collection have turned out to have been painted well on in the reign of Henry VIII. His father, however, did have a court portraitist, a man called Maynard, variously referred to as French or English but most likely a Walloon, and we know that he took north with him, to James IV of Scotland, portraits of the King, Elizabeth of York, the Prince and Margaret Tudor in 1502/3.[10] Maynard's work is now known only from later copies of his originals. These are portraits in the familiar formula that emerged at the Burgundian court from about 1465 onwards, simple half lengths with the sitter's hands placed on a ledge at the front.

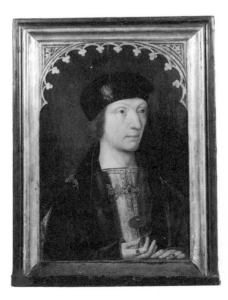

8 Anonymous artist, *Henry VII*, *c*.1515. An example of the earliest instance of the manufacture of sets of portraits of the Kings of England

7

The earliest series of royal portraits conceived from the start as a set can be dated by the process of dendrochronology to about 1515–20.[11] These represent the first stirrings of interest in portraiture at the court of Henry VIII and include the earliest likeness of the King and revamped copies of existing pictures of Edward IV, Henry VII, Elizabeth of York and Prince Arthur. Their format is identical and in the same late fifteenth-century Netherlandish vein, depicting the figure half length, the spandrels of the usually rectangular panels filled with Gothic tracery in gold, and the sitter's hands placed on a ledge coincidental with the frame before him and sometimes holding a symbolic flower. Their quality is not high.

8

It has been suggested that this series was prompted by the burning of the Palace of Westminster in 1512 and the building of Bridewell Palace, which was complete enough to receive the Emperor Charles V in 1522. This may, indeed, have provided the immediate stimulus, but it must be set in a broader context. Although the Burgundian court continued to be the pattern for the early Tudors, a rival appeared on the scene in 1515 with the accession of a new young French king, François I. The rivalry of the French and English kings was to be a major cultural force throughout the reign. It was strong even at the close of the 1530s when Henry embarked on Nonsuch and imported French craftsmen in order to emulate the Château de Chambord and the stucco-adorned galleries of Primaticcio and Rosso at Fontainebleau. But the rivalry was there from the very start and the dating of this earliest set of Tudor royal portraits coincides exactly with the emergence of a major exponent of portraiture at the French court, Jean Clouet.

François I had inherited two court artists who were illuminator–painters, Jean Pérreal and Jean Bourdichon.[12] Both were essentially illuminators but both are also known to have painted portraits. Pérreal died in 1521 and Bourdichon in 1530. By then Clouet had established himself as the prime exponent of the portrait genre, which developed into a mania with the accession of the new king and was expressed not only in the form of a celebrated series of chalk drawings, a uniquely French contribution, but also in panel pictures and miniatures. Recent research makes it clear that these drawings, later in the century circulated as detached portraits in their own right, began as studies for portraits in other media. As in the case of the portrait drawings by Hans Holbein, which we shall discuss later, these are often annotated with notes on colours or details of jewellery. Clouet also worked in other fields, painting religious pictures and designing embroidery. But the accent was on portraiture. Some of the earliest works by him were the series of portrait miniatures, based on the chalk drawings, of the heroes of the Battle of Marignano, the famous *Preux de Marignan*, which were inserted into the margins of the *Commentaires de la Guerre Gallique* portraits. These have been proposed as the precursors of the portrait miniature and the format, indeed, is identical to that which was to be used by Hornebolte, although we have no evidence that he had seen them.[13]

10

9

But had he seen something like them? The answer is almost certainly, yes. In 1526 François I's sister, Madame d'Alençon, sent Henry VIII two costly gifts in an effort to persuade him to intercede with the Emperor for the release of the French King's two sons who had been handed over as hostages. That gift, which clearly caused a minor sensation at the Tudor court, consisted of two

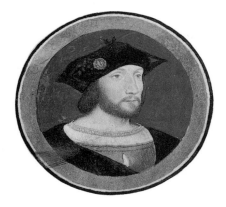

9 Jean Clouet, *Miniature of Guillaume de Gouffier, Seigneur de Bonnivet in the 'Commentaires de la Guerre Gallique'*, c.1516

10 Jean Clouet, *Drawing of Guillaume de Gouffier, Seigneur de Bonnivet*

11 Attributed to Jean Clouet, *The Dauphin François*, c.1525

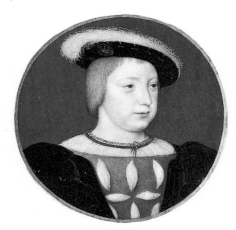

symbolic jewels in the form of lockets containing portrait miniatures set within an allegorical programme in enamel and goldsmith's work. Gasparo Spinelli, secretary to the Venetian ambassador in England, described both objects in great detail in a letter dated 2 December 1526.

> Picture to yourself, then, a round and plain form, slightly larger than that of the 'spechi da fuoco' which are sold on St. Mark's Place but of the same kind and which opens; the cover is attached on one side and that cover is of a very finely worked gold; when it is open it contains on one side the portrait of the very Christian King, very naturally painted on paper, and on the other side of this portrait are sculptured F's . . .

He continues to describe the cover, which had symbolic columns, mottoes in Latin and was enamelled in emblematic colours. Its companion was similar.

> Opening it then, on one side one could see the portraits of the Dauphin with the two H's and the Duke of Orleans with HG., for Henrico.[14]

That too had an elaborately worked cover. The description suggests something like the locket containing miniatures of Catherine de Medici and Charles IX dated 1570 by François Clouet, in the Kunsthistorisches Museum. In terms of setting, both objects anticipate the jewelled lockets enshrining votive images of Gloriana at the close of the century.

88

There is still a miniature of the Dauphin François in the Royal Collection, although its provenance is unknown.[15] The most recent scholarship on Jean Clouet advances this as a possible instance of a detached miniature by him. It is executed in the same manner as those on the pages of *Les Commentaires de la Guerre Gallique* using gouache on parchment. The miniature is circular and depicts the sitter's head and shoulders silhouetted against a blue background, the whole encompassed by a gold border. It is close to a drawing at Chantilly but it could go back to another lost drawing. It is therefore surely probable that it was the sight of something like this by Henry VIII that prompted him to request his new court painter, Lucas Hornebolte, to copy and emulate. The fact that the miniatures of Henry VIII and Catherine of Aragon start at precisely the same time cannot be a coincidence.

The English court had no equivalent to the painter–illuminator Jean Clouet and it is probably the search to find a court artist of this type that was to end in the recruitment of Lucas Hornebolte in 1525. Now that we are able to date the early panel portraits of the royal family it is clear that before Hornebolte's arrival there was no portrait painter of any standing in England. As the demand for portraits increased, Henry VIII must have been acutely aware of this. His existing court painters, from what we know about them, were first and foremost designers of scenery and costumes for the magnificent fêtes that were such a marked feature of the first twenty years of the reign.[16] John Brown had been granted the office of King's Painter in December 1511 and had been in royal service as early as 1502. His masterpiece had been the décor for the Field of Cloth of Gold and his finale was the *mise-en-scène* for the 1527 fêtes. He died in 1532. Brown often worked in tandem with a second artist, Vincent Volpe, a Neapolitan, who acted as his principal assistant both in 1520 and 1527. Volpe's annuity of £20 was equal to that of Brown and in 1520 he was referred to as a King's Painter. He died in 1536. Neither of these artists, however, is known to have painted easel pictures.

All the evidence suggests that by the 1520s Henry VIII may well have been anxious to find an illuminator–painter of the Clouet type. There was, in other words, need for a new type of court artist whose prime task from the start would have been seen in terms of painting portraits, although he would have been expected to be equally active if called upon as a designer for the decorative arts. In spite of the fact that no single work by Hornebolte dating from his Low Countries period is known, he must already have been seen as being the man capable of fulfilling this need. That he was paid three times as much as Brown or Volpe reflects that from the moment of his arrival he was to take up a position as *the* King's Painter, a role which not even the appearance of Holbein was to threaten.

In the summer of 1527 Henry VIII was able to send, through his representative in Paris, portraits of himself and of the Princess Mary to François I. On the back of them were painted various royal devices, which were explained to the French King who, at the first sight of Henry VIII's face, took off his bonnet saying 'Je prie Dieu que il done bone vie et longe.' He then contemplated and commended that of the Princess.[17] Surely this is Henry VIII emulating Madame d'Alençon's gift of symbolic portrait miniatures six months previous? The Hornebolte family had by then arrived and were working for the Tudor court.

The members of the Hornebolte family that came to England were three: Gerard, the father, his son Lucas and a daughter, Susanna.[18] They were representatives of a family of artists who had lived and worked in Ghent for several generations. Although Gerard is the least important from the point of view of the history of the portrait miniature, he is the central link from whence sprang its technical tradition as well as epitomizing the extensive orbit of activity that was to characterize the limners of the Tudor and Jacobean court. Gerard was admitted to a full membership of the Guild of St Luke in Ghent in 1487 and henceforth presided over a large and important atelier and became, in 1515, court painter to Margaret of Austria, Regent of the Netherlands. With the exception of the Bennincks, the Horneboltes were the foremost exponents of the Ghent–Bruges School of illuminators. Gerard's notable contributions to the *Grimani Breviary* and the *Sforza Book of Hours*, for which he was paid in 1521 for having executed sixteen miniatures, have long since been identified by historians of the art of illumination but – and this is crucial – he presided over a family workshop that received commissions for portraits, altar-pieces, designs for vestments, stained glass windows and tapestries. He is even known to have executed maps and plans of towns. Indeed, his last recorded payment from Margaret of Austria was for a portrait of Christian II of Denmark. The fact that no one so far has identified his other work has obscured its existence. It has obscured along with it the range that such artists working within the ambience of the opulent late Burgundian court were expected to cover as the norm of their activity.

Very little is known about Gerard Hornebolte's stay in England, which was short, for the accounts only record payments to him between October 1528 and April 1531 – although at that point there is a break in the records.[19] Various scholars have drawn together a coherent *oeuvre* for Gerard during these four years in England. The most spectacular items are the illuminated *Epistolary* from Christ Church and *Lectionary* from Magdalen College, Oxford, which were first attributed to the Hornebolte family in 1953.[20] Both these splendid manuscripts were probably intended for use in Cardinal Wolsey's foundation, which was re-established by Henry VIII as Christ Church. The style is that of the *Sforza Book of Hours*. There is an overlay of Renaissance decorative detail in the architecture of the scenes and in the putti, for example, supporting the coats of arms, along with the customary naturalistic sprays of flowers scattered in the margins.

In the 'Expences laid owt by Thomas Crumwell aboute my Lord his Colledge at Oxford' from Michaelmas 1528 to 1529, there is a payment of 16*s* 8*d* 'To Gerarde' in connection with the writing and decoration of the patents.[21] So startlingly different in style are these from their predecessors and so accomplished in draughtsmanship is the likeness of the King that it would be difficult to deny that this 'Gerarde' must indeed have been the recently arrived Flemish illuminator. There are three patents in all, one for Cardinal College, Ipswich, dated 26 May 1529, and two others for Cardinal College, Oxford, dated 5 May 1526 and 25 May 1529 respectively. They are all by the same artist, executed in pen and wash, variants of a single frontal image of the King, all with the same mannerisms in the pen work particularly in the treatment of the robes. So similar are they that one would suspect that a pattern of some sort was kept to hand. The likeness of Henry VIII is a portrait likeness in keeping

12

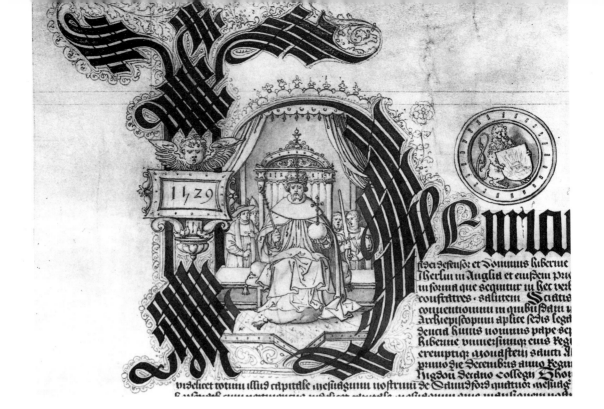

12 *Henry VIII enthroned*, on the patent for
Cardinal College, Oxford, 1526. Drawing
attributed to Gerard Hornebolte

13 The emergence of the portrait
miniature. A portrait of Henry VIII
attributed to Lucas Hornebolte on the
letters patent to Thomas Forster, April
1524

with the strong portrait tradition in the Ghent–Bruges School as indeed are the flanking figures in two of the patents which depict Cardinal Wolsey and Thomas Howard, Duke of Norfolk. As a group they break totally new ground in their presentation of the monarch in terms of three-dimensional pictorial space. One more document, unfinished, has also been assigned convincingly to Gerard, the drawings on the obituary roll of John Islip, Abbot of Westminster in 1532. It is in the same line and wash manner as the patents.[22]

Lucas, the son, was cast from the outset to be a dominant figure in the court art of Henry VIII. He arrived earlier than his father, for he is mentioned in the accounts for September 1525.[23] By any standard the annuity granted to him was generous. Gerard was awarded £20 p.a., his son, just over £30 p.a., more than was given later to Holbein. This he was to draw until his death in 1544. The amount implies a position as *the* artist above every other serving the court. The position that he occupied should perhaps be seen as exactly analogous to that of Bernard van Orley (*c.* 1492–1542), who served two Regents of the Low Countries, Margaret of Austria and Mary of Hungary, as court painter. As well as religious pictures, he painted portraits of members of the ruling house; but in addition he was active as a designer for the decorative arts, in particular stained glass and tapestries. Hornebolte, with a slightly different range, was as important an artist for the life of the Tudor court, a fact which has been lost sight of because we have become so accustomed to seeing it in terms of the work of Holbein, who was only effectively in its service from about 1536 to 1543. Hornebolte served Henry VIII for almost twenty years and needs therefore to be pushed to the front of the stage as the major artist of the court, at least in the eyes of its King.

Money must have been one significant inducement to the Horneboltes for coming to England, but religion, it has been suggested, may have been another. Lutheran sympathies were strong among the artists of the Low Countries and England offered one of the few havens from the imperial ban promulgated by the Emperor Charles V in 1521. Another possible link, it has also been suggested, may be the Boleyns. Sir Thomas Boleyn had been sent on an embassy to the Low Countries with Sir Edward Poynings in 1512 and remained there a year at the court of the Regent. Subsequently his daughter, Anne, was placed as *demoiselle d'honneur* to Margaret of Austria. The Boleyns were leading Lutheran sympathizers and as the King's mistress Anne's star rose fast during precisely the period that Hornebolte entered royal employ. Indeed, Lucas is first referred to as King's Painter in 1531, a grant which was confirmed for life on 22 June 1534, the day before Anne's brother was made Lord Warden of the Cinque Ports. The grant by the King reads as a eulogy: 'For a long time I have been acquainted not only by reports from others but also from personal knowledge with the science and experience in the pictorial art of Lucas Hornebolte and I nominate, constitute, and declare him by these present letters to be my painter.'[24]

Early Tudor artists continue to be mysterious figures and it is important at this point to establish what we certainly know that he could do as against what we may speculate that he and his workshop could have done. One certain fact is that Lucas had been trained by his father as an illuminator and Vasari refers to him in his *Vite* as among the four Flemish illuminists who 'have been excellent', his father figuring among the other three.[25] A collection of Latin

epigrams by John Leland, humanist and antiquary, refers to Hornebolte as painting the devices of the King and his third queen, Jane Seymour.[26] This means that he was capable of decorative painting, although what form those particular ones took we have no means of knowing. His connection with the art of portrait minuatures, however, entirely hangs on a statement made by Carel van Mander in 1604 and it is to a consideration of this that we must now turn.

Lucas Hornebolte:
the miniatures

Van Mander says that it was only at a late period that Holbein took up the art of miniature painting. At the time he met at court a very famous master in that art, named Master Lucas.[27] Without that fact we would never know that a painter called Lucas at the court of Henry VIII taught Holbein how to paint portrait miniatures. What follows must depend on an acceptance of the equation of that 'Master Lukas' with Lucas Hornebolte and the association of that figure with the just over twenty miniatures that can be assigned to the period *c.*1525–44 and which have the same stylistic features and technical mannerisms.

There are twenty-three miniatures that can be attributed to Lucas Hornebolte.[28] They are all absolutely consistent in style and set the format for the Tudor miniature for the remainder of the century. They are all painted on vellum mounted onto card, circular in form, except for two which are rectangular, and their diameter ranges between about 30 mm and 50 mm. Their background is of blue bice smoothly floated on and the portrait is always confined within an inner circle of gold. Hornebolte's delineation of his sitter is over a transparent 'carnation' ground that was usually a stronger pink than, for instance, Hilliard was later to use. Over this the features are built up by hatching with the brush in red and grey lines. Two mannerisms which unite his rendering of the features are the pouchy heavy look he gives to the eyes of his male sitters and the full red lips he gives all of them. Hair is drawn in single lines over a middle tone in exactly the same way as the costume is modelled. The overall effect is of a transparency heightened by the even frontal lighting of the sitter. The kinship of this technique to that of the illuminator is emphasized above all in the delicate touches of gold outlining patterns on the dress or defining the shape of a jewel. Gold came in powder form and for these details was applied over an ochre ground, whereas for the encompassing line it was applied directly over the vellum. A final feature that nine out of twenty-two share is the lettering, which represents perhaps Hornebolte's least happy addition to his compositions. The letters, which are in gold and placed on the blue ground on either side of the sitter's head, are in Roman capitals and give the age and sometimes their identity in contracted form.

One vital document has only recently emerged, the miniature of the King on the letters patent to Thomas Forster dated 28 April 1524. The document pre-dates the earliest detached miniature, although this decoration could have been added slightly later and indeed so close is it to pl. 16 that it seems likely that this was the case. Whatever the truth of the matter, we are looking here at a limning of the King as part of a manuscript executed either just before or just when it became a detached object in its own right.

Unlike the portraits of Jean Clouet, these were observed from life in the case of each prime version, without any intermediary drawing. But patterns quite clearly were kept in the workshops enabling the manufacture of repetitions.

13

33

Most of Hornebolte's miniatures exist in duplicate and in some instances up to as many as four versions are known. In two instances, portraits of the Emperor Charles V and Margaret Beaufort, Countess of Richmond and Derby, he copied oil portraits. But there is another remarkable fact. Out of the twenty-two, seventeen are identifiable beyond dispute. They are all members of the royal family: Henry VIII, his first queen, Katherine of Aragon, his third queen, Jane Seymour, his son, Edward VI, his eldest daughter, Mary I, his illegitimate son, Henry, Duke of Richmond, his grandmother, Margaret Beaufort, his nephew by marriage, Charles V. The only sitter seemingly from outside this charmed circle is Thomas Seymour, Lord Seymour of Sudeley, but he married Henry's sixth queen Catherine Parr on the King's death and was brother to his third queen. What we may conclude from this is surely the extreme exclusivity of these tiny likenesses by the King's Painter. The sitters can be plotted across a family tree of the Tudor dynasty and its collaterals. This is powerful evidence that the three sitters that remain less certainly identified in fact record the features of two more queens – Anne Boleyn and Catherine Parr – and Charles Brandon, Duke of Suffolk, the King's brother-in-law. We are not in a position absolutely to prove this but the evidence would point that way.

The miniatures attributed to Lucas Hornebolte, which begin with the *Henry VIII* in the Fitzwilliam Museum, have no predecessors in England. In the Low Countries, the detached cabinet miniature, generally rectangular, had been in 14 existence since the previous century and had included portraits.[29] But in England we have to postulate an element of novelty, an innovation that suddenly caught on, prompted, as we have already suggested, by the portrait miniatures of Jean Clouet. That innovation could easily have been accelerated by an urgent need for portraits for diplomatic use. Limning, unlike oil painting, was a fast medium. Later Holbein, faced with little time, solved the dilemma by painting the King's fourth bride, Anne of Cleves, in this way. 45 Miniatures also had the advantage of being small and easily transportable.

Hornebolte's miniatures fall into two distinct groups. The first group opens with the Fitzwilliam *Henry VIII* and continues with three more of the King, all part of a group of early Tudor miniatures presented by Theophilus Howard, Earl of Suffolk, to Charles I.[30] Two are repetitions of the Fitzwilliam Henry with variants in the dress. This establishes that limners were expected to produce replicas and repetitions of royal portraits from a basic pattern in the studio, an aspect which, by the Jacobean age, had reached almost factory proportions. The third bears again the age of thirty-five, but the King is 16 bearded and in spite of the fact that Abraham van der Dort, the compiler of the catalogue, misleadingly categorizes it as 'but meanlie done', it is unlikely to be other than from life, the result of a second sitting. In all these the basic format is derived from Jean Clouet – the circular form, pose, blue background and gold border – but as seen through Flemish eyes. There is also a striking comparison with Dürer's portrait woodcuts, in which he makes use of the head and shoulders format, whereas the standard Flemish format was half length, generally with the hands placed on a ledge before the sitter. Lucas Hornebolte knew Dürer, who had visited Gerard's atelier in 1521. The connection with these large portrait woodcuts goes beyond the use of the head and 19 shoulders formula, however. Hilliard was later to advise copying such woodcuts as training for limning because the lines of the engraver technically

Lucas Hornebolte

Henry VIII's court painter for almost two decades, 1525–1544

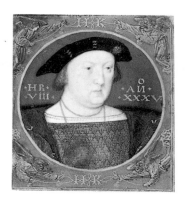

14 *Henry VIII*, 1525–6
(see also colour pl. I)

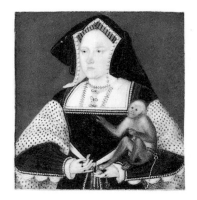

15 *Katherine of Aragon*, *c*.1525–6

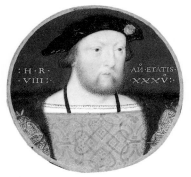

16 *Henry VIII*, 1525–6

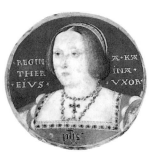

17 *Katherine of Aragon*, *c*.1525–6

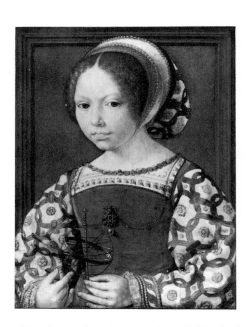

18 Mabuse, *?Jacqueline, daughter of Adolphe de Bourgogne, Lord of Beveran and Veere*, *c*.1520–25

19 Dürer, *Woodcut of the Emperor Maximilian*, *c*.1518–19

echo exactly the process of building up a miniature over coloured grounds by means of lines and cross-hatching in watercolour.

Portraits of the King are inevitably complemented by a series of the Queen, Katherine of Aragon, which can be dated to the same period and includes repetitions.[31] Of these, one is of outstanding importance, a unique rectangular miniature depicting her feeding her pet marmoset.[32] This is the only miniature by Hornebolte which extends the figure to a half length and includes both hands. The composition derives from a portrait formula with which he would have been familiar, that evolved in the period immediately prior to his departure from the Netherlands by Jan Gossaert, also known as Mabuse (active 1503, d.1532), who worked for the collateral branches of the Habsburg family in the Low Countries, including occasionally the Regent Margaret of Austria, to whom Lucas's father, Gerard, had been court painter. Gossaert's portrait of a little girl, traditionally identified as Jacqueline, youngest daughter of Adolphe de Bourgogne, Lord of Beveran and Veere, painted about 1520–25, is a typical example.[33] It advances beyond the format inherited from the previous century and still used by Bernard van Orley, in which the figure fits tightly into a small panel surface with the hands placed on a ledge at the front, by giving the sitter more space, dispensing with the ledge and engaging the hands in gesture, in this instance holding and pointing to an emblematic armillary sphere. Lucas Hornebolte's portrait of Katherine of Aragon does exactly the same in terms of space and by placing her hands before her waist; her left arm supports her marmoset, and in her right hand is a morsel of food.

Other of Lucas Hornebolte's miniatures continue these initial statements into the early 1530s: an emaciated Mary Tudor wearing a huge jewel inscribed 'Emperor',[34] two of an unknown man, probably the Duke of Suffolk, two more which are possibly of Anne Boleyn,[35] likenesses which would, if correct, confirm her enormous attraction and vitality beside the corpulent, flaccid Katherine, and, as a *tour de force*, the pale, almost deathly features of Henry VIII's illegitimate son, Henry FitzRoy, Duke of Richmond, clad in nightcap and shirt, and probably painted on his sickbed.[36]

Hornebolte seems so far to have been totally unaffected by the work of Hans Holbein. The latter had arrived in England only a year later than Hornebolte, in 1526, but his work had been almost exclusively confined to the humanist circle of Sir Thomas More and his friends. No interest was shown by the King or the court. Holbein went back to Switzerland until the religious disturbances led him to return again to England in 1532. As on the previous occasion the court initially showed no interest whatever. Holbein's potential seems to have been recognized first by the dominant figure of the decade, Thomas Cromwell, who was masterminding the legislation carrying through the vast politico-religious revolution of the Reformation. Cromwell quickly cast Holbein into the role of a visual propagandist and by 1536 he had entered the service of the King. The two artists must have met earlier, however, for according to Van Mander Holbein was taught the art of limning by Hornebolte. We can certainly date their relationship to at least as early as the first known Holbein miniature, which is of Thomas Cromwell himself, painted *c.*1533–4. It seems that at long last the King and the court recognized Holbein's infinite superiority as a portraitist, a fact which surely must explain why so few miniatures by Hornebolte survive from the period after about 1535.

Lucas Hornebolte *Portraits of the royal family*

20 *?Charles Brandon,*
Duke of Suffolk, c.1530

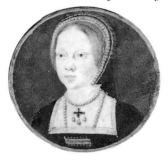

21 *Mary I as a Princess,*
c.1525–9

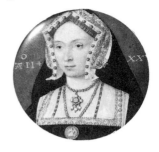

22 *?Anne Boleyn,*
c.1532–3

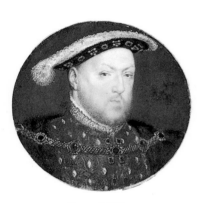

23 *Henry VIII, c.1537*

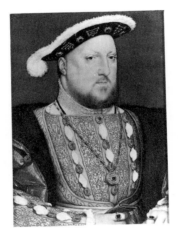

24 Hans Holbein, *Henry*
VIII, c.1536–7

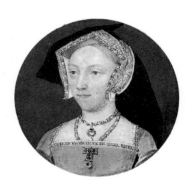

25 *Jane Seymour,* 1536–7

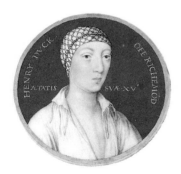

26 *Henry FitzRoy, Duke*
of Richmond, c.1534–5

27 *Edward VI as Prince*
of Wales, c.1541–2

28 *?Catherine Parr,*
c.1543–4

By far the most important of these is that of Henry VIII.[37] It is a deceptive 23
object. In the past it was attributed to Holbein, but it is by a right-handed artist
and the style is typical of Hornebolte. That it was assigned to Holbein is hardly
surprising for it is related seemingly so closely to the sitting Henry VIII gave
for the portrait now in the Thyssen Collection which once formed a diptych 24
with one of Jane Seymour. This was the likeness which Holbein also initially
used in the cartoon for the wall-painting of the Tudor dynasty in the Privy
Chamber of Whitehall Palace in 1537 but ended up by replacing with a full
frontal view of the King's face.[38] In fact the Hornebolte miniature is more
independent of the Thyssen portrait than appears on first encounter. The hat is
the same but the shirt, doublet and coat are different and the only jewel to
appear is the great collar of rubies that is in the cartoon but not the painting. So
close is the face but so lively in its painting that it is arguable whether it has
been worked up from the Thyssen portrait or whether it was the result of
independent observation under its influence.

The Jane Seymour portrait too[39] seems at first to be no more than a 25
derivative of the well-known Holbein portraits. The dress, however, is
different, as is the jewel on her bodice. The necklace and pendant are the same,
as is the jewelled gable headdress, but the arrangement of the folds of its black
tube is again quite different. Such a portrait could have resulted from a sitting.
This problem does not arise, however, in the case of the remaining miniatures
and the one of the boy Prince Edward[40] is quite clearly a totally independent 27
image, as is the one of a woman whose costume is of the early 1540s and who 28
could be a likely candidate for a portrait of Catherine Parr.

This reference to Henry's last queen brings with it a final baffling piece of
documentation. In May 1547 in her accounts there occurs an entry which pays
the sum of 60s to 'Lucas wyfe for makynge of the Quenes pycture & the
Kynges'.[41] Is Lucas's wife Hornebolte's widow? Does it mean that Lucas's
wife painted portraits? If so the sum of 60 shillings would rule out limnings
on account of its size. A painter called Maynard was paid 40s in 1511/12 for
painting a portrait of Margaret Beaufort and thirty years on,[42] and with all the
intervening inflation to take into account, George Gower was only charging
twenty and forty shillings for half-length portraits.[43] These would indicate that
the payment must have been for life-size portraits. Catherine Parr had a
passion for miniatures which we find reflected in a letter dated 17 May 1547
from her husband-to-be, Thomas Seymour, Lord Seymour of Sudeley: 'Also I
shall humbly desyer yor highnesse to give me one of yor small pictures, if ye
have any left . . .'.[44] By then the court had a successor to Hornebolte called
Levina Teerlinc.

*The Hornebolte
Workshop*

Gerard, Lucas and his sister, Susanna, must have formed a workshop on their
arrival in England along the lines of that which they had run in the Low
Countries, able to accept a wide variety of commissions. Such a workshop
would automatically have included assistants to grind colours, prepare panels
and carry out routine parts of commissions after the master's designs. The
resulting quality would have been enormously variable according to the
importance of the commission and to the ability of those who carried it out.
Gerard's workshop illuminated manuscripts, prepared designs for vestments,

tapestries and stained glass windows and painted portraits. It would be surprising if the talent and technical expertise in all these fields were consistent. Lucas, it would be reasonable to conclude, must have run an atelier along the same lines. And it is to a speculation of what that might have produced that we must now turn.

The twenty-two portrait miniatures span two decades. They can never have been much more than a side-line for Hornebolte in his role as King's Painter. Using them, we ought to be able to postulate an *oeuvre* drawn from a far wider sphere of activity. In the first place, Hornebolte was an illuminator and, as we have already seen, fully capable of executing important miniature portraits of the King on official documents. One of the most significant compilations of the 1530s was the *Valor Ecclesiasticus*, or the 'King's Book', the valuations of church property in England and Wales – bishoprics and benefices as well as monasteries and colleges – begun by Cromwell's commissioners in 1535. This contains two splendid miniatures of Henry VIII, one from 1535 and the other from 1539. His detached portrait miniatures are, of course, executed far more tightly, as one would expect, but the style and handling of the hatching in these illuminations are unmistakable. In both instances the monarch is flanked by officials – certainly the result of study from life. The style is exactly what we would expect, a continuation of that of Gerard, but less assured in manner and less certain in line. These are two instances that relate to a whole series of illuminations of Henry enthroned which adorn letters patent and charters issued during the last decade of the reign; such illuminations could have stemmed from the Hornebolte atelier.[45]

The first initial in the *Valor Ecclesiasticus* recalls strongly an even more celebrated image of the King, that on the title-page of the *Great Bible* of 1539.[46] The figures in a frieze along the top on either side of the enthroned monarch re-echo exactly, in the movement of their legs, the gestures of their hands and the angles of their heads, the attendant courtiers in the portrait initials. The *Great Bible* was a government sponsored publication, the supreme act of the King in giving the Word of God to his people in the vernacular. It is, of course, far less distinguished than Holbein's title-page to Coverdale's Bible of 1535. The *Great Bible* title-page is conceived not in terms of its medium but in those of an outline drawing for an illumination. That drawing could have stemmed from the Hornebolte workshop.

These formal images of the King allow us to suggest one other object which could have been from a Hornebolte pattern: Henry VIII's third Great Seal in use from 1542.[47] The inscription incorporates the vast changes in the politico-religious structure of the state in the words 'et in terra ecclesiae Anglicanae et Hibernicae supremum caput'. The features that look out are those familiar from the initial illuminations, and the treatment of the folds of the robes is the same. As is well known, Hilliard was to design Elizabeth I's second Great Seal and he prepared patterns for a third. Could this not mean that in the normal terms of the Tudor age he was doing what previous court painters had done, that is supplying designs for the seals of state? The work of engraving and making the models and dies for the Great Seal was, of course, quite a separate operation, and it was the province of the King's goldsmith and the engravers at the Mint. Henry VIII's third Great Seal is as dramatic a break with its Gothic predecessors as Gerard Hornebolte's portrait illuminations had been in 1526.

Two other manuscripts deserve consideration as examples of the activity of Hornebolte and his workshop during the 1530s. Both are regal items, ones directly used by or familiar to the King. The first is the *Liber Niger* which records the history and annual chapters of the Order of the Garter, written and illuminated in the year 1534.[48] The Garter was revived by Henry VII and above all by his son as a chivalrous order to emulate that of the Golden Fleece. Its ceremonies were deliberately elaborated and it was Henry VIII who, for example, made it mandatory for all its Knights to wear the badge of the Lesser George at all times. Throughout the century and into the next it lay at the heart of Tudor chivalry. Although several hands were at work in the *Liber Niger*, which is profusely illuminated, the visual formula followed is consistently that of the Ghent–Bruges School. In other words, it was probably the major commission of the year 1534 by the Hornebolte atelier and the main scenes are certainly by Lucas himself. The borders vary between the traditional ones of naturalistically depicted flowers, against a plain or chequer-board background, and arabesques in the early northern Renaissance style. The book opens with a full-length portrait of Edward III's queen, Philippa, in a Tudor dress of gold with a gable headdress, flanked by a herald and an official with six ladies-in-waiting behind her. Henry VIII himself first appears kneeling at prayer in a portrait image which draws on likenesses of him in the early part of his reign before Hornebolte's arrival. This is followed by a long series of illuminations of all the monarchs from Edward III, culminating in a series depicting the Garter ceremonies of 1534.

29

On the upper part of the first page, Henry VIII is shown enthroned in the familiar Hornebolte format. He is depicted as he was in that year and the portrait is of a much older man. On either side stand his Knights, each one a portrait and, certainly in the case of the English members, the result of observation. As in the case of the *Valor Ecclesiasticus*, the portraits are less highly finished than they would have been for a detached miniature, but the approach and brushwork are identical. This scene is followed, in the lower part of the page, by the beginning of a procession which winds its way across the next page through two rooms, ending with three Knights being received by a prelate in a chapel. Above each Knight hangs his coat of arms so that we are able to identify them and each, again, is a portrait. The *Liber Niger* must surely rank as one of the finest achievements of the Hornebolte atelier in the 1530s. It is, in any case, perhaps the most remarkable product to survive from it. It evokes Tudor chivalry, the obsession of the court with portraiture, its preoccupation with stately ceremonial and the free mingling of styles which was so typical of the period, sinuous late Gothic figures encompassed by pure Renaissance decoration in the new antique manner. The *Liber Niger* ranks as one of the major manifestations of Tudor court style.

30

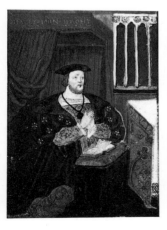

29 *Henry VIII at Prayer.* Illumination from the *Liber Niger* of the Order of the Garter, *c.*1534

The borders of the *Liber Niger*, with their early Renaissance arabesque ornament on a blue ground, classical profiles within medallions and royal coats of arms flanked by putti, recall directly a spectacular survival, Henry VIII's writing desk, now in the Victoria and Albert Museum. This sumptuous and rare piece is the only surviving instance of what must have been a quite normal type of decorative item produced for the court. Among the presents received by Henry VIII on New Year's Day 1539 was a fire-screen: 'By Lewcas paynter a skrene to set afore a fyre, standing uppon a fote of woode, and the skrene blewe

34

Hornebolte as an illuminator and designer

30 *Henry VIII Enthroned Flanked by Knights of the Garter*. Illumination from the *Liber Niger* of the Order of the Garter, *c.*1534

31 *Henry VIII Enthroned*. Illumination from the *Valor Ecclesiasticus*, 1535

32 *Henry VIII Enthroned*. Woodcut from the *Great Bible*, 1539, possibly after a design by Lucas Hornebolte

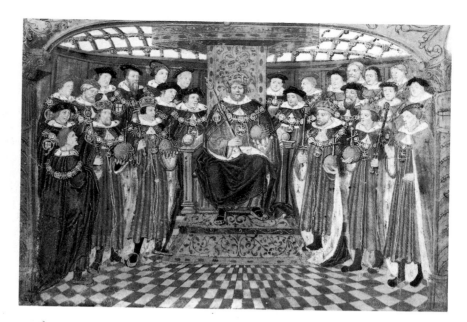

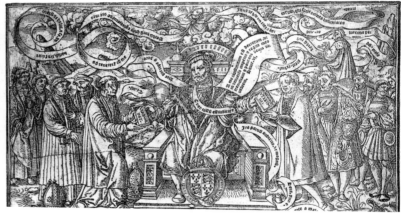

33 Henry VIII's last Great Seal, 1542, by Morgan Wolff, possibly after a design by Lucas Hornebolte

34 Henry VIII's writing desk, *c.*1525–9, possibly designed and decorated in the workshop of Lucas Hornebolte

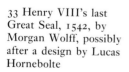

worsted'.[49] Although it can be argued that Hornebolte's workshop did not make this screen it can as equally be argued the other way. I would at least like to suggest that the writing-desk would fit neatly into the output of such a workshop. In the midst of one of the decorative panels the face of Christ as *Salvator mundi* stares out in a manner familiar from countless Ghent–Bruges manuscripts. The desk is a costly object, an innovation from abroad reflecting the new luxury of the court. It must date from before 1529 as it still celebrates Henry and Katherine of Aragon bearing many of her badges: H and K joined by a lover's knot, the pomegranate and the sheaf of arrows. The allusions to them are elaborated in the figures of Mars and Venus (after woodcuts by Hans Burgkmair) and there is a Latin inscription which invokes God to give the King 'a great victory' over his enemies. Such an object must have had a designer and Lucas Hornebolte would seem the most likely candidate.

Hornebolte and the Cast Shadow Master

The years *c*.1525 to 1544, during which the Hornebolte atelier was active, coincide exactly with a series of paintings which at present are given to the workshop of an anonymous painter called the Cast Shadow Master, in reference to the shadow which appears almost like a signature in all of them. Consideration should be given as to whether the Cast Shadow Workshop and the Hornebolte atelier could have been one and the same thing.[50] About a dozen of these pictures have been identified, although their condition is variable and few have been subjected to modern scientific cleaning and restoration. As a group, they continue the tradition established under Henry VII of sets of kings and queens based, in the case of the earlier monarchs, on pictures already in the Royal Collection. As we have seen, at about 1515–20 there was a similar spate of workshop likenesses of this type of kings and queens. The Cast Shadow Workshop paintings form a quite separate series, however, beginning in the 1530s and coinciding exactly with the great activity in palace decoration necessary to adorn the interiors of Whitehall and Hampton Court. Examples include portraits of Henry V, Henry VI, Edward IV, Henry VIII, Jane Seymour and Edward VI as a boy.[51] The last takes us right up to the close of Hornebolte's life in 1544 when the prince was seven. It is significant perhaps that none can be dated later.

All of these portraits are somewhat mechanical in quality, repetitions with variations of older or existing versions, and their function from the first was as interior decoration. The format stems from Netherlandish portraiture of the early 1520s, and in particular the work of Bernard van Orley, who was court painter to Margaret of Austria at the same time as Gerard, Lucas's father. The sitters are nearly always depicted half length with their hands placed on a ledge in front of them, the figure tight within the panel's surface, with the shoulders and arms cut into. In other words, the format was old-fashioned for the 1530s. The backgrounds are always a plain colour, brown, orange or green, with a cast shadow to one side. What links them so strongly to Hornebolte is the calligraphic approach to the handling of the paint for, like the miniatures, the features and hair are drawn and hatched in calligraphically rather than by means of glazes. The hair is drawn as a series of lines and each eyelash is painted separately. The lips are the small rosebud lips of the miniatures.

These portraits can never have been more than workshop pieces for palace decoration, which Hornebolte may have supervised. One picture which shares

The Cast Shadow Master

A series of portraits by this painter and his workshop postulate an equation with Lucas Hornebolte and his atelier.

35 Cast Shadow Master, *Margaret Pole, Countess of Salisbury, c.*1530

36 Cast Shadow Workshop, *Henry VI,* 1530s

37 Bernard van Orley, *Margaret of Austria, c.*1525

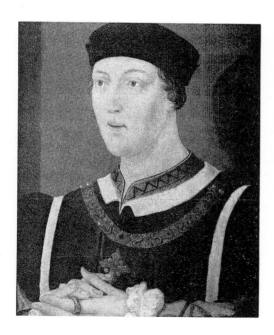

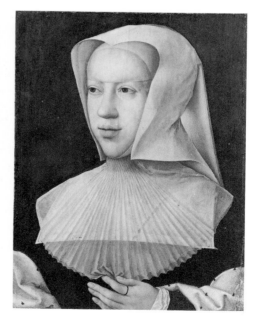

the same tricks and mannerisms is far superior in quality and that is the portrait believed to depict Margaret Pole, Countess of Salisbury,[52] a Plantagenet by birth and a devout Catholic, who was governess to the Princess Mary. She ranged herself with her charge and her mother, Katherine of Aragon, over the divorce, and the portrait should date from before 1533 when she ceased her role as governess. Against a plain green ground with the customary cast shadow arises the figure of a middle-aged lady (she would have been fifty in 1533) with a blanched lean face, the usual tiny lips and her hands, not as in the workshop productions placed on a ledge, but arranged at her waist clasping a honeysuckle and a ribbon from which is suspended a symbolic jewel. The formula is identical to that of the rectangular miniature of Katherine of Aragon. It has the same slightly glazed look about the eyes that runs through all Hornebolte's portraiture. The gesture of the left hand clasping the flower matches exactly, but in reverse, Katherine's right hand holding the morsel for the marmoset. In this we may be looking at the cornerstone for any future development of autograph panel paintings by Hornebolte.

Susanna Hornebolte

Lucas's sister, Susanna, was also trained as an illuminator, for no less a person than Dürer saw and admired a detached miniature by her, a *Salvator Mundi*, when he visited the Hornebolte atelier in 1521.[53] Auerbach makes a case for her being the author of a unique depiction of Christ as the Man of Sorrows on the Plea Roll for Easter 1545.[54] This is in the usual Ghent–Bruges School manner and would seem a typical contribution from the Hornebolte atelier. She did not receive a separate annuity, so that we have no way of knowing whether she worked for her brother or not, and to a degree the point is irrelevant since according to the workshop terms under which they operated, work would have been farmed out, shared or undertaken co-operatively. The facts of her life indicate a detached existence but yet not so detached that she could never have practised the art of illumination. She married twice, firstly John Parker, Yeoman of the Robes, who died in 1537 or 1538, and secondly John Gylmyn, Serjeant of the Woodyard. Anne of Cleves made her 'first of her gentlewomen' and she was later in attendance on Catherine Parr. This removed her out of the social level usual for artists and craftsmen categorized as tradesmen and artificers and formed a precedent for her successor as a lady limner, Levina Teerlinc.

Hornebolte in context

This chapter closes, as indeed does almost any study of early Tudor art, with a question mark hanging over it. I cannot pretend to have offered solutions but rather opened up problems and possibilities in a treacherous field of research. Hornebolte was never to be a Mabuse, much less a Holbein, but we have lost track of the fact that this man was for twenty years *the* painter to the court. This attempt to look at both him and his workshop as a rounded entity is deliberately speculative but it faces up to a problem more usually bypassed. Time and again we return to the central and imponderable issue of marrying the documentary evidence, rarely less than cryptic, to the surviving artefacts from the period. This chapter offers no more than what seems a reasonable hypothesis that would justify such an annuity and such a rank as King's Painter. One fact is undeniable and that is that the group of miniatures that we now associate with his name are the foundation stone of the art of limning.

HOLBEIN'S MANNER OF LIMNING: *Hans Holbein*

Hans Holbein was, of course, a far greater artist than Hornebolte, one of international stature, and his appearance within our genealogical tree of limners is at first glance disturbing.[1] It would be far easier, in fact, if he were not there. As we have already seen, we owe to the Dutch historian of the arts, Carel van Mander, the knowledge that he was taught to paint miniatures by Lucas Hornebolte and this we are now able to corroborate by the technical evidence. In order to preserve the story of the limners it is essential to place such a dominant innovative and creative force within a very sharp perspective and this is what I shall attempt to do in considering Holbein's role as an exponent of the limning tradition as it was passed down to Hilliard and the Elizabethan age.

Holbein and the art of limning

Holbein came to England first, as we have already said, in 1526 armed with letters of introduction from Erasmus to Sir Thomas More and his friends. His earliest work was the famous portrait of More himself and the great lost monumental group of the family. His other sitters were almost all correspondents of Erasmus: William Warham, Archbishop of Canterbury, Nicholas Kratzer, who taught astronomy and mathematics to the More family, and Sir Henry Guildford, Master of the Household. It was probably through the last that in 1527 'Master Hans' – if this is he – executed a panorama of the siege of Thérouanne as part of the décor for the fêtes which welcomed the ambassadors of François I. This indicates the first awareness of Holbein by the court but by August of that year he was back in Basle.

It was religious turmoil and lack of patronage that drove him to return to England some time between the end of 1531 and the spring of 1532. The country was changing fast as the momentous events of the Reformation took their course and the humanist circle of Sir Thomas More and his friends was swept away in the revolutionary tide. In spite of the fact that a small army of painters was working on Whitehall Palace between 1530 and 1533, Holbein was not to be numbered among them. His initial commissions came from the London agency of the Hanseatic League in the form of portraits of its members but principally in the two lost wall-paintings for their Banqueting Hall of the *Triumphs of Riches* and *Poverty*. Holbein reappears on the fringes of the court when he was taken up by the King's minister, Thomas Cromwell, who masterminded the legislation which was to destroy the fabric of the medieval English Church and establish the monarchy as absolute. Holbein began by painting Thomas Cromwell and his friends and by designing the frontispiece for Miles Coverdale's translation of the Bible (1536). He came to prominence

in royal service during the period that Jane Seymour was Queen. Conceivably, as Hornebolte may have been a protégé of the Boleyns, he might have slightly fallen in royal favour, but it is more likely that it was quickly recognized that Holbein was an infinitely superior painter of panel portraits. He was also experienced in an area unknown to Hornebolte, monumental wall-painting, something which much preoccupied the King as the vast palace-building programme of the 1530s got under way. Holbein's association with the More circle, not traceable after 1536, was forgiven or forgotten. His years of service to the King entailed a major commission in the form of a celebration of the Tudor dynasty in the wall-painting for the Privy Chamber in Whitehall Palace (1537) and expeditions to paint brides. The annuity he was awarded was just £30 p.a., a fraction less than Hornebolte's.

As Holbein produced so few miniatures and they are recognized to be of such importance it is desirable to print a new listing based on an examination of them in laboratory conditions.

(1) *c.*1533–4 *Thomas Cromwell, Earl of Essex (Private collection)*
All Holbein's portraits of Cromwell stem from a single sitting when he was Master of the Jewelhouse and Privy Counsellor and the most important life-size version is in the Frick Collection, New York. There is no surviving original drawing and Holbein has made no adjustments in reducing this portrait to a miniature, merely lifting the sitter's head and shoulders and placing them within the circular form. Although this miniature could have been painted later in the 1530s its relatively rudimentary approach to the limning format would indicate that it was an early work.[2]

(2) *c.*1535 *George Neville, Lord Abergavenny (Duke of Buccleuch)* 39,
Holbein's drawing of Lord Abergavenny is at Wilton and was once part of the series of Holbein drawings in the Royal Collection. No painting on panel is known to exist by Holbein. As Abergavenny died in June 1535 the sitting must have taken place shortly before that date. The miniature could, of course, have been worked up posthumously but a date close to the Cromwell would seem likely as they are identical in concept. The inscription on the miniature is a later addition by Nicholas Hilliard in his characteristic calligraphy.[3]

38

(3) *c.*1535 *Thomas Wriothesley, 1st Earl of Southampton (Metropolitan Museum* 38
of Art, New York [Rogers Fund, 1925])
This miniature has been trimmed to an oval shape from what must have been its original circular format. As in the case of Abergavenny no oil painting from the hand of Holbein is known but the original drawing is in the Louvre. The dating depends on its close relationship to the miniature of William Roper (no. 5).[4]

38 *Thomas Wriothesley,*
1st Earl of Southampton,
*c.*1535. Trimmed to an
oval at a later date

(4) 1536 *Margaret Roper (Metropolitan Museum of Art, New York [Rogers* 43
Fund, 1950])
The age in the inscription is given as thirty and as Margaret Roper was born in 1505 this firmly dates this miniature to 1536. This and its pendant are the earliest instances of Holbein conceiving of a miniature as a composition in its own right without a related oil painting. No drawing is known.[5]

(5) 1536 *William Roper (Metropolitan Museum of Art, New York [Rogers Fund,* 42
1950])
Pendant to no. 4 and therefore also datable to 1536.[6]

(6) *c.*1536 *Margaret Throckmorton, Mrs Robert Pemberton (Victoria & Albert* 44
Museum [P.40–1935])
The identity of the sitter depends on the coat of arms mounted into the back of
the miniature. This bears the date 1566 although the painting is seventeenth
century. The arms are those of Robert Pemberton of Pemberton, Lancs., and
Rushden impaling those of his wife Margaret Throckmorton. The usual date
assigned to this miniature is *c.*1540–43 but both costume and pose are virtually
duplicated in the portrait of a young woman wearing a white coif at Detroit,
which Ganz dated *c.*1534. More important is the introspection of mood which
it shares with the Margaret Roper. After 1537 Holbein only paints ladies of the
court and the approach is quite different.[7]

(7) ? *c.*1538 *Elizabeth Grey, Lady Audley (HM The Queen, The Royal* 46, 47
Collection [9.v.I])
Previously the sitter was identified as Elizabeth Tuke, wife of the 9th Lord
Audley, but a recent far more likely suggestion identifies her as Elizabeth Grey,
daughter of Thomas Grey, 2nd Marquess of Dorset who married Thomas,
Lord Audley of Walden, in 1538, which could have been the occasion of the
miniature. The drawing is in the Royal Collection.[8]

(8) 1539 *Anne of Cleves (Victoria & Albert Museum [P.153–1910])* 45
The most fully documented of all the miniatures, Holbein having been sent to
paint Anne as a prospective fourth wife for the King. The miniature as a form
enabled Holbein to provide him with a likeness far faster than an oil painting.
An indication of the urgency behind the commission is the fact that the life-size
portrait in the Louvre is on the parchment bearing the original drawing which
has been fastened down onto a wood panel. There would have been no demand
for a miniature of Anne after July 1540 when the marriage was declared null
and it would be reasonable to conclude that the two portraits proceeded in
tandem.[9]

(9) *c.*1540–42 *?Catherine Howard (HM The Queen, The Royal Collection [13])* 48
Two versions exist of this miniature which indicates that it is a sitter of
exceptional status. Duplicates in the case of Hornebolte exist certainly only for
the Queen, which supports the traditional identification of this miniature as
Catherine Howard. The sitter is in addition wearing a jewel which previously
appears around the neck of Jane Seymour. The dating depends on the
identification. An examination of this miniature side by side with no.10
established this to be the livelier of the two and hence the first version.[10]

(10) *c.*1540–42 *?Catherine Howard (Duke of Buccleuch)* 49
A second version of no.9. It was once the same size but has been reduced by
trimming.[11]

Holbein as a miniaturist

Holbein was taught the techniques of limning by Hornebolte and painted miniatures in the decade c.1533–43

39 *George Neville, Lord Abergavenny*, probably c.1535. The inscription is a later one by Hilliard.

40 Drawing of Lord Abergavenny, c.1535

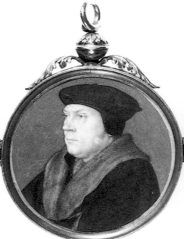

41 *Thomas Cromwell, Earl of Essex, c.*1533–4

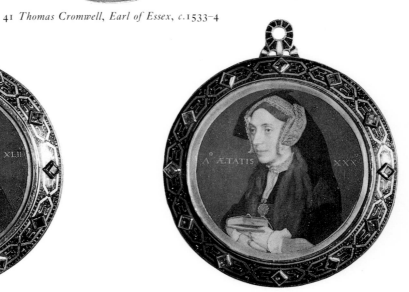

42 *William Roper*, 1536

43 *Margaret Roper*, 1536

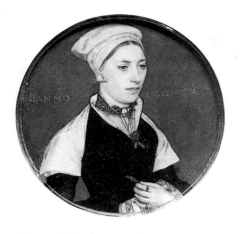

44 *Margaret Throckmorton, Mrs Pemberton, c.1536*

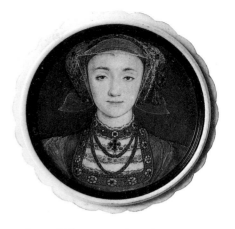

45 *Anne of Cleves*, 1539 (see also colour pl. II)

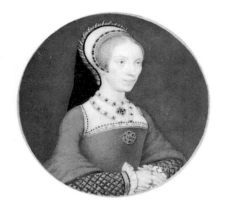

46 *Elizabeth Grey, Lady Audley*, probably *c.1538*

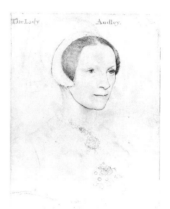

47 Drawing of Lady Audley, probably *c.*1538

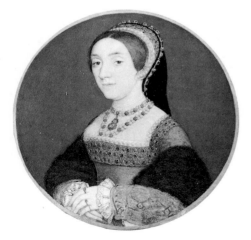

48 *?Catherine Howard*, *c.*1540–42

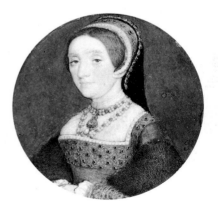

49 *?Catherine Howard*, *c.*1540–42.
Trimmed at a later date

50 *Henry Brandon,*
2nd Duke of Suffolk, 1540–41

51 *Charles Brandon,*
3rd Duke of Suffolk, 1541

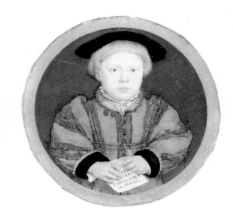

(11) *c.*1535–40 *Unknown Youth (HRH Princess Juliana of the Netherlands)* 52
A difficult miniature to date. It shares the contemplative mood of Mrs
Pemberton and Margaret Roper. The costume could as easily belong to the
mid-1530s as *c.*1540.[12]

(12) 1540–41 *Henry Brandon, 2nd Duke of Suffolk (HM The Queen, The Royal* 50
Collection [18])
The inscription on this miniature ETATIS. SVAE.5.6. SEPDEM./ANNO/1535 is
confusing as it combines the age of the sitter, five, with the date of the month
when the portrait was painted (6 September), with below the impossible year
1535. This could refer to the sitter's birth on 18 September 1535 but it seems
unlikely as the companion (no.13) records the date of the portrait. Henry
Brandon would have been five in 1540–41 and the miniature must have been
painted as one of a pair. Examination under intense magnification suggests that
the date could have been altered.[13]

(13) 1541 *Charles Brandon, 3rd Duke of Suffolk (HM The Queen, The Royal* 51
Collection [17])
The miniature is dated on the piece of paper before the sitter:
ANN–/1541/.ETATIS SVAE 3/.10. MARCI.[14]

(14) *c.*1540–43 *Unknown Man aged thirty-five (Yale Center for British Art* 53
[B.1974.2.58])
Formerly attributed by Reynolds to Hornebolte, neither in composition nor in
profundity of characterization has this miniature anything to do with his work.
It fits well into the series by Holbein, monumental in concept, graphic in
treatment and with an inscription which is typical of Holbein's miniatures and
quite unlike that on ones by Hornebolte. The dating can only be reached on the
grounds of costume: the bonnet and short cropped hair is *c.*1540, close in style
to that worn by William Parr, Marquess of Northampton, in the drawing of
him made almost certainly either in 1541 or 1542.[15]

Two miniatures alone have not been subject to such detailed scrutiny. One is of
Heinrich von Schwarzenwald dated 1543, which was in the former

Stadtmuseum, Danzig, but was destroyed in the last war. The second is of a man called Harry Maynert in the Bayerischesmuseum, Munich. At present we can conclude that there are fourteen certain miniatures by Holbein, with the possibility of a fifteenth and a sixteenth whose status will remain forever indeterminate.

The miniatures present few stylistic problems because they follow exactly the development of Holbein's large-scale portraits during his second English period. But here we must add a *caveat*. Holbein is to some extent a confusing artist within the tradition. His Anne of Cleves and Thomas Cromwell are reduced versions of life-size portraits. In this he stands at variance with all other exponents of the art of limning during the Tudor and Jacobean periods. The explanation is a simple one. Holbein's method of painting a miniature followed closely the process taught him by Hornebolte in all but one thing. Whereas Hornebolte always painted from life with no preliminary studies, directly onto the vellum, Holbein began by executing drawings. In this he is likely to have been influenced by Clouet's drawings, or copies of them, which were circulating both in France and in England.[16] The celebrated series of studies at Windsor is the fruit of these initial encounters with his sitters. These began with a vague indication of form, secondly a detailed drawing in chalk and, finally, the addition of an etched line in ink emphasizing the major contours. From this repertory of patterns, joined to what must have been an astounding visual memory, Holbein was able to scale up and down and thus produce portraits of any size that a sitter might require. We can follow this more precisely in two examples – Lord Abergavenny and Lady Audley – where the original drawings actually survive. This indicates another factor that puts him at variance with his teacher. Whereas Hornebolte must have moved from proficiency in manuscript illumination to painting on panel, Holbein made the reverse journey. The resulting portraits are inevitably very different in character, for they are scaled-down versions of formulae evolved within the monumental portrait tradition of the High Renaissance.

Although Holbein followed Hornebolte's limning techniques, the use of the paint is always aimed at achieving a much more solid and opaque feeling, closer to oil painting and quite unlike the transparent effect of Hornebolte's

39, 40
46, 47

miniatures which derive from the illuminated page. There is also one other significant and useful difference. Holbein was left-handed which excludes, therefore, all miniatures which are hatched by a right-handed person. By this means we can establish that the miniature of Holbein himself must be a copy by Lucas Hornebolte of a lost self-portrait.[17]

The difference between a miniature by Hornebolte and one by Holbein does not lie in technique but in handling and style. In other words Holbein put Hornebolte's technique to different ends. The hatching lines are more regular and the emphasis on the contours of the shape of the head or the features or the costume is not softened but made definite in the same manner as in the drawings and the oil portraits. And the 'carnation' besides being opaque is rarely as pink. The inscriptions, where they occur, are, unlike Hornebolte's, beautifully placed as an integral part of the composition.

Holbein's miniatures excel because of his gift for expressing profundity of character, the face as a mirror of the human soul. This was allied to a minute observation of detail in the form of dress and jewels, an ability to depict the tactile values of cloth and fur, gold and precious stones, all of which are bound together by shapes and forms that confine and hold the portrait image in the simplest terms, ones that belong squarely to the revived classical tradition of the south as against the Gothic twilight of Burgundy. There is an enormous variety in his approach to the placing of a sitter's face and eyes compared with the monotony of presentation by Hornebolte. They can engage the onlooker, as in the case of Anne of Cleves or Catherine Howard, or be downcast, as with Mrs Pemberton or the Unknown Man, or look far away into the distance as with Thomas Cromwell, Lord Abergavenny or Margaret Roper. Because he draws on his formulae for large-scale portraits he includes the hands which he always deploys as an extension of the expression of a sitter's character. This first happens with the Ropers in 1536, she holding a prayer-book to signal her devotion to the Catholic faith, he toughly tugging at the fur lapels of his coat. In the case of Lady Audley the hands express composure as much as in that of Catherine Howard, where the same pose suggests tension. Mrs Pemberton clutches a symbolic leaf, while Charles Brandon writes with pen in hand, an image which reflects the eulogy by contemporaries of his and his brother's precocious intellectual brilliance. Holbein takes over the circular format unquestioningly from Hornebolte, although he superimposes onto it his own calligraphy familiar from his panel pictures.

The Holbein Tradition

The painting of portrait miniatures can never have been more than a side-line for Holbein. The fact that he learned the technique at all is indicative that the Tudor court automatically expected their artists to produce them, as much as being an indication of his own innate curiosity. Certainly in Holbein's case we do not have to argue his involvement in diverse forms of activity: we know that he designed title-pages and woodcuts, that he executed designs for goldsmiths' work and jewellery, that he could carry out commissions for panel portraits and wall-paintings. The diversity of Holbein's activity is documented and it supports the view that in Lucas Hornebolte's instance a similar range of activity was the case.

Half a century on, Nicholas Hilliard was to declare: 'Holbein's manner of limning I have ever imitated, and hold it for the best.'[18]By about the year 1600,

when Hilliard was penning these lines, the appreciation of painting for painting's sake was only just emerging and there was a sudden awareness that in the reign of Henry VIII this country had had in the person of Holbein one of the great geniuses of Renaissance art. Hilliard, despite what he said, did not imitate Holbein's manner of limning, but that of Hornebolte and Levina Teerlinc, neither of whom he ever mentions. He was not to know of the existence of the Holbein drawings, or of the 'great booke' in which they were then mounted which lay hidden in the collection of John Lord Lumley in Nonsuch Palace. Hilliard always assumed that Holbein had painted his miniatures from life, which he had not. The inspiration of Holbein was not a technical one but one of composition and of approach to a sitter.

Holbein's miniatures are so outstanding that they momentarily lifted the art of limning out of its insularity. But after Holbein's death in 1543, as the Reformation cut the country off from direct contact with Italy, that insularity became increasingly apparent. It was already reflected in Holbein's late portraits, including his miniatures, with their more formalized presentation of the sitter and in their preoccupation with the microscopic delineation of dress and jewels. In Holbein's case that exercise still breathes the air of Renaissance scientific observation and discovery. In that of his successors it quickly degenerated into an obsession with external trappings designed to set the sitter apart from ordinary humanity.

GENTLEWOMAN TO THE QUEEN: *Levina Teerlinc*

The demise of both Lucas Hornebolte and Hans Holbein in rapid succession in 1543 and 1544 left the late Henrician court bereft of two of its most important artists. Patronage of the arts was not in abeyance as the King entered late middle age. On the contrary, work on his most extravagant building project, in emulation of François I, Nonsuch Palace, continued unabated until his death in 1547. The problem was, therefore, to find an artist or two who could between them manage first to execute large-scale panel portraits of the King and members of the royal family and, secondly, produce miniature portraits in the Hornebolte tradition and illuminate books. Both Hornebolte and Holbein had come by way of the Low Countries and the indications are that a search must have been initiated there to find who was available. By the autumn of 1545 one artist had been recruited in the form of William Scrots, court painter to the Regent of the Netherlands, Mary of Hungary, who was granted 'at the King's pleasure' an annuity on the same scale as that awarded to Hornebolte of £62 10s.[1] Scrots was a portrait painter. As in the case of Hornebolte no work by him has come to light from his Netherlandish period but a group of portraits can be fairly safely attributed to him in England and establish his role as the purveyor of a glossy court portraiture, stemming from Jacob Seisenegger and Christopher Amberger, which depended for its effect on a dazzling rendering of the surfaces of embroidered and gem-encrusted silk robes. By 25 March 1546 the search for a miniaturist had also reached a successful conclusion in the figure of the female painter, Levina Teerlinc.[2]

Mistress Levina Teerlinc

For some reason scholars have tended to make Levina Teerlinc into a far more mysterious figure than she need be, for there is a relative plethora of documentation. Levina's father was the most famous of sixteenth-century Flemish illuminators, Simon Benninck, head of the family which, together with the Horneboltes, made up the chief exponents of the Ghent–Bruges School of illuminators.[3] He was an artist of international standing, renowned above all for his contribution to the Grimani Breviary. Benninck was born about 1483, a date deduced from the age he attached to his self-portrait, and Levina was the eldest of five daughters. A birth date, therefore, in the decade 1510–20 seems likely, probably nearer 1510, as she came to England already married to a certain George Teerlinc who occupied a minor post at court as a Gentleman Pensioner. Her artistic range was far less than that of Hornebolte but her annuity of the sum of £40, was larger than his. Her social status was also much higher and indeed explains a great deal about her work, for she 'was sworne of the privye chamber to the Quenes Majestie'.[4] Levina

was never a tradesman or an artificer. She was a lady in the entourage of the Queen, a fact which must have contributed to her low output, for portrait miniatures from this period are of the utmost rarity. Those sitters that we can identify continue to belong to the same closed circle that Hornebolte painted of the royal family and its immediate connections.

The first direct reference to her painting a portrait occurs in a warrant from the Privy Council dated 20 October 1551 which orders the payment of £10 to George Teerlinc 'being sent with his wyfe to the Lady Elizabeth's Grace to drawe owt her picture'.[5] The difficulty is to interpret precisely what this payment means. It is a huge amount: with twenty-five years more of inflation Cornelius Ketel was only charging £5 for a full-length portrait and £1 for a head.[6] Even in the Jacobean period Hilliard was charging £4 for a portrait miniature. The payment thus totally defies interpretation because it can be used to prove neither that this must have been an oil painting nor a limning in a jewelled setting. It tells us nothing beyond the fact that a portrait of the Princess Elizabeth was painted in 1551.

More interesting is the fact that as a gentlewoman to the Queen she had to present her mistress each 1 January with a New Year's gift. These begin in 1553 with an appropriately devout miniature for Mary, 'a smale picture of the Trynite'.[7] This piece of documentary evidence has been known since the last century but as most of her gifts to Elizabeth I have not been published and as they shed an abundance of light on Teerlinc's work it is worth while recording them in full:

1559 'By Mistress Levina Terlyng the Quenis picture finly painted upon a Card. With the Quene by Mistress Newton.'

1562 'By Mistress Levina Terlyng the Quenes persone and other personages in a boxe fynely paynted.
With her said majestie.'

1563 'By Mistress Levina Terlyng a Carde with the Quenis Majestie & many other personages.'

1564 'By Mistress Levina Terling a certayne Journey of the Quenes Majestie and the Trayne fynely wrought upon a Carde.'

1565 'By Mistress Levina Terling a howse paynted and theraboute certayne parsonages in a case of walnuttree.

1567 'Mistress Levyne Terlyng the Picture of the Quene her Majesties whole stature drawne upon a Carde paynted.
Delyverid to Elizabeth Knowles.'

1568 'By Mistress Levina Terling a paper paynted with the Quenis majestie and the knightes of thorder.
Deliyverid to the said Blaunch Pary.'

1575 'By Levina Terlinge a carte paynted vpon a carde of her Majestie and dyvers other personages.'

1576 'By Mistress [Levina] Teolyng the Quenes picture upon a Carde.'[8]

These entries tell us more than any other surviving documents. They reveal the Queen's passion for miniatures of herself, for New Year's gifts always aimed to please, and any doubt that they did so is dispelled by the annotation 'with her said majestie', which meant that two pleased her so much that she held onto them instead of passing them on to the relevant member of her household. The range of subject-matter is enormously ambitious, far more

than was ever to be essayed by Hilliard, who never rose to attempting these elaborate tableaux of the Queen on a progress or surrounded by her court. These lost miniatures put Hilliard's work into sharp focus because they reveal that Levina was still painting the Queen in 1576, four years after Hilliard's famous miniature of her. Furthermore, as early as 1567 she was executing full-length miniature portraits, a format Hilliard was not to embark upon until the late 1580s. Subject-matter must have been radically affected by the Reformation; religious subjects were dropped, leading to the concentration on secular themes connected with the exaltation of the monarchy typical of the Elizabethan age.

John Shute and John Bettes

But before we consider the surviving miniatures from the middle years of the century and their association with Levina Teerlinc we should take into account two other artists who are recorded as practising the art of limning. 'Limnings,' Richard Haydocke, the translator of Lomazzo, wrote in 1598, 'much used in former times in Churchbookes, (as is well knowne) as also in drawing by the life in small models, dealt in also of late yeares by some of our Country-men, as *Shoote*, *Bettes*, &c., but brought to the rare perfection we now see by the most ingenious, painful and skilful Master Nicholas Hilliard'.[9] Writing at the close of the century in the patriotic afterglow of the defeat of the Spanish Armada, Haydocke, like Hilliard, never refers to either Hornebolte or Teerlinc. His statement could, in fact, suggest a quite different line of ascent along the tree of limning.

John Shute can be quickly disposed of.[10] By training he was a painter–stainer and it was Basil Long who described him as practising 'book illumination and painting of portraits and probably miniatures'. He produces no evidence for this apart from Haydocke who wrote forty years after. Shute was the author of *The First and Chief Groundes of Architecture* published in 1563, in which he describes himself on the title-page as 'architect and painter'. He was the only Englishman known to have travelled to Italy 'to confer with the doings of the skilful masters in architecture' and that journey had been made possible by the Duke of Northumberland. John Shute died in 1563.

We know a good deal more about John Bettes.[11] He is first recorded in 1531 engaged in decorative painting in the Palace of Whitehall. Next comes a signed and dated panel portrait of a man from 1545 which is now in the Tate Gallery. This establishes him as an artist of considerable talent with mannerisms in his draughtsmanship that reflect an intense study of if not training by Holbein. In 1546/7 he appears in Catherine Parr's accounts as being paid five shillings for 'vj pictures being lymmed'.[12] There is a title border to William Cunningham's *Cosmographical Glasse* (1559) which could be by him. It is signed IBF and he is thought to be the 'skilful Briton' that executed a woodcut portrait of Franz Burchard, Chancellor of Saxony, in the same year. John Foxe refers to him as dead in 1570 but how long before that date we do not know. A small group of panel portraits that can be attributed to him with some degree of certainty has emerged but none later than 1549. Vertue, however, actually records seeing a limning by him dated 1548:

a picture of an old Gentleman his beard broad a black cap in his right hand holding a spear or javelin. in his left a shield black round (his head.) being full 2 In. $\frac{1}{2}$. CEPTVM IN CASTRIS AD BOLONIAM. 1440 the face in water colours on a card paper. and a small

border round it this in a box and latelyer writ. Sr John Godsalve Kt. made by John Betts.[13]

Sir John Godsalve was clerk of the signet and controller of the mint and died in 1556. The date on the miniature, which was but no longer is in the Bodleian Library, Oxford,[14] makes no sense at all. It was, however, engraved by Sylvester Harding in 1795 for *The Biographical Mirror*. Although Vertue gives it a pedigree back to Christopher Godsalve, who died in 1694 and was clerk of the victualling office under Charles I, it is difficult to reconcile the evidence of the engraving with anything resembling a mid-Tudor limning. Vertue's comment 'latelyer writ' makes the object even more dubious.

This, of course, complicates the issue in respect of the few surviving miniatures from *c*.1545–70. Shute may be regarded as a doubtful starter as the only reference to his ability to limn occurs forty years on and there is no reference to portraits. He was also out of the country, in Italy, for what may have been a considerable part of the 1550s and he cannot be associated with any of the miniatures painted after 1563. Bettes could be a more serious contender. He was patronized by Catherine Parr and he was paid for limnings of royal portraits that were engraved in stone. Vertue claims to have seen a miniature by him. But it is interesting that no paintings in his highly idiosyncratic style have come to light later than *c*.1550 and that all the limning references are confined within the same period, 1546/7 and 1548. What we now have to do is to square these facts with the surviving miniatures.

Levina Teerlinc: a suggested nucleus

About a dozen miniatures are extant from this period. Teerlinc still ranks as the front runner that we can associate with most of them. We know that she painted Elizabeth I both in single portraits and in groups depicting events and ceremonial at court. We can start with the latter, for the miniature of an Elizabethan Maundy must be the foundation upon which any reconstitution of her *oeuvre* depends.[15] The costume in it is mid-1560s and there is nothing to exclude its equation with one of the New Year's gifts of a picture of 'the Quenes persone and other personages'. Originally this miniature must have been square or rectangular and it has been cut into an oval at a later date. Unlike the direct portrait miniature painted from life in the studio this must have been compiled from observations of the event which were worked up after. The figures are not particularly well drawn. They are typically elongated with a Gothic angularity and spikiness; the arms are always very thin. Features on this minute scale are indicated by means of dots and lines of colour and the palette is bright with blue, crimson, green and scarlet. The Queen and her ladies wearing long aprons process to the left ready to embark on the ritual feet-washing of the poor women who sit muffled up in rows on either side, while the vista is closed by choristers and Gentlemen of the Chapel Royal and the halberds of the Gentlemen Pensioners.

From the hunched figure of the Queen with her matchstick arms it is a short step to a portrait miniature of the same period listed in the collection of Charles I: '. . . a Certaine Ladies Picture in her haire /in a gold bone lace little ruff. and black habbitt/ lined wth white furr goulden Tissue sleeves/ wth one hand over another supposed to have bin-/ Queene Elizabeth before shee came to the Crowne'.[16] The identity is a perfectly possible one but what are the links

60

54

57

between this and the preceding miniature? In the first instance the draughtsmanship, which is weak and stylized. In the second the thinness of the paint. Although the face has been entirely repainted and there is abrasion and staining over the rest of the surface there is enough of the dress to show that it is thinly painted. As in the Maundy miniature the head is too large for the body and the hands are drawn and clasped at the waist in exactly the same manner. The techniques are those of an artist trained in the Ghent–Bruges tradition. The miniature is on vellum mounted on a playing card and there is the familiar blue bice ground although the gold edgeline is lacking owing to trimming.

The progression from this to a third miniature in better condition, from *c*.1555–60, is easy. It depicts Catherine Grey, Countess of Hertford, sister to Lady Jane, who like her was brought up as a princess at the Tudor court. This time the gold edgeline survives but the hands are not included. The placing of the figure is identical to that in the probable portrait of the young Elizabeth, the colour is also thinly applied, the features are defined with a minimum of line and modelling, and the fur sparingly indicated by lines of the brush in exactly the same manner as in the previous miniature. There is a second much repainted version of this portrait, but what it does include are the hands clasped at the waist in an identical manner to the Elizabeth.[17] What is interesting is the source for these portraits, for they draw directly on the man who was virtually court painter to Mary I, Hans Eworth. The half-length formula with hands clasped at the waist recurs in his work from 1557 onwards.

There is a fourth miniature of a lady of the court painted in the same style.[18] This time it bears an inscription recording her age, eighteen, in calligraphy in the Hornebolte manner. The dress is about 1550 and the sitter wears a highly important jewel: an *à l'antique* profile head of a Roman emperor in jet with the laurel garland and looped mantle in gold, with sprigs of acorn and cowslips tucked into it. Remembering the closed world from which the sitters for early portrait miniatures were drawn, the possibility that this could be an early portrait of the young Elizabeth I cannot be discounted. Stylistically it belongs to the sequence of court ladies. The head is slightly over-size, the features lightly drawn in with transparent strokes of the brush in lines, the arms as usual almost emaciated. And again we can detect the influence of the large-scale painters, for the approach to the sitter recalls the 1544 portrait of Mary I as a princess in the National Portrait Gallery.

I would round out these five with two more; this time they are of men and both are dated 1569. They have nothing to do with Hilliard, who emerges two years later in quite definite style. Both are important and like the Maundy miniature establish Teerlinc as an innovatory artist. The first is of a man aged twenty-seven in 1569.[19] It is oval in shape, not round, and there is no question of it having been trimmed at a later date because the gold edgeline is still intact. This is the earliest instance of the oval, a format which Hilliard was to adopt only on his return from France at the close of the seventies. The inscription is also new, for it encircles the edge of the miniature and uses italic script. With this we are but one step away from Hilliard's customary practice from his earliest professional portrait dated 1571. The second miniature is even more extraordinary for it is the earliest *impresa* miniature,[20] a form Hilliard was not to embark upon until the middle of the 1580s. It depicts a man encased within a golden armillary sphere which he clasps with his left hand at the bottom while

54 *Elizabeth I, c.*1565

55 *Catherine Grey, Countess of Hertford, c.*1555–60

57 *?Elizabeth I as a Princess, c.*1550

Levina Teerlinc

A suggested nucleus of miniatures from c.1545 to c.1575

56 Hans Eworth, *Unknown Lady,* 1557

58 *Unknown Man,* 1569. The earliest oval miniature

59 *Unknown Man,* 1569.

he places his right to his ear as though listening or attuning himself to the heavens. This is reflected in the motto: *SO . CHE . IO . SONO . INTESO*, which may be translated as 'I know that I am in harmony'. Both are executed in the same manner. In the *impresa* miniature the hands are drawn in the same way as those in the portraits of the court ladies, small and angular, the fingers individually outlined by the brush over the carnation. The draughtsmanship is awkward, the painting somewhat thin and cursory and, another uniting feature, the pupils of the eyes are slightly overlarge and always they engage the sitter.

I cannot claim to offer more than what seems a likely nucleus for Teerlinc, one based only on miniatures which have been subject to thorough and exact examination. Others could be suggested but must await investigation.[21] The impression conveyed is that her work in this field never rose above a trickle, rather than a river wending its way across the middle years of the century. What is advanced is an hypothesis which reveals Teerlinc as a not unimportant contributor to the limning tradition, an artist of the second rank in terms of aesthetic quality but not one devoid of originality of approach and vision.

Teerlinc's work as an illuminator and designer

The Reformation must have severely curtailed demand for illuminated royal manuscripts, one of the prime products for the manufacture of which she was initially employed. Her father was one of the most famous of Flemish illuminators.[22] The iconoclasm which developed under Edward VI accelerated a decline already well in progress with the advent of the printed book. The subject–matter and style of the Elizabethan Maundy miniature, however, leads us on to one manuscript that can, with some certainty, be assigned to her, the Cramp Ring Manuscript in Westminster Cathedral Library.[23] Mary's reign naturally witnessed an attempt to put the clock back so that it is hardly surprising that this illuminated book should come from those years. It is a profusely decorated manuscript, but the two most important pages are those containing scenes of royal ceremonial with portraits of the Queen executed in exactly the same manner as those in the larger and more highly finished portrait miniatures. In 'one, Mary kneels in prayer in a chapel, blessing bowls containing rings to heal cramp which are placed on either side of her. In the second, she touches a young man suffering from the King's Evil, by placing her hands on his neck. Behind is another portrait likeness of her chaplain with his stole round his neck. Both scenes are set into weakly delineated architecture in the Ghent–Bruges style and there is a third folio with a Crucifixion which is a poorly executed stock pattern of the School. The borders are richly adorned throughout with scrolls, bunches of grapes, caryatids and masks in the antique style interspersed with feeble representations of the virtues and the inevitable Tudor emblems. The borders, as one would expect, reflect the type of antique motifs and grotesques that made up the decoration of Nonsuch Palace.[24] They also include variants of engraved ornament based on a series of engravings issued in England by Thomas Geminus, *Morysse and Damashin renewed and encreased very profitable for Goldsmythes and Embroiderars* (1548).[25] —

The Cramp Ring Manuscript relates directly to an indenture dated 21 August 1559 'between our most gracyous Soveraigne lady Elizabeth . . . And the dean and cannons of the free Chappell of Seynt George the Martyr within the Castell of Wyndsor of the other partye'.[26] This established the Poor

61

64

Knights of Windsor, one of Elizabeth's earliest acts in fulfilment of her father's will. The relationship of the manuscripts is both technical and stylistic. This time there are only two illuminated pages. The borders are of the same type, with arabesques in bright colours against white vellum, but this time with no antique motifs. It is the usual mixture of Tudor coats of arms and symbols with bunches of grapes, gillyflowers and roses in blue, mauve, orange, red and pale green. The most striking feature is the full-length image of the Queen on the seventh page executed in the same manner as the portraits of Mary. Elizabeth sits enthroned beneath a scarlet pelmet with a blue cloth of estate, her feet on a scarlet dais. It is an autograph version of the formal pattern image of the Queen for official documents used for the first decade of the reign, depicting her in ermine-lined robes of state of a pink colour shaded in cerise with a scarlet girdle.[27] The crown, orb and sceptre are ochre heightened with gold as is the claw-footed throne.

Garter manuscripts provide a key to the limners because they are one of the few forms of illumination to survive the Reformation. The *Liber Niger* decorated by Hornebolte and his workshop is succeeded by the *Liber Ceruleus* or Blue Book. This opens with a sequence of illuminated pages covering Mary alone, Mary together with Philip and, finally, Elizabeth. All of them are damaged but all are set into the same loosely painted borders in exactly the same style as those for the Cramp Ring Manuscript and the Indenture for the Poor Knights. As everything tended to work by precedent it reinforces both the stylistic and technical evidence that here is a complete group of illuminations attributable to Teerlinc.

The Poor Knights Indenture has been compared to the miniature of Elizabeth in her coronation robes by Hilliard. It was usual at one time to date the latter to the close of the 1560s, amongst Hilliard's earliest works, but its slick mechanical sophistication places it firmly about 1600. What is important is that Hilliard's miniature, as demonstrated from documentary sources, shows Elizabeth in the robes that she actually wore and therefore it presupposes an original on which it was based apart from the large-scale painting at Warwick Castle, which we now can also date to *c*.1600. That original is likely to have been a miniature by Levina Teerlinc.

The relationship of these illuminations to the images that appear of Mary and Elizabeth on their great seals would make it a logical supposition that they were an extension of Levina's activities and that she drew the initial patterns for these.[28] Mary is the same emaciated figure seated beneath a canopy with a high tester, an unhappy empty composition with too much floor on either side. A seal for a queen regnant was an innovation and the artist had to adapt the content of its masculine predecessors. The reverse transforms the image of a warrior prince on horseback into that of a lady on progress, a doll atop a trotting palfrey with a solitary fleur-de-lis floating in the background. The seal for Elizabeth is much more satisfactory. The composition is framed by an elaborate architectural chair of state and the blank areas on both obverse and reverse are filled with symbols, coats of arms and spiralling rose branches. The arrangement of the figure on the throne and the fall of the folds of the robe are virtually identical to those on Edward VI's great seal, which could also be after a Teerlinc pattern.[29] As a design, it is little more than a clumsy adaptation of Henry VIII's second great seal.

147

66

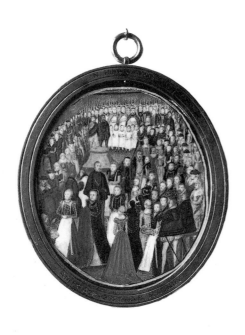

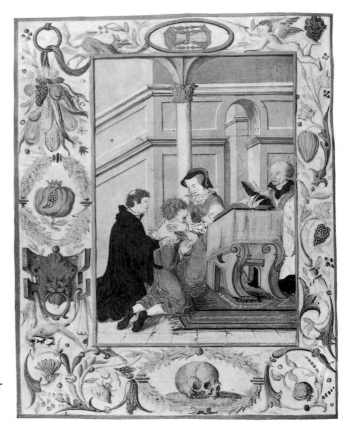

Levina Teerlinc's work as an illuminator
and designer

A suggested nucleus

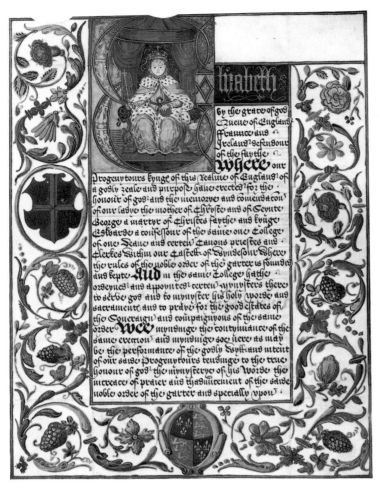

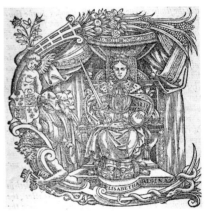

64 Indenture for the establishment of the Poor Knights of Windsor, 1559

65 Woodcut of Elizabeth I enthroned attended by the three estates of the realm, 1563, possibly after a design by Levina Teerlinc

66 First Great Seal of Elizabeth I by Dericke Anthony, probably after a design by Levina Teerlinc

Opposite

60 Elizabeth I performing the Maundy ceremonies, *c*.1565. Poor women are seated on benches on either side as the Queen, wearing a long apron, advances to perform the ritual feet washing.

61 Mary I heals a man suffering from scrofula in the ceremony of Touching for the King's Evil, *c*.1553–8.

62 Woodcut of Elizabeth I at prayer, 1569, possibly after a design by Levina Teerlinc

63 Woodcut of Elizabeth I picnicking during a hunt, from Turbevile's *Book of Hunting*, 1575, possibly after a design by Levina Teerlinc

It is surprising that no separate miniature of Mary I has survived. Any extension of the work of Teerlinc's ought logically to be found among the range of woodcuts of Elizabeth that fell from the presses in government-sponsored publications. It would be natural surely to turn to Levina Teerlinc, who was a book illustrator and portrait painter in the royal service, as the source for such images. The enthroned Elizabeth attended by the three estates of the realm encompassed by the letter C, first used in John Foxe's *Actes and Monumentes* 65 (1563), is but a variant of the Poor Knights of Windsor Indenture.[30] The portrait of Elizabeth at prayer used in the profusely illustrated *Christian Prayers and Meditations in English* (first edition 1569) could be another.[31] It is a 62 repetition of the type of record that we have of Mary in her chapel in the Cramp Ring Manuscript.

One year before Levina's death, on 24 June 1576, two books appeared by George Turbevile, the *Booke of Hunting* and the *Booke of Falconrie*. Unique in 63 presenting us with scenes of the Queen at the chase, they are the result of direct observation, depicting her at the kill, hawking on horseback, picnicking beneath the shade of the greenwood tree and taking receipt from a standing or platform erected in the forest of the 'Report of a Huntesman vpon the sight of an Hart, in pride of greace'.[32] These scenes are the true and only successors to the surviving miniature and the other lost ones depicting Her Majesty with 'dyvers personages'. Could these too be after patterns by Levina Teerlinc?

Conclusion

As in the case of most Tudor artists, the documents cannot tell us everything. The annuity of £40 means that no itemized accounts exist. Even allowing for a low production rate, what has so far been suggested as attributable to Teerlinc is still meagre when considered as the output of three decades. Only by casting her in a broader context and jettisoning the compartmentalization that has bedevilled the study of the art of the period can any sense begin to be made of her work in royal service. As in the case of Hornebolte, it means accepting the view of an uneven proficiency in a variety of fields and allowing for deterioration in quality as other craftsmen interpreted her work. With Teerlinc the most impenetrable chapter of the limning story draws to its close. I think it unlikely that the earlier period will ever come quite into sharp focus by the very nature of the material. It will always remain a field for art historians to quarrel over attribution and style but not move onto any firmer ground. In the case of Hilliard we begin to tread on just that for the first time. When Teerlinc died in 1576 she was not replaced by the Queen, a symptom not of any lack of demand for royal portrait miniatures but of economies in Crown finances.

LIVELY COLOURS: *Nicholas Hilliard*

Economy was indeed everything to the incoming government in 1558. For the visual arts the effect of the political and religious disturbances of the reigns of Edward and Mary, followed by the massive financial cut-backs of Elizabeth, set the scene for an isolationist, iconic court art. Writing at the close of Elizabeth's reign, Nicholas Hilliard gives an acute if fragmentary account of this recession of which he was to be a prime victim.[1] Suddenly he pauses in his argument to eulogize Henry VIII, 'a prince of exquisite judgment and royal bounty, so that of cunning strangers even the best resorted unto him and removed from other courts to his'.[2] Never was a truer word written but no such tribute falls from his pen for any of his successors. When he has to pay a compliment to the reigning Queen it is for her views on art and certainly not for her lavish patronage. The woes of the middle years of the century are summed up for him in the sad career of one John Bossam, 'for his skill worthy to have been Serjeant Painter to any king or emperor', but who ended his days in religion as a reader on account of his poverty.[3] That was the fate of those who 'live in time of trouble, and under a savage government wherein the arts be not esteemed'.[4] Nothing that he writes in his *Treatise*, however, would lead the reader to believe that the arts were in fact particularly 'esteemed' in his own age. The fact that we can write Nicholas Hilliard's own life almost entirely in terms of financial disasters sums up the enormous change that had taken place since the 1520s and 1530s. There was never to be a return to Crown prodigality in the arts until the Stuarts, by which time Hilliard had only an outmoded style to offer.

That our initial approach to the art of Nicholas Hilliard should begin with money or rather the lack of it is important. The vast army of artists in royal service typical of the reign of Henry VIII had no successors. There were to be no new building projects. When forced to construct a *salle des fêtes* for the French embassy in 1581 Elizabeth erected in haste a building of wood and canvas which was still standing, rotten, in 1603. Elizabeth lived within her father's palaces. She never collected works of art. She expected to be entertained and not entertain herself. There was to be no programme of court festivals such as had been the life-blood of her father's court. Patronage of the visual arts henceforth flowed from the new aristocracy but not until after 1570 when the Northern Rebellion was repulsed and the Elizabethan system began to enter its long heyday. The fact that Hilliard had to wait until 1599, by which time he was more than desperate for money, before he was granted an annuity, and a meagre one at that, sums up the policy of Elizabeth. It was art on the cheap. Only after 1570, but more particularly after 1580, was there a realization

of the power of visual propaganda in creating a potent image of the Queen. The problem then centred on how to achieve that at the least possible expense to government. The stinginess of the Crown generated its own problems, ones unknown to the court of Henry VIII, for if there were no painters in its employ appalling difficulties arose over the control of the royal image. And it is with this that we shall begin because it is arguable that it was this very fact that was responsible for Hilliard emerging as court artist *par excellence* from the moment that he had finished his training.

Origins and training

When Elizabeth came to the throne in 1558 she must have inherited as court painter her sister's painter, Hans Eworth.[5] No picture by him of the young Queen has ever come to light and indeed the indications are that he was not in royal favour, for all his sitters from the sixties are Catholics, members of the Marian court: the Norfolks, Nicholas Heath, Mary's Archbishop of York or Lord Montague. In view of the failure to patronize the one painter of any ability, it is hardly surprising that the Queen's early portraits are of such a low quality, so low that in 1567 the Earl of Sussex had to explain to the Regent of the Netherlands, Margaret of Parma, 'that the picture commonly made to be solde did nothing resemble Your Majestie'.[6] Four years before, a draft proclamation had been drawn up forbidding the production of debased images of the Queen until 'some speciall person' should paint her portrait and thus establish a 'patron' (i.e. pattern) which was to be copied by other painters and engravers. That 'speciall person' was probably Steven van der Muelen; but what emerges from these facts is that without a salaried court painter of the status of Hornebolte, Holbein or Scrots, it became virtually impossible to control the royal image. The problem was how to get a painter who would produce images in line with government thinking without incurring too much expense. Levina Teerlinc was getting old and the Queen had a penchant for miniatures. A replacement was needed but there would be no repetition of the expensive arrangements of 1525 and 1544.

This was the situation when Hilliard was a boy. The artist himself in his *Treatise* is reticent about his origins. In fact, he came of a strongly Protestant Exeter family, his father being a goldsmith of some standing in the city. As a child he had been sent for safety during Mary's reign into exile along with another Exeter family, that of the future founder of the Bodleian Library, Sir Thomas Bodley. Their arrival in Geneva is recorded on 8 May 1557 in the *Livre des Anglois*.[7] It is not known what education he received there but he certainly learnt to speak French. On the accession of Elizabeth in 1558 the Bodley family returned not to Exeter but to London and it would be reasonable to believe that the young Nicholas came with them.

Previously our earliest evidence of Hilliard's future potentialities as a miniaturist has been three miniatures dated 1560; two are self-portraits[8] and one is of Edward VI's Lord Protector, Edward Seymour, 1st Earl of Hertford and Duke of Somerset.[9] The two self-portraits can now be discounted as evidence, one certainly being a later copy and the other being of dubious authenticity. The third, however, of Somerset is perfectly authentic. Technically it has no connection with Hilliard's style after 1570 but there is nothing to disprove that it is a crude attempt at limning by a thirteen-year-old boy who has attempted to unravel some of the methods of the limners working

67 *Edward Seymour, Duke of Somerset*, 1560. A copy made by Hilliard at the age of thirteen, probably after Levina Teerlinc

68 *Edward Seymour, Earl of Hertford*, 1572. One of Hilliard's important early patrons

within the Ghent–Bruges tradition. The features and hair are worked over a 'carnation' ground and the bright red lips evoke a familiar Hornebolte feature. The background, which is gold over an ochre ground, is unusual if not unique and the lettering reveals no trace of Hilliard's later calligraphic style. More to the point it is one of the handful of miniatures which he has actually signed in monogram, NH.

Somerset had been executed in 1552, so that the miniature must be a copy of a lost original, probably by Teerlinc. The Duke was a noted patron of the arts and, as brother of Henry VIII's third queen, Jane Seymour, would have qualified for access to the royal limner. But where would a young boy aged thirteen have been able to study such an object? All I can do is to offer an hypothesis. In 1560 the original of that miniature ought to have been in the hands of Somerset's son, Edward Seymour, Earl of Hertford. In that year he had incurred Elizabeth's wrath by marrying her cousin, Catherine Grey, a noted patron of Teerlinc. In one miniature she even wears what may be a Teerlinc portrait of her husband. We know that Hilliard knew Hertford later. When the miniaturist was in France in 1578 the Earl was eagerly writing to him in Paris via the English ambassador, Sir Amyas Paulet, on no less than two occasions.[10] Hilliard also painted Hertford at an early date, a miniature which was in the collection of Charles I depicting the Earl 'in a black Capp and black feather' with a black suit slashed over white with a little gold chain and golden lettering.[11] This description matches exactly a miniature which recently passed through the saleroom. In addition, the date, 1572, and the age, thirty-three, also fit Hertford.[12] These, of course, are little more than fragments of evidence but they are suggestive that the pattern of connection could have been through the Bodleys, a reformist family along with the Hilliards who had supported Somerset in the south-west during the Prayer-Book Rebellion of 1549, with the Seymours to the Greys and thence to Teerlinc.

Here was a young boy aged thirteen with a flair for limning, an extraordinary precocity in sixteenth-century terms. Two years later he became an apprentice to the Queen's Jeweller, Robert Brandon, an important member of the influential Goldsmiths' Company. No one knows precisely what training went on in such a workshop, but it cannot have been a narrow one. Later Hilliard was to teach his own pupils not only to paint miniatures but also to paint on panel and canvas and to practise goldsmithing. With the court looking for an artist, we cannot exclude the possibility that Hilliard was actually trained from the start with the role he was to occupy in mind. Limning, as we know,

68

was an art of secrets passed from master to pupil. Who, therefore, other than Levina Teerlinc could conceivably have trained Hilliard? And if this were the case we have every reason to suppose that he was being groomed to succeed her.

The argument that Teerlinc trained Hilliard can only be based on the technical evidence. It cannot be supported by documentary material. In Hilliard Elizabeth found her limner. But she also needed a painter of oil portraits and she had no intention of paying two artists where one with adequate training would do. The highly formalized and decorative style of Hilliard's earliest panel portraits would indicate that he was trained in the studio of an artist such as the Master of the Countess of Warwick, conceivably to be identified as Nicholas Lizarde.

Hilliard himself is almost wilfully mysterious about his own training. His most famous comment turns out, in the light of recent research, to be his most misleading: 'Holbein's manner of limning I have ever imitated.'[13] Nothing could have been further from the truth, for both his style and technique flow down directly from Hornebolte and Teerlinc and not Holbein. The idea of a preliminary drawing, fundamental to Holbein's way of working, had no place in Hilliard's method. What he describes in the *Treatise* must to a degree be a record of how he was trained. One sentence almost sums it up: 'For limning is but a shadowing of the same colour your ground is of.'[14] By shadowing Hilliard means hatching with the brush in the manner of an engraving. Training, he states, centres on copying engravings, in this instance those by Dürer:

> Whereof hatching with the pen, in imitation of some fine, well engraven portraiture of Albertus Dürer's small pieces is first to be practised and used before one begins to limn; and not to learn to limn at all till one can imitate the print so well as one shall not know the one from the other that he may be able to handle the pencil point in like sort. This is the true order and principal secret in limning, which that it may be the better remembered, I end with it.[15]

Any of Hilliard's miniatures viewed under intense magnification will bear this out and his few drawings are full of the idiosyncrasies of Dürer's engraved style. The lines of the limner are those of the engraver. From this arises another ignored point. If he was trained to be a limner by copying engravings it would naturally lead to a proficiency in preparing designs in that medium. Before Hilliard painted miniatures he had to be a master of black and white.

Hilliard's miniatures follow the technical tradition that goes back to Hornebolte.[16] They are on vellum mounted usually onto a playing card and they are constructed in precisely the same way with a 'carnation' ground colour upon which the features were built up with hatching in transparent watercolour in red and grey and brown and blue; the background is of blue bice or ultramarine and the costume is worked up in opaque colour. The differences in a Hilliard miniature stem from variations and style. Hilliard's sitters are paler, the 'carnation' is fairer for the flesh tints. Although his brushwork is as free as Teerlinc's it is also far more accomplished and its assured freedom brings a flickering effect to his portraits so that we almost anticipate that the lace ruffs might bristle. And although he continues to use the gold over ochre technique for the jewels he technically develops the use of metallic pigments, the result of his training as a goldsmith, so that he can simulate or rather imitate the jewels a sitter wears. He also painted the gold edgeline over the other paint

and not, as his predecessors had done, over the bare vellum. Owing to oxidization the silver highlights have blackened with time but a Hilliard miniature in its pristine state shimmered as it caught the light. The result was an object far removed from its chaster forbears and ideally suited to record the clothes of the opulent age he depicted.

Hilliard emerged from his apprenticeship in 1569 as a goldsmith and jeweller, a painter of panel portraits and miniatures, an executor of woodcuts and an artist capable of producing designs to be engraved by others. There is no doubt that he was immensely talented. He was to differ, however, in one major respect from his predecessors: there was to be no official position at court for him, no certain salary. Instead he was to occupy the highly unsatisfactory role of unpaid artist to the Crown and be forced to open up shop in the City like any other tradesman or artificer.

Early Elizabethan: 1571–1576

The earliest miniatures by Nicholas Hilliard span five years, 1571–6, and culminate with his attaining a salaried post in the household of the Duke of Alençon, soon to be Anjou. This half-decade opens with the formal ending of his apprenticeship, when Hilliard was received as a freeman of the Goldsmiths' Company on 29 July 1569. A year later he was himself already trying to engage an apprentice. Evidence of work for the Queen comes in the form of a grant for the reversion of the lease of the rectory and church of Clyve in Somerset as a reward, in 1573, for 'his good, true and loyal service' coupled, in October of the same year, with a payment of £100 under warrant of the Privy Seal. The period ends in July 1576 when he married Robert Brandon's daughter, Alice.[17]

About fourteen miniatures survive from these years. From the start Hilliard was an accomplished artist. There is nothing tentative about these miniatures, but there are also few, if any, startling innovations. The circular format and size follow exactly the established norm in every instance except in the case of a pair of rectangular portraits of a husband and wife which must once have formed a diptych within a locket or jewel.[18] As in the case of Teerlinc his formulae stem from the fashionable portrait painters of the day. On the one hand, he responds to the prevailing Anglo-Flemish stream of painters, such as Eworth or Steven van der Muelen. The portraits of men particularly reflect this. Two unknown sitters from 1572 place the head in the same three-quarter position, the eyes engaging the onlooker but with a downward, slightly disdainful look.[19] The bearing of the sitter is erect and taut with lighting from the front. On the other, there is evidence of the impact of a new, native born, painter, George Gower, who was already an established London portrait painter by 1573 and whose career was to run parallel with that of Hilliard.[20] Gower, like Hilliard, was highly responsive to his female sitters and developed early in the 1570s a decorative style, in which a sensitively observed head, with eyeballs turned almost to one corner of the eye looking outwards, was the focal point of compositions which depended for their effect on the detailed rendering of lace and embroidery, ribbons and jewellery. It is a formula which matches exactly Hilliard's own approach in some of his most entrancing early portraits, the unknown woman dating from 1576[21] and the Jane Coningsby dating from 1574.[22] In the case of both artists there begins that steadily increasing attention to decorative trappings that was to result in the icons of the 1580s.

69–70

72

69, 71

78

75, 76

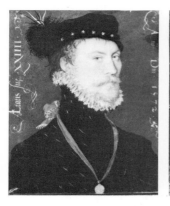
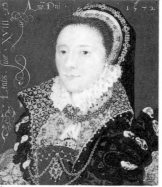
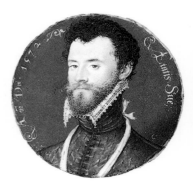

69 *Unknown Man*, 1572 70 *Unknown Lady*, 1572 71 *Unknown Man*, 1572

72 Hans Eworth, *Thomas Howard, 4th Duke of Norfolk*, 1563 (detail)

73 *Unknown Man*, 1571. Hilliard's earliest known miniature of his maturity

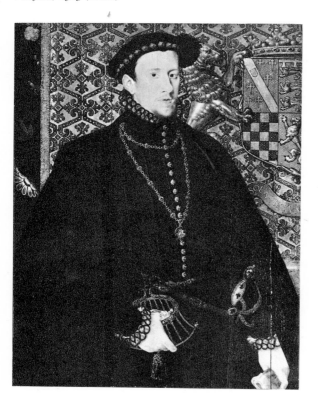

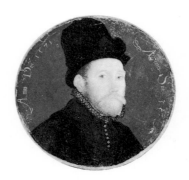

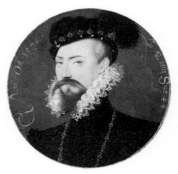

74 *Robert Dudley, Earl of Leicester*, 1576

Hilliard's early work

During the years 1572 to 1576
Hilliard produced arguably his
finest work.

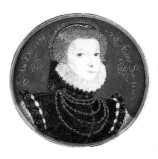

75 *Unknown Lady*, 1576

76 *Jane Coningsby*, 1574

77 Master of the
Countess of Warwick,
?Helena, Marchioness of
Northampton, 1569

78 George Gower,
Elizabeth Cornwallis,
Lady Kytson, 1573

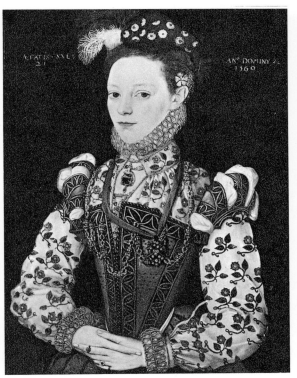

The most noticeably new feature is Hilliard's calligraphy, representing a return to the work of Hornebolte and the tradition of including in the inscription the sitter's age and the date. Unlike Hornebolte's inscriptions, however, Hilliard's are rarely an unhappy addition. From the first miniature, dated 1571,[23] they were conceived as an integral part of the composition. Hilliard's script was to remain virtually unchanged throughout his career. It presupposes training, probably by a writing-master, copying from one of the most widely influential manuals to be published in England, that by Jean de Beauchesne (1570).[24] It is a neat, careful, italic script allowing for elaborate flourishes both above and below the line. All Hilliard's miniatures during the 1570s include complex flourishes to the letters, particularly the capital A and, in one instance, his portrait of Jane Coningsby, he introduces flourishes to flank the head purely as decoration independent of the script.

Even allowing for a high percentage loss, about fourteen miniatures can hardly account for his total output over five years. As in the case of his predecessors, limning was probably only one form of activity of what was a workshop with a wide brief open to many sorts of commission. Hilliard stood apart from his predecessors in the limning genealogy in that he was a goldsmith rather than an illuminator. In this he seems to have begun his practice in tandem with his brother John. In April 1571, a difference between them and a certain Craddock led to the calling in of the wardens of the Goldsmiths' Company to act as arbitrators over what was clearly an altercation over a commission to make jewels. The ones in question were a 'rose of gold enameled with a diamond on it, and a pearle hangynge at it', a 'litle rynge of gold with a parrett vpon it' and '2 litle rynges of gold with ragged staves in them'.[25] This is the earliest reference to his patronage by the Queen's favourite, the Earl of Leicester, whose cognizance was the bear and ragged staff.

79 Specimen of italic script from Jean de Beauchesne's writing book, 1570, the source of Hilliard's calligraphic style

72

80 Woodcut title-border, 1571

81 Woodcut title-border, 1574

The hypothesis that the previous royal limners acted as draughtsmen who also provided patterns for title-pages receives support, in Hilliard's case, from two title-pages which he designed in the 1570s.[26] Only one of them is signed NH in monogram, but both bear the initials of the engraver, C.T., and both are in absolutely the same style. As woodcuts they were used repeatedly on a whole series of books until well into the next century. The first is from 1571 and takes the form of a partly ruined archway, the pilasters encircled with ivy and grass, and plants sprouting from it. At the foot there is an oval containing an emblem of a dragon sprawling with a panther (?) at its throat and the motto NON VI SED VIRTUTE. The second from 1574 is signed NH at the top and is also an arch, but this time flanked by the twisted columns of the temple of Solomon entwined with vines growing from a vase at the bottom. At the top, the strapwork takes on the same form of fantastic decaying architecture with plants springing from it, and in the centre there is a medallion bearing a slain lamb. Placed alongside the miniatures they come initially as something of a surprise. 80 81

There is another reference to Hilliard designing for engravers, by a certain Agnes Rutlinger who promised to deliver to one Thomas Clerke 'a booke of portraitures' which was finished but yet remained in the hands of Hilliard in February 1572. Agnes's husband was Jan Rutlinger, who worked as an engraver at the Mint in 1596/7 where he was in receipt of a salary of £20 p.a., and who, in 1600, was eulogized to Robert Cecil as 'a most exquisite man in that kind of profession'.[27] By then he was elderly for he was probably the 'John

Rutling' who is mentioned in the *Returns for Aliens in London*, in 1568, and who, with another person with the same surname, is described as 'Doche persons, goldesmythes'. A few months after Rutlinger's reference to Hilliard he is mentioned in the Court Minutes of the Goldsmiths' Company as undertaking to finish a 'book of gold' for Robert Dudley, Earl of Leicester. What, however, was the book of portraits that Hilliard and Rutlinger were involved in together? Conceivably it was a series of portraits in the form of illuminated pages by Hilliard with book covers by Rutlinger. It seems unlikely that the reference can be to engravings.

The Earl of Leicester, the Queen's favourite then at his apogee, was by far the most lavish patron of the arts in the 1570s when his building projects at Kenilworth Castle, Wanstead and Leicester House were still in train. In 1575 he received the Queen at Kenilworth with a series of fêtes in emulation of the French court form of *Magnificences*. In the same year he was responsible for bringing to England the Italian Mannerist painter, Federigo Zuccaro, for a short, somewhat unfruitful visit.[28] Three miniatures of Leicester by Hilliard are known,[29] but there was a fourth 'in a yet box draune in his Cloake with a Cap and Feather' which is listed in Laurence Hilliard's will as a family heirloom.[30] Many of Hilliard's numerous children were given Christian names that reflect the Leicester circle, including Robert (Dudley), Lettice (Knollys), Francis (Knollys) and Penelope (Rich).[31]

As Hilliard was not a salaried court artist he painted whoever would commission him, and obviously his sitters cannot be tabled as a family tree consisting only of members of the ruling house and their collaterals. The earliest miniatures are nearly all of unknown or misidentified sitters but they are clearly not all aristocrats. One who is definitely not and whose identity is certain is Jane Coningsby, the daughter of Humphrey Coningsby of Hampton Court, Herefordshire, gentleman treasurer to the Queen, whom he painted in 1574. She was certainly of the court by connection but her status was only that of the wife of a country gentleman, William Boughton of Little Lawford, Warwickshire. She certainly inspired Hilliard to paint arguably his masterpiece from the 1570s in the bold linear style in which he approached his female sitters prior to his visit to France.

As a result of this and of Hilliard's longevity there are more surviving miniatures by him than by any other limner and they provide a remarkable panorama of Elizabethan society. Furthermore he was far more talented as an artist than either Hornebolte or Teerlinc. There is no hesitation in his use of the brush. On the contrary he wields it with boldness, making vibrant strokes expressive of his immediate response to what he saw. The very process of their production excluded any possibility of their being laboured, for they were direct impressions onto the vellum from the sitter. With large-scale paintings the long process of manufacture deprived them of the spontaneity in which for modern eyes lies the main attraction of his miniatures. Few though these early miniatures are in number Hilliard was never to surpass them for bravura of brushwork, strength of characterization or simplicity of composition. Without doubt they form his aesthetic peak, far outshining later images such as the legendary *Young Man among Roses* that we have come to accept as the climax of his art. Viewed in cold detachment, apart from periodic flashes of the old early brilliance, his career was a steady spiral downwards.

74

Nicholas Hilliard's two-year stay in France remains one of the enigmas of his life. The facts are well known but should be briefly rehearsed.[32] On 8 December 1576 Sir Amyas Paulet, Elizabeth's new ambassador to the French court, wrote to England referring to the cost of his train, amongst whom he numbered Hilliard. Over a year later he alluded to Hilliard again, this time alerting the English court to the fact that the miniaturist was considering leaving the Queen's service 'having repaired hither . . . with no other intent than to increase his knowledge by this voyage, and upon hope to get a piece of money of the lords and ladies here for his better maintenance in England at his return. He would have been back by this time if he had not been disappointed by some misfortunes. He intends to go shortly, and carry his wife with him.'[33] Hilliard was still in Paris, however, in March and June 1578 when Paulet wrote to Edward Seymour, Earl of Hertford, twice delivering his letters to him and apologizing that the miniaturist had not finished a jewel but that he had been unwell. Hilliard, he writes, could 'bring or send it'.[34] We also learn from the accounts of the Duke of Anjou, Henri III's brother, that he enjoyed a post in his household as *valet de chambre*. These plus a few other snippets of information, to which we shall come, and a handful of miniatures are all that we know about these years. That he failed 'to get a piece of money' is obvious, for the next reference to him in England is on 14 July 1579 when he signed an indenture between himself and his father-in-law, Robert Brandon, for a loan.

Paulet's letter is useful in that it lists the objectives: money and knowledge. In the case of the latter it reveals that Hilliard felt himself inadequate. He needed 'knowledge' of a kind unobtainable in England. Perhaps it was the visit of Federigo Zuccaro in 1575 that made Hilliard aware of his own insularity. Italy, the normal mecca of artists from the north, subsequent to the papal excommunication of Elizabeth was virtually closed until the middle of the 1590s. The Low Countries were in turmoil. This alone left the Valois court, certainly the most sophisticated in northern Europe, as a substitute and all through the 1570s relations with England had been close. Throughout the century what innovations from Renaissance Italy did arrive came in the main via France. But there was no precedent for an English artist seeking 'knowledge' there. That he expected work implies also that he was known. One would assume that this awareness came through the portraits of Elizabeth that were sent to France in connection with the projected match with the future Henri III.[35] In March 1571 a portrait was sent and subsequently Catherine de'Medici, the Queen Mother, expressed a desire for a further likeness but this time *en petit volume* like the one that she already had of Leicester. Although Teerlinc was still alive and painting, it may well be that these were a panel picture and miniatures by Hilliard but we cannot be certain. It is unlikely, however, that he would have gone to France entirely on a speculative basis.

Paulet's embassy came in the aftermath of the Treaty of Monsieur establishing peace between Henri III and his brother, Anjou, and his brother-in-law, Henry of Navarre. Hilliard was in France, therefore, when there was a lull in the wars of religion. There was also a lull in the negotiations between the two courts for the marriage of Elizabeth, this time to Catherine's youngest son, the Duke of Anjou. This project was not to be revived until May 1578, by which time Anjou had fled the Valois court and was embarking on his bid for power in the Low Countries. So we cannot postulate that Hilliard was also sent

deliberately to paint the Duke, the state of whose pock-marked face was a perennial reason for Elizabeth refusing to advance the marriage negotiations. A more important reason may have been Hilliard's awareness that after François Clouet's death in 1572 there was no miniaturist or indeed major portrait painter at the Valois court.

The tradition of portraiture at the late Valois court was a far different one from that at the Tudor.[36] It is summed up in a letter from the papal nuncio to Rome in 1573 when endeavouring to cope with a request for portraits of Charles IX, the Duc de Guise and Admiral Coligny to aid Vasari in his painting celebrating the Massacre of St Bartholomew. He wrote: 'qu'ils soient naturels sera difficile, parce qu'en France on soit peu peindre au naturel'.[37] He is referring to the chalk drawings which emanated from the studio of Jean Clouet's son, François. These were especially cultivated and collected by Catherine de'Medici and albums and individual drawings were sent to the courts of Europe. More successfully than in Elizabethan England the distribution of these images was strictly controlled as the prerogative of Clouet's studio in his role as *peintre du roi*. The drawings were already known in England. When the negotiations for the marriage of Elizabeth with the future Henri III entered a serious stage in 1571 two drawings of him were sent to England, one a study of his head and a second *en pied*.[38]
82

Hilliard arrived in the aftermath of the break-up of the Clouet atelier. Three artists continued a feeble version of the style: Pierre Gourdelle who was *valet de chambre* to Charles IX and also painter to Catherine de'Medici, a Fleming, Georges Boba, painter to the Cardinal of Lorraine, and Marc Du Val, painter to both Catherine and Charles IX but who left the court on the King's death.[39] Hilliard would have been exposed to an abundance of these chalk drawings and their immediate impact can be recognized in his enchanting rendering of his wife, Alice, and in the debonair self-portrait.[40] Throughout the 1580s the fleeting intimacy that characterizes these drawings was to be a major influence on his portrait miniatures. Unlike the Holbein drawings, but like Hilliard's miniatures, these chalk drawings were conceived as portraits in their own right and not as preparatory studies, so that his study of them would in no way have upset his preconceived method of producing a portrait. It is remarkable, however, that they did not affect his style of drawing, which remained totally linear, like the engravings he copied as an apprentice, and hopelessly archaic in European terms. What has not been commented upon is the change in shape of the portrait miniature. All Hilliard's miniatures up until 1577 are round. Few after that date are. This radical change, to which he was to adhere for the rest of his career and which was to be adopted by his successors, may have come as a result of seeing miniatures by Clouet. Hilliard probably saw something like the famous jewel now in the Kunsthistorisches Museum in Vienna and once part of the imperial collection, a gold enamelled locket containing oval miniatures by Clouet of Charles IX and Catherine de'Medici.[41] He would have realized at once the advantages to be gained both in terms of composition and as a shape lending itself to bejewelled enclosure.

For Hilliard to have become a member of Anjou's household can also be explained. Although unreliable, the Duke was sympathetic to the Huguenots, of whom there were a number in his service, and he was at that moment creating an entourage in his capacity as heir to the throne. During this period

François de France, Duc d'Alençon, mort en 1584. il était frère de Henry III.

82 François Clouet, *Henri III*, c.1571–2. A version of this drawing was sent to Elizabeth I and the format influenced Hilliard's cabinet miniatures

he was closely linked with his brother-in-law, Navarre, as being somehow *politique*. Anjou had not the religious scruples of his brother when it came to negotiations for the English marriage and was adored by his sister, Marguerite. A miniature of him by Hilliard in the Musée Condé must date from 1577,[42] during the summer of which both the Duke and the English embassy travelled south as far as Poitiers to the Navarre court. This fits exactly with the miniature of Marguerite which is dated 1577.[43] Her painter was a certain Jacques Gaultier with whose son, Leonard, Hilliard was in contact as late as 1592.[44]

87

83 *Self-portrait*, 1577
(original: dia. 4.1 cm)

84 *Alice Hilliard*, 1578

85 French School, *Anne,
Duc de Joyeuse*, c.1580

86 François Clouet,
Elizabeth of Austria, 1571

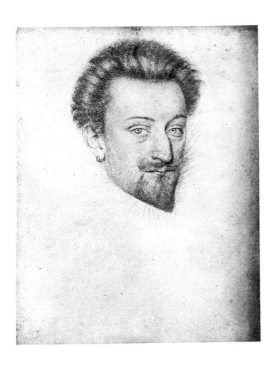

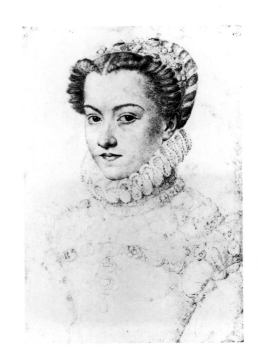

78

Hilliard in France, 1576–78/9

The artist was almost three years in France during which time he responded particularly to the portraiture of Clouet and his school.

87 *Marguerite de Valois,* 1577

88 François Clouet, *Charles IX,* ?1571

89 Woodcut portraits of the Duke and Duchess of Nevers, 1578. The portraits alone are by Hilliard

One commission that Hilliard received came through the humanist Blaise de Vignère, secretary to Louis de Gonzague, Duc de Nevers.[45] De Vignère was a man of immense erudition who moved on the fringes of the academy. In 1578 the Duke and Duchess had made a deed of gift for the dowries of daughters on their marriage, the event was to be marked by a document written on parchment in the best script and adorned with woodcuts of the donors. However, the latter proved unsatisfactory. They had initially been engraved by a Maître Bernard, after which a Maître Georges had been employed, but the result was no better. On De Vignère's advice the offending pieces of boxwood were removed and replaced by ones by Hilliard, establishing that he was able 89 not only to provide designs for woodcuts but also execute them himself. The results are as we would expect: Hilliard miniatures transmuted into black and white. De Vignère subsequently suggested that the Duke should commission Hilliard to produce a series of woodcuts of the illustrious of the period for which he, Vignère, would write the lives and eulogies, but the idea came to nothing.

More interesting are the references in De Vignère's correspondence to the difficulty of finding Hilliard. At precisely this time Paulet had written of the painter's imminent return alluding to his disappointment 'by some misfortunes'.[46] De Vignère had thought that Hilliard was in the house of one 'maistre Herman l'orfevre', who has been identified as either being Germain Pilon, goldsmith and sculptor to Henri III, or Pierre Hotman, another goldsmith. Hilliard was, however, eventually found in the house of 'maistre Georges, le peintre de la reyne'. 'Maistre Georges' was a Fleming, a pupil of Floris, one Georges van der Straeten.[47] No work by him has ever been identified. The letter states that Hilliard was discovered *hidden* in his house. What does this mean? What was he hiding from? I cannot pretend to offer a definitive solution but we should remember that Hilliard was not only English but more particularly Protestant. He had been brought up in Geneva and indeed always uses the Geneva Bible when he quotes in his *Treatise*. This means that he was Puritan, which may also explain why there is not one single miniature of a cleric of the established Church by him. Paris was ultra-Catholic, moving fast towards the heady days of the League and already in the grip of Henri III's endless penitential processions and extreme demonstrations of Counter-Reformation piety. Hilliard was safe in the English embassy which had acted as a haven for those escaping the Massacre of St Bartholomew, safe too in the entourage of Anjou and in the ambience of the Navarre court. It would seem to have been a serious misjudgment, however, to think that he, a Puritan Englishman, could expect to make a living in Paris.

No wonder that so few miniatures that can certainly be assigned to his French period have ever surfaced. Apart from the Marguerite de Valois dated 87 1577 and her brother, Anjou, there is only for that year an unknown gentleman[48] and the self-portrait. Francis Bacon, dated 1578,[49] was a young attaché in the English embassy in Paris but the Alice Hilliard from the same 84 year could as easily have been painted on the return to England. More problematic is the portrait of his father.[50] The age on the miniature is fifty-eight but the last figure of the date has flaked away and been restored as 1577. This would mean that the elderly Hilliard *père* must have been in France with his son. A more likely explanation is that the date was mis-restored and that it

should read 1576, the miniature being painted shortly before Hilliard departed for France in July.

During these two years Hilliard would have seen Valois court civilization at its height before the deluge that was shortly to come in the terrible wars of the League, which lay just five years off. It is a world that we know well from the Valois tapestries depicting the court fêtes of the reign of Charles IX. In spite of the earlier depredations of civil war it far outshone the court of Elizabeth, which always made strenuous efforts, whenever a French embassy arrived, to emulate it. For the Valois kings patronage of the arts was an act of policy, which it was never to be for Elizabeth I. Hilliard would have seen Fontainebleau in all its glory, with its elaborate decoration by Primaticcio and Rosso intermarrying stucco and paint in a revolutionary form. He would have seen the Louvre and the Queen Mother's palace of the Tuileries with its marvellous gardens. What strikes one most, however, is not how much but how little of all this actually rubbed off on him. One senses that the visit was a disappointment. Although Hilliard's work from 1580 onwards is Continental in feeling and one can trace, as we shall see, allusions to Valois court art, when one considers what he was exposed to, the lack of change and variety is all the more extraordinary. Almost a decade passed before he was to embark on the full-length miniatures which certainly echo in their arrangement and elongated doll-like figures the drawings of sitters *en pied* by Clouet and Antoine Caron. What the French visit reveals, in fact, are the limitations of the man. He was either too old – he was thirty – or unable to respond to the enormous challenge of the complex and erudite visual fabric that the Valois court epitomized. What he could offer them, the watercolour *ad vivum* miniature, although recognized by both De Vignère and the poet, Ronsard, as exceptional, was not central to their tradition. The portrait miniature along with the panel portrait had evolved over a half-century in England as the established means of recording likeness. In France that means was a different one, the chalk drawing.

Hilliard and the Image of the Queen: c.1572–c.1590

From the outset it is clear that Hilliard was envisaged as some kind of solution to the perennial problem of the royal portrait. As the reign progressed the multiplication of images of Elizabeth became a part of government policy as the myth of the Virgin Queen was actively propagated. This coincided with the revival of building during the 1570s, which was to reach boom proportions in the eighties and continue well into the new century. Portraits became a feature of interior decoration on a scale unknown before and the focal point of any galaxy of portraits of family, friends and patrons was inevitably one of the Queen. This was a quite new phenomenon in the Elizabethan period and it presented government with a problem which it never quite solved.[51]

That problem was how to control the production of royal portraits, both the images circulated and the actual quality of the painting. The 1563 draft proclamation, to which we have already referred, is the first of a number of pieces of documentation which indicate that government never did. In 1575 the Painter Stainers' Company petitioned the Queen about the low standard of workmanship by those who were insufficiently trained as painters 'as well as counterfeyting your Majesties picture and the pictures of noble men and others'. Twenty years later, in 1596, the Privy Council ordered all officers to assist the royal Serjeant Painter, George Gower, in seeking out unseemly

likenesses of the Queen to destroy them. They had been, it is stated, 'to her great offence', which points to a strong personal opinion by Elizabeth herself.[52] The problem had never arisen under her predecessors for two reasons. In the first instance they had been prepared to spend considerable sums maintaining artists as part of the royal household and entourage, something Elizabeth and her ministers had set their face against. Secondly, there had not been the demand for the royal portrait, nor had government woken up to the full potential of manipulating the royal image as a focus of loyalty to the state. The contrast with the successful absolute control later to be achieved by Charles I, by way of Van Dyck presiding over a large royal portrait factory, is a striking one. Nicholas Hilliard's career became inevitably inextricably intertwined in this problem in his role as a kind of court painter *manqué*.

From 1572 onwards there is a sudden dramatic improvement in the quality of the Queen's portraits, reflected in a series of oil paintings which are usually assigned to Hilliard but can surely now be given with complete confidence. One piece of documentary evidence, which has not been alluded to up until now, corroborates this. In a letter from Edward Horsey to Don John of Austria, dated 22 March 1577, there is reference to the archduke's desire for a portrait of the Queen and how this request could not be met because the man who usually painted 'sa pourtraicture entiere' was in France.[53] Although the man is described as 'ung Francois' this could only ever refer to Hilliard and the allusion must be to an oil painting.

The earliest of the group of panel portraits assigned to Hilliard are the 'Pelican' and the 'Phoenix', both painted in the years immediately after 1572.[54] They are frontal formalized images of the Queen directly in the manner of the Master of the Countess of Warwick, very close to what we might expect Hilliard's large-scale paintings to look like, linear in concept, exact in their rendering of every curl of her hair and every jewel on her dress. They are, however, considerably stiffer than even the Master of the Countess of Warwick and are positively primitive compared with the work of Hans Eworth. Hilliard was less good at oil painting than at miniatures. Their relationship to the famous 1572 miniature in the National Portrait Gallery[55] is much closer than we would guess. If the miniature is viewed under ultra-violet light it can be seen that subsequent restoration has softened the features which, originally, were as sharp as those in the painted panels. In the case of both these pictures and possibly a third[56] we would find little difficulty in accepting them as by Hilliard. All the problems over the attribution to him of large-scale paintings arise only after his return from France and the answer to this must surely lie in a modification of style.

Hilliard tells us that he went to France for 'knowledge'. The year before, his whole livelihood was threatened by the arrival, at the invitation of his patron, the Earl of Leicester, of one of the most sophisticated exponents of courtly Mannerism, Federigo Zuccaro.[57] Our understandable reaction to the nineteenth-century attribution to him of seemingly every other Elizabethan portrait has driven us to an opposite extreme of underestimating the impact of his visit. It must surely have been one of the prime reasons for Hilliard going to France. Up until now all that we have had by Zuccaro from the period of about six months that he spent in England has been two composition sketches for full lengths of Leicester and the Queen. Neither survives and there is no evidence

82

Hilliard and the Queen (1)

Between 1572 and 1576 Hilliard occupied the role of court painter manqué to Elizabeth.

90 The Pelican Portrait, *c.*1572–6

91 The earliest miniature, 1572

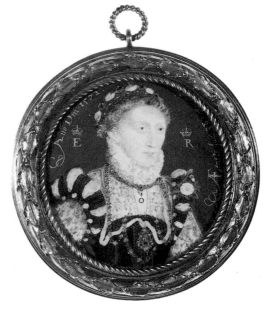

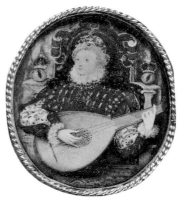

92 Hilliard's finest surviving miniature of the Queen, *c.*1580, probably painted for her cousin, Henry Carey, Lord Hunsdon

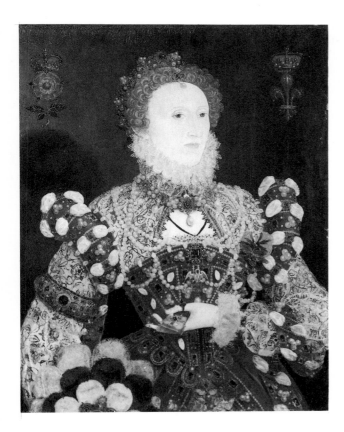

in the case of the latter that it was ever painted. So many portraits have been cleaned since the middle 1950s, when research was last done on this topic, that I believe we are now able to suggest, at least, the famous Darnley Portrait as the most likely one to be by Zuccaro.[58] He has, of course, conceded to the royal wish of being presented as a pale mask, but the placing of the figure, the free brushwork and total assurance of the composition are quite unlike anything else. It stands apart and is never repeated. The face was to be a basic 'pattern' in use for the whole length of the reign. Its impact was to be enormous on the presentation of the royal image until the middle of the 1580s when insularity again set in. It, together with his experiences in France, must also have affected Hilliard's portrait style in a direction which makes it difficult for us to bracket any of these later pictures with those by the man who executed the 'Pelican' and the 'Phoenix'.

93

Documentary evidence establishes that he was working as a painter in the eighties. In 1586 he presented the Queen with a New Year's gift which was not a miniature but a panel painting: 'a faire Table being pyctores conteyninge the history of the fyve wise virgins and the fyve foolyshe virgins'.[59] By 1590 Lord Lumley had in his collection a panel painting by Hilliard of a 'conyng perspective of death and a woman'.[60] In view of all this, we must surely be prepared to accept that he and his workshop may have been responsible for some of the never-ending output of royal images during the 1580s. The grander ones are perhaps easier to attribute. One, in a private collection, moves on from the earlier portraits by adopting a slightly looser style, by making the figure fill the surface more and by turning it to one side in the manner of the Darnley Portrait.[61] Where difficulties arise is in the high number of other paintings of her that survive. Hilliard did not make use of assistants in the painting of miniatures at this date. He did, however, use them in the case of illuminating documents. He did also supply designs for others to execute as medals or engravings. The process of producing a large-scale painting presupposes help and our new view of the limners, in addition to Hilliard's economic straits, would indicate that some panel paintings of quite uneven quality probably came out of the Gutter Lane studio.

One event, however, could have lessened the pressure to produce large-scale portraits of the Queen. This was the appointment, in 1581, of the portrait painter, George Gower, as Serjeant Painter. His predecessor, William Herne, who had held the post from 1572 to 1580, is only known to have carried out the endless round of decorative painting and repair in the royal palaces that continued to be the core of the office.[62] The fact that Gower succeeded him probably reflects a decision reached by the Queen when she was left bereft of the man who normally did 'sa pourtraicture entiere' from 1576 to 1579. With Hilliard away in France the Queen had to turn to other painters and Gower must have been the first. In 1579 appears the earliest series of portraits depicting her as the Roman Vestal Virgin Tuccia holding a symbolic sieve. The formula derives from the Darnley Portrait, three-quarter length and facing to the right, but, for the first time, with a heavy allegorical overlay. By far the most important version has recently been cleaned and fits neatly into George Gower's *oeuvre*.[63]

It is interesting that it was Gower and not Hilliard who was appointed to the post. Hilliard was certainly qualified for it but had proved unreliable. We can take what must have been an uneasy relationship between these two painters a stage further by examining a patent of monopoly drawn up in favour of Gower in 1584 for the manufacture of portraits of the Queen.[64] It was only a draft and there is no evidence that it advanced beyond that, a conclusion supported by the surviving portraits. In it Gower was to produce all portraits of the Queen except 'in small compasse in lymnynge only'. This document has usually been read as a joint attempt by the two painters to obtain a monopoly. It can more reasonably be read as an attempt by Gower to cut Hilliard out altogether except for the miniatures, for the draft was to give the Serjeant Painter the right over 'all maner of purtraictes and pictures of our person, phisiognomy, and proporcion of our bodye, in oyle cullers upon bourdes or canvas, or to grave the same in copper, or to cutt the same in woode, or to printe the same beinge cutt in copper or woode, or otherwise . . .'.[65] And it is to an examination of these that

we must now turn, for the stylistic evidence would indicate that it was Hilliard and not Gower who was in fact to be the dominant creator of the royal image throughout the eighties.

About a dozen miniatures of Elizabeth survive from the 1580s and only at the very close of the decade is there definite evidence of several repetitions of a single face mask being manufactured.[66] The condition of the features in most makes it extremely difficult to decide whether they are *ad vivum* or not. The clothes always are. In each one the dress is different and observed from life true to the limner's technique. Hilliard was only painting what was set up before him and the Queen's miniatures presuppose access to her fabulous wardrobe, the dressing of a lay figure with costume and jewels which he proceeded graphically to record with his brush. This sequence of portraits opens with the most outstanding surviving miniature he ever painted of her, that at Berkeley 92
Castle.[67] Its provenance would indicate that it belonged to her first cousin, Henry Carey, Lord Hunsdon, whose granddaughter and heiress married Sir Thomas Berkeley. Owing to the oxidization of the silver in her dress its dramatic impact is now lessened, but once the figure shimmered against the black velvet chair trimmed with gold in which the Queen sits. It is unique in depicting Elizabeth playing a musical instrument and the quality of precise linear draughtsmanship on a minute scale both in this and in the hands Hilliard was rarely to equal. In fact no other miniature of the Queen was to surpass this one for sheer virtuosity.

The Berkeley Castle miniature must have been a major commission and the liveliness of the interpretation of the face indicates a sitting. This is a rare instance where we can reach that conclusion for in the case of the rest, where condition permits, they emerge as observations at a remove in the studio. One from the early 1580s[68] shows Hilliard evolving a formula for producing these 96
miniatures. The Queen's face has been reduced to the simplest arrangement of defining lines. All the flickering energy has gone into the dress and jewellery; the use of thick impasto white paint to delineate the lace of the ruff, the subtleties of black on black for the bodice and sleeves, the complex build-up of swags of necklaces and single jewels heightened with gold and silver.

By 1586–7, the date of the miniature in the Drake Jewel, this process of 98
production had been still further refined.[69] The Jewel represents a turning-point for we know that it was given to Sir Francis Drake by the Queen sometime during the winter of 1586–7. It pinpoints exactly the moment when this act became an acknowledged sign of regal favour. Two other versions of this face-mask exist, one in the Victoria and Albert Museum[70] and one in the 99
Beauchamp Collection.[71] The face in all of them is by now a dull, mechanically produced mask matching exactly Sir John Harington's eulogy of Hilliard for his ability 'in white and blacke in foure lynes only, [to] set downe the feature of the Queenes Maiesties countenaunce'.[72] So adept was he at doing this that Harington adds the interesting technical point that Hilliard did it 'without any paterne'. In sharp contrast the observation of the dress and jewels is as exact and detailed as ever. The V & A version includes the earliest reference in her portraiture to the Queen's apotheosis as the moon-goddess, Cynthia, Diana or Belphoebe. A crescent-moon jewel can be seen nestling at the centre of her hair and it is surrounded by little silver arrows, attributes of Diana as goddess of the chase.

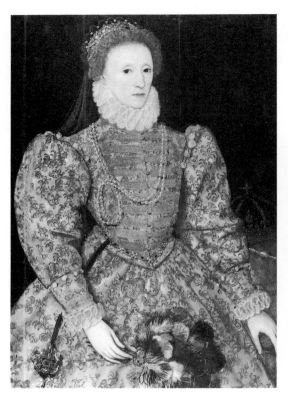

93 Attributed to Federigo Zuccaro, The Darnley Portrait, ?1575. The most influential portrait of Elizabeth ever painted

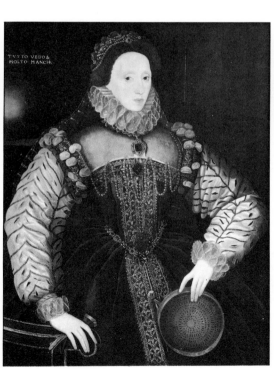

95 Hilliard's response to The Darnley Portrait, c.1580

94 George Gower, The Sieve Portrait, 1579. Based on the Darnley Portrait but with an allegorical overlay

Hilliard and the Queen (2)

Although Hilliard failed to be appointed Serjeant Painter, after his return from France he was to be the dominant force in the creation of the cult images of the Queen during the 1580s.

96 A miniature from the early 1580s

97 Illumination of the Queen in a lost prayer-book, c.1580–84

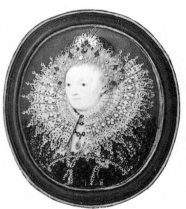

98 Jewelled locket presented to Sir Francis Drake by the Queen, 1586–7. It contains the earliest instance of a portrait which was to be repeated.

99 A repetition of the portrait in the Drake Jewel containing an early allusion to the Queen as the moon-goddess, Cynthia, c.1586–7

As we know, there is no difference in executing a miniature for a locket from painting one on a document of state. One of the most important likenesses of Elizabeth, alas now lost, must have made the point perfectly, the miniature of her which features as an illumination in a Prayer-book executed during the height of the negotiations for her marriage to Anjou (it also included one of him).[73] It was a half length, close to the presentation of her in one of the post-1579 oil paintings but part of a page, the oval image framed in a golden wreath interspersed with Tudor roses. But without doubt the most splendid illumination of the decade appears on the foundation charter of Sir Walter Mildmay's Emmanuel College, Cambridge, in 1584.[74] Mildmay was a known supporter of Hilliard and the charter illumination is by him and his studio. All the portrait miniatures so far are autograph in their entirety but here for the first time more than one hand is discernible. The figure and dress of the Queen, in black with a splendid patterned golden petticoat, is by Hilliard himself; so too should be the design of the border consisting of allegorical figures, a coat of arms, strapwork and decorative serpentining sprays of flowers. But these are coloured by an inferior hand. By that date we know Hilliard had at least one apprentice in his workshop: Rowland Lockey.

Nor should Hilliard's participation be excluded from woodcuts of the Queen, which he was fully capable of executing. That, for instance, which appears before Henry Lyte's *The Light of Britaine* (1588), a celebration of Gloriana, depicts her arising from between branches of eglantine and Tudor roses in a way deeply reminiscent of the *Young Man among Roses* which was being painted simultaneously.[75] Even more strikingly Hilliardesque is a single image of her from about 1580.[76] Both are built up in exactly the same way, with the use of rows of lines to give form to the face, the very detailed rendering of the jewels and dress and the highly stylized hands resting before her; in the case of one the mannered arrangement of the fingers holding the sceptre duplicates that in the Emmanuel College Charter.

One design we know that Hilliard certainly did supply was the pattern for the second Great Seal.[77] We owe knowledge of this fact to the chance survival of the warrant, in itself a rarity. The usual process whereby a new seal was made lay in the hands of the Graver of the Mint. It was he who paid for patterns and the warrant for 8 July 1584 was a joint one to both Dericke Anthony and to Hilliard: 'You shall embosse . . . patterns for a new Great Seal according to the last pattern made upon parchment by you Our servant Nicholas Hilliard . . . And by the same pattern you shall, work, engrave, sink, finish and bring to perfection ready to be used . . . such a new Great Seal in silver.'[78]

That seal was completed two years later and remained in use until 19 July 1603. The warrant is a vital one for establishing that limners were the most likely artists to provide patterns for the Great Seals and what happened in 1584 would very likely have occurred according to the precedent of 1558 and earlier. What is unusual is that the warrant implies that Hilliard took part in the actual manufacture of the silver matrix, something which, as a goldsmith, he was quite capable of doing.

The second Great Seal was not deemed to be a success, however, and almost immediately the Queen ordered patterns to be made for a third. Whatever the objection, the Hilliard seal as a design is far superior to Elizabeth's first Great Seal, to which it owed a degree of inspiration by way of the treatment of the

100 Charter establishing Emmanuel College, Cambridge, 1584. Designed by Hilliard, the figure of the Queen is entirely by him with the borders completed by assistants. The borders provide a key to his decorative style

Hilliard and the Queen (3)

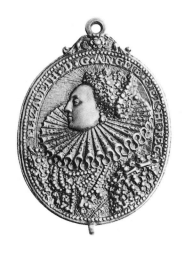

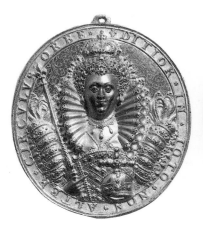

figure on the reverse and the use of the spiralling rose branches. Although the format for a seal was a fixed one, Hilliard's was to a considerable degree without precedent in presenting the monarch embraced within celestial rays and with the robes of state borne up by divine hands issuing from clouds. Naturally this reflects the increasing exaltation of the Crown during the years leading up to the Armada, but the source of the motif is to be found elsewhere. At first glance one might suggest the Virgin of the Annunciation, with the descending Dove of the Holy Spirit, but there is perhaps an even more likely source, the imagery connected with Henri III's creation of the Order of the Holy Spirit in 1578 during precisely the period that Hilliard was in France. A great picture was painted to mark the event and placed in the Church of the Augustins in Paris; it 102 depicted the King surrounded by officers of the Order in the same manner that he was depicted on its seal.[79] In this Henri sits enthroned with tongues of fire encircling him and the Dove of the Holy Spirit descending. This is perhaps what Hilliard had in mind, dropping the dove as a concession to Protestant susceptibilities. In the sculptured three-dimensional form in which we know the seal it is easy to overlook its source, but the elegant figure of the Queen and the serpentine draperies and abundance of sinuous flowers and foliage recall the work of the Fontainebleau Mannerist artist known as the Maître de Flore.[80]

The Great Seal was Hilliard's *chef d'oeuvre* of three-dimensional design, a commission upon which much care was lavished, for it was an object which the Queen herself constantly saw in use. Closely related to it is a series of medals.[81] There was virtually no tradition of medal-making in England and it was not until the visit of Steven van Herwijk in 1562 that a distinguished series was struck. These had no successors, for those that were produced in series in the 1580s and early 1590s, and that must stem from Hilliard designs, nearly all bear rings for suspension. In other words they are not medals in the strict sense of the word but medallions or jewels. One even bears three rings at the bottom from which to suspend pendent pearls. They may be commemorative and might well have been commissioned as gifts subsequent to the defeat of the Armada but no one knows. About one fact we can, however, be certain: their appearance coincides exactly with the increasing momentum of the cult of the Queen which was so marked in the 1580s. The medallions appear simultaneously with the miniatures and both are expressions of the same impulse. They must have been deliberately commissioned and their iconographic content laid down. There are four in all and they vary in quality. The indications are that although the design was certainly by Hilliard, as in the case of seals, the procedure of execution could vary. Hilliard's role could have been confined solely to the production of a pattern for execution by another craftsman at the mint. In other instances it would seem that he and his workshop carried out the whole project. The ones that are less highly finished are two profile images of Elizabeth, one presenting her as Garter Sovereign, and struck probably to commemorate the investiture of Frederick II of Denmark in 1582 or of Henri III in 1585, and the second, with a ring for 105 suspension, depicting her encircled with rays of light and with a reverse bearing the earliest use of the Ark emblem and the motto *Saevas tranquillas per vndas*. The design of both is pure Hilliard in its profusion of decorative detail in the jewels and dress but the execution and above all the casting are rudimentary and lack finish. Neither feature is true of the two other medallions

from the close of the 1580s, both certainly post-Armada, to judge by the dress. Both are designed to be worn, and survive in gold and silver and not baser metals, indicating that they were conceived from the outset as precious. The reverses are identical: a bay tree on an island unscathed by the lightning that strikes from the sky. The clouds are modelled in the same way as those on the Great Seal. One likeness of the Queen is frontal, the other three-quarter face.

Paintings, miniatures, the Great Seal, medals, illuminations, drawings and designs for woodcuts, together these provide a vivid picture of the activity of the Hilliard workshop during the 1580s. What needs to be stressed is that the miniatures only make sense when placed into this overall context of his activities in other fields and the ease with which he so clearly moved from one to the other. What also emerges is his central position as the government's creator of the official image of the Queen. One becomes very much aware in the 1580s of the multiplication of images and the varieties of media in which they could be expressed. The Queen to a large extent established her own vision of herself, but it depended on appearances in person. These were consciously increased both in grandeur and in frequency; state ceremonials and court festivals were devised as a foil for the exhibition of the Queen to her people.[82] But portraiture went beyond that. It provided permanent and tangible evidence of her and her rule. The control of that image was not so much an act of vanity as an act of state and it is fully comprehensible why government was perennially obsessed by it. During the 1580s Nicholas Hilliard successfully manufactured, no doubt under direction from the court, ever more glittering icons of Gloriana; the Queen, in response to the great crisis of the reign, was systematically built up as a semi-divine being set apart. So successful was he at establishing this icon of power that three centuries later we find it hard to recognize portraits of her as a young woman or indeed to think of her as a human being at all. Hilliard was the perfect artist for the visual expression of the ideals of the Elizabethan state.

High Elizabethan: 1575–1593

The 1580s represent the climax of Hilliard's career. Statistically more miniatures survive than from either the decade before it or from either of the two that followed: about sixty-five in all. During this period he had no competition as both Isaac Oliver and Rowland Lockey were training in his workshop. Only by the close of the eighties did Hilliard feel any pressure to experiment, when the younger generation began to practise independently, and only after 1593 is there a deliberate change of style in his painting to meet the challenge. For a time his aesthetic was triumphant and was to have a powerful influence on a new generation of painters. These too were years of virtual insularity during the worst phases of the wars of religion in both France and Flanders. All this conspired to make Hilliard's art the visual embodiment of a fiercely patriotic period of English history, as Queen and country moved towards the great crisis of the Armada.

The events in his private life can be quickly summarized, punctuated as they were by either the birth of a child or financial difficulties.[83] Shortly after his return from France he sank and lost money in a dubious gold-mining project in Scotland. In March 1585 he fell back yet again on his father-in-law, Robert Brandon, then Chamberlain of the City, who lent him and two others money from a fund for orphans. Four years later Hilliard and a certain John Maryett

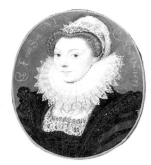

107 *Unknown Lady*, 1578

110 Jean Rabel,
Henri IV as King of Navarre

112 French School, *Madame de Liancourt*, c.1579

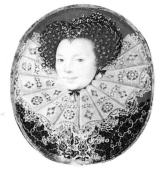

108 *Unknown Lady*, c.1585–90
(see also colour pl. III)

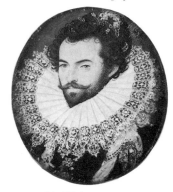

111 *Sir Walter Raleigh*, c.1585

The influence of France

During the 1580s the portraiture of the Valois court continued to influence Hilliard.

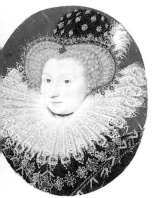

109 *Unknown Lady*, c.1585–90

admitted that they could not repay the loan and acknowledged a debt of £200. In 1590 he was forced to mortgage the lease of his house in Gutter Lane and the year after both he and his children went unmentioned in Robert Brandon's will, giving a sharp insight into the family relationships. Provision was made for his wife Alice by way of the Goldsmiths' Company so that no money need be entrusted to Hilliard himself.[84] The picture that emerges of Hilliard the man is far from an attractive one.

The miniatures open with one of an unknown lady dated 1578,[85] which is in exactly the same vein as the Alice Hilliard of the same year, both of which could have been painted by Hilliard after his return to England sometime during the winter of 1578–9. They form a marked contrast to his portraits of women prior to 1576, which are far harder and more masculine in character. After France the stress is on their charm, femininity and intimacy, an aspect emphasized by a trick familiar from the French chalk drawings of closing in on a sitter and tightly focusing on face and ruff. This becomes a typical formula for a series of female portraits from the late 1580s, one to which he never returned. These close-ups provide some of his most memorable glimpses of court ladies, at times shyly smiling and at others more quizzical and provocative.[86] In the case of his male portraits he seems sometimes to be depicting *mignons* of the court of Henri III rather than Elizabethan courtiers. Sir Walter Raleigh,[87] with his

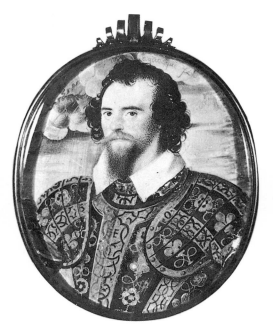

The allegorical miniature

In the middle of the 1580s Hilliard begins to paint allegorical portraits incorporating emblems and imprese *at the behest of his sitters.*

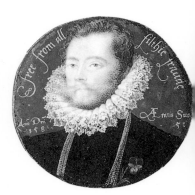

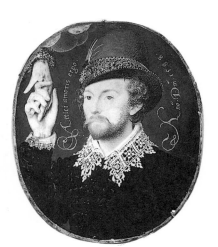

Concordia.

In bellum ciuile duces cùm Roma pararet,
Viribus & caderet Martia terra suis:
Mos suit in partes turmis coëuntibus easdem,
Coniunctas dextras mutua dona dari.
Fœderis hæc species:id habet Concordia signum,
Vt quos iungit amor,iungat & ipsa manus.

113 *George Clifford, 3rd Earl of Cumberland*, c.1586–7. Attired in armour for an Accession Day Tilt with a favour tied to his arm, his *impresa* of a stormy sky with lightning and the motto, *Fulmen acquasque fero*, is behind him.

114 *Unknown Man*, c.1590–93. He is depicted hand on heart as a lover set against a unique black background to signify his constancy.

115 *Unknown Man*, 1585. The purity alluded to in his motto is complemented by a symbolic pansy or love-in-idleness.

116 *Unknown Man*, possibly Lord Thomas Howard, 1588. He clasps his mistress's hand let down from heaven.

117 Clasped hands as an emblem of faithful love from George Wither's *Emblemes* (1635)

118 Clasped hands as an emblem of Concord from Alciati's *Emblemata*

bonnet on his head, his huge cartwheel ruff and pink sash swagged with pearls 111 painted about 1585, compares closely, for example, with an engraving by Rabel of the young Henri IV. These were the years when contact with the Valois 110 court was at its closest as negotiations for the Anjou match reached their climax in the great embassy to England in 1581.

The oval format he evolved about 1577 remained virtually unchanged, but so astoundingly vibrant are these portraits, executed with a brilliant sureness of touch and a mercurial response to the fleeting mood of the human face, that their lack of any development tends to be obscured. It is only in the last three or four years of the decade that innovations suddenly begin again, prompted perhaps by the highly experimental work of his brilliant pupil, Isaac Oliver, whose earliest signed miniature is dated 1587. 186

The first evidence of this change is probably the miniature of George Clifford, 3rd Earl of Cumberland.[88] It depicts the sailor Earl in an elaborate 113 suit of Greenwich School armour (which is now in the Metropolitan Museum of Art, New York) with the usual and by this date monotonous blue background replaced by a stormy sky with rain falling and a fork of lightning in the form of a caduceus. On his right arm there is tied a blue favour. This can only depict Cumberland in his role as one of the leading figures in the Accession Day Tilts which were staged each 17 November to commemorate the anniversary of Elizabeth's accession to the throne.[89] The origins are uncertain but during the 1580s these tournaments were developed into great public spectacles; the Queen was seen to receive the homage of her knights in an event which was designed to be the quintessence of Elizabethan chivalry. The contenders came to them in fancy dress, escorted by attendants in disguise and often mounted on pageant cars or triumphal chariots. The description of that of 1584, at which Cumberland tilted, recounts how the combatants arrived

> disguised like savages, or like Irishmen, with the hair hanging down to the girdle like women, others had horses equipped like elephants, some carriages were drawn by men, others appeared to move by themselves; altogether the carriages were very odd in appearance. Some gentlemen had their horses with them and mounted in full armour directly from their carriages.[90]

Central to this *hommage à la reine*, however, was the presentation to the Queen by each knight of a pasteboard shield bearing his *impresa* or device for that particular tournament. This gesture could be accompanied by speech and song. These always eulogized the Queen and allegorically dramatized her relationship to her knights. After the event the shields were hung up in a gallery of the Palace of Whitehall where they formed a prominent feature noted by all visitors to the palace.

This cult of *imprese* had an immense influence on Elizabethan art, particularly from the 1580s onwards. They reinforced the anti-naturalistic tendencies already inherent by emphasizing the essentially symbolic nature of all painted images. The preoccupation with them changed the miniature into an equivalent of the Italian Renaissance medal in which portrait obverse and allegorical reverse were meant to be read as a single statement expressing the ideals and aspirations of the sitter. William Camden was present at the tilts as a herald and noted down many of the devices that were carried. He also gives us a useful definition of what an *impresa* was:

An *Impress* (as the Italians call it) is a device in Picture with his Motto, or Word, borne by Noble and Learned Parsonages, to notifie some particular conceit of their own, as Emblems . . . do Propound some general instruction to all . . . There is required in an *Impress* . . . a correspondency of the picture, which is as the body; and the Motto, which as the soul giveth it life. That is the body must be of fair representation, and the word in some different language, witty, short and answerable thereunto; neither too obscure, nor too plain, and most to be commended when it is an Hemistich, or parcel of a verse.[91]

When applied to the miniature, what was the obverse and reverse of a medal were fused and the portrait was allegorized by the introduction of symbols and a motto of the kind that would have been separately painted onto a pasteboard shield and given to the Queen in tribute.

The Accession Day Tilts were at the heart of the pageantry of the reign, an ideal vehicle combining courtly chivalry with hermetic imagery. So many of Hilliard's miniatures directly or indirectly allude to that world that we can conclude that it was the tilts and the desire to record their glory that produced the *impresa* miniatures. And the innovation was more probably the patron's than the artist's. Cumberland's is the first, probably *c.*1586–7, recording him at an actual tilt in which he wore this armour patterned with Tudor roses and fleurs-de-lis linked by true lovers' knots and into whose background has surely been let down the contents of the shield which he presented to the Queen. Although it presents a naturalistic sky-scene, nature never figures in any of Hilliard's miniatures other than in an emblematic context. In this instance the combination of lightning, the knight in armour and his motto, 'I bear lightning and water', is close to an *impresa* in Sir Henry Goodyere's *Mirrour of Maiestie* 119 (1618), which is strongly in the tilt tradition. It is dedicated to the young 3rd Earl of Essex, son of Elizabeth's favourite, and depicts an armoured hand issuing from a cloud clasping thunderbolts and the motto *Quis contra nos?* This portended

119 Thunderbolt device from Sir Henry Goodyere's *Mirrour of Maiestie* (1618)

> . . . *auntient* Valour, *that which hath advanc'd*
> Our *Predecessours, (while fine Courtiers danc'd)*
> *That's heere infer'd, to re-informe the mind*
> *By view of instances, where we find*
> *Recorded of your Ancestrie, whose fame*
> *Like forked thunder, threaten'd cowards shame* . . .[92]

In this way the miniature takes up the allegorical, symbolic and commemorative role first postulated in the *impresa* portrait of 1569. 59

Cumberland is perhaps the seminal revolutionary miniature of a group. In an unknown man from 1585 Hilliard retains the blue background but inserts a 115 symbolic heart's-ease or pansy into the foreground and the motto 'Free from all filthie fraude'.[93] The pansy or love-in-idleness was part of the Queen's symbolism, an emblem of her chastity. In this miniature it rests on the sitter's heart, assuring the miniature's recipient of the purity of his love. In the case of another younger unknown man the blue background is replaced by a black one 114 at the behest of the lovesick sitter who places his hand on his heart.[94] The black presents Hilliard with insuperable technical problems but it is there in its emblematic capacity as alluding to the youth's constancy in his affections. The most intractable and obscure is the one of a man clasping a lady's hand issuing 116 from a cloud with the motto *Attici amoris ergo*.[95] This miniature is quite as

important as the Cumberland portrait and indeed exists in two versions. One descended as part of a group which included the Raleigh in the collection of the Howards of Castle Howard. The other came from the collection of Sir Henry Sloane and affords few clues as it was called Essex. The former could constitute a case for arguing that the miniature is an early portrait of Lord Thomas Howard, better known as the Suffolk of James's reign, who was twenty-seven in 1588 and, like Cumberland, a leading contributor to the Accession Day Tilts. He was a friend of Raleigh and served as a volunteer in the fleet against the Armada, for which he was knighted on 25 June; this would have provided an occasion to commemorate. The sitter raises his right hand which is clasped by a lady's hand let down from heaven through a cloud. Clasped hands recur in emblem books from Alciati onwards as symbols of Concord and plighted faith. Geoffrey Whitney's *A Choice of Emblemes*, published two years before, includes two soldiers clasping hands as Concordia. In the sitter's case the concord is between knight and lady although the motto, *Attici amoris ergo*, is difficult to explain satisfactorily. A later English emblem book, George Wither's *Emblemes* (1635), provides the best parallel, in which hands are clasped over an altar with a flaming heart and the couplet:

<div style="margin-left:2em">

Death, *is unable to divide*
Their hearts, whose hands True-love *hath tyde.*

</div>

Simultaneously Hilliard embarked on a small group of minute full lengths. They occur at exactly the same period as the cabinet miniatures but are abandoned as a format almost immediately. The indications are that they were not popular and that he found the formula unsuccessful. What they do reveal forcefully for the first time is Hilliard's inability to define space in terms of Renaissance scientific perspective. As long as he adhered to his head and shoulders formula his limitations remained unrevealed. The miniature of Hatton, which exists in two versions, one at Belvoir and one in the Victoria & Albert Museum,[96] establishes his total ignorance of the laws of perspective, that converging lines mean distance and that space radiates out from a single vanishing-point. He was clearly never instructed in these basic rules and the lines not only do not meet but can actually go in two completely different directions. They heighten the reactionary aspect of Hilliard's art in the context of the rest of Europe.

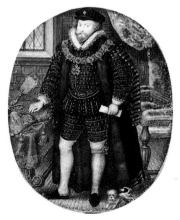

120 *Sir Christopher Hatton*, 1588–91. An experimental full-length portrait, a format soon abandoned

97

To the images of the Queen and to the miniatures we must add a considerable
corpus of other work. There is no identifiable goldsmith's work but this should
not be any cause for concern because Elizabethan plate and jewellery can
virtually never be assigned to a particular maker with any certainty. One
aspect, however, not considered up until now, ought to be explored in the light
of a petition made by two painter–stainers to Robert Cecil in 1594. In it they
follow up one from the previous year seeking a monopoly in the manufacture of
decorative painting for funerals but this time they 'are very well content that
there may also be ioyned with them to perform suche works, Mr Nicholas
Hillyard her Majesties servant to your Honors well knowne for his sufficiencie
and care in his woorks . . .'.[97] Nothing came of this but it does mean that
Hilliard ran a workshop that undertook ephemeral decorative painting. The
kind of work that is being petitioned for is the highly skilled task of executing
coats of arms, banners and hatchments used in funerals. But I would suggest
that he was more active in another related field.

The clue comes in his *Treatise* in a passage in which he actually gives us a
very odd definition of the orbit of a painter. Although he goes on to state that
the artist's 'perfection is to imitate the faces of mankind', that is practise
portraiture, this follows a description of what he sees as the parameters of the
painter's art:

> Now know that all painting imitateth nature, or the life; in everything, it resembleth
> so far forth as the painter's memory or skill can serve him to express, in all manner of
> story work, emblem, impresa, or other device whatsoever.[98]

We know that he engaged in 'story work' because he painted panel pictures of
the Wise and Foolish Virgins and Death and a Woman during the eighties,
besides a limning of the defeat of the Spanish Armada.[99] All these are lost. It is
the reference to emblem and *impresa* which is odd in the context of what we
have normally assumed his sphere of work to have been. And yet if we peer into
the background of the famous miniature of Cumberland as Queen's
Champion[100] we can see hanging on the tree what he means: an *impresa* shield
moulded like a cartouche and decoratively adorned with gold and azure, onto
which the device of the sun, moon and earth in eclipse and the motto have been
painted. These *imprese* were certainly highly finished objects of decorative
painting commissioned by the bearer and subsequently part of the décor of
Whitehall Palace.[101] There are several lists of these. William Camden, herald
and historian, for example, describes a series that must have been at one tilt:

> Another presenting himself at the Tilt, to shew himself to be but young in these
> services, and resolving of no one Impress, took only a white shield, as all they did in
> old time that had exploited nothing, and in the base point thereof made a painter's
> pensil and a little shell of colours, with this Spanish word, 'Hazed meque quires', *id
> est*, 'Make of me what you will'.
>
> At that time one bare a pair of scales, with fire in one balance and smoke in the
> other, thereby written, 'Ponderare, errare'.
>
> The same day was born by another many flies about a candle, with 'Sic
> splendidiora petuntur'.
>
> In another shield (if I am not deceived) drops fell down into a fire, and there-
> under was written, 'Tamen non extinguenda'.[102]

And so the list continues. But who painted them and what did they look like? Henry Peacham's *Minerva Britanna* published in 1612 not only refers to the famous Accession Day Tilt *imprese* of Gloriana's reign but includes a few which we can prove were copied from the Shield Gallery or were slight variants. One was of the Caspian Sea borne by Sir Philip Sidney; another depicted balances with a pen outweighing a cannon, which was used by Essex, as was the third of a blank cartouche inscribed *Par nulla figura dolori*.[103] These 122 devices are Hilliardesque in feeling, far removed from the Flemish sophistication of those in Geoffrey Whitney's *A Choice of Emblemes* (1586). We know Peacham could draw his own emblems but both his publication and Goodyere's of 1618 stem from the tilt tradition and visually stand apart from European emblem books, however dependent they may be for individual devices. The way of depicting them is within the Hilliard tradition, which discounts or is ignorant of the norms of Renaissance pictorial representation and relates directly to how he uses emblems in the miniatures. They represent a vigorous if quaint native tradition that lived on into the Jacobean age, but the stylistic impulse could have been Hilliard.

The tilts also had elaborate scenery and costumes which someone must have designed. In 1590 the Vestal Virgin Temple was erected in the tiltyard with a crowned pillar embraced by an eglantine tree before it.[104] It was the setting before which Sir Henry Lee, the Queen's Champion, passed on his position to Cumberland, Hilliard's patron. In other words we cannot exclude Hilliard from conceivably being one of the major designers for the festivals of the age, or at the least a contributor. The fact that some of the early Inigo Jones costume designs used to be associated with Isaac Oliver could be memories of a more complex tradition which would make Jones's own advent less abrupt than at the moment it appears. One of Sir Henry Lee's most treasured possessions was a 'picture' (clearly a miniature) of himself and Essex at the tilt.[105] It would be logical that Hilliard had some hand in setting the visual style of these festivals of royalist chivalry.

121 Accession Day Tilt *impresa*

122 *Impresa* shield of Robert Devereux, 2nd Earl of Essex, from Peacham's *Minerva Britanna* (1612). Shields of this kind were presented to the Queen at the Accession Day Tilts.

The most important series of compartments or decorative borders, tail and headpieces cut in the later years of the sixteenth century in England was that of fourteen (and probably more), of which five were first used in 1582 in Thomas Bentley's *Monument of Matrones*.[106] These initial compartments contain flanking pillars with little cuts of famous women (including Queen Elizabeth) kneeling at prayer. The style in which they are executed links them to the wood engraver C.T., who cut the Hilliard designs in the 1570s. And indeed McKerrow and Ferguson assemble a formidable group of woodcuts which they believe on stylistic grounds were all cut by C.T., probably identifiable with a certain Charles Tressell, Treasure or Tressa, a Dutchman, who, in 1582, is described as 'a carver to the printers'. A point of departure for any attribution to Hilliard is the border to the Emmanuel College Charter of 1584, which gives us a clue as to the type of allegorical figures and strapwork decoration that we should expect. The basic features are no doubt the same, that is a bold enclosure formed by strapwork and cartouches into which figures are inserted, but with the heaviness enlivened by delicate curving sprays of flowers, greenery and swags of drapery. The *Monument of Matrones* is a celebration of Elizabeth Regina in her religious aspect, through the prayers and meditations of holy women, herself needless to say included. Book III even contains 'sundrie formes of diuine meditations & Christian praiers; penned by the godlie learned, to be properlie vsed of the QVEENES most excellent Maiestie, as especiallie vpon the 17 daie of Nouember, being the daie of the gladnesse of hir hart . . .'.

Nothing, of course, can be proved but so many lines in printing lead back to the government presses that it seems likely that the designs for title-pages and borders would have been by someone close to the court. Many of the designs listed by McKerrow and Ferguson were used on publications by the Queen's printer, Christopher Barker. These include that for the Book of Common Prayer (1580) (M. & F., no. 168) and the series for the 1578–9 edition of the Bible (M. & F., nos 158–9) with figures of the virtues directly in the manner of those standing on the Emmanuel College Charter.[107] Hilliard cannot be excluded either as a major contributor or influence.

80

12.

123 Detail of the border of the Emmanuel College Charter, 1584 (pl. 100)

124 Woodcut title-border to Thomas Bentley's *The Monument of Matrones*, 1582, possibly after a design by Nicholas Hilliard

This is perhaps speculation, but it is certainly true that the miniaturist's influence and style were at their most potent with other painters in the eighties.[108] George Gower progressively moved towards producing in large scale flat formalized icons of court ladies, culminating in his 'Armada Portrait' of the Queen which is highly indebted to Hilliard. Robert Peake is derivative of Hilliard in his pastel shaded palette and flat linear rendering of his sitters lit evenly like Hilliard's from the front. The herald William Segar belongs to the same group, delineating the eyes in his large-scale panel portraits in exactly the same manner as Hilliard would do for a miniature. No wonder that the years immediately after 1590 bring the earliest eulogies by Henry Constable and Sir John Harington to 'our countryman' who 'is inferior to none that liues at this day'.[109]

125 *Young Man among Roses*, probably Robert Devereux, 2nd Earl of Essex, *c.*1587

The cabinet miniatures: c.1587–c.1595

126 *Sir Anthony Mildmay, c.*1590 (original: 24.5 × 18.5 cm)

The full-length large-scale or cabinet miniature appears with all the suddenness of a novelty that caught on. Seemingly it sprang abruptly from nowhere about 1587 in the shape of the most famous miniature Hilliard ever painted, the *Young Man among Roses*.[110] The elongated shape, never to be repeated, the allusions to the art of Fontainebleau in the cross-legged pose and sinuous figure, obscure the fact that Hilliard could draw on a long indigenous tradition of life-size full-length portraiture stretching back to Holbein's monumental wall-painting of the Tudor dynasty in the Privy Chamber of Whitehall Palace. Full-length copies of the Henry VIII were manufactured throughout the century and the format had a continuous, if fluctuating vigour down into the 1580s passing via Master John in the 1540s, William Scrots in the 1550s, Federigo Zuccaro, who painted Elizabeth and Leicester full length in 1575, Cornelius Ketel, who executed a life-size portrait of Frobisher in 1577, and the mysterious Hubbard who painted Lettice Knollys and her son in 1584.[111] Hilliard was not short of examples to scale down, and after 1590 the demand for full lengths rose as Gheeraerts and then de Critz and Larkin

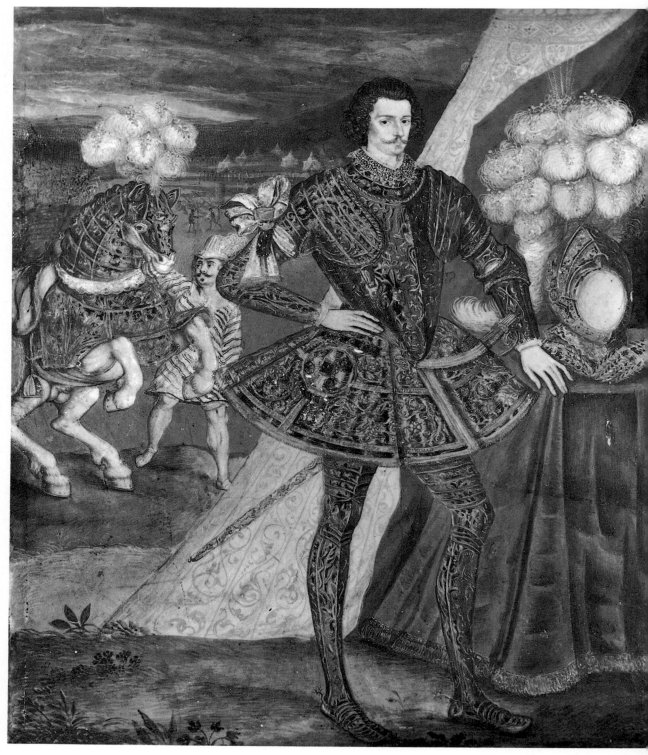

127 *Robert Devereux, 2nd Earl of Essex, c.*1593–5 (original: 24.9 × 20.4 cm). The miniature commemorates the Earl's appearance at an Accession Day Tilt. His *impresa* is embroidered on the skirts worn over his armour. (See also colour pl. IV)

Hilliard and the
Accession Day Tilts

*The allegorical pageantry of the
tournaments held annually on the
Queen's Accession Day, 17
November, had a powerful
influence on Hilliard's miniatures.*

128 Hendrik Goltzius, *Marcus Curtius*, 1586. The likely source for the horse in
pl. 127.

129 Hendrik Goltzius, *A Pikebearer*, 1582. The source of Hilliard's portrait of
Cumberland

130 *George Clifford, 3rd Earl of Cumberland,* ?1590 (original: 25.8 × 17.6 cm).
A portrait painted to commemorate his appointment as Queen's Champion at the
Tilt in that year.

manufactured the great costume pieces that were commissioned in sets for the long galleries of the prodigy houses.

The initiative, however, must have come from the sitter and perhaps it all began with the *Young Man among Roses* which quite clearly answered to a series of particular demands by the patron, including a special setting. In contrast all the others are rectangular. From the outset they were items of immense costliness merely in terms of labour. All the sitters were people of very high rank and, if not considerable wealth, at least noted for their prodigality: Essex, Cumberland, Mildmay, Dudley and Northumberland. In many Hilliard had to insert a complex iconographic programme of the sitter's devising that could never have been crammed into the surface of the small head and shoulders miniature.

The result is that he is so uncertain that he falls back on engraved sources to solve his problems. *Cumberland*[112] is closely based on an engraving by Goltzius (an artist referred to more than once in the *Treatise*) of a Pikebearer dated 1582. This gives him not only the pose of the sitter, lance in hand, but the tree with its suspended shield to the right and the placing of the figure silhouetted against a low-lying landscape, in this instance a contracted view of London looking across the Thames from the south bank towards Westminster and the tiltyard over which Cumberland presided as Queen's Champion each Accession Day after 1590. It is landscape as emblem. Goltzius is again raided for the prancing horse in the background to his portrait of *Essex*, and it is likely that other engraved sources may come to light.

Both these reinforce the association, already discussed, of many of the miniatures with the Accession Day Tilts. Two certainly are commemorative. *Cumberland* must mark his succession as Queen's Champion. He is attired in symbolic garb, embroidered with emblematic spheres, caducei and branches of olive, his hat with the Queen's glove sewn to it and his *impresa* shield behind him. The *Essex*[113] refers again to a definite tilt, for Camden records the *impresa*, which was a diamond, in his *Remaines* and it was listed amongst the Accession Day Tilt shields in the Shield Gallery of Whitehall Palace. Essex too wears the Queen's glove tied to his tilting arm and conceivably the portrait refers to his famous appearance at the tilt of 1595, when Francis Bacon wrote the speeches for a complicated presentation of the Earl as torn between the conflicting paths of war, statecraft and contemplation. The background, as in the case of Cumberland, is symbolic. Essex, his horse and attendant are in the pageant clothes of Gloriana's holy day but behind them is a panorama of tents, massed infantry and guns, an emblematic reference perhaps to his expedition in support of Henry of Navarre in 1591.

The third miniature which has tilt allusions is that of Leicester's son, the heir of Kenilworth, Robert Dudley,[114] who likewise was a leading figure at the tilts throughout the nineties. A lady's favour, a jewel, is tied to his left arm by a ribbon. This logically should have been bestowed by the Queen and jewels were prizes at the tournament. In contrast Dudley is posed inside standing before a hanging with his hand placed on a helmet to the left. The pose is that of the *Essex* but in reverse and it is repeated in that of *Sir Anthony Mildmay*.[115] These are not especially innovative but are conventional in their formulae, echoing in particular Zuccaro's portrait of the Earl of Leicester which could have been a powerful and, as usual with Hilliard, belated influence.

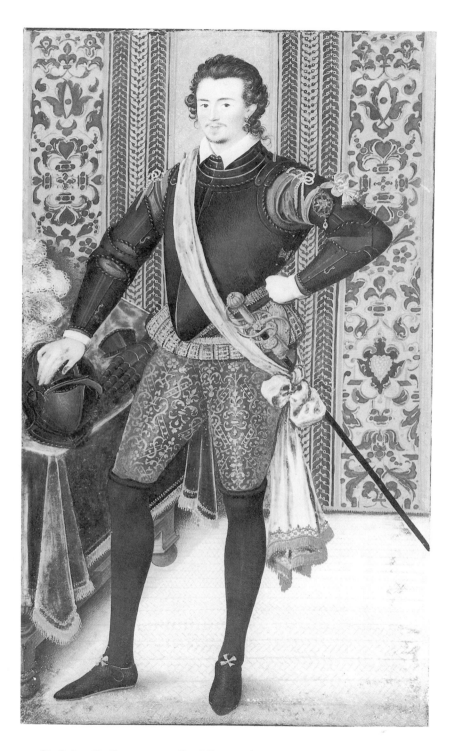

131 *Sir Robert Dudley*, *c*.1591–3. Partially armed and with a favour in the form of a jewel tied to his arm, this is likely to allude to an Accession Day Tilt.

Although nearly all these miniatures are connected with Accession Day Tilt pageantry, three stand apart. Sir Anthony Mildmay,[116] son of Hilliard's patron, Sir Walter, is depicted in the context of a formal portrait of a man at arms with no complex symbolic overtones. *The Young Man among Roses*[117] I 125 have discussed at length before and the likelihood is that it is the young Essex pining for love of the Queen, whose colours of black and white he wears and in the branches of whose emblematic flower, the single white eglantine, he is embowered. But the miniature which is by far the most cryptic is that of Henry Percy, Earl of Northumberland.[118] It is not easy to date. The tighter style of 132 painting, the result of the influence of Oliver, would place it after 1593, but in that year the young Earl became a Knight of the Garter. However, the portrait shows no sign of the insignia of the Order. This should not, though, preclude a dating between 1593 to 1595 because in the case of the portraits of both Cumberland and Essex, similarly Garter Knights, the insignia is also missing. And this fact is due to the allegorical nature of their portraits. Northumberland patronized Hilliard extensively. In 1595–6 he was just over thirty and two years before, in 1594, he had married Essex's sister, Dorothy Devereux, widow of Sir John Perrot. During the 1590s it is generally accepted that Northumberland was one of a group of noblemen and their friends, of whom the key member was Raleigh, who devoted their time to deep philosophical and mathematical studies but imbued with Renaissance occultism and hermetism. The programme for this miniature must have been laid down by the Earl and is designed to cast him in precisely such a light. George Peele's poem, the *Honour of the Garter*, is dedicated to Northumberland in his new role as Garter Knight and evokes the ambience:

(Renowmed Lord, Northumberlands fayre flower)
The Muses love, Patrone, and favoret,
That artizans and schollers doost embrace,
And clothest Mathesis in rich ornaments,
That admirable Mathematique skill,
Familiar with the starres and Zodiack.
(To whom the heaven lyes open as her booke)
By whose directions undeceiveable,
(Leaving our Schoolemens vulgar troden pathes)
And following the auncient reverend steps
Of Trismegistus and Pythagoras,
Through uncouth waies and unaccessible,
Doost passe into the spacious pleasant fieldes
Of divine science and Phylosophie.[119]

132 *Henry Percy, 9th Earl of Northumberland, c.1590–95. The philosopher earl presented in a highly symbolic portrait in which he reclines in a garden atop a mountain emblematic of his pursuit of 'divine science and Phylosophie'*

The last few lines almost describe the miniature. The Earl reclines in a rectangular garden, enclosed by a clipped hedge, on the summit of a mountain with vistas of ascents in the distance. The location must be 'the spacious pleasant fieldes/Of divine science and Phylosophie', to which he has gained entrance 'Through uncouth waies and unaccessible'.

He is attired in black, his shirt and doublet undone, his hat and gloves cast to one side. Both the recumbent pose and the negligent dress are attributes of the melancholic and the image is an expression of the Ficinian revaluation of the Saturnian influence.[120] George Chapman's *The Shadow of Night* mentions Northumberland in the preface as one of the noblemen devoted to deep studies

and the poem is a celebration of the Saturnian humour in the profound contemplations of night.

Normally melancholy man seeks his solace beneath the shade of the greenwood tree outside the confines of ordered nature as epitomized by the art of the garden. Northumberland, however, has deliberately placed himself within the orbit of cultivated nature: a clipped rectangular hedge, a path, grass, a sloping bank followed by a second rectangular hedge. Perhaps the clue to the meaning of all this is Mathesis, to which Peele refers. Mathesis is one of the four 'guides in religion', of which the others are Love, Art and Magic. Northumberland's concern was the mathematical arts in this sense, which meant diagrams and geometrical shapes not only embodying the symbolic Pythagorean and numerological approach of the Middle Ages but reinforcing it with all the ramifications of Renaissance occultism as expressed in hermetism and cabalism.[121] Hilliard's perspective is so inadequate that the likelihood is that what we are intended to see is a square into which the Earl has placed himself. The square is first and foremost a hieroglyph of wisdom signifying its firmness and constancy.[122] This in turn is complemented by an *impresa* suspended from a tree in which a feather outweighs a sphere or a cannon-ball with the motto TANTI. This and the *Young Man among Roses* constitute Hilliard's two most complicated portrait images and emphasize, when their meaning is examined, the highly symbolic nature of what at a superficial glance would strike the onlooker as merely a landscape and woodland setting.

The most successful of these miniatures are those with landscapes, for the obvious reason that Hilliard only had to cope with the softening of colour of aerial perspective and did not have to come to grips with the problems of mathematical perspective. When he does the result is confusion because he not only failed to grasp the basic principles of linear perspective, so that there is never a single vanishing-point, but his tonality betrays often an equal failure to appreciate the rules of aerial perspective. The intensity of the blue of the

Hilliard's innovations in the 1590s

With the advent of competition from his own pupils, Isaac Oliver and Rowland Lockey, Hilliard began to experiment.

133 *Unknown Lady*, 1593. The earliest dated example of Hilliard painting a sitter's hair in the tight manner of Oliver

134 *Henry Wriothesley, 3rd Earl of Southampton*, 1594. The earliest dated instance of a folded curtain background

135 *Sir Henry Slingsby*, 1595. Hilliard making use of his new background formula in a portrait whose quality borders on the schematic

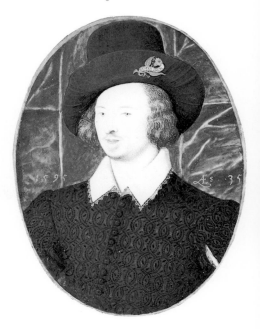

braiding of the tent in the miniature of *Mildmay* is exactly the same as that for the table-cloth in the foreground. One of the last of these miniatures is the only one of a woman, obviously a lady of very high rank.[123] The hair is painted in his loose pre-1593 manner and she stands silhouetted against a folded crimson velvet curtain, a feature first certainly introduced in 1594, which dates it fairly closely. It is unfinished. Is this Hilliard admitting defeat? Oliver makes use of this format over the whole span of his career but for Hilliard it was an experiment that lasted nearly a decade and was then abruptly abandoned. If we were more objective about these miniatures we would perhaps hold them in less esteem than we do. Their quality is in the main uneven and in places slapdash. Only in the hypnotic *Young Man among Roses* does Hilliard succeed in producing the one great image of an age.

Late Elizabethan:
c.1593–1603

Hilliard's miniatures from the 1590s can be neatly categorized according to an abrupt stylistic change that occurred in the year 1593. The *Unknown Lady formerly called Mrs Holland*[124] from that year usefully embodies all the new characteristics. Foremost amongst these is his handling of the hair, which 133 suddenly tightens in a direct imitation of the manner of his pupil Isaac Oliver. Up until that date Hilliard always rendered hair and costume in his usual free bravura manner. After 1593 a tightness sets in which can affect even the treatment of the dress. Change also occurs in the backgrounds. A year after the *Unknown Lady* comes the earliest dated instance of the folded velvet curtain painted in the wet-in-wet technique, in which the crimson pigment is worked over a paler layer before it dries. The portrait is one of Shakespeare's patron *Southampton*,[125] followed the next year by *Sir Henry Slingsby*,[126] and in both 134/5 cases the new format results in the inscriptions being somewhat unhappy as the gold lettering fails to register against a ground of uneven tonality.

By the middle of the 1590s Hilliard's work must have begun to look increasingly old-fashioned in comparison with that of Oliver. About forty miniatures are extant, reflecting no dramatic decline as yet of patronage. The

136 *Jane Seymour*, *c.*1600. One of four miniatures of Tudor monarchs from a lost jewel by Hilliard

137 *Unknown Lady*, 1602 (see also colour pl. V)

138 *Edward Seymour*, *Duke of Somerset*, *c.*1600. A copy after a lost miniature probably by Levina Teerlinc, 1550

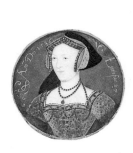
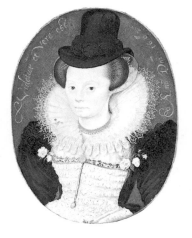

innovations do not, however, seem to have met the challenge and one senses in many of the miniatures a certain tiredness and, even worse, at times, a mechanical slickness. The four miniatures of Tudor monarchs[127] that were part of an elaborate enamelled jewel of his design and making are hard and facile in feeling. The fact that they were based on earlier pictures may account for their lack of life but Hilliard was by then old in sixteenth-century terms. He was fifty-six in 1603. The sparkle could, of course, return if a sitter entranced him, as must have been the case with a young citizen's wife with her tall hat and flowers tucked into her bodice who sat for him in 1602.[128]

136
137

Hilliard's copies of earlier pictures are an overlooked aspect of his work. It would seem that he could not only copy earlier miniatures but also retouch them. Lord Abergavenny by Holbein and one of the young Elizabeth by Levina Teerlinc both have Hilliard lettering. More important is the copy of a miniature of 1550 of Protector Somerset.[129] The circular format and the placing of the figure indicate that it ought to be after a lost portrait by Teerlinc.

138

Overall, however, Hilliard's miniatures are out of key with the prevalent aesthetic mood of the 1590s. It is significant that Robert Devereux, Earl of Essex, by 1596 had switched from a combination of Segar for large-scale and Hilliard for miniature portraits to one of Gheeraerts and Oliver. The atmosphere had changed and Hilliard belonged to the fairy-tale world which was deliberately kept alive around the ageing Queen whose tastes certainly remained fixed. His private life centred on battles to remain in his Gutter Lane house and workshop. Essex intervened with the gift of the large sum of £140 towards redeeming the £200 mortgage. The lease was only renewed as a result of intervention from court in the form of a strongly worded letter from the lords of the Privy Council headed by Robert Cecil (who, typically, sat for Oliver and not Hilliard). The document dwelt on him in his role as 'her Majesty's servant'. That was in June 1600, a year after he had actually achieved that status, one which had been enjoyed by his predecessors as court artists. His annuity of £40 was precisely the same amount that had been paid to Levina Teerlinc with no allowances for the intervening inflation.[130]

We know that Hilliard was so pushed for money that he gave drawing lessons[131] (a fact interesting in itself as we shall discuss in the next chapter) but perhaps the letter that sums up the decade is the one of 1601 to Robert Cecil.[132] This time he unsuccessfully applied to the Secretary for permission to travel abroad to avoid his debtors and refers to his training of others 'both strangers and English'. These now, he goes on to say, are doing him out of business. He writes with mingled sarcasm and bitterness that they have produced miniatures that 'have pleased the common sort exceeding well', a tasteless jibe at Oliver, whose work outshone his master's. At about the same time he was compiling his *Treatise* where again he has another swipe against his competitors: 'so one botcher nowadays maketh money'.[133] In the letter to Cecil he continues that without further help from the Queen 'I am myself become unable by my art any longer to keep house in London'. It is a sour, unhappy document dispelling forever any lyrical view of Hilliard. This loss of work was not only fashion but his own fault. In miniatures like that of Sir Henry Slingsby his work has become so schematic and mechanical that it would not have needed much of an eye to have perceived the superiority of Oliver. Mediocrity had crept in.

135

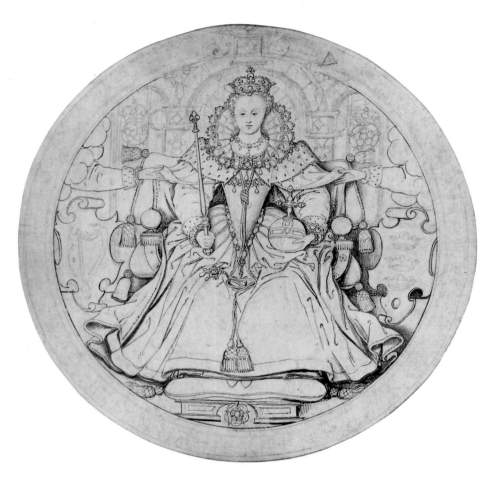

139 Design for a Great
Seal of Ireland, *c.*1590

*Hilliard's other
work in the 1590s*

In contrast to the earlier periods there are odd documentary pieces of evidence
that enlarge our vision of Hilliard's work in the 1590s. In the first instance we
have a jewel by him. This came into the possession of Charles I from the Earl of
Pembroke, who obtained it from Hilliard's son, Laurence. We have already
referred to the slick nature of the portraits of the Tudor monarchs in the
Bosworth Jewel but van der Dort annotates his entry on it with the significant
words 'done both Je/well & Pictures/by ould Hilliard'.[134] The obverse exterior
had an enamelled picture of the Battle of Bosworth opening to reveal Henry
VII and Henry VIII. On the reverse a Tudor rose on a green ground (the
Tudor colours were green and white) opened to reveal Jane Seymour and
Edward VI. Dated by scholars to *c.*1600–10 the emblematic contents of the
jewel eliminate any date after 1603 for it is a eulogy of the Protestant
succession. What is unusual is the absence of Elizabeth who is, by implication,
the missing culmination of its imagery, the living embodiment of the Tudor
pax subsequent to the Wars of the Roses. This would indicate that the Jewel
was made for presentation to her, conceivably as the final gesture of an
entertainment on progress that never happened.

Another project that we know he was continuously involved in was
producing designs for a third Great Seal.[135] This probably began before the

death of Lord Chancellor Hatton in November 1591 and it was still in hand in 1600. We only know about it through the payments made to the Graver of the Mint, Charles Anthony, in the Jacobean period. It is perhaps worth quoting those connected with making 'a great seal for the late Queen Elizabeth' in full:

> Drawinge and embossinge sondrye paterns for the saide greate Seale viz. twoe in the yeare 1592 xl*s*; sixe other patternes somewhat lesser in the yeares 1594 and 1596 lx*s*; embossinge a patterne in white waxe for the foreside of the saide great Seale in the yeare 1597 lxx*s*; embossinge one other patterne in white waxe after a patterne which Mr Hilliarde did lymne in parchmente in the yeare 1599 c*s*; embossinge a greater patterne in white waxe which after many mendings was liked by her Majestie xj*li*; and for makeinge sondrye patternes for the horsbacke side of the sayde greate Seale in the year 1600 xij*li*: x*s*. In all . . . xxvij*li*.[136]

To this we must add a draft warrant to Anthony dated 17 May 1600 ordering the seal to be made 'according to a patern which we have redy and [which] remayneth with Nicholas Hilliard our servant'.[137] The fact that Hilliard is only specifically referred to in 1599 as limning a pattern does not mean that he was not responsible for the whole series of patterns from 1592 onwards.

There is a drawing in the British Museum which is one of these patterns for a seal, but it is for a Great Seal of Ireland. It would be tempting to link it with the long series of references to pattern drawings for the third Great Seal but in fact careful examination of the costume evidence would place it earlier. The costume and in particular the ruff can be paralleled in portraits dated 1589. The drawing is also closely related to the second Great Seal of England, which surely suggests that one for Ireland should have followed. I would therefore place this 'pattern' as one sequential to the second Great Seal drawn sometime between 1586 and 1591, when the Queen embarked on her third for England.[138]

One final document rounds off the story of the seal, for a certain Thomas Harrison had amongst his luggage examined in October 1601 a metal picture of Elizabeth which, he stated, 'Hilliard dyd make . . . emongst the moddels that he made for the seale for the Queenes picture'.[139] It was 'made about the tyme that Mr Hyllard dyd make workes for the great seale in the tyme of Sir Christopher Hatton'. Hatton became Chancellor in 1587. This would indicate that Hilliard was concerned not only with designing the seal but making 'moddels' and matrices, for the metal picture must have been a matrix. That participation in this process was unusual for the designer is reflected in the miniaturist's letter to the Earl of Salisbury in 1606 when he writes 'I had once envy enough about a Great Seal for my doing well in other men's offices'.[140] The evidence is confusing but it would seem reasonable to conclude that Hilliard and Anthony worked as an unhappy team on the seal but that the design must always have begun with Hilliard.

Hilliard promised to paint 'a faire picture in greate of Her Majestie' for the Goldsmiths' Company in 1600.[141] Presumably this vanished in the Great Fire of London, but it means that Hilliard was still active painting life-scale portraits of Elizabeth three years before her death. This cannot have been a sudden revival of a lost skill. What it implies is that Hilliard was continuously employed painting large-scale pictures. He must, for instance, have trained his pupil, Rowland Lockey, in painting both on canvas and on panel, a fact which we tend to forget because there is no reason why there should not be pictures by

140 The Hardwick
Portrait, probably 1599.
Although of workshop
quality, the concept and
composition are directly
in the style of Hilliard.

141 Called Queen
Elizabeth I, *c*.1600. An
outstanding portrait in
the already archaic
manner of Hilliard

Hilliard on canvas, which came into its own in the 1590s with the advent of the fashion for full-length portraits.

We have already noted that his major innovation in 1594 was the introduction of a crimson velvet curtain with its chequer formed by the folds. Such curtains are a resurrection from Eworth's portraits of Mary Tudor in the middle of the century. But their appearance is not an isolated one because they are also present in a small group of portraits, all of which are in the Hilliard manner. The first of these is a famous picture, the full length of *Elizabeth I* at 140 Hardwick Hall, which may be related to payments for bringing a picture of the Queen north in 1599.[142] Bess of Hardwick we know patronized Hilliard and his pupil Lockey. She was a great age by 1599 and her taste would not have moved onto the younger generation. The *Elizabeth I* has recently been subject to modern scientific cleaning and restoration and everything in it points to Hilliard's workshop as its source. It is mechanical, even mediocre in quality, but so were many of the miniatures painted during the same period. The face is the mask of youth pattern which is the standard image he uses in his final miniatures of her and the composition is identical with the unfinished full-length lady in the Fitzwilliam Museum.[143] The approach to pictorial space, with the carpet on which she stands tipped up, is as archaic and as misunderstood as in the full-length miniatures. Hilliard only ever paints what he sees and there is nothing invented in this picture. It is an exact record of Elizabeth I's fantastic wardrobe. An additional factor is that the head and headdress figure as part of a large wood-cut of the Queen which again Hilliard may have designed and even cut.[144]

The Hardwick Elizabeth is, as I have said, a mediocre object, possibly even Lockey working from a Hilliard design. There is at least documentary evidence to suggest that it could have emanated from the Hilliard circle. I cannot produce that evidence for two other pictures, both outstanding in quality, which should be referred to in any discussion of Hilliard's influence as a painter on other artists. They do not remotely relate to the established *oeuvre* of either Peake or Gheeraerts, the leading portrait painters of the decade. In fact they anticipate what may be described as the final revival of the iconic tradition about 1610–15 by William Larkin. They are of the same woman wearing different dresses but the same jewellery rearranged upon them. One is in the Parham Park Collection and the other in the Metropolitan Museum of Art, New York. They share with the later miniatures the same folded crimson velvet curtain, and the brilliant front-lit figures are pure Hilliard in their approach to the sitter and their rendering of the dress and jewellery. For the moment they must remain categorized as in the manner of Nicholas Hilliard but they form the two masterpieces in large-scale painting in his style from the turn of the century.

I make one more suggestion. In 1590 one of the period's more curious

Hugh Broughton's 'A Concent of Scripture', 1590

There were two editions of the Concent, *one with engravings by Jodocus Hondius and a second with ones by William Rogers. The latter has variants but both are directly in the manner of Hilliard.*

142 Title-page based on Hilliard's woodcut border of 1574 (pl. 81) engraved by Hondius

143 *The Kingdomes that Overruled the Holy Hebrewes.* Engraving by Hondius

144 *The State of Rome for Crucifying our Lorde.* Engraving by Hondius

illustrated books was published, Hugh Broughton's *A Concent of Scripture*.[145] The work was devoted to the complex subject of scriptural chronology and it appeared in two editions in the same year, with engravings by Jodocus Hondius in the first and by William Rogers in the second, the latter including slight variants. They form a quite extraordinary series of images. A connection with Hilliard as the designer of these apocalyptic visions can only be based on two circumstantial pieces of evidence. The first is the author. Broughton was a prominent Puritan divine who received an allowance for a private lectureship in Greek from the miniaturist's patron, Sir Walter Mildmay. In the eighties he had settled in London and the first, unillustrated edition of the *Concent* had appeared in 1588. The second piece of evidence is the title-page, which is an engraved version of Hilliard's border of 1574. This is not to say that it could not have been pirated but the Protestant milieu and Mildmay would fit in with what we know about the miniaturist. So would these engravings. They are close to the aesthetic of the cabinet miniatures with their low-lying vantage-point, their misunderstood perspective and their abundance of decorative detail. The picture of 'Babylon the mother of filthy fornication' is like a perverted version of one of Hilliard's intricate late portraits of the Queen.

142–4

After the 1580s there is no evidence to indicate that Hilliard ever painted the Queen *ad vivum* again. This is important, for what I wish to argue is that this must indeed have been the case and that the last time Elizabeth ever sat for a painter was in the early 1590s, once for Marcus Gheeraerts, for the Ditchley Portrait, and a second time for his future brother-in-law, Isaac Oliver, for a pattern for the production of miniatures with engraving also in mind. Both were deliberate efforts to come to terms with a new generation of artists and a new aesthetic. In the case of the latter that experiment proved a total failure, leading to the reinstatement of Hilliard and the establishment of the government-promoted official image which we generally and conveniently label the 'mask of youth'. Elizabeth was sixty in 1593 and more than usually sensitive on the subject of her decaying physiognomy. This sensitivity coincides exactly with the advent of Hilliard's long series of miniatures in which the monarch undergoes a sensational rejuvenation back to girlhood.

I have already discussed the mask of youth elsewhere and its place in the cult of the Queen during the last decade of the reign.[146] John Davies, under the patronage of Robert Cecil, was its principal literary articulator in his endless lyrical celebrations of her as 'Beauty's Rose', 'Queen of Love', 'Queen of Beauty' and 'our state's fair spring'. These are, indeed, the final transmutations as the image of Gloriana was expanded into the extremes of a messianic cult, in which the ruler, embodying the stability of the state and seemingly the cosmos, was presented as apparently capable of miraculous regeneration. Hilliard, as I have already argued, was the formulator of its visual expression but the question is whether he did this of his own volition. In the light of our increased knowledge of the workings of Elizabethan government and the arts as its handmaid the answer must inevitably be a negative one. We are looking at a government-promoted portrait.

Various circumstances must have led to this. In the first instance, unlike the eighties, the Queen's image became increasingly difficult to control again during the nineties.[147] Raleigh in his *History of the World* records, without giving any date, that at one period the Queen had ordered all the portraits made of her by what were categorized as 'common painters' to be burnt. This probably refers to the act of the Lords of the Privy Council in July 1596, already cited, ordering all public officers to aid the Queen's Serjeant Painter, still Gower, to seek out these unseemly likenesses which were to her majesty's 'great offence' and have them defaced. No more portraits were to be produced without the approval of Gower. Prints went the same way, for Evelyn records that 'vile *copies* multiplyed from an ill Painting' were seized and used by the cooks in the kitchens of Essex House. The Queen's attitude to her own image is reflected too in her endless procrastination, lasting a decade, in approving any of the endless pattern drawings by Hilliard for a third Great Seal.

We are witnessing a recurrence of the problem faced by the government in the 1560s but with a novel twist to it, for this time there was no lack of painters. What had not had to be done before was to suppress totally any public representation of the monarch as old. Although partly regal vanity, the problem of the uncertainty of the succession must have made the government aware that it was unwise to multiply images that emphasized the physical vulnerability of the wearer of the crown. These are the facts that presumably resulted in a sequence of events roughly as follows.

Everyone at court in the early 1590s, in the aftermath of the Armada, must have been conscious of not only a vast surge of patriotic confidence in the nation's destiny but also its expression in the arts. In the case of painting this was epitomized by a new generation of painters headed by Gheeraerts and Oliver. Sir Henry Lee, the Queen's Master of the Armoury and personal Champion at the Tilt, in his role as the creator of the Elizabeth legend through the Accession Day Tilts was one of the first to respond by commissioning a whole series of portraits by Gheeraerts for his long gallery at Ditchley. So close was Lee to Gheeraerts that the ancient knight stood as godfather to one of the painter's children.[148] The climax of that series of pictures was the celebrated Ditchley Portrait (National Portrait Gallery) commemorating either the Accession Day Tilt of 1590, when Lee retired as Queen's Champion, or the Queen's visit to Ditchley in 1592.[149] In this picture Gheeraerts, then a young man of about thirty, brilliantly succeeded in marrying myth with reality. The Ditchley Portrait is from life, although it is noticeable that derivatives tend to rejuvenate the face along the lines of the mask of youth.[150] More or less simultaneously Gheeraerts' future brother-in-law, Isaac Oliver, was granted a sitting for a miniature in the new style (a pattern more familiar to us from its use by engravers). Judging from the fact that only the painting from life and one version worked up from it survive we can conclude that it was not a success.[151] This brave flirtation with the new manner was abandoned and the decision must have been reached that Hilliard should evolve a timeless image of the Queen based on earlier prototypes but not on a sitting.

198, 200

The fact that sixteen of these miniatures survive, a number unparalleled by any earlier group, indicates the deliberation behind its official promotion.[152] All the evidence points to the fact that there were no more royal sittings, so that the mask was adopted by Robert Peake for the *Procession Picture*, by Gheeraerts for the 'Rainbow Portrait'[153] and by the Hilliard workshop for the Hardwick Elizabeth. The argument that the mask of youth miniatures do not precede this encounter with Oliver is corroborated both by the costume evidence and by the frequent appearance in many versions of the folded curtain background, a feature not used before 1594.

140

That these portraits were seen from the start as official propaganda we know from the fact that they were given as presents. In 1598 Lord Zouche was given one by the Queen and wrote to Robert Cecil: 'I would I could have as rich a box to keep it in as I esteem the favour great.'[154] This establishes that the jewelled picture boxes had to be commissioned by the receiver from his own goldsmith. These, in their turn, extended the initial mythology of the portrait by enclosing it within a personal imagery in gold, enamel and precious stones. In the case of one the celebration of Elizabeth is as *Stella Britannis* with a lid of pierced gold in which the star rays are rubies.[155] The enamelled reverse includes dolphins in allusion to her as Venus, Queen of Love. Her chastity is emphasized in the initial portrait in which her hair is worn loose falling onto her shoulders as a virgin. The Heneage Jewel moves in layers from an external tribute to her as *Elizabetha Regina*, in her role as both ruler and as Governor of the *Ecclesia Anglicana*, to an internal one as 'Beauty's Rose'.[156] Others include the crescent-moon-shaped jewel in allusion to the most prevailing of all the cults, that of her as Cynthia, Queen of Seas and Lands.

145

146

148

The Queen, *c*.1594–1603

Hilliard's idealization of Elizabeth known as the 'mask of youth' evolved subsequent to her unsuccessful encounter with Isaac Oliver.

145 The Queen as *Stella Britannis*, *c*.1600, with a star-burst of rubies on the lid of the locket

146 The Heneage Jewel, *c*.1600. The most complex of the jewelled settings to survive

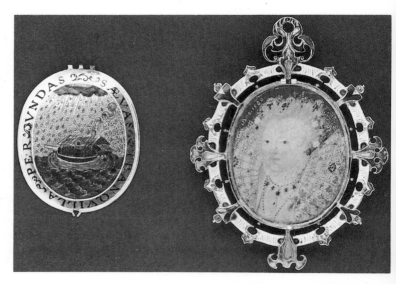

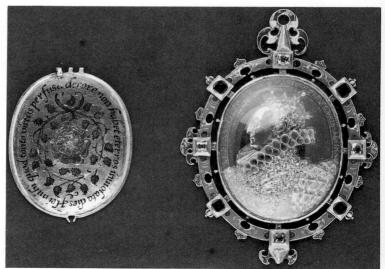

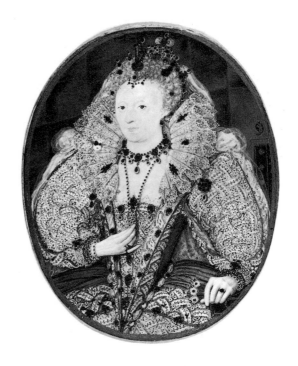

147 The past re-lived. Hilliard's copy, *c.*1600, of a lost portrait of the Queen wearing her coronation dress

148 An exceptionally large version of the mask of youth, *c.*1595–1600, this miniature seems to be the source for Delaram's later engraving (pl. 160).

149 A large woodcut possibly designed by but certainly after Hilliard, making use of the mask of youth, *c.*1600. The face and hair are identical to that in the Hardwick Portrait (pl. 140).

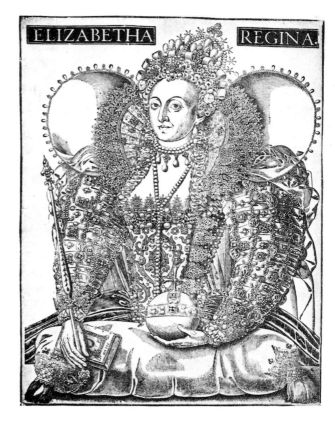

The quality of these miniatures is for the first time noticeably very variable. A version in the Fitzwilliam Museum, Cambridge, is autograph but it is poorly painted.[157] There is, too, at least one which is not by Hilliard but by the workshop or a follower.[158] By 1603 the pressures of producing these endless votive images must have begun to tell and the scene was set for the rapid deterioration that followed.

One miniature, however, deserves separate treatment and that one is of Elizabeth in her coronation robes.[159] Dated by previous scholars to the early years of the reign this miniature belongs to a group that includes those in the Bosworth Jewel. It is painted in the same hard mechanical manner and includes the distinctive feature of a blue wet-in-wet folded velvet curtain, which dates it no earlier than 1594. The use of ultramarine as well as blue bice in the curtain indicates that it was an expensive commission, something even more forcefully emphasized in the real diamond inserted into the cross of the orb. This new dating matches exactly that of a related painting which according to tree ring analysis is *c.*1600.[160] Both must go back to some lost portrait of the Queen painted in or about 1559 depicting her wearing the dress she wore for her state entry into London and her coronation, but with the bodice distended to a post-1590 silhouette. As in the case of the Bosworth Jewel it is an instance of the period reliving itself as it drew to its fateful close.

Within the world of the court the control of the legend seems to have been total. A large woodcut, possibly by Hilliard himself but certainly using his mask of youth, represents an attempt to spread the vision to the populace, but it is a lone example.[161] On the whole the engravings that survived the destruction recorded by Raleigh stem in the 1590s, unlike the 1580s, not from Hilliard but from Oliver and his connections with Crispin van de Passe and William Rogers. In creating the mask of youth Hilliard was betraying the traditions of the limner who only painted what he saw. What we see instead is a deliberate fabrication. Only in their record of Elizabeth's amazing wardrobe do these miniatures continue the tradition. In Edward Norgate's words: 'but for the apparell, Linnen, Jewells, pearle and such like, you are to lay them before you in the same posture as your designe is, and when you are alone, you may take your owne time to finish them, with as much neatnes and perfection as you please, or can'.[162] In considering these as works of art it is, therefore, Hilliard's response to his mistress's repertory of wigs, jewels, ruffs, veils and dresses that makes them major manifestations of Mannerist court portraiture carried to an iconic extreme. In some that response has faltered and inspiration has given way to peremptory, mechanical and, one would guess, hurried workmanship. By 1603 they were lamentably out of date by European standards.

Hilliard and the Stuarts

It was a stroke of luck for Hilliard that James I on his accession continued unquestioningly to accept him as his limner. In this the King, through lack of interest in the visual arts (he loathed sitting for his portrait), prolonged the life of a style which his advent should have curtailed. Progressive trends in the arts were to centre around the rival courts, first that of his wife, Anne of Denmark, and subsequently that of his precocious son, Prince Henry. While their portraiture came to terms with the new style, the King's remained in a state of mummification. The miniatures of him produced by Hilliard and his atelier became increasingly, as the reign progressed, monuments against change.

Hilliard, to make matters worse, could never respond to the Stuarts as he had to Elizabeth with the result that his portraiture of James, Anne and their children makes up the least pleasing part of his *oeuvre*.

These portraits are, however, one of the most well-researched aspects of his work and I do not intend to linger in detail over what is a depressing saga.[163] The documents from the Declared Accounts of the Treasurers of the Chamber[164] provide a handy index of the rhythm of production:

1603 28 December: certain pictures of James I for the Danish ambassador, 19*l*. 10*s*.

1608 Michaelmas: 'for his Majesty's picture given to Sir Roberte Carre iij*li*. for the Kinge and Princes pictures given to the Launcegrave of Hessen and one other of his Majesty given to Mrs. Roper with cristall glasses that covered them' 15*l*., in all . . . 19*l*.

1609 10 July: 'two pictures by him made, one of his Majesty and the other of the Duke of York and delivered for his highness' service', 9*l*. 5*s*.

1612 5 June: 'for makinge of twoe pictures and twoe tabletts of golde for his Majesty's service', 24*l*. 12*s*.

1614 3 November: 'for one tablett of gold graven and enameled blue conteyning the Princes highnes with a Christall thereon . . .', 12*l*.

1615 31 January: a 'picture of the Prince in lynnen drawen to the waste with a riche christall thereon and delivered to Mr Murray, his highnes tutor', 8*l*.

1616 18 October: 'for woorke doone by him aboute a table of his Majesty's picture garnished with diamondes given by his Majesty to John Barkelaye', 35*l*.

1618 Michaelmas: 'a small picture of his Majesty delivered to Mr. Herryott his Majesty's jewellor', 4*l*.

These tell of the production of portraits of the King and Charles, Duke of York, and that Hilliard would sometimes be asked to provide the jewelled setting and on other occasions would pass a miniature on to the King's jeweller. A great number of these miniatures have survived.

The miniatures of James I ascribed to Hilliard have been categorized into three face-masks. The first must have come into circulation soon after 1603 and about half-a-dozen examples are known.[165] Those examined have turned out to be autograph, however summary in quality the brushwork. They all depict James in a black plumed hat and white doublet, with variants in braiding and jewels, the blue riband of the Garter and standing in front of either a blue background or a crimson velvet curtain. A typical example is in the Royal Collection in which the doublet has been enlivened with bands of silver braid. 150 This was followed by a second face-mask, of which almost a dozen instances are extant, including examples dated 1609, 1610 and 1614.[166] And here a change occurs, for in addition to variable quality we can detect miniatures which are quite definitely entirely by different hands. An autograph example is enclosed within the Lyte Jewel, presented by James to Thomas Lyte of 151 Lytescary in gratitude for the presentation of an enormous royal pedigree back to the Trojan king Brutus. The King is depicted without a hat in front of a crimson velvet curtain, his doublet braided with gold. It is by no means bravura painting but it is adequate. A second example dated 1614 in the Royal 152 Collection is, however, certainly not by Hilliard. The brushwork by comparison is niggling and uncertain, characteristics of the style of Hilliard's pupil, Rowland Lockey. By that date the miniaturist was sixty-seven, a great age in early seventeenth-century terms, so that it is hardly surprising that other

150 *James I*, *c*.1603–9. An example of Hilliard's first portrait of the King

152 Rowland Lockey, *James I*, 1614. Lockey making use of Hilliard's second portrait of James

Hilliard and the Stuarts

151 *James I*, 1610. An example of Hilliard's second portrait of the King in a jewelled case which James presented to Henry Lyte

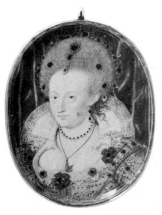

153 Rowland Lockey, *Anne of Denmark*, *c*.1605. Lockey making use of a Hilliard pattern

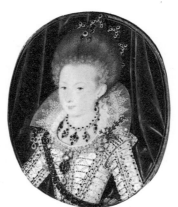

154 *The Princess Elizabeth*, *c*.1605

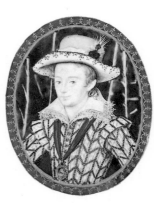

155 *Prince Charles*, *c*.1613

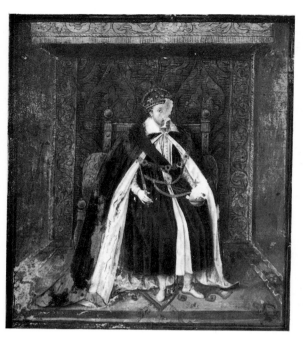

156 Illumination of James I enthroned, 1603, in the *Liber Ceruleus*

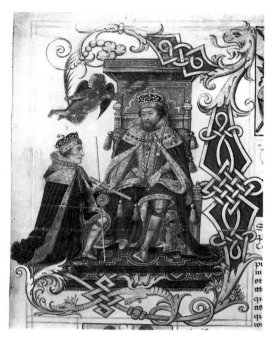

157 Illumination of James I and Henry, Prince of Wales, in the letters patent creating the latter Prince, 1610. The faces only are by Hilliard

158 Medal to mark peace with Spain, 1604

159 Charles Anthony after a design attributed to Hilliard, Great Seal of James I, 1603

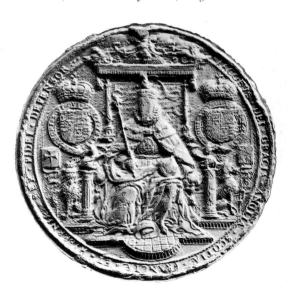

hands were needed to maintain production. What we do not know is whether that production was actually ever systematized. As we shall discuss later, Lockey carried out versions of his master's miniatures in the 1590s and would have been fully capable of painting these portraits of the King. By 1603 Hilliard's son Laurence would also have been able to assist his father in the workshop and it is tempting to associate some of the more depressing examples with his work. Some miniatures suggest a division of labour, with Hilliard drawing the composition and passing it on for completion.

All the portraits of James that we can definitely trace back to Hilliard fall into these two groups, plus a number which have been assigned to a third group, that vary only in the direction in which the eyes look. The only certain miniatures that make a definable third category have costume of c.1620 and are executed with a lack-lustre talent; they are undoubtedly the work of Laurence, who succeeded his father as royal limner in 1619, or followers.[167]

James's queen, Anne of Denmark, also sat about 1603 for a type which often acted as a pendant portrait to that of her husband. About eight of these survive, nearly all feeble in quality.[168] By 1605 Anne had switched to Isaac Oliver but this did not impede the continued production of the Hilliard face-mask. One in the National Museum, Stockholm, is another likely candidate for Lockey, with its busy wiry brushstrokes delineating the hair and its weak draughtsmanship. 153

One new document does shed a gleam of light on this minor industry. It is a letter from Nicholas Hilliard to Sir William Herrick, jeweller to the Crown, dated 2 February 1613–14:

> Sir with my humble duty these ar to let your worship vnderstand that I am sent vnto by one of his Majesty's bed chamber for a small picture of his majesty which I hope that will serve wherevpon I borrowed 40s of you in my great need in september last past which mony with my humble thanckes I haue sent you by this my servant . . .[169]

This pathetic missive reveals that Hilliard was reduced to pawning one of his miniatures of James I. The truth of the matter was that royal patronage had virtually evaporated. In the case of James two sittings at the most had been granted. In that of Anne one. The royal children all sat but it is noticeable that with maturity they all switched to Oliver. Neither James nor Anne ever really inspired Hilliard and it is only in the *ad vivum* portraits of the children that any of the old fire returns. The ravishing likeness of the Princess Elizabeth,[170] with a bluebell tucked into a rosette on her bodice, or the thirteen-year-old Prince Charles[171] set within an elaborate gold on ochre border rank with any of his finest characterizations. Although he plays with this introduction of borders for inscriptions and simulated jewels, both his approach and aesthetic were archaic; just how antiquated must have been only too apparent in the context of the brilliant court of the Prince of Wales, whose picture gallery was hung with the latest works of the Flemish and Italian schools, including pictures by Beccafumi and Tintoretto. 154
153

If one had to categorize the relationship of Hilliard to the Crown after 1603 one might use the word 'convenient'. There was no radical drive behind the promotion of a new royal image. James was quite content to inherit a system and let it continue, although from the start the seeds of its destruction lay in the rival patronage of Queen Anne and Prince Henry. It was only a matter of time before it finally broke down when, after Hilliard's death, Prince Charles and

Buckingham were able to persuade the King to move on to Mytens, Rubens and Van Dyck. But the rot was there early on in the reign. In the first instance there is no evidence that Hilliard ever executed a large-scale portrait of James. In 1603 there seems to have been an agreed division of royal portraiture which resulted in John de Critz and Marcus Gheeraerts cornering the market for the large-scale canvases. But in the same year Hilliard held his own in designing as his predecessors had James I's Great Seal.[172] No one has ever attributed this to 159 Hilliard but it is in his style and everything that we know about the manufacture of such seals would indicate that he alone could have designed it. It is pure Hilliard in its articulation of the draperies, its repetition of the flanking royal arms encircled by the Garter and crowned, its attendant lion and unicorn supporting fluttering banderoles. In this we see the frustrated team of Hilliard and Anthony at last producing a new Great Seal after a decade of preparing endless patterns for the prickly Elizabeth.

He also continued to execute illuminations. Inevitably on James's accession there had to be a miniature of him placed in the *Liber Ceruleus* of the Order of 156 the Garter. Hilliard, following Hornebolte and Teerlinc, depicts James in robes of state seated beneath a golden canopy with his feet on a pink carpet. Although damaged, in particular the face, the page as a whole is arrived at by a division of labour in exactly the same manner as in the case of the charter for Emmanuel College, Cambridge. The border here is by another hand but certainly within the workshop, for the design and execution are typical of Hilliard's style, with naturalistic pansies, honeysuckle, thistles and strawberries scattered along the margins. A division of labour is even more apparent in the letters patent whereby the King created his son Prince of Wales in 1610. In 157 this the heads only are by Hilliard; in the case of James his normal second portrait-mask of the King has been reversed but in that of his son we have a sparkling profile characterization which must have been the result of observation, even if only from afar. It is strange that neither the figures nor the overall design of the document otherwise seem to have any connection with Hilliard at all.

In 1617 Hilliard was billed amongst other things as 'Imbosser of our Medallions of Gold' and in the accounts we have already quoted he was paid for twelve such in 1604.[173] There seems, therefore, no reason to doubt that he was the designer of the medallions which have always been traditionally assigned to him: the Accession Medal of 1603, the gold medal celebrating peace with Spain in 1604, the Attempted Union Medal of 1604 and the Badge which 158 reuses Elizabeth's ark *impresa*. These are Hilliard designs but only the gold 1604 medal is of high enough quality to have been cast and chased by Hilliard himself. The others, it would be reasonable to conclude, are the work of Anthony after Hilliard patterns.

Hilliard and the Engravers: Delaram and Elstracke

In the 1617 document just referred to, the King granted his 'wel-beloved Servant Nicholas Hilliard, Gentleman, our Principal Drawer for the small Portraits and Imbosser of our Medallions of Gold', a monopoly for twelve years to make, engrave and print royal portraits.[174] Hilliard would have been the incredible age of eighty-two if this had run its course. As it was he was seventy when it was granted. The reason it was given was for his 'extraordinary Art and Skill in Drawing Graving and Imprinting of Pictures . . . of us and

Hilliard as a designer of engraved royal portraits

160 Francis Delaram after Hilliard, *Elizabeth I*, *c.*1617–19. The portrait is based on pl. 148.

161 Renold Elstracke, probably after Hilliard, *The Princess Elizabeth as Electress Palatine and Frederick, Elector Palatine*, 1613

162 William Hole after Isaac Oliver, *Henry, Prince of Wales*, 1612

163 *Elizabeth, Electress Palatine, and her son, Frederick Henry, c.*1615. An unused design by Hilliard for an engraving

others'. So far only one print has ever been cited as an example of this in operation. This is Francis Delaram's print of Elizabeth I inscribed *Nich: Hillyard delin: et excud cum priuilegio Maiest:*. This is based on Hilliard's miniature of her which is now at Ham House.[175] It is difficult to believe that this is the only instance and indeed the wording of the monopoly states that it has been granted because of his 'Art and Skill' in doing precisely that, i.e. he had already been doing it?

All too little is known or is ever likely to be known about engravers and their sources in the Elizabethan and Jacobean periods, but we have already suggested that the limners must have been a central source for their images. In the Jacobean era we have a vital clue as to how this worked in the case of royal portraits in Isaac Oliver's drawing of Prince Henry fighting at the barriers; this was executed to be engraved by William Hole.[176] The actual engraving is inscribed *William Hole sculp:* and we would never have been able to prove Oliver's connection with it if it had not been for the fact that Inigo Jones preserved what must have been the drawing and gave it to Charles I.[177] Without that piece of vital information there would be no way of knowing that Oliver was its source and that a limner was in the habit of providing a design for which he received no printed acknowledgment.

With this fact in mind we need to scrutinize the work of Jacobean engravers of portraits of members of the royal family, for many of these must stem from drawings by Hilliard. Laurence Johnson's half length of James I issued in 1603 is surely based on Hilliard's earliest image of the King[178] but it is Renold Elstracke (1570; active 1598–1625) above every other engraver whose endless images of the Stuarts speak most directly in the language of Hilliard.[179] Hind suggests that he was taught engraving by William Rogers and remarks he 'has all the characteristic awkwardness of the English School at the turn of the sixteenth and seventeenth centuries and nothing of the suaver manner of Crispin van de Passe, and his Netherlandish contemporaries'. De Passe had a connection with Oliver, we know. Can we postulate a similar arrangement between Elstracke and Hilliard? I believe that we can.

It is amongst Elstracke's full-length renderings of members of the royal family that we find ourselves most strikingly back in the uneasy world of the large full-scale miniatures.[180] These engravings are surely their lineal descendants. The figures either stand in a confined space, with misunderstood lines of perspective causing carpets or tables to look tipped up at impossible angles, or they ride along on horseback against a low-lying landscape. The solutions are the ones Hilliard first essayed in the miniatures of Robert Dudley or Cumberland. And always pattern spirals its way over nearly everything in a line-for-line rendering of the fabric and jewels of the costume and in the pattern and embroidery on table-cloth, cushion, chair or curtains. Elstracke certainly used other designers than Hilliard but there is no denying that a great number of his engravings betray all the signs of having come from the Gutter Lane workshop.

There is one more piece of evidence which reinforces this conclusion. In the British Museum there is a drawing by Nicholas Hilliard of Elizabeth, Queen of Bohemia, and her son, Prince Frederick Henry, a child who, after the death of Prince Henry, was second in line to the British throne after the sickly Prince Charles.[181] The composition is an allegory of the Protestant succession, with

160

148

162

161

163

PER TAL VARIAR SON QVI.

So here, in Type, unto mens of late, the Prince of Bohemia, Star of France:
Shames Loose Faithss Shield, and Queene of Hope, Of Armes, and Learning, Peace, and Chaste
In briefe, of women, nere were seene, so greate a Prince, so good a Queene.

ELIZABETHA REGINA.

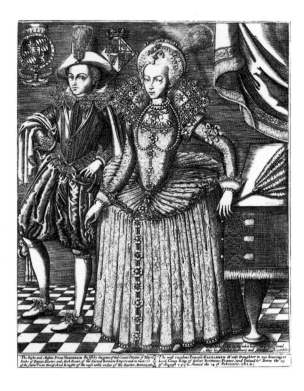

The Highe and Mightie Prince FREDERICK the fift by the grace of God Counte Palatine of Rhein
Duke of Bauier, Elector, and Arch Sewer of the Sacred Romain Empire and in minoritie
of the same Tutor therof. And Knight of the most noble order of the Garter. Borne 1596

The most excellent Princesse ELIZABETH ye onlie Daughter to our Soueraigne
Lord, Iames King of Great Brittaine, France, and Ireland &c. Borne the 19
of August 1596. Maried the 14 of Februarie 1612.

William Hole fecit

NH

the child clasping a sceptre which his mother supports with her right hand. This drawing is the vital missing link, a drawing by Hilliard for an engraver.[182] It is a curious composition. Initially it is Hilliard's full-length miniature style with the usual uncomfortable attempts at architecture which are not complete, perhaps abandoned or left for the engraver to finish. To the left there is a scrolled shape jutting sharply into the composition which was probably the outline for what was to bear a coat of arms or inscription. There is no reason to question the subject's identity as Elizabeth as it is fully compatible with her features in other Hilliardesque engravings by Elstracke.

This drawing is our crucial piece of evidence linking Hilliard with the Jacobean engravers. Conceivably it was a design prepared for but not engraved by Elstracke. Let us now return to Francis Delaram. Whereas Elstracke's work fits into the archaic aesthetic of Hilliard, Delaram's does not. Francis Delaram (working c.1615–24) shows none of that naive awkwardness.[183] His roots are Netherlandish but there are stylistic affinities with the products of the de Passe family and the work of Otto Vaenius. Hind conjectures that he could have been brought to England by Cornelius Boel, who worked for Henry, Prince of Wales, at Richmond Palace on the title-page to the Authorized Version of the Bible. Delaram belongs to the new wave of artists whose precursors in England had been Oliver and Gheeraerts. The inscriptions on many of his engravings indicate that he was responsible for the original design. Unlike Elstracke, Delaram's relationship with Hilliard would not have been a norm but an exception, a forced resort to an old-fashioned artist because he held the monopoly as a result of the patent of 1617. Placed in this perspective the grant can be seen as a last effort by someone who had lost his grip: it was an attempt to force engravers back to Hilliard for designs for royal portraits. This was already a lost cause. The miniaturist died two years later and the curtain finally fell on the Elizabethan monarchical aesthetic when James's Queen sat for the newly arrived Netherlandish painter, Paul van Somer.

The Last Years: 1603–1619

Everything, therefore, points to a dramatic decline in patronage in the new reign. About twenty-five miniatures apart from those of the royal family are all that have so far surfaced. The indifferent quality of the majority of the mass-produced images of the royal family has obscured the fact that Hilliard's genius lasted to the end. Two miniatures epitomize this fact: the first is that of an unknown lady of c.1615;[184] the second that of an unknown man dated 1616,[185] painted when Hilliard was sixty-nine. Both include the innovation of a simulated jewelled border, the earliest dated instance of which is his miniature of Prince Charles (Belvoir Castle)[186] dated 1614, in which paint has been used to create a brilliant border of rubies, emeralds and pearls. This introduction of a painted frame suggests a change by Hilliard in his attitude to a picture's surface, that the frame was an enclosure through which the eye crossed into a world governed by the principles of Renaissance optics. In the case of the unknown man he even introduces a cast shadow as if to emphasize the fact. Both images are approached with a control of the medium as powerful as that in his finest miniatures from the 1570s but their chief motivation is to challenge Oliver. The unknown man is Hilliard's attempt to rival Oliver's renderings of melancholic Jacobean gentlemen. The painting is broad and definite in its use of solid opaque colour to map in the doublet, ruff, cuff or hand. But the greatest

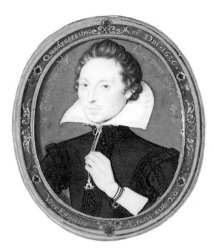
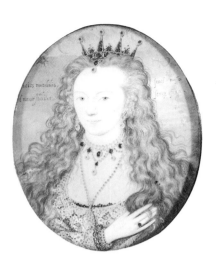

of all the miniatures is the grand lady embowered within a bed of estate. This is 164
Hilliard's answer to the virtuoso monochromatic large-scale portraits of ladies
that figure amongst the apogee of Oliver's art. Confining his natural impulse
towards the polychromatic to the border, he moves in the portrait itself
through shades of grey into white with tiny glittering highlights of gold and
silver. In its iconography, no doubt laid down by the sitter, it is without
parallel, for she reclines in a bed, a curtain of which is visible to the right. Her
diaphanous widow's wired cap and veil have been arranged over the huge
pillow which supports her. She wears an ermine-lined cape and clasps a prayer-
book. Up until now wrongly assigned to the 1580s and called Mary Queen of
Scots, this is Hilliard's final masterpiece.

These are the triumphs but they are to be set against a considerable corpus of
somewhat indifferent work. Typical of this is a miniature of Lady Elizabeth 166
Stanley dated 1614[187] which can be quickly placed in perspective when set
beside Oliver's masterly gentleman from the same year. It is in fact carelessly 236
painted, with little vigour or enthusiasm, which in the case of a female sitter
was rare for Hilliard. Comparing it with Jane Coningsby painted exactly forty 76
years before catches the extent of the slippage. It is thin and papery, and the
bold linear quality inherited from Holbein is preoccupied not with form and
shape but pattern and decoration.

This trickle of work from an old man reflects the poverty that must have
faced him.[188] We have already quoted the letter that alludes to his 'great need'
in the September of 1612. He came out of his Gutter Lane house, where he had
been since 1578 at least, in 1613 when his son Laurence moved in. In 1617 he
was imprisoned in Ludgate for debt. The sum in question was £40, owing to a
certain William Pereman, a yeoman usher of the Chamber, although Hilliard
went to prison because he had signed the joint security that included a loan to
one Longford.[189] His will dated 24 December 1618 confirms his indigence: 20*s*
to the poor of the parish and household goods to the value of £10 to his servant,
a woman who had nursed him. The remainder passed to his son Laurence with
no mention of any of his other children. He was buried on 17 January 1619 in St
Martin-in-the-Fields.

During the last fifteen years of his life Hilliard probably had a struggle to exist. His production not only of miniatures but of everything else must have slowed down both on account of age and in the face of massive competition from younger artists. It is difficult to find any large-scale paintings after 1600 which could remotely be attributed to him. Fashion in jewellery also passed him by in favour of a new style promoted by Anne of Denmark and executed by George Herriott and Arnold Lulls. Only in the occasional engraved title-page and border can one find a sprinkling of items in the Hilliard manner. Amongst these the most persuasive are a title border first used in 1609 for an edition of Bishop Jewel's works.[190] It includes the familiar features of the vine-encircled columns, a naive lion and unicorn close to those on the Great Seal and springing branches of rose and thistle. *A Booke of Sundry Dravghtes* (1615) has birds in the same manner as the 1570s title-page, with the usual swags of indented drapery and fruit.[191]

But the most puzzling of all is the title-page to John Stow's *Annales* published in 1615.[192] Across the top there are the ingredients familiar from the Mildmay Charter of 1584, the sprays of roses and thistles arranged in sinuous style and the indented swagged drapery. Within a compartmented triumphal arch stand the figures of a Roman, a Saxon, a Dane and a Norman with James, Anne and Prince Charles above. This reworks with some alterations the title-page engraved by Jodocus Hondius of John Speed's *Theatre of the Empire of*

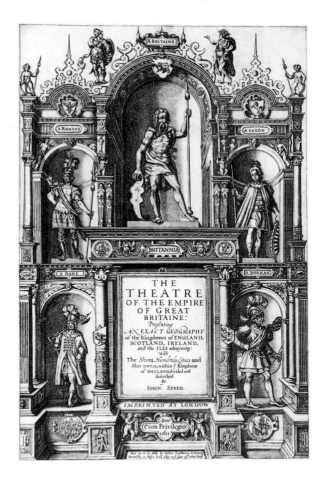

167 Woodcut title-border in the manner of Hilliard, 1609

168 Woodcut title-border in the manner of Hilliard for Stow's *Annales* (1615)

169 Engraved title-page by Jodocus Hondius for Speed's *Theatre of the Empire of Great Britaine* (1611–12), after a design in the manner of Hilliard

Great Britaine (1611–12).[193] There is nothing against the possibility that this is a Hilliard design and this raises an interesting hypothesis. Although Hondius was in England from about 1583 to 1593, during the Jacobean period he was in Amsterdam. It must therefore be inferred, as Hind pointed out, that Speed's drawings were sent there for engraving, for Hondius was then head of the greatest firm of map engravers. And yet Speed's maps are not merely maps. The borders contain inset pictures of the kings and queens of England, costume figures and views of buildings, plans of cities and coats of arms. These must have been drawn in England before their despatch to the Low Countries. Could Hilliard have been a contributor?

In 1606 Hilliard wrote yet another letter to Robert Cecil which opens up one final orbit of activity, for he petitions to be allowed to colour Queen Elizabeth's tomb:

> as a Goldsmith, I understand howe to set foorthe and garnishe a pece of stone woork, not with muche gylding to hyde the beawty of the stone, but where it may grace the same and no more. And, having scill to make more radient cullers lyke unto Amells [enamels], then yet is to Paynters knowne, I would have taught sum one which woulde not have made it common . . .[194]

He did not get the job but the letter implies that he had done work of this kind before. It is interesting to speculate which great Elizabethan may lie in a tomb under the delicate handiwork of Nicholas Hilliard, the limner.

Hilliard in Context The study of Hilliard has taken us to the heart of the limning tradition and at the same time to the central dilemma that we need to come to terms with in our study of the limners. It is not until the middle of the seventeenth century that the media became compartmentalized. They never were in Tudor and Jacobean England. An obsession with Hilliard as a miniaturist has led to a totally distorted view of his work. We must cease to think of him with modern minds which divide the arts into 'fine' and 'decorative'. Worse, within even those categories, scholars pursue in isolation their separate paths as historians of engraving and illustration, title-pages and borders, of jewellery and metalwork or of tomb sculpture. And yet all these were the province of the limner's workshop, so normal and taken for granted that no one would have commented upon it at the time. Although this book focuses on the miniatures – Hilliard's greatest achievement – the aim is to reverse this traditional view. I am aware that in doing so I have had to make some imaginative jumps which may or may not be confirmed by later research, but we need to upset once and for all the traditional view of Hilliard. What emerges is something quite different, a man of unsteady character, not to be trusted with money, conceivably even unreliable in his work, struggling to make a living as he turned his hand across the wide field of activity that was in fact absolutely characteristic of late medieval and Renaissance workshops. This extended vision of his work also makes far more sense of his dominance of the aesthetic of his age, which it would be difficult to accept in the narrow context of miniature painting alone. He could and did make jewellery as well as designing it. He was equally capable of producing a drawing for a portrait engraving or for a title-page. He could accept commissions for portraits both on panel and on canvas, and could paint history pictures. He was also involved in painting emblems and *imprese*, probably for court fêtes for which conceivably in the eighties and nineties he may have played a large part in setting the visual style. Moreover he knew 'howe to set foorthe and garnishe a pece of stone woork'.

If Hilliard is to be characterized as against Oliver we might term him a *quattrocento* as against a *cinquecento* artist. Perhaps this may be too crude an equation but let us pause and finally place Hilliard's art into the ideological context of late-sixteenth-century England. Central to our understanding of this must be the enormous time-lag that existed between England on the fringes of northern Europe and all that had happened and was happening in the world of the visual arts in Italy. It was only at the close of Elizabeth's reign that England began to assimilate the technical terms and aesthetic commonplaces of Renaissance art and it was not until the 1620s that this was to a large degree achieved.[195] Holbein distorts the picture. He was an artist cast in the Renaissance mould who understood and worked from such premises, but they were ones understood for a brief period by a small handful of humanist scholars. There was no awareness of these ideals in Elizabethan England, nor was there any appreciation of Holbein as a great artist. His work was collected in sixteenth-century London by the foreigner Andreas de Loo, and it was not until the new century that Arundel and Lucy Harington began to start ardently searching out his works from the manor houses of England. By then they had learnt to look at his pictures in a wholly new manner, as epitomizing 'curious' or 'artificial painting', an art which embodied a total mastery of illusion by means of line, shadow and perspective. All this starts in earnest only in the

1590s, with stirrings in the 1580s, when allusions to painting and to its great exponents suddenly escalate. It is then we find references, unheard of before, to Michelangelo, Raphael, Holbein and Dürer, with Hilliard tacked on at the end as England's answer to them. Francis Meres' *Palladis Tamia* (1598) is interesting evidence of the effort to muster names of painters and limners to answer the foreign roll-call. The inclusion of Hilliard in this new pantheon of the foremost exponents of 'curious painting' was from the outset mistaken for he was being cast in a role that he was unable to fill. Hilliard, on the contrary, represented the earlier, medieval tradition and it can only have been his connection through Sir Thomas Bodley with Oxford that led Richard Haydocke, fellow of New College, to ask Hilliard to compile his *Treatise on the Arte of Limning*. It would have been more logical to have asked his pupil, Isaac Oliver, who did represent the new cult of 'curious painting'. Hilliard, as his *Treatise* reveals, belonged to an earlier era. Lucy Gent sums up precisely the ethos of this artist craftsman in Elizabethan London, cut off from experiencing the achievements in painting of Renaissance Italy:

> Thus the native concept of painting is that it proceeds from a relatively unskilled outline drawing, which together with the under-drawing provides the *adumbratio*, or shadow, to the skilled application of colours. The English tradition has no place, no words, for artistic drawing, for composition, perspective, design and chiaroscuro . . .[196]

Both the vision and the practice remained essentially medieval. Drawing from life was not the norm for painters in Elizabethan England and the idea of a drawing as a work of art did not exist before the first decade of the seventeenth century.

The view of painting as outline and colour was one reinforced by the Queen herself in the exchange Hilliard records in his *Treatise*. She enquired of him why the Italians, the best painters, made no use of shadow in their work. The question showed a dismal ignorance of Italian art, and the only Italian painter she had ever encountered was Zuccaro. The conversation could proceed, however, without contradiction because Hilliard's knowledge was as limited as his sovereign's. He replied by saying that shadow was only used by artists who required a 'grosser line'. 'Here,' he says, 'Her Majesty conceived the reason, and therefore chose her place to sit in for that purpose in the open alley of a goodly garden where no tree was near, nor any shadow at all . . .'.[197] Any of Hilliard's miniatures of her reflect precisely that kind of flat, even frontal, light. When the Queen attempted to come to terms with new developments in the early 1590s by sitting for Isaac Oliver the result from her point of view was a failure: 'curious painting' wounded her vanity and destroyed the myth of the eternal Gloriana by its shadows emphasizing her age and physical vulnerability. She returned to Hilliard and as long as she lived her court art remained a rock against change. The indifference of James prolonged that aesthetic still further. Its perpetuation was aided ironically by the cult of emblematics which developed in the 1580s. Although they enlivened the monotonous formulae of Hilliard's portraiture, emblems and *imprese* did nothing to advance the cause of 'curious painting'. Instead they made Elizabethans look at pictures entirely in terms of symbolic meaning in addition to their usual enthusiasm for 'lively colours'.

Hilliard's *Treatise on the Arte of Limning*, written subsequent to 1598 but prior to 1603, embodies the tensions of this moment when all around him Elizabethans were awakening to a totally new idea of what a picture could be, and of the hitherto unrecognized powers of the visual arts to achieve illusion.[198] It was a fatal irony that it was Hilliard who was asked to expound what was to him an alien philosophy. The result, as one would expect, is a disjointed and unhappy document, rambling and intellectually derivative, which in the end he abandoned.

Haydocke would have seen Hilliard's revelation of his technical processes in a very different way from the miniaturist. To Hilliard they were trade secrets, mysterious recipes whereby he was able to achieve his special effects, which were to be covertly passed from master to pupil. The atmosphere is still essentially a medieval one and Hilliard, in fact, deliberately holds back from divulging all his tricks of the trade. Haydocke, on the other hand, as the translator of one of the most influential late Renaissance treatises on the visual arts, would have viewed such skills and recipes in a magico–scientific context. The treatise he translated by Paolo Lomazzo was saturated in late Renaissance platonism and a view of the cosmos which was essentially hermetic. The intellectual gulf between this and the painter of Gutter Lane was huge and it is hardly surprising that the miniaturist never finished his treatise. It is a document saved, however, by the rhythm of its language and occasional flashes of delight, as when he dwells on the beauty of the English as a people or tells us that it is the limner's role to 'catch those lovely graces, witty smilings, and those stolen glances which suddenly like lightning pass, and another countenance taketh place'. Perhaps an apter epitaph for Hilliard would be that he was England's last great medieval artist, just as Isaac Oliver, *pace* the misunderstood Holbein, was to be its first Renaissance one.

Rowland Lockey

Hilliard had an enormous impact on the aesthetic of his age through the sheer range of the commissions that he must have undertaken and by his influence on other painters, on George Gower, Robert Peake, William Segar and William Larkin. But more particularly there were those that he trained, those 'both strangers and English' to whom he refers in his letter to Robert Cecil in 1601. We know that these included his son Laurence, who began his apprenticeship about 1597 and became a freeman of the Goldsmiths' Company in 1605. He also taught Isaac Oliver. But both of these I shall, for the moment, place to one side while we focus attention on the one artist who, in the derivative sense, was to be his most important pupil, Rowland Lockey.

Lockey is important as a coda to the art of Hilliard because his work reinforces the view of Hilliard as a painter whose expertise was various.[199] He was born about 1565–7 and we know that by 1600 he was a freeman of the Goldsmiths' Company. His training, therefore, exactly duplicated that of Hilliard. The fact that we have signed or documented miniatures, oil paintings and a title-page by him reflects exactly the pattern of activity which we would expect from someone trained in the Hilliard studio. It establishes too that Hilliard must have taught Lockey all these skills. Two of his oil paintings are signed, one a copy of Holbein's group of *Sir Thomas More and his Family*, whose recent cleaning has revealed the date of 1592, and a second of Margaret

170 *The Family and Descendants of Sir Thomas More*, *c*.1593–4 (original: 24.6 × 29.4 cm). The garden view is evidence of Lockey's fame for 'perspectives'.

Beaufort, Countess of Richmond and Derby, dated 1598. Payments to him in the account books of Sir William Cavendish covering the years 1608–13, during which Lockey executed a large number of pictures for him, are in the main, it seems, for copies of older ones. One entry in 1612 records him painting copies of Sir William Maynard and his wife, Lady Frances. The latter picture is still at Hardwick Hall as are almost half-a-dozen others which are all clearly by the same hand, one of indifferent quality, revealing an artist whose draughtsmanship was feeble and whose handling of paint uncertain and smudgy.[200] It would take us too far off our course to disentangle Lockey's large-scale work but the panel of Margaret Beaufort makes the point that we need.[201] Although it may have been based on a picture of 'The Duches of Richmonte and Darbie sitting upon her knees' in St James's Palace in 1549–50, the composition is purely Hilliardesque in manner, with the familiar misunderstood perspective in which the figure, as in the large-scale miniatures, is viewed straight on while the floor and table are tipped up. There is the customary indulgence in decorative detail in the embroidered canopy, the cushion and the cloth thrown over the *prie-dieu*.

Rowland Lockey

Hilliard's apprentice in the 1580s, he practised as a miniaturist, painter and designer from c.1590 to 1616.

171 *Margaret Beaufort, Countess of Richmond and Derby*, 1598

172 Title-page of the *Bishops' Bible*, 1602. Designed by Rowland Lockey and cut by Christopher Switzer

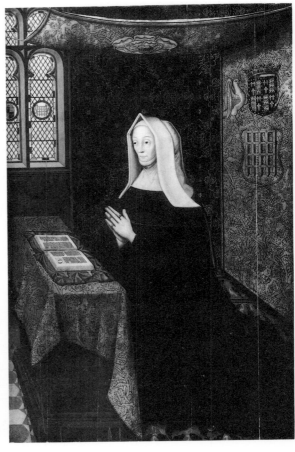

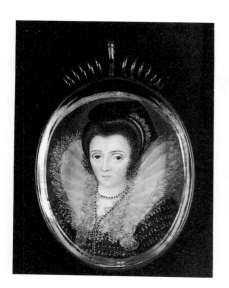

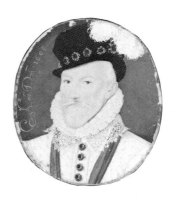

Rowland Lockey

A suggested nucleus of miniatures

Hilliard's apprentice in the 1580s, he practised as a miniaturist, painter and designer from c.1590 to 1616.

In addition to copying Holbein's group of Sir Thomas More, Lockey also painted for Thomas More II a second version into which the saint's descendants have been inserted. The importance of this lies in the fact that it was recorded in the painter's studio by William Burton, the antiquary, who writes that 'Nicholas Hilliard . . . left . . . another expert scholler, Mr Rowland Lockey, . . . who was both skilful in limning and in oil-works and perspectives'. There can be no doubt that the miniature version now in the Victoria & Albert Museum[202] is also by Lockey. The importance of this can hardly be overestimated, for what we now have to take into account is a miniaturist working in Hilliard's pre-1593 manner active between about 1590 and 1616. The More Group establishes that style. Technically and in both its colour range and stylistic approach it is exactly within the Hilliard format, but the brushwork is fussy and uncertain and the drawing poor.

There is a nucleus of miniatures that fall into this area. One of an unknown lady[203] was painted shortly after the More group and in exactly the same manner of those female sitters from the Elizabethan period, with busy, slightly muddled and tentative brushstrokes and noticeably feeble draughtsmanship. We can take Lockey's work during the 1590s a stage further on the basis of payments to both Hilliard and Lockey in the accounts of Bess of Hardwick. They follow directly one on the other on the same day but the crossings out reveal confusion as to who did what. The final version awards 40s to Hilliard for 'one Pictur' and the same to Lockey 'for the draweing of one other'. The two pictures were miniatures of Arabella Stuart and were 'a gratter and a Lesser'.[204] It is unlikely that there were two separate sittings; the fees probably represent a payment to Lockey for copying in another format an *ad vivum* by Hilliard. This would correspond neatly with another instance that we have of precisely this process. There are two virtually identical miniatures of a lady called the Duchess of Richmond,[205] depicted with a grandeur close to the Queen's mask of youth; the original is clearly that in the Buccleuch Collection and the copy the one at Stockholm. The dress in the latter is observed at a remove and the hair and features have the same smudgy appearance as in the unknown lady. In addition the painter has miscalculated the size for he has been forced to add a piece of vellum to one side.

This initial group can be considerably enlarged as Lockey's working career extended from the 1590s down to his death in 1616. In the Jacobean period the manner is traceable in a miniature formerly attributed to Hilliard of Charles Howard, Lord Howard of Effingham, dated 1605,[206] which shares an identical calligraphic inscription with one of an unknown man in the same manner in the Buccleuch Collection.[207] Both have the customary weak handling of the brush characteristic of Lockey. The earlier miniature, dated 1599, is particularly close to the heads of the younger male members of the *More Family*. *Lord Howard* is also an indication of patronage at the highest level. So too is the portrait of Prince Henry dated 1607 in the Royal Collection, which was assigned by van der Dort already in the 1630s to 'ould Hilliard'.[208] Van der Dort's catalogue shows a total lack of knowledge of Tudor and Jacobean painters and this miniature of the Prince shares all the common Lockey characteristics. From the same period comes a lady at Stockholm with the same busy brushstrokes in place of the decisive movements of Hilliard even at his most indifferent.

The *More Family Group* establishes that Lockey was capable in the early 1590s of accepting commissions for cabinet miniatures. Among those by Hilliard there is one which fits less happily than the others, the *Essex* with the diamond *impresa*. The composition is unhappy, with a cut-out cardboard figure derived from Hilliard, but the painting is a hybrid with passages that are difficult to reconcile with him: an impressionistic panorama of tents and artillery close to the garden view in the *More Family*, hair painted in the Oliver manner, armour treated in a style recalling that worn by Prince Henry, and gold embroidery on the tent which is more poorly executed than anything by Hilliard. The stylistic evidence would point to Lockey at least assisting with considerable sections of this miniature.

127

There is room for a considerable expansion of Lockey's *oeuvre* amongst the minor miniatures which continue to come to light. He should not, however, be turned into a convenient label to cover all sub-standard Hilliard miniatures. There may well also be room for expanding what may be attributed to him as a designer. At the moment there is only one title-page, which was pointed out as long ago as 1931 by McKerrow and Ferguson, who suggested that the R L and C S on the Bishops' Bible (1602) were Rowland Lockey and Christopher Switzer.[209] Although the design owes something to a 1599 edition of the Genevan Bible it is none the less an enormously elaborate composition indicative of Lockey's capabilities as a designer within the field of the decorative arts. That he was not cast entirely in a reactionary mould is reflected in his will in which he leaves 'all my Italian Printes' to his brother Nicholas, also a painter, and also in Edward Norgate's reference to him in his list of artists who drew in crayons.

172

We should not ignore the fact that Hilliard does state that he had trained 'both strangers and English' and that so far we can identify specifically only three of these. There are many miniatures which survive that do not as yet fall satisfactorily into any group. Often their condition is such that this will never be possible but others are by unknown hands. Their numbers are not great and their existence in no way upsets the thesis of a tree of limning with a slender ascent along its branches. There can never have been more than a small handful of people who had grasped the rudiments of this highly complex art with its secret recipes and tricks. The quality of some of these miniatures reflects that fact. Lockey is an exception because he mastered most of the tricks of the trade and although of no significance as an artist when placed by Oliver, what we can assemble as an *oeuvre* establishes him as a miniaturist of far greater talent than the abysmal Hilliard *fils*.

Conclusion

Hilliard was seventy-two when he died. None of the other limners was ever to enjoy such a dominant role over so long a period of time. If we regard Hilliard as the embodiment of an aesthetic it is astonishing how all its prime exponents, both in large-scale portraiture and in miniature, died within a few years of each other: Rowland Lockey in 1616, William Larkin, Robert Peake and Hilliard himself in 1619. After 1620 everything that that aesthetic had represented was in retreat, relegated by the 1630s to the provinces in the work of Gilbert Jackson in large or Laurence Hilliard in miniature. In this was sounded the death knell of 'lively colours' and the triumph of 'curious painting'.

CURIOUS PAINTING: *Isaac Oliver*

Horace Walpole wrote: 'of the family of Isaac Oliver I find no certain account; nor is it of any importance; he was a genius: and they transmit more honour by blood than they can receive'.[1] Two centuries later and after substantial archival research, there is still almost total mystery surrounding this artist. No payment to him has come to light before the Jacobean period and his early years are virtually devoid of documentation. All this means that our approach to him has to be far different from that to Hilliard, whose money problems and official connections leave a train of information whereby to reconstruct his life and art. Oliver's life has to be pieced together from what can be deduced from his work. The result, as we shall see, is quite startling when set into the context of Elizabethan England. In the case of Isaac Oliver we are recovering a major artistic personality; we are grappling with the problem of the emergence of a new era, the arrival of painting as an expression of human genius and as art with a complex aesthetic language of its own. With Hilliard we are touching the end of a tradition.

Origins

The origins of Isaac Oliver are extremely obscure but some new facts can be added to the existing ones. These, however, tend to deepen rather than clarify the mystery. It was Leslie Hotson who first pointed out that a Pierre Olivier, goldsmith of Rouen, arrived in Geneva five months after Nicholas Hilliard in 1557.[2] He had no wife with him as far as is known. He next appears in London in 1568 lodging in the house of a pewterer in Fleet Lane but this time with a wife, Typhane, and a child, Isaac.[3] These two facts pinpoint the birth date of the miniaturist to within just under a decade. Vertue states that Oliver was sixty-one or sixty-two when he died in 1617, which would give a birth date of 1555 or 6. It must be later than that, but not much, so that Oliver could have been as old as eight in 1568.[4] They also make it clear that his father was a Huguenot fleeing from the persecutions of 1557–8. It would seem likely that he returned to Rouen at the latest by the time of the issue of the Edict of January 1562, which guaranteed religious toleration to the reformed faith, and left for England probably soon after the outbreak of the third religious war in 1568.

Who were the Oliviers of Rouen? Although Pierre's decision to go to England may not necessarily imply existing English connections, it could. There was a Pierre Olivier, who may have been his father, who was a printer. Along with Martin Morin, Pierre Violette, Richard Hamillon, Robert and Florentin Valentin, Nicolas Le Roux and Jean Le Prest, he catered for the English market between 1490 and 1556.[5] It would seem a likely hypothesis that Isaac's father was a member of the printing family with existing English links through the book trade.

What followed in London is even more inexplicable. The house in Fleet Lane, in the Old Bailey Quarter of the parish of St Sepulchre-without-Newgate, was, as an examination of the surviving lay subsidy rolls demonstrates, a clearing house for exiles from France and the Low Countries. Everyone moved on; everyone that is except Pierre Olivier. We know that he was there in 1568 but he was still there in 1577 listed along with his wife and son and again in 1581–2 when there was no listing of wives or children.[6] In other words his status remained that of an impoverished lodger with no profession, for none is listed, for at least fourteen years.

Of their indigence we are left in no doubt, for the poll tax levied on them is the lowest one of 4d. By 1581–2 the future miniaturist would have been about twenty. Oliver's earliest miniature is dated 1587 and with this fact it is usual to postulate a training similar to that of Hilliard who set up as an artist in his own right at twenty-two after an apprenticeship of seven years. Are we right to? In fact we cannot assume that Oliver was ever an apprentice to Hilliard – which is often taken for granted. In contemporary sources he and Lockey (who was Hilliard's apprentice) are referred to as 'schollars' under Hilliard and again Oliver is 'his well profiting scholler'.[7] The records of the Goldsmiths' Company survive for precisely the period when such an apprenticeship would have been recorded but it is not mentioned.

We assume that Oliver grew up in England but any examination of his work quickly establishes that apart from the technical expertise necessary for the craft of limning Oliver makes no use of Hilliard at all. His miniatures from the outset spring from a totally different aesthetic viewpoint. If he had been trained under Hilliard for seven years his early work would, however precocious, have been related to that of his master in the same way as that of Lockey or Laurence Hilliard, but it does not. Surely the succession here reverts back to a relationship of the kind that existed between Holbein and Hornebolte, that is not of master and pupil but of master and master. All the evidence would indicate that Oliver came to Hilliard as a fully trained artist in his own right who was then taught to paint miniatures.

We are now faced with the problem of how he was trained, if not by Hilliard. The absence of any records in England points to training abroad. Too often we forget that the exile colony in London from France and the Low Countries was a migratory one. As the political situation changed abroad they often returned. In the case of artists alone Joris Hoefnagel, Cornelius Ketel and Marcus Gheeraerts the Elder all came and went. And this is what must have happened to Isaac Oliver.

Isaac Oliver françois: evidence from the drawings

What I would suggest is that the most fruitful approach to him is not through the miniatures but through his other work. The identifiable other work is in the form of drawings, often very highly finished ones, conceived as works of art in their own right. It is they which I would suggest offer us the key to Isaac Oliver.[8] A complete study of Oliver's drawings is a *desideratum*. Those so far attributed to him form a disparate group, so in order not to take us too far off the trail of Oliver the miniaturist I propose to confine my comments to five only which are signed.

We have a point of departure in that *The Lamentation over the Dead Christ* in the Fitzwilliam Museum, Cambridge,[9] is not only signed but dated. Although

186

182

143

rubbed and faint the certain figures in that date are '15–6', the third figure being either an '8' or '6'.[10] The few facts that we know about Oliver eliminate 1566 as a possibility so that here we have a fully authentic drawing by Oliver executed a year before his earliest signed miniature. The importance of this discovery can hardly be overestimated for it is certainly not the drawing of a student but of a fully trained artist. This single drawing eliminates for ever our preconceived notions of his relationship with Hilliard. It also corroborates the evidence indicating that Oliver was in his twenties in the 1580s.

Before we consider that drawing we need to examine any which may precede it in date. Certainly the most hesitant Oliver drawing is the *Moses striking the Rock*, which is first recorded in the inventory of James II.[11] It is in grey and brown wash heightened with white and the most striking feature is the relegation of the central subject-matter to a shadowy vision in the distance, while the foreground is used as a vehicle for figures arranged in an elegant tableau whose source could only be the School of Fontainebleau. This has all the marks of an early work for it lifts and combines a number of favourite recurring motifs in the *oeuvre* of artists of the Fontainebleau School. To the right the Parmigianesque figure, at once sensuous and chaste, of a woman is familiar from the work of Niccolò dell'Abbate and Luca Penni.[12] The group to the left of the centre is a variant of another formula, one for Charity, which again is a recurring one from Jean Cousin onwards.[13] Around the Charity group are women bearing vessels in a manner directly reminiscent of those carrying them in sacrifice in a fresco in the gallery at Fontainebleau.[14] And the *à l'antique* warriors to the extreme left recall the classical world as reinterpreted by Antoine Caron.

Moses striking the Rock is accomplished but it remains a series of separate motifs rather than a coherent composition. It has, however, one daring touch: the foot of the Charity figure extends over the frame of the drawing. This is not the work of an artist in the workshop of Nicholas Hilliard. It must be by someone probably trained in France, who practises drawing from the life, who knows about linear and aerial perspective, who has been in direct contact with the work of artists at the Valois court and who can start from a premise that a drawing can be a work of art in its own right, an idea which was not referred to in England until into the first decade of the next century. Not for nothing, therefore, did Oliver occasionally sign himself *françois* for we must surely assume that he received his grounding in France. In 1576 the Treaty of Monsieur guaranteed religious toleration to the Huguenots everywhere except in Paris and for almost a decade an uneasy compromise reigned, albeit with lapses. This could have been the period when he was in France being trained under someone close to the court. Even in 1611 he was referred to as the 'French painter', which would hardly have been applicable to someone who had been raised as a Londoner from his arrival in the 1560s as a child.

There is one other possibility. Recent research has shown that the Olivers had strong connections with another exile family from Rouen, the Laniers.[15] Isaac was to marry as his third wife in 1606 Elizabeth, daughter of a court musician of French birth, James Harding. One of his colleagues was Mark Anthony Galliardello, whose daughter Frances married in 1585 another French musician, John Lanier. Their second child Nicholas became the well-known amateur painter, composer and picture dealer and their third, Judith,

Isaac Oliver's drawings (1)

Oliver's drawings reveal an extensive knowledge of French, Flemish and Italian art which would indicate study and travel abroad.

179 *Moses striking the Rock*, before 1586. A composition heavily dependent on the School of Fontainebleau

180 Niccolò dell'Abbate, *The Discovery of Moses* (detail)

181 Fontainebleau School, *Charity*, c.1560

was to be the first wife of the author of *Miniatura*, Edward Norgate. Now the latter refers to Isaac Oliver as 'my deare Cozen', certainly implying some blood relationship between the two families. Conceivably this may have ante-dated their arrival in England when there could have been some marriage perhaps between an Oliver and a Lanier. Be that as it may the important figure is another Nicholas, probably brother of John and uncle of the Caroline Nicholas, who was also a court musician. In 1578 we find among 'licences to pass beyond Seas' one to 'Nicholas Lanyer for iij monethes to see his friends in France'.[16] It is possible that the young Isaac went with him. At the least it establishes that there was considerable coming and going during the late 1570s.

As far as the drift of French political events went the real turning-point was the establishment of the Catholic League in March 1585. By then Valois court civilization was fast disintegrating and the prospects of patronage for a brilliant young artist would have been minimal. The 1586 drawing, besides being dated and bearing his signature, has one other word on it. The most satisfactory interpretation of the decipherable letters (?*Tuarnicum*) so far would indicate that it is a place name and the one that fits is a variant of the Latinized versions of Tournai (e.g. *Thomua, Turnacum*), a town just over the border from France in the Low Countries.[17] This would fit the hypothesis exactly that Oliver left France with the advent of the League and went north into Flanders. He cannot have been there that long. The 1586 drawing shows his response to Flemish Mannerism of the 1560s and 1570s but by 1587, the date of his earliest miniature, he is responding to the work of a new generation in the person of Hendrik Goltzius of Haarlem. It is at least worth suggesting that Oliver headed north and that his route to England was facilitated by contact with the first major military expedition by the English commanded by Elizabeth's favourite, Robert Dudley, Earl of Leicester. The Earl arrived late in 1585 and was not to return until the close of 1587. Leicester was a major patron of the arts, had indeed been responsible for Zuccaro's visit to England in 1575 and was an important patron of Hilliard. Goltzius executed a fine engraved medallic portrait of him and he seems to have been used as an artist to propagate the English cause.[18] Two of Oliver's earliest miniatures were of sitters that he could have met in the Leicester circle in the Low Countries, Sonoy, an ardent Leicestrian, and Lord Willoughby d'Eresby, whom Elizabeth appointed as commander of the army on the Earl's return. He could also have met Leicester's stepson, Essex, who returned to England late in 1586 and who was later to be a major patron. Whatever the truth of the matter enough elements are there to suggest the contacts that could have led back to England. And Leicester would have been an ideal person to secure an entrée to the Hilliard studio.

The Lamentation over the Dead Christ fits exactly into Flemish Mannerism of the 1560s and 1570s of the type exemplified by the work of Frans Floris. The monochrome treatment and the use of a sharp delineation of the foreground figures as against a shadowy indication in outline and wash of the background ones is the same as in the Fontainebleau style drawing but the compositional approach is far different. Here the surface is crowded with over-large figures, so much so that we are hardly aware of the make-up of the background. There are noticeably Flemish Mannerist details such as the hat of the man supporting the dead Christ or the cut of the costume of the Magdalen to the left. The

abilities to compose have advanced since the first drawing but the draughtsmanship is still often tentative.

The third drawing, *The Entombment*,[19] in the British Museum is a reworking of the 1586 *Lamentation* in the light of a visit to Italy, which took place in or around 1596, as I shall discuss below. The implications of this are enormously important. In the first place it means that the 1586 drawing was probably still in Oliver's possession over a decade or more on. This foreshadows the phrase in the artist's will in which he leaves his son, Peter, amongst other things 'all my drawings allready finished and unfinished . . . be they historyes, storyes . . .'.[20] In the second place it means that Oliver was capable of returning to a subject over the decades as he attempted to reach a more satisfactory solution. The later drawing is far finer in quality than the 1586 one. The composition contains most of the figures from the earlier one but they are now spread out, more monumental in concept. Flemish Mannerist clutter and details of dress are eliminated and the whole is contained within a definable architectural setting. The figure of the Virgin is virtually repeated but above her hovers a Leonardesque St John. The Magdalen is dropped and the motif of the hand-kissing woman is developed into a sinuous Parmigianesque figure. Two putti are introduced into the foreground and all the male figures are heavy with allusions to heroic High Renaissance prototypes.

As in the previous drawings it is conceived, as far as he has taken it, as a finished object in its own right and not merely a preparatory sketch for a miniature. The fact that he did begin a miniature based on this drawing which was left unfinished at his death in 1617, and is now in the museum at Angers, does not necessarily mean that the drawing should be dated as late as that. The miniature, completed by his son Peter, is recorded by van der Dort as follows:

> Which peece is dated / 1616 / being the buriall / of Christ in white linnen by 4. of his disciples is – / Carried to the grave, one standing wth outstreatched / Armes to receave him into the said grave and / a farre of some / 5. disciples in sadnes and mourning, / And a standing woeman takeing Christ by / his left Arme, kissing his hands, Our lady lying / along in a sound in a redd garmt and blew drapery / upon St Johns lapp, Also a Mary Maudlin – / siting by on the ground wringing / both her hands a greiving, Likewise another woeman in an – / Oring drapery houlding a goulden vessell, And more another woeman by in a yellow habbitt – / looeking upwards wth opening hands in sorrowe, / Behinde all theis said figures there is a Troope a farr of some .9. disciples a grieving, whereof / one in greene another in yellow, another in blew, & / Three in purple draperies wch are in all some lessor and bigger figures.[21]

A second entry states the number of figures to have been twenty-six. The van der Dort entry, bar the addition of a few figures in the background, matches Oliver's drawing exactly. The fact that the miniature was still in the painter's possession when he died almost certainly means that it was not commissioned. What this material surely tells us is that Oliver suffered the fate of countless artists who sought refuge and employment in England. Basically they were painters of subject pictures but for a living they had to respond to the insatiable demand for portraits. Holbein earlier and Van Dyck slightly later enjoyed the same fate. The drawings are in fact the heart of Oliver's work; their execution reveals a passion that is often absent from the repetitive miniatures.

Having established this framework we can now briefly place in it two other

182 *The Lamentation over the Dead Christ*, 1586

183 *The Entombment*, after 1596

148

Isaac Oliver's drawings (2)

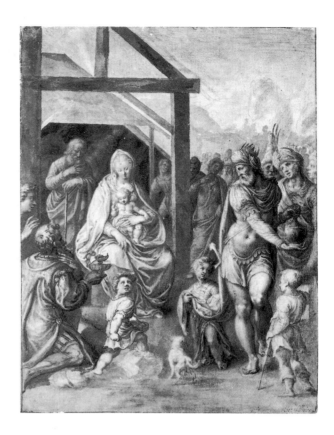

184 *The Adoration of the Magi*, after 1596
185 *Nymphs and Satyrs*, probably after *c*.1610

signed drawings. One is an unfinished *Adoration of the Magi* which must, in the
light of our evidence, belong to the post-Italian period.[22] It is more
accomplished than the 1586 *Lamentation* but its compositional approach is
exactly the same, with large figures crowded onto the scene and the Madonna
sitting within a Brueghelesque stable. The sources of the figures are Italian.
The final drawing is the *Nymphs and Satyrs* at Windsor, which is by far the
most accomplished of all Oliver's drawings.[23] The technique is black ink and
wash, heightened with white, on brown paper. It is a highly finished object, a
monochromatic miniature in its own right which must have taken a great deal
of time to execute, as much if not more time than the large-scale portrait
miniatures. It presupposes drawing from the nude and also preliminary
studies, one of which is probably a drawing in the British Museum of a satyr
lifting a curtain peering at a reclining female nude. *Nymphs and Satyrs* at once
establishes Oliver as a great Mannerist artist in European terms and when set
in the fastnesses of Jacobean England it is little short of astonishing. The
subject-matter is equally without precedent. Was it done for his own pleasure
or was it the result of a commission? The latter presupposes a patron interested
in what is without doubt the most frankly erotic picture of the Jacobean age. It
belongs to mythological groups of the kind painted by Dutch artists in the
1590s in response to Spranger and in particular recalls Cornelis van Haarlem.

Having discussed his most important drawings we have finally to set them
against the ideological attitudes of the period, which adds an even more
curious twist. Although various theorists on the attributes and accomplish-
ments necessary for the perfect gentleman had included drawing among them,
their views in fact went unheeded.[24] Elizabethan educational theorists had no
place for drawing even as a practical skill. It was not referred to by Roger
Ascham; Richard Mulcaster allied it with penmanship, while Sir Humphrey
Gilbert's 'Queene Elizabethes Academy' provided it as a last contingent for a
teacher to show aristocratic youths how to draw maps and charts, a purely
practical diagrammatic function with no hint of any aesthetic overtones.
Drawing was a demeaning activity, unworthy of cultivation by the educated
ruling classes. Although John Dee in his preface to *Euclid* (1570) invents a new
word for it, 'Zography', he presents the skill not as an art but as a science, a
technical skill necessary for the mechanical classes to whom his publication was
addressed. It is not until 1606 when Henry Peacham published his *Arte of
Drawing* that its techniques were presented as a desirable attribute of the
aspiring classes.[25] Even then it was presented in heavily practical terms as
useful for the art of war or in travelling, although its aesthetic value was raised
by references to the large sums of money that popes and princes paid for
paintings and to drawing as expression of the Idea. In the 1612 edition of his
book, retitled *Graphice*, he takes the case for drawing a stage further, linking
the inability of gentlemen to do so with the absence of patrons and the generally
low state of English art. By that date Peacham was on the fringes of England's
first truly Renaissance court, that of Oliver's patron Henry, Prince of Wales.
The overwhelming philistinism of these attitudes means that virtually for the
whole of Oliver's life no one was capable of regarding his drawings as works of
art at all. For them drawing was only a 'rude draught', for the concept of the
visual arts as founded on *l'arte disegnatrice* did not exist. Even in the 1430s
Alberti recognized a drawing as a work of art in its own right. As late as the

1620s in England Edward Norgate, whose *Miniatura* was to sum up the limning tradition, writes that when all is said and done a drawing 'is but a drawing, which conduces to make profitable things, but is none it selfe'.[26] No wonder that Oliver was able to will them to his son.

This examination of five of Oliver's drawings opens up for the first time the problem and the mystery of the man. I cannot pretend that they solve it. Doubtless in some foreign archive sooner or later a document will appear enabling us to chart these peregrinations. Until then the drawings suggest the training and influences to which Oliver would have been subject before he entered Hilliard's workshop in the late 1580s. Hilliard, we know, spoke French so that there would have been no linguistic problem. With these ideas in mind we are now able to turn to examine Oliver's contribution to the art of limning with a fresh eye.

The earliest miniatures: 1587 to c. 1595

Oliver's work would have been totally incomprehensible to the Elizabethan court of the mid-1580s. Here was an artist of the utmost sophistication and talent, a draughtsman and by implication a painter, worthy of the patronage of the most esoteric Mannerist court. Instead Oliver found himself in an alien ethos which he was to live long enough to see dispelled but not for another decade or more. There can have been no demand for what he could offer and it is perhaps not too far-fetched to speculate that he took lessons in miniature painting from Hilliard because that skill would at least have guaranteed him a living. That training, as described by Hilliard in his *Treatise*, would have involved the slavish copying of engravings so that the copy was indistinguishable from the original. In the case of Hilliard's training those of Dürer were used; in that of Oliver probably the portrait engravings issued by Goltzius in the years immediately prior to his probable return from the Continent.

From the outset, however, Oliver's method was different, in some ways a reversion to that of Holbein because preliminary sketches seem at least to have been part of the working process, possibly not always but certainly in the case of his most ambitious compositions. Only one such drawing[27] survives from the Jacobean period but we know that they once existed for other miniatures. Vertue records in c.1729–30 seeing a sketchbook by Isaac Oliver with the dates 1609 and 1610 which included 'many Sketches. postures &c done with a Silver pen' and he transcribes the list of sitters written in phonetic English. Among the names mentioned are those of the Queen, the Countess of Arundel and Sir Henry Roe.[28] Unlike Hilliard, therefore, each sitter presented Oliver with a separate problem demanding a different solution not only in terms of pose but in those of colour and technique. Throughout his career he was always able to go back to an earlier manner if he thought it appropriate for a particular sitter. The resulting gallery of portraits was from the start distinguished by its stunning variety.

His earliest miniature, dated 1587, is of a woman aged twenty.[29] The format is original, owing nothing to Hilliard. It is a three-quarter length derived from a formula used by Goltzius in a number of engravings. The blue background and the gold lettering derive from Hilliard but we are already looking at something new, a type of portraiture that depends on light and shade to obtain verisimilitude, that emphasizes rather than softens character and features. The handling of the paint is tighter and different, much more solid, and he is

246

186

187

Oliver and
Hendrik Goltzius

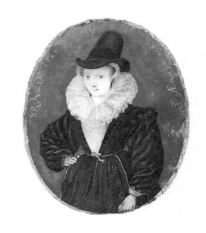

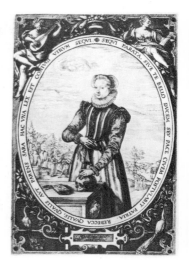

186 *Unknown Lady*, 1587

187 Hendrik Goltzius,
Josina Hamels, 1580

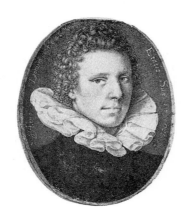

188 *Unknown Man*, 1588

189 Hendrik Goltzius, *A
Young Man Aged 22*,
1580

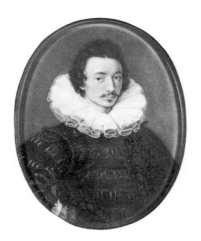

190 *Self-portrait*, *c*.1590–95

191 Hendrik Goltzius,
Hieronymus Scholiers,
1583

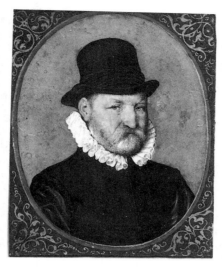

193 *Diderik Sonoy*, 1588

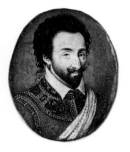

192 *Peregrine Bertie, Lord Willoughby d'Eresby*, c.1590

quickly experimenting, embarking on the use of stipple to attain his more startling effects. The sitter is of the merchant class with her black dress, apron and high-peaked hat. Three more miniatures depict bourgeois ladies in the same dress[30] and many of the miniatures of men could be of sitters from the same social milieu, so lacking in ostentation is their attire. During these years he produced some of his most astounding characterizations. In the self-portraits and in the series of portraits of unknown men he presents a sequence of images stemming directly from Goltzius's engraved portraits. These all use dramatic chiaroscuro in which the head emerges from the shadows. In addition the colour is opaque and strong, very akin to the impasto of oil paint, and poles away from the feathery brushwork of Hilliard with its concern with decoration and transparency of effect. Although Oliver began by using calligraphy in the Hilliard manner to record age and date, this must always have worried his aesthetic sensibilities as it destroyed pictorial space as he (but not Hilliard and the Elizabethans) knew it. After 1590 he rarely made use of it.

These early portraits, where the sitters are identifiable, are useful corroborative evidence that a Low Countries link of some sort must have existed. That of Diderik de Sonoy[31] used to be cited as evidence of Oliver's presence in the Low Countries in 1588 but we now know that he must have painted it in London. Sonoy, an ardent partisan of Leicester, had gone into exile and arrived in England in September 1588. What would have been more natural than that he would have gone to an artist with connections with the Low Countries and the exile Flemish community? The format is an innovation, an oval set into a rectangle with spandrels decorated with arabesques. Peregrine Bertie, Lord Willoughby d'Eresby,[32] reiterates the connection because he succeeded Leicester as commander-in-chief of the English troops in the Low Countries. Finally there is Oliver's portrait of the Queen.[33] Although we have discussed this in the context of the imagery of Elizabeth during the last decade of the reign, it is in addition an important document which enlarges our understanding of Oliver's connections in Elizabethan London. The portrait of Elizabeth stemmed from a commission

193

192

198
200

198

153

195 *Unknown Girl*, 1590

194 *Unknown Girl*, c.1592

by Jan Woutneel, a bookseller and printseller who settled in London in 1592, and the resulting image was sent to the Low Countries and engraved by Crispin van de Passe in 1592.

Due to the fact that Oliver virtually abandoned the use of inscriptions, his miniatures can be extremely difficult to date closely, as in most cases the evidence is only that of the limited amount of costume visible. Two miniatures, however, are very closely linked on grounds of style to the pattern portrait of the Queen painted in or about 1592. This would indicate that they should precede Oliver's visit to Italy in 1596 and establish that he was already being taken up by the aristocratic classes. They have too the same stylistic approach, for they are consciously Hilliardesque in feeling, the palette range is deliberately lightened, the hair is painted in a loose Hilliard manner and the accent is not upon dramatic chiaroscuro but upon hair ornaments, the pattern of lace and embroidery and the sparkle of jewels. The portrait of a little girl called Arabella Stuart[34] is unfinished, the result of only two sittings, but it shares with the pattern of Elizabeth the same heavy black line delineating the eyelid and the same blocking in of the ruff. What is even more striking is the enormous advance Oliver has achieved in such a few years when a comparison is made between this miniature and one out of the pair of miniatures of little girls aged four and five which he painted in 1590.[35] The latter are presented in a flat iconic manner contrasting sharply with the sophistication of the courtly young girl whose head is turned into a three-quarters position and who is placed against another innovation, a crimson velvet curtain, instead of the usual blue bice background.

Although he could mimic his master's manner, his large-scale miniatures, unlike those of Hilliard, are not the isolated phenomenon of a few years, but a recurring theme over thirty. They are above all the link with his drawings and it is important to consider them as they occur. To the pre-Italian period we can assign two, both painted in a manner directly related to his recent training. The first is of an unidentified sitter presented as a melancholy young man seated on a bank under a tree in a 'dump' or 'muse'.[36] It is difficult to believe that Oliver could have painted this without having seen Hilliard's *Young Man among Roses* and his full length of *Cumberland*, as he reuses the props of tree and bank. Oliver, however, at once surpasses his master in his handling of space. The compositional formula emerges straight out of his drawings which, as we have

seen, at this period always worked by ignoring the middle distance, contrasting a sharply defined foreground set against a distant, less defined backcloth. In the same way the young man, his bank and tree form a cut-out against the view of house and garden. Even more than in the head and shoulders portraits we are suddenly aware of another innovation, a light source. From the left it streams down giving shape to the tree and form to the figure. The handling of the perspective view of the house and garden is correct and exact, with a vanishing-point on which all lines converge. To place this side by side with any of Hilliard's full-length miniatures is not to compare master to pupil but to be confronted by two totally opposed aesthetics.

The second, *An Allegorical Scene*,[37] as in the case of his later *Nymphs and Satyrs*, presents us with one of the most tantalizing images of the period. To his monogram he adds the word *in(venit)*. This is significant for Oliver is saying that the allegory is of *his* invention, a statement which removes him again from the medieval Hilliard and ranges him instead with the Mannerist and Baroque masters who were capable of devising iconographic programmes for the works of art they created and indeed owed part of their status in society as learned painters to this ability. Hilliard, in contrast, carried out the emblematic dictates of his sitters. A comparison with Hilliard's *Northumberland* of about the same 132

197

196 *Unknown Melancholy Man*, c.1590–95, with folded arms and broad brimmed hat. He seeks the shade of the greenwood tree in contrast to the walks of the formal garden in the distance. (See also colour pl. VI)

197 *An Allegorical Scene: Virtue confronts Vice,* *c.*1590–95

date once again emphasizes the enormous gulf that divided the two artists. Hilliard could never have conceived so complex a composition whose essence was movement and action. The handling of the landscape manipulates aerial perspective in the manner of Gillis van Coninxloo or Lucas van Valckenborch, the trees twisted and gnarled, the whole wood atop a height from which one views a typical northern European panorama of rivers and lakes, castles and mountains. The very idea of a landscape setting must have been revolutionary and virtually incomprehensible in the early 1590s. That it did not exist as a genre is confirmed by the absence of a word for it. An early appearance is a decade on when Ben Jonson adapts the Dutch and describes the curtain that concealed the seascape in the *Masque of Blackness* in 1605 as 'a Landtschap consisting of small woods, and here and there a void filled with huntings'. The year after, Henry Peacham felt that he had to explain the term to his readers: 'Landtskip is a Dutch word & it is as much as wee shoulde say in English landship, or expressing of the land by hilles, woodes, Castles, seas, valleys, ruines, hanging rockes, Cities, Townes, &c as far as may bee shewed within our Horizon'.[38]

The wood in the miniature is a garden of love, the wrong kind of love, where the hunting of hawk and hound for prey is paralleled by the pursuit of lust and pleasure by the sexes. The frank scenes of amorous involvement anticipate the

156

more explicit eroticism of *Nymphs and Satyrs*: lovers dally and embrace both in the shadows and on the ground; wanton women display their breasts. A lady, not of the court but of the city, attended by two servants, is led in by a gentleman to confound this scene of vice in a dénouement redolent of Milton's *Comus*.

<div style="display:flex">
<div style="font-style:italic">Oliver, de Passe
and William Rogers</div>
</div>

No more than about thirty miniatures by Oliver can be dated before his Italian visit. The link between him, Woutneel and de Passe, however, enables us to suggest what else he might have been engaged upon. To do this we have to start with a posthumous engraving of the Queen inscribed: *Isaac Oliver effigiebat.* 202 *Crispin van de Passe incidebat. procurante Joanne Waldnelio.* This means that this portrait was produced by a repetition of the arrangements of 1592. The portrait was instigated by Woutneel in London; Oliver provided the drawing which was sent to the Low Countries where de Passe engraved it.[39] The fact that it was produced abroad resulted in an inscription which actually acknowledged the artist. This was rarely if ever the case in England where the engraving recorded only the name of the man who carried through the physical process of making the plate.

There must have been a rush to produce the engraving on the Queen's death because it made use of an old portrait which had already been engraved by William Rogers. Rogers was the first English-born engraver to emerge and the 203 verses beneath his version of the Oliver portrait make it clear that the Queen was still alive.[40] But what is its date? The face-mask is that of the *c.*1592 pattern, but with the eyes turned in the opposite direction, and the dress is also *c.*1592 and absolutely parallel in cut and decoration to the one in the famous Ditchley Portrait. This means that Isaac Oliver ought to have been responsible for the original design. The difference between what de Passe does with an Oliver design and what Rogers does with it is in itself instructive. De Passe was obviously closer in spirit to the ideals of Oliver's art. In the hands of Rogers the decorative detail is accentuated and the result is flatter. If his engraving was issued *c.*1592 it is, however, far more advanced than anything Hilliard was able to achieve in his awkward full-length miniatures produced during the same period. Rogers' perspective is absolutely correct and a far cry from Hilliard's inept attempt in his Sir Christopher Hatton. There are no cast shadows in his 120 large-scale miniatures but in Rogers' engraving the Queen stands firmly within a room bounded by aerial and linear space; in addition, however – more revolutionary than anything else – she actually stands next to a window through which beams of light can be seen to fall on her, casting one side into shadow. Hilliard would never have dared depict her in such a manner, nor would she have approved of it. Elstracke's engravings of James I and his family, engraved two decades later, probably after designs by Hilliard, are seen to be hopelessly retrogressive when placed by the side of this. The evidence would point to Oliver as the source of this famous image.

Two other engravings of Elizabeth make use of the Oliver face-mask and are possibly after designs by him. One is the *Queen Elizabeth between columns* dated 1596, which was probably engraved by de Passe but commissioned and published by Woutneel.[41] The second is William Rogers' *Rosa Electa* of about 201 the same date which presents Elizabeth three-quarter length with a table before her exactly as in the engravings of ladies by Goltzius in the early 1580s.[42]

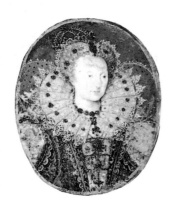

Oliver and the Queen

The Queen sat for Oliver c.1592. From her point of view the encounter was a failure.

198 Oliver's studio pattern painted from life, *c.*1592

199 Engraving by Crispin van de Passe after Oliver, 1592

200 The only known miniature after the studio pattern, *c.*1592

201 Engraving by William Rogers, probably after Oliver, *c.*1590–95

Opposite
202 Engraving by Crispin van de Passe after Oliver, *c.*1603

203 Engraving by William Rogers after Oliver, *c.*1592

All these depict her as old with a slightly hooked nose and the extreme rarity of impressions makes one wonder whether this fact can be linked to John Evelyn's account in his *Sculptura* that 'vile *copies* multiplyed from an ill Painting were called in and furnished the cooks at Essex House for several years with *Peels* for the use of their ovens'. William Rogers clearly drew on more than one artist for his engravings resulting in a somewhat incoherent *oeuvre* that vacillates between old style Hilliard and new wave Oliver. The possibility that Oliver drew some of the designs for other engravings, for example that of the Earl of Cumberland, also cannot be excluded.[43]

Oliver in Italy

The visit of Oliver to Italy is known from two pieces of purely fortuitous information. One is an inscription in Italian on the reverse of an unfinished miniature of a man called Sir Arundell Talbot dated 1596. In translation it reads: 'The 13th day of May 1596 at Venice done by Mr. Isaac Oliver French man I.O. May 14th for £8.'[44] Whoever it was who had sat for his portrait had not completed the sittings, for the miniature is the result of two only. A second inscription, slightly later in date, identifies that sitter as a certain Sir Arundell Talbot, but no evidence has yet appeared that such a person existed, which is surprising in the case of a name incorporating two great aristocratic families.

The second piece of evidence is an entry in van der Dort's catalogue of Charles I's collection. It occurs amidst a list of three large paintings lent by the King to Henrietta Maria.

204 Paolo Veronese, *The Mystic Marriage of St Catherine*, 1575. A picture copied by Oliver during his visit to Italy

Whereof the first being a bigg peece of liming wch was first done in Italy and since / over don and touched by Isack Oliver / being An our Lady St Katherine and manie Angells. / and other figures don after Paule Veroneiz being / aboute a foote in height wth an Iseing Glass / over it, in an Ebbone frame, wth a shuting dore of Ebbone.[45]

In the margin it reads: 'bought by yor/Maty of Isack/Oliver'. This would have made the purchase one of the King's earliest as Oliver had died when he was only seventeen. To relate this miniature to the 1596 visit we would have to accept that Oliver did not return again to Italy after that date. There is, however, as we shall see, a possibility that he did return. The entry is of extreme interest as it establishes that it was Isaac Oliver who initiated the idea of making miniature copies of famous masterpieces and that this miniature must have been the fount of the long series of such limnings commissioned by Charles I from Peter Oliver.

This picture was one of the most famous Veronese ever painted, the *Mystic Marriage of St Catherine*, now in the Accademia. It is astonishing to think that an artist familiar with the archaic art of Tudor England could have copied this and carried it back to Elizabethan London. The visit to Italy must, however, be placed in some sort of political context. In 1593 Henri IV was received into the Church of Rome and the year after entered Paris. By 1596 the Edict of Nantes and the Treaty of Vervins are only two years away. The roads to Italy were reopening, and once in Italy Protestant visitors from the north could travel with safety within the *stati liberi*, principally the Republic of Venice, the Duchy

204

of Savoy and the Grand Duchy of Tuscany. By the close of Elizabeth's reign Inigo Jones had already travelled extensively in Italy, aristocrats such as Lord Roos and Edward Cecil had been received at the Tuscan court and a Venetian ambassador had arrived in London. So Oliver's visit must be seen within the overall context of the cessation of the wars of religion and the entry of Europe into that uneasy period of truce mingled with hope that was to last until the outbreak of the Thirty Years War in 1619. In spite of the fact that Oliver regarded himself as French he was the first painter to visit Italy from England in the 1590s. He probably *precedes* Inigo Jones, whose long and spectacular life has hitherto tended to establish him as par excellence the apostle of the avant garde. Bearing in mind Isaac Oliver's brilliance we now need to throw him into the forefront of the revolution that was already taking place in the visual arts before the death of Elizabeth.

'Curious painting':
Oliver's work: 1596
to 1603

We do not know when Oliver returned to England but it cannot have been long after 1596, for he painted Robert Devereux, 2nd Earl of Essex, bearded as he returned from the Cadiz expedition.[46] Essex was very concerned with his own image. Up until the middle of the 1590s he had been faithful to Hilliard and to his follower in large, William Segar, but after 1596 he switched to a combination of Oliver for miniatures with the limner's future brother-in-law, Marcus Gheeraerts the Younger, for large-scale portraits. In Gheeraerts' case the result was the full length (now at Woburn Abbey) of the Earl in silvery white standing on the seashore with Cadiz ablaze in the distance.[47] The resulting image in Oliver's case was also a very different one, consonant with Essex's pursuit of power, concentrating on presenting him not as the knight of the Queen, the hero of Accession Day Tilt pageantry, but as the man of affairs, the statesman, with broad forehead and thoughtful brooding eyes. The multiplication of these portraits bears testimony to their success. For Oliver the advent of his patronage must have been a decisive turning-point in his career.

207

Although the Queen herself stood as a rock against change, Essex and the impatient younger generation that surrounded him must have included those pioneers in the revolution in the visual arts that was to find its hero in the tragic figure of Henry, Prince of Wales. Our knowledge of this 'revolution', if we may call it such, is still fragmentary in terms of actual people and patrons but it is no longer so in terms of ideas. The profound change was the recognition of painting as an expression of human genius, and that that genius lay not in 'lively colours' but in 'curious painting', in which the component parts were verisimilitude to nature achieved through the Renaissance disciplines of scientific and aerial perspective and the use of light and shade.[48] Richard Haydocke's translation of Lomazzo's *Trattato* published in 1598 is quite rightly pinpointed as some sort of watershed. If we are to believe Haydocke something of that revolution had already been achieved by that date because he actually refers to people collecting pictures as works of art, something totally unknown in England up until then: '. . . some of our Nobility, and diverse private Gentlemen, have very well acquited themselves; as may appeare, by their Galleries carefully furnished, with the excellent monuments of sundry famous ancient Masters, both Italian and Germane'.[49] Was this wishful thinking? Who were these collectors? At the moment we do not know but

206 *Unknown Lady,*
*c.*1595–1600

205 *Unknown Man,*
*c.*1595–1600

Haydocke's statement and his book mark a change in atmosphere in late Elizabethan England coincidental with Oliver's return from Italy. The prevailing medieval concept of painting as line and colour, a lowly mechanical art, was being challenged by the recognition of painting as a liberal art that depended on the use of shadow and perspective to achieve total optical illusion. This has been traced in the literature of the period where, during the 1590s, writers became obsessed by the miraculous effects of shadow and perspective as a totally new visual phenomenon. The works of Drayton, Chapman and Shakespeare are full of tributes to the virtuoso skill of the painter in achieving illusion by means of these ingredients. On the other hand these skills took time to understand and assimilate. It demanded a new way of looking at the visible world. In the case of perspective Sir John Harington in 1591 writes about his engraved illustrations to *Orlando Furioso*: 'For the personages of men, the shapes of horses, and such like, are made large at the bottome, and lesser upward, as if you were to behold all the same in a plaine, that which is nearest seemes greatest, and the fardest, shewes smallest, which is the chiefe art in picture.'[50] Forty-five years later, and after years of attempting to educate the eye of the court by the means of the masques, Inigo Jones's perspective scenery for a play on the occasion of the King's visit to Oxford was still not understood by at least one member of its audience.[51] In the case of shadow Norgate could yet write, as an exponent of the obsolete Hilliard tradition in the 1620s, that 'Chiar-Oscuro' is 'a Species of Limming frequent in Italy but a stranger in England'.[52]

All this indicates that by 1596 the tide was beginning to turn and this is reflected in Oliver's rise in fashionable esteem. His approach in the case of Essex was a cautious one for when he paints him full length what he produces is a formal late Elizabethan portrait in miniature but with a complete understanding, unlike Hilliard, of perspective. The carpet lies upon the ground with converging lines of pattern and the Earl's feet are placed firmly upon it. Sitter and setting are seen from the same viewpoint, unlike Hilliard's full lengths in which they are seen from at least two.

207 *Robert Devereux, 2nd Earl of Essex, c.*1596. Oliver's most influential new patron who abandoned Hilliard

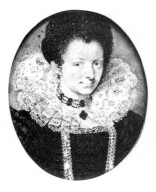

208 *Unknown Lady,*
*c.*1595–1600

209 *Unknown Lady,*
*c.*1595–1600

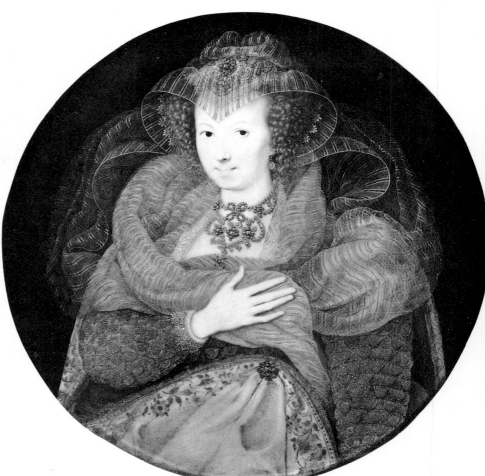

210 *Unknown Melancholy*
*Man, c.*1595–1600

211 Emblems of constancy:
the rock and ship amidst
a stormy sea, from
Peacham's *Minerva*
Britanna (1612)

The impact of Italy on Oliver

After his return from Italy after 1596 a series of
works follow which reflect the influence of the
Milanese and Venetian schools.

212 Paolo Veronese, *Unknown Lady*, c.1560

213 Francesco Melzi, *Flora*, c.1510

214 Giampietrino, *St Mary Magdalen*, c.1525

This change of atmosphere meant that there must have been a circle of patrons who appreciated what Oliver had to offer. The main stylistic trends in the years following are an increasing tightness of brushwork, greater use of stipple to obtain striking chiaroscuro effects, constant experimentation with size and scale and also with various coloured backgrounds, and a palette which could display its virtuosity in bravura exercises in the monochromatic. These developments round out the span of Oliver's career down until his death in 1617. Although the advent of the Stuarts in 1603 was to bring official court patronage it did not affect his style.

With the exception of one or two citizens' wives, and in particular the spectacular portrait in the Royal Collection,[53] his sitters after 1596 are of the court. And his masterpiece from these years is the circular miniature of an unknown lady formerly called Frances Howard, Countess of Essex.[54] The circular format is not a revival of the earlier limning tradition but is surely inspired by having seen the Renaissance *tondo* form. The lady is conceived from the outset as an Elizabethan Mona Lisa, half-smiling, emerging from the shadows encircled by billowing veils. The colour is virtually monochromatic, very close in this way to the subject drawings, moving through permutations of grey to white with touches of silver and gold. Her fair hair and pallid features lend the only colour to a composition and concept that are lineally descended from the painters of the Milanese School who specialized in *sfumato* renderings of enigmatic, smiling, often highly androgynous figures. The extended hand, later to become a leitmotif, also makes its first appearance here and this surely is derived from north Italian and Venetian portraiture. The sitter must have been a lady in the forefront of the Elizabethan world, rich and grand, but also appreciative of 'curious painting'. Is it Sidney's sister, Penelope Devereux, celebrated as a flaxen-haired beauty, sister to Essex and mistress to his friend, Charles Blount? The identity probably lies within that charmed circle.

This mysterious half-smiling formula for women is one that Oliver repeats,[55] as he does the monochromatic effect. Blue backgrounds now give way to grey, grey-green or puce. Inscriptions virtually vanish making dating even more difficult. The gallery of distinguished portraits of men continues, even though the brilliance can become a little mechanical. One of Oliver's most superb characterizations from the period captures in its brushwork his response and excitement to a sitter.[56] The brushwork is at first glance typically tight and smooth but under intense magnification it is revealed as tense and nervous as Oliver attempts to come to terms with the intelligence of the man before him. In the last years of Elizabeth's reign and into the early Jacobean period this head and shoulders format becomes a standardized one from which he rarely departed.

In the case of two miniatures he does, and both are emblematic and immediately establish his ability to deal with this subject-matter more satisfactorily than Hilliard. The first[57] used to be assigned to the latter but the style and stipple technique are Oliver's. As usual it is difficult to date but the cut of the hair is close to that in two Gheeraerts portraits dated 1599. The sitter is presented in his shirt clasping what is probably a picture box at the end of a chain around his neck standing in front of a background of flames. The emblematic allusions lead us to devices of the phoenix arising unscarred out of the flames of its own funeral pyre as a symbol of resurrection, rebirth and

166

215 *Unknown Man,*
*c.*1600, enveloped in the
flames of his passion

216 Emblem of passion in
the form of an inverted
flaming torch, from
Whitney's *Emblemes*
(1586)

chastity and, more pertinently, to the crowned salamander. Vaenius's
Emblemata (1608) includes a salamander amidst the flames in a specifically
amatory context:

> *Unhu'rt amidds the fyer the Salamander lives*
> *The lover in the fyer of love delight doth take*
> *Where lover thereby to live his nouriture doth make*
> *What others doth destroy lyf to the lovers gives.*[58]

In the miniature the sitter draws his hand and the picture box towards his
heart. The imagery can as equally be paralleled with another common emblem, 216
that of an inverted flaming torch and the motto *Qui me alit me extinguit:*

> *Even as the waxe dothe feede, and quenche the flame,*
> *So love gives lyfe; and love, dispaire doth give . . .*[59]

The second miniature is even more extraordinary.[60] It too may be a love 210
token. In it a naked young man crosses his hands on his chest and casts his eyes
heavenwards. In the distance there is a rock arising out of a stormy sea on
which a ship is tossed. The miniature figured in Charles I's collection and was
listed as 'a Certain naked young mans picture' and also as St John the
Evangelist. Later it became called 'The Prodigal Son'.[61] There is no reason to
accept this identification, for it is clearly a portrait and the pose places it in a
long gallery of melancholic gallants from the 1590s that includes the amorous
young John Donne.[62] The nudity due to his other role as St John on Patmos
makes dating even harder as we are reduced to placing the extremely long hair,
which seems best related to the extremes of dandiacal affectation posed by
Shakespeare's patron, Southampton, as recorded in his portraits. The 134
emblems in the background are those which later gained currency as part of
William Marshall's famous engraved portrait of Charles I in the *Eikon Basilike*,
in which they allude to the constancy in adversity, in both the political and 211
religious sense, of the King. The theme of the miniature does, therefore, point
to a religious as opposed or in addition to an amatory context. That this is a

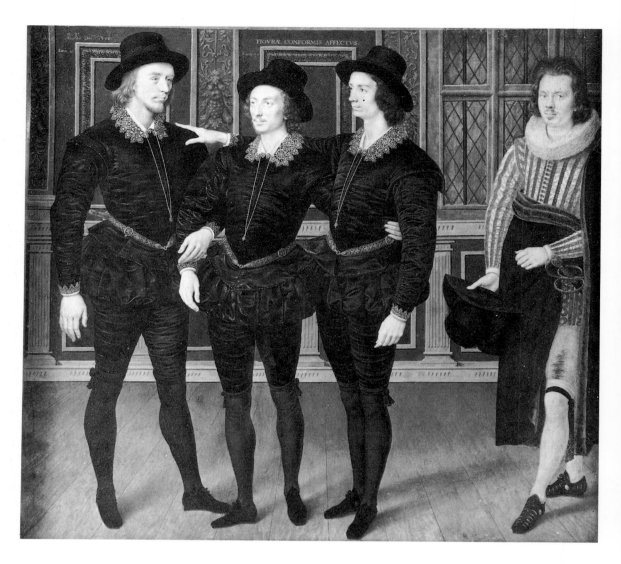

217 *The Three Brothers Browne*, 1598 (original: 24 × 26 cm)

218 Marc Du Val, *The Three Coligny Brothers*, 1579

possible interpretation is reinforced by the iconographic source of the composition, for this combination of long hair, nudity, ecstatic gaze and crossed arms derives above all from late sixteenth-century representations of the penitent Magdalene as depicted by the Milanese School in the aftermath of Leonardo.

214

The fact that we have to search for sources for Oliver's compositions reflects the complexity of the man when faced with any major commission. In the case of his second large miniature from this period, that of the Browne brothers, dated 1596,[63] Oliver is probably recalling, in his group of the three Catholics linked arm in arm, Du Val's engraving of 1579 of the three Coligny brothers. Allusions to the classical group of the Graces would also seem to be implicit. The arrangement of the brothers against the panelled wall of a room with a window might also reflect knowledge of Hans Eworth's treatment of Lord Darnley and his brother.[64] The miniature again repeats the monochromatic colour range of the unknown lady, moving through gradations of black, grey and brown with touches of silver. And once more light streams onto the figures casting shadow backwards across the receding planks of the floorboards.

217

218

Oliver, Anne of Denmark and Prince Henry: 1603–1617

Suddenly from the very last years of Elizabeth's reign we are confronted with a mass of payments and other facts about Oliver. On 6 September 1599 his first wife, Elizabeth, died at the age of twenty-eight. We know nothing about her and the surmise that she was Netherlandish remains unproven. She could as easily have been French. On 9 February 1602 he married as his second wife Marcus Gheeraerts the Younger's sister, Sara. Through this marriage he connected himself with the key portrait painters of the period, for two other Gheeraerts sisters were married to the painter John de Critz and to the sculptor Maximilian Colt. This would have placed Oliver for a brief period (for she died three years after) at the heart of Jacobean portrait studios. In the year that Sara died, 1606, he was married for the last time at the Thames-side village of Isleworth to Elizabeth Harding, the daughter of a court musician of French descent. Mary Edmond's researches have recreated this Isleworth milieu, which was made up of a network of families in the service of the court and through direct marriage and friendship establish Oliver's connections with Nicholas Lanier and Edward Norgate. She suggests that Oliver's parents might have been there in the 1570s, for the burial of two Olivers, possibly children of Pierre, one with a French Christian name, occurs in the registers for 1579. Perhaps the key document that is missing is indeed the register of the French Church, which does not survive before 1600. This would have told us probably about Oliver's first marriage and about the births of children. The circle it places him into domestically is that of the Protestant exile community of artisans, craftsmen and performers that served the court.

On 22 June 1605 he was appointed 'painter for the Art of Limning' to the new Queen, Anne of Denmark, with a salary of £40 p.a.[65] In March of the same year he received £100 and in June a further £50, both part of the huge sum of £200 owed to him 'for his great Charges in attending her highnes service and for certain pourtraictures made for her Majestie in divers places aswell here at London as in progresse'. Anne had sat for Hilliard once and, as a woman with a taste for the avant garde in the arts, abandoned him immediately. Gheeraerts was principally to paint her in oil, Oliver in miniature. The entry implies many

sittings and that Oliver went with the Queen on progress. So large is the sum of money that we should not perhaps exclude the possibility that he painted a life-scale portrait. The results of these early sittings must have included the two magnificent *ad vivum* miniatures now at Waddesdon and at Berkeley Castle.[66] The former, to judge by the costume, is the earlier of the two, a brilliant rendering of the new Queen, her hand elegantly extended across her bodice. No repetitions of this have come to light and it is likely that it is the result of Oliver's first encounter with her. The Berkeley Castle miniature is also *ad vivum* and the largest he ever painted of the Queen. In both he lightens his palette to respond to the new style of dress that she promoted with its abundant use of multicoloured rosettes of ribbon.

Oliver must have been quick to respond to the innovations of Inigo Jones, whose *Masque of Blackness* in 1605 put 'curious painting' in one sense on stage. Oliver's appointment as Anne's limner took place in the same year and the events must have moved in tandem. Jones could present the Queen by a manipulation of light, painted scenery and allegorical costume as a Platonic *idea* made visible to the court in the esoteric revels devised by Ben Jonson. A miniature by Oliver encapsulated this vision in a permanent artefact that would have been looked at in exactly the same way as the masque tableau. Oliver's portrait commemorating Anne's appearance in what may have been her dress for Ben Jonson's *Masque of Beauty* of 1608[67] is the *idea* of Anne as Divine Beauty. In the masque a floating island bearing the Queen and her ladies seeks and finds the island empire of Great Britain to pay homage to its King. And this perhaps explains something else, for the Stuart assumption of the style of King of Great Britain was an assertion of revived ancient empire. Ancient Britain was once part of the antique world, both on account of its foundation by the Trojan Brutus and by its later role as part of the Roman Empire, and as a consequence the revived classical style was correct for it as the whole of Inigo Jones's career illustrates. Hence surely the presentation of Anne *à l'antique* in medallic profile. We are contemplating in this miniature not only a commemorative record of a vanished court production but an image whose thought and sight assumptions are identical with those who devised and presented the masques. In it the *idea* of the archetypal *Imperatrix Britanniae* fuses with her simultaneous manifestation as Beauty come down to earth.

We can round off our study of Oliver and Anne with one other major portrait,[68] which was once dated 1609 and may have been a studio pattern. It is a superb characterization of the by now ageing Queen, detracted from by the unhappy addition of costume and background by a later hand. No finished version is known of this.

There are about a dozen miniatures by Oliver of the Queen. Nearly all seem to be the result of fresh encounters with her (she enjoyed sitting for her portrait) and only in the case of one face-mask do four versions survive.[69] Even then the costume always, as in the case of Hilliard's miniatures of Elizabeth, varies and the jewels, including the familiar letter c for her brother of Denmark, the letter s for her mother Sophia of Mecklenburg and the picture box patterned with table-cut diamonds, are placed in some new arrangement.

By 1609 the focus had shifted from Anne to her son Henry, Prince of Wales, who was to provide Oliver with abundant patronage. Precocious to a degree, he created around himself for three years a court of extreme brilliance that far

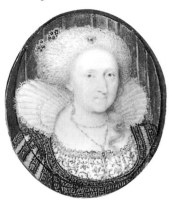

Oliver and Anne of Denmark

Oliver was appointed limner to the new Queen in 1605.

219 The earliest miniature of the Queen, *c.*1604

220 The largest miniature of the Queen, *c.*1605

221 Pattern miniature of the Queen, 1609, completed by a later hand

222 The Queen in masque costume, 1608 or 1611

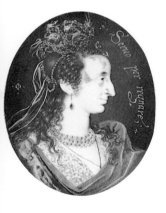

outshone his father's.[70] His patronage of the arts was on a massive scale with vast, never to be fulfilled building projects. His was the first major collection of Renaissance and contemporary pictures ever to be formed in England and the gallery of St James's Palace, with its paintings by members of of the Venetian and Dutch Schools, must have been a revelation to Oliver after years of visual isolation. Oliver fitted naturally into the world of this princely Maecenas whose concern with his public image was even more obsessive than his mother's.

Oliver was quick, no doubt under direction, to respond. The earliest official likeness is one of the Prince *à l'antique*, turned in profile with cuirass and looped cloak silhouetted against a classical shell niche. Three versions are extant, one signed (Fitzwilliam Museum, Cambridge), one autograph (National Portrait Gallery)[71] and a copy by Peter Oliver (Rijksmuseum, Amsterdam). The image directly expresses Inigo Jones's presentation of the Prince in the *Barriers* of 1610, Henry's first public exercise of arms, in which he and his companions appeared before king and court in the guise of the heroes of Ancient Britain and Arthurian romance reborn. Jonson's text refers to him as 'like Mars . . . in his armour clad' and he further alludes to his resemblance to an heroic predecessor, Henry V, 'to whom in face you are so like'.[72] All Henry V's portraits, as they were manufactured for sets of kings and queens in the Jacobean period, are of the same type, depicting the King posed in profile.[73] So the miniature refers not only to the knights of the Britain of antiquity but to those of the intervening Gothic ages. A year later this role was developed further and elaborated in the *Masque of Oberon, the Fairy Prince* and for this the costume designs survive. They all depict Henry *à l'antique*, his head garlanded with laurel. Oliver's profile miniatures of Prince Henry are direct expressions of this programme of political propaganda.

225

The most important of all the miniatures, however, is the large one in the Royal Collection,[74] certainly painted in the last year of Henry's life and the basis for repetitions on a smaller scale. It combines bravura painting with the optical trick, first encountered in Oliver's Fontainebleau style drawing, of the

223

179

Oliver and Henry,
Prince of Wales

Oliver was limner and subsequently painter to Prince Henry from 1610 until his death in 1612.

223 The largest and finest miniature of the Prince, *c.*1612, with an *à l'antique* vision in the background in the vein of the tableaux of Henry and companions in Jonson's *Barriers* (1610) and *Oberon* (1611) (see also colour pl. VII)

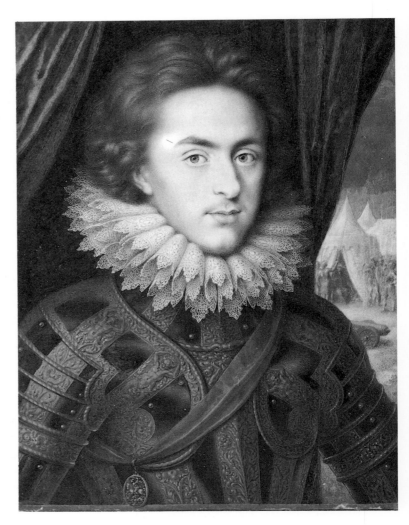

224 The Prince *à l'antique*, *c.*1610–11, a direct reflection of the role he adopted in his court festivals

225 Inigo Jones, *Design for a headdress for the Prince in 'Oberon'*, 1611

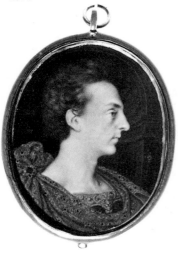

172

badge of the Garter overlapping the enclosing gold frame, and a shimmering pastel-coloured vision of what must again be Ancient British heroes grouped around a warrior seated within a tent. This is a masque-like tableau in which the real sitter has placed himself into his ideal world in an epiphany before the court of the kind that took place annually.

We can round off the relationship of Oliver to the Henrician court with one extraordinary fact which complicates the story. In the Prince's funeral cortège in December 1612 a 'Mr Bilford' walked as his 'limner' and Oliver as his 'painter'.[75] We can enlarge on this. Bilford is described by Thomas Coryate in his *Crudities* (1611) as one of the 'principal gentlemen' attendant upon the virtuoso ambassador, Sir Henry Wotton.[76] Bilford, in fact, was one of his secretaries and his position as miniaturist to the Prince goes back to a wager recorded by John Chamberlain in a letter to Dudley Carleton on 6 November 1611. Ever anxious to report on the doings of 'Signor Fabritio' he writes:

> . . . he hath preferred to the Prince, with asseveration and wagers of three of his choice pictures against three of the prince's horses, that he shall draw or pourtray the Prince better than Isaack the French painter in Blackfriers: but the common opinion is that he must have many graines of allowance to hold waight with Izaake.[77]

The fact that Bilford actually entered the Prince's household means that he must have won, certainly that he painted a miniature of the Prince. Nothing so far has ever emerged that can be associated with Bilford but his existence as limner to the highly sophisticated Henrician court has to be borne in mind.

On Henry's death Oliver immediately entered the orbit of the diminished court that was appointed to serve the sickly Prince Charles and his name duly makes its appearance in the accounts.[78] He was responsible for producing miniatures for presentation but he must by now, judging from their quality, have been making use of his son, Peter. Of the future Charles I, Oliver was to produce only one quite outstanding likeness,[79] without doubt the single most important portrait ever painted of the Prince as a youth. The existence of a finished version in the National Museum, Stockholm, with the head by Oliver and the summarily painted costume probably by Peter,[80] indicates that we are contemplating a studio pattern, an unfinished *ad vivum*. It is painted with a broadness of handling and a solemnity of presentation that argue Oliver's study of the Venetian portraiture which we know was in the collection of Prince Henry. The contrast in the mood of the portraiture of the two brothers is

227

Oliver and Prince Charles

226 *Charles I as Prince of Wales*, c.1615–16. A studio pattern for repetition

227 *Charles I as Prince of Wales*, c.1615–16. A finished version in which the head is by Isaac Oliver and the remainder by his son, Peter

startling. In the case of Henry one senses the aggression of untold ambition and pride. In that of Charles hope has given way to apology.

The 'greate' pictures In Prince Henry's accounts there occurs the following payment: 'for three Pictures 32*l*. one greate Picture 34*l*. three other Pictures 30*l*. one greate and two little pictures 40*l*.'[81] This has been cited as evidence that Oliver painted large-scale oil pictures for the Prince. Unfortunately it is not so easy to draw that conclusion, for the payments occur amidst a long sequence of ones for the acquisition of pictures for his gallery at St James's Palace. They include, for example, one to Filippo Burlamachi for a huge shipment of pictures from Venice. The context, therefore, would favour reading this as evidence that Oliver dealt in pictures.

The problem, however, does not end there for we know from Vertue that oil paintings by Oliver did exist in the collection that descended directly from him. There can be no doubt either that he must have been trained to paint large-scale pictures. The only certain oil paintings by him descended, along with a substantial collection of subject drawings, to the painter Theodore Russell (born 1614) whose son, Anthony, was Vertue's informant. He was, however, often inaccurate. Vertue's description of Oliver's picture of St John the Baptist is worth quoting in full:

> Isaac Oliver the Limner certainly painted in Oyl very well. I have seen a portrait from the Life of a figure representing St. John with a Cross in his hand & a lamb on his lap. the picture painted on board [the Model for this picture was his Servant a gardiner.] the size of a half lenght. the face apeard to be a man of 50 years Old. painted certainly from the Life for the face & hands were tinctur'd with the sun as most Labouring men are. the body of a paler & Clearer colouring. the drapery well folded the Landskip & sky not so well finish'd – the face painted with a pointed pencil, the hair curiously neat the Eys nose & mouth firnly drawn. & the whole head for strength of Colouring, light & shade. of great force highly & perfectly finisht equal I think to any of those Masters of that time of day. the hands well drawn & the whole in a great manner tho' wanting the Sublime. the back seeming by the bulgeing out to be an imperfection in Nature which he has stricktly follow'd . . .[82]

Later he adds: 'this picture I bought'. The second was a Holy Family which he also describes and praises at some length.[83] To these we can add a self-portrait which Vertue records in the same collection in 1716: 'another painting in Oil as big as the life of himself & his own painting'.[84] This follows a reference to a self-portrait miniature which was 'much the best'. These three oil paintings were presumably dispersed in the sale of 1724.

There are some more dubious steps forward from Vertue in respect of Oliver's oil style. He refers to the series of portraits of gentlemen at Wroxton, which he saw in 1741, as being by Oliver, although now they seem to fit neatly into a likely *oeuvre* of Larkin.[85] Vertue describes them as 'savouring of the manner of limning'. The portrait probably of Frances Howard, Countess of Somerset, at Woburn Abbey, now also given to Larkin, was assigned by Vertue to Oliver.[86] We have the problem, however, that there seems to have been a possible connection between Oliver and Larkin, for Lord Herbert records that the miniaturist copied one of Larkin's oil portraits of him for Lady Ayres.[87] Sooner or later one of the subject pictures will probably emerge, particularly as Oliver usually signed, but until then the problem must be held in abeyance.

174

The final years
The fact that we cannot neatly categorize the last decade of Oliver's work reflects exactly the ferment in visual ideas that was taking place during the opening decade of the seventeenth century. From 1610 to 1612 the Prince of Wales presided over a brilliant court which promoted a policy in the arts unmatched since the reign of Henry VIII. Under his aegis the first great collection of Renaissance paintings was formed, the first Renaissance bronzes reached England, Serlio was translated into English, Salomon de Caus, the great hydraulic engineer and theorist, embarked on vast Mannerist garden schemes, Constantino dei Servi, the Florentine architect and painter, began a project to rebuild Richmond in the classical style, while Inigo Jones, as the Prince's surveyor, propagated the new aesthetic and its ideals through the emblematic tableaux he presented annually to the court in the masque. These were years of dynamism which subsided sharply on the Prince's death in November 1612. Oliver's most vibrant miniatures from the Jacobean era date from these years. His early ones in the new reign continued his late Elizabethan manner and those from the last two or three years of his life become niggling and tired. The aesthetic revolution had lost its driving force, which was not to return until after 1620 with any strength. The Renaissance that Henry embodied assimilated the culture of Renaissance Italy and that of Mannerist Prague into a fiercely Protestant ethic. It never alienated the populace as did his brother's aesthetic precocity in which the triumph of 'curious painting' too quickly could be read as the triumph of Roman Catholicism.

Arguably the most surprising miniature of all is his *Madonna and Child in Glory*.[88] It is startling not only in terms of subject-matter but also composition for Jacobean England. Initially it owes its inspiration to Federico Barocci's engraving *The Madonna of the Clouds* but the central portion of the miniature raises something much more disturbing for it presupposes knowledge of Rubens' *Madonna Worshipped by Angels*, completed for the high altar of Santa Maria in Vallicella in Rome in 1609. We have always assumed that Oliver went to Italy only once, in 1596, and that we only know from a chance inscription on the reverse of a miniature. There is, in fact, nothing to preclude a later visit, as Oliver was not of suffficient importance to warrant the granting of a licence to travel beyond seas. A visit to Rome about 1610 would mean that he would have been familiar with all the latest works by the masters of proto-Baroque. A second visit to Italy would certainly explain the astonishing *Madonna and Child in Glory*; it would also place into perspective the two years he laboured upon his largest limning depicting *The Entombment* prior to his death.[89] In addition it would give some background to the puzzling *Head of Christ*[90] which is very difficult even to date. It is unique in Oliver's oeuvre in being executed entirely in chiaroscuro stipple, representing a diametrically opposed technical statement to that of Hilliard. In this instance a specific Italian source cannot be designated, the head being of a generalized north Italian type in the manner of Correggio.

There is a third puzzling subject miniature, a gouache on cambric dated 1615, which again is technically unique, of the head of *Diana*.[91] In this case it is easy to recognize different antecedents going back via Goltzius to Spranger, but what a surprising object and why was it commissioned? Could it be, for instance, a copy of part of a picture in Prince Henry's collection? These three miniatures alone establish that we are dealing with an enormously complicated

228

231

230

232

229

228 *Madonna and Child in Glory, c.*1610–17

229 *Diana*, 1615

231 Federigo Barocci, *Madonna of the Clouds*, 1570

230 Rubens, *Madonna Worshipped by Angels*, 1608 (detail)

232 *Head of Christ*, probably after *c.*1610

Oliver's late subject miniatures

These are a unique phenomenon in the Jacobean period, even providing evidence that Oliver may have returned to Italy c.1609.

177

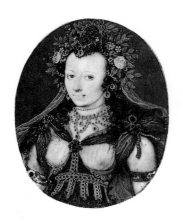 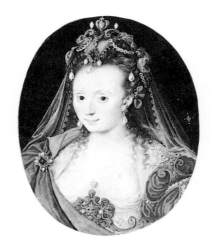 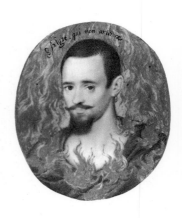

233 *Lady in Masque Costume, c.*1605

234 *Lady Masquer, probably in Jonson's 'Masque of Queens'*, 1609 (see also colour pl. VIII)

235 *Unknown Man amidst the Flames of Passion, c.*1610

artist who was able somehow to keep abreast of developments in painting on the mainland of Europe. Let us now turn to consider in some detail a few of his portrait miniatures during the same period. Less mysterious than the subject ones they too are not devoid of problems and paradoxes.

The masques, as we have already said, must have had a profound effect on Oliver and apart from his masquing portrait of the Queen, there are at least two others which record sitters in allegorical costume. The first[92] is a lady in a dress and mantle of grey, shot with silver, which is gathered under her breasts, exposed beneath transparent fabric, with an elaborate girdle or *cestus* adorned with pearls. Her hair is decorated with pansies and pale pink roses, the flowers of Venus. The dress is of a type worn in all the early court masques as designed by Inigo Jones. The second[93] is later in date, bolder and more monumental in concept, avoiding fussy detail and placing the sitter against a sombre brown background. The most distinctive feature is the sitter's headdress, a scrolled coronet from which a veil falls. Her hair is further adorned with pearls and ultramarine bows, her dress is pink with blue sleeves and scrolling, over which there is looped a green mantle lined with orange. Fantastic headdresses were a major feature of only one masque, *The Masque of Queens* danced on 2 February 1609.[94] The masquers, led by Anne of Denmark, came as twelve heroic queens who had been triumphant in war, something which accords with the bodice cut like a breastplate. All the masquers were dressed differently and there were changes not only in cast but also in costume design and in choice of character. Not all the designs survive, so that the likelihood is that this is one of the queens.

These allusions to the antique recur in a portrait of a man in the vein of an earlier miniature consumed by the flames of his own passion but wearing a mantle looped in the classical manner.[95] It is a style of attire which appears in portraits by Gheeraerts at exactly the same period. During the 1590s the two seemed to be revolutionaries together but in the Jacobean period Gheeraerts slips, his portraiture ceases to be adventurous and eventually ends up as archaic and provincial. In 1614 he painted the full length of Sir John Kennedy at Woburn Abbey.[96] It is a formalized costume piece with an awkward attempt at

178

236 *Unknown Man*, 1614

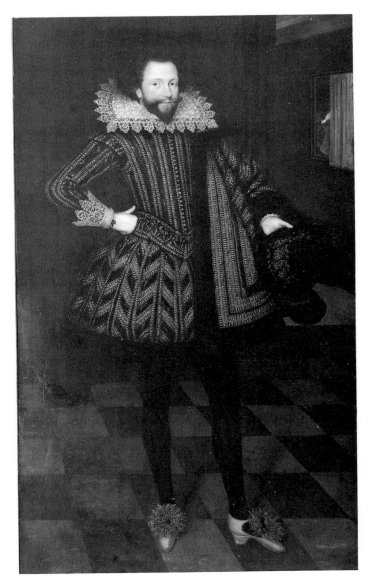

237 Marcus Gheeraerts,
Sir John Kennedy, 1614

238 Elizabeth Harding, *Mrs Oliver*, c.1610–15

239 *John Donne*, 1616

240 *Unknown Lady*, c.1615

Oliver's later cabinet miniatures

241 *Edward Herbert, Lord Herbert of Cherbury*, c.1610–14 (original: 18 × 23 cm). Oliver reverts to the bright colours of Hilliard to present the sitter in his twin aspects as man-at-arms and philosopher.

242 Winged heart emblem from Wither's *Emblemes* (1635)

243 Giulio Campagnola engraving of Kronos in the guise of an antique river god, a possible source for Oliver's miniature of Lord Herbert

a perspective tiled floor and view of a long gallery beyond. Compared with his full-length Essex almost a decade before, this portrait is a step backwards to the Elizabethan icon. In the same year Oliver painted an unknown man[97] dressed in black, his plum cloak wrapped round him like a toga. The contrast with Gheeraerts could not be more marked, for here we step sharply forwards and anticipate in little what was shortly to come in large-scale painting with the arrival of Paul van Somer, Blyenberch and Mytens.

Oliver must have been aware the whole time of developments in painting, particularly in the Low Countries. Nothing confirms this more strongly than the portrait of his wife, Elizabeth Harding.[98] It is quite without precedent in English painting, a bourgeois lady approached very differently from the citizen's wives Oliver painted in the 1590s. No doubt the freedom of painting a member of his own family liberated him as much as did his drawings, for the robust earthy approach to this woman, delineated with none of the softening he would accord a lady of the court, recalls more closely than anything the early work of Frans Hals, which was being executed at precisely this period. And yet in 1616 he was to paint the future Dean of St Paul's, John Donne,[99] in a style which, if it were not for the date on it and the dress, we would assign to the 1590s, utilizing the Hilliard manner with loose brushstrokes and placing the figure against an old-fashioned blue background. And when he was bored with a sitter we get a fussy picture surface in which interpretation of character is replaced by concern with dress.[100]

Can we, however, take these contradictory statements any further, for as we look through Oliver's portrait miniatures we seem in some to leap ahead and then in others suddenly to take steps backwards? A consideration of his late large-scale miniatures might, I think, give an insight into this seemingly erratic output. They open with that of Lord Herbert of Cherbury.[101] The miniature can be dated by the costume to about 1613–14, which would fit the sitter's movements, for Lord Herbert was in England between 1610 and 1614. Painted at the height of an incipient aesthetic revolution it, like the miniature of John Donne, suddenly lurches backwards to the 1590s in the free brushwork and brilliant colouring which are the essence of the Hilliard manner. It is, in fact, far closer to the tilt portraits of Cumberland and Essex. In this sense the miniature is old-fashioned in its approach, lacking in subtlety, a return in short

13
12

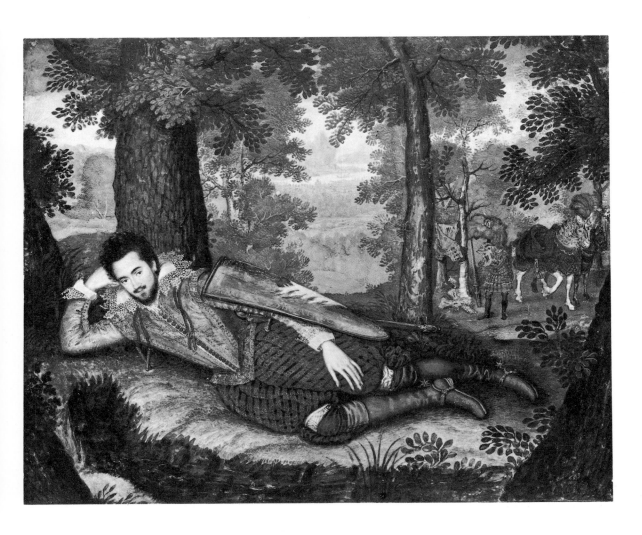

181

Oliver's later cabinet miniatures

244 *Richard Sackville, 3rd Earl of Dorset*, 1616 (original: 23.9 × 15.7 cm). An instance of Oliver responding to the reactionary aesthetic demands of his patron

245 William Larkin's portrait of Dorset, 1613, the work of an artist who epitomized the final phase of the Hilliardesque

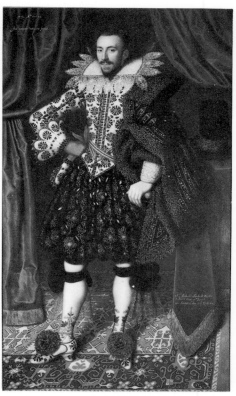

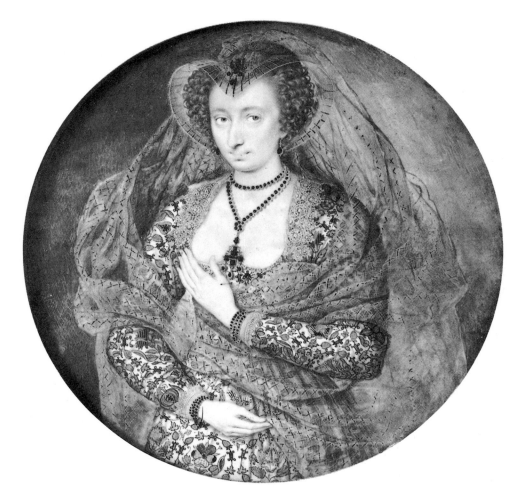

246 *Lucy Harington, Countess of Bedford, c.*1615. In response to the avant garde tastes of the sitter, Oliver reworks the tondo form and monochromatic formula he used for his *Unknown Lady, c.*1595–1600 (pl. 209).

247 Compositional sketch by Oliver, indicating that the miniature was initially conceived as being rectangular

to 'lively colours'. This is all the more strange because the subject-matter ought to have demanded something very different in terms of style. Why is this? It can only surely be traced back to the sitter's expectations. Lord Herbert sustained a life-long interest in his own image which he records in his *Autobiography*. His tastes were conventional. In 1604 he sat to Robert Peake in the robes in which he was created Knight of the Bath.[102] About 1609–10 he sat for that quintessence of the iconic tradition, William Larkin, for the picture now at Charlecote. Copies of this, he states, were procured from Larkin by Richard Sackville, 3rd Earl of Dorset and 'a greater person', presumed to be no less than the Queen. The portrait was also borrowed by Lady Ayres who 'gave it to Mr. Isaac Oliver, the painter of Blackfriars, and desired him to draw it in little after his manner'.[103] One can hardly be surprised, therefore, that Oliver gave his client what he wanted, a romantic Hilliardesque vision.

This must be qualified in that Oliver's handling of the composition is far more successful than Hilliard's comparable attempt, Northumberland. It is conceivable that this formula of the sitter placed like an antique river god might have been suggested by Giulio Campagnola's engraving of Kronos. The miniature is a careful celebration of Lord Herbert as man-at-arms and philosopher. The former is relegated to the background in the figure of the attendant hanging up arms and armour and in the caparisoned horse. The latter is the sitter himself seeking the shade of the greenwood tree with a trickling stream, classic attributes for the Ficinian philosophic melancholic. The linking symbol is the *impresa* on the shield which is a heart rising from flames or wings with smoke and golden sparks ascending upwards and the motto *Magica Sympathia*, referring to the doctrine of sympathetic magic. All *imprese* are open to purely personal interpretation but the allusion is to some sort of ascent. George Wither's *Emblemes* (1635), although later in date, contains a number of flaming heart emblems and one in particular of a winged heart on a book onto which divine rays fall:

> The *Winged-heart*, betokens those *Desires*,
> By which, the *Reasonable-soule*, aspires
> Above the *Creature*; and, attempts to clime,
> To *Mysteries*, and *Knowledge*, more sublime:
> Ev'n to the *Knowledge* of the *Three-in-one*,
> Implyed by the *Tetragrammaton*.
>
> The *Smokings* of this *Heart*, may well declare
> Those *Perturbations*, which within us are,
> Vntill, that Heavenly wisedome, we have gain'd,
> Which is not, here, below, to be attain'd;
> And, after which, those *Hearts*, that are *upright*,
> Enquire with dailie studie, and delight.[104]

This must be close to the general intent of Lord Herbert's miniature in which he casts himself as philosopher, poet, intellectual and man-at-arms. And yet one feels how very different this miniature would have been if Oliver had been allowed to approach the sitter not in terms of 'lively colours' but in those of 'curious painting'.

We can confirm this by a second example in the form of Oliver's final large portrait miniature, that of another Larkin patron, the Earl of Dorset, to whom

we have just referred.[105] No other miniature corresponds so closely with the formalized portraits ascribed to Larkin, whose studio produced a dazzling 245 series of reactionary costume pieces c.1610–15 in which sitters are posed in elaborate attire standing on turkey carpets framed by shiny silk curtains. Dorset himself sat twice for portraits virtually identical in formula to the Oliver miniature. One of these is dated 1613, just three years previous.[106] The miniature, however startling as a feat of virtuosity, is so uncharacteristic of Oliver in its composition and multicoloured tonality that it could only ever have stemmed from the demands of the client. If his clients were still in the world of 'lively colours' this is precisely what he had to give them.

If, however, the patron was a noted collector of 'curious painting' the results could be far different although painted by Oliver virtually simultaneously. Lucy Harington, Countess of Bedford,[107] was a noted patroness of the arts 246–7 from literature through to gardening. She also collected pictures and her passion for seeking out the works of Holbein from the manor houses of England is recorded.[108] No wonder her miniature offers such an amazing contrast to the previous two. It has been dated to c.1605 but the vogue for embroidered bodices and billowing veils can be traced in portraits dated 1614 and 1615. In this Oliver has returned to the adventurous *tondo* form and if this miniature had survived without the severe damage to its background that it has sustained it would probably have eclipsed its late Elizabethan predecessor. The portrait is all subtlety of colour, the embroidered dress muted, the billowing veil an excuse for virtuoso monochromatic chiaroscuro to enhance the Countess who emerges from the half light. Oliver must have been at his happiest working with a sitter of this kind who was in the vanguard of all that was avant garde in the world of the arts of Jacobean England.

Oliver in retrospect In the last chapter I suggested that a truer epitaph for Oliver was as Britain's first Renaissance painter. In the history of the visual arts of that country he is the embodiment of that revolution; a painter of genius at his best, we watch him in his art responding as the pressures change. His tragedy lies in the fact that he came too early. So much of his career and his abilities were in a sense wasted as he came to terms with making a living in the backwaters of Elizabethan London. Oliver now emerges as by far the greatest painter to work in England between Holbein and Van Dyck. He is the first painter that we actually know executed drawings as works of art in their own right and who drew from the nude model. Everything that we can deduce seems to indicate that this mysterious figure must have been a man of some intellect and learning and yet, when the poets were fishing around for an English Michelangelo, the laurels were always accorded not to Oliver but Hilliard. The clue to this lies surely in the fact that he was always 'françois'. Even in 1611 Chamberlain still refers to him as the 'French painter'. This must mean that he was never thought of as being British. To the day he died the English regarded Isaac Oliver as a foreigner. Ironically it was to a foreign connoisseur of the type of Constantine Huygens that he was 'Oliverus, Britannus celeberrimus'.[109]

NEW BRANCHES: *Laurence Hilliard and Peter Oliver*

Oliver died in 1617 and Hilliard two years later. The years around 1620 should be regarded as a watershed in the history of the arts in Britain. In 1619 the Thirty Years War broke out in Germany, and England entered the period of absolutist rule that was to end in the destruction of Caroline civilization in the Civil War. The disastrous Spanish match was the turning-point in more ways than one, for it once again quickened the aesthetic pulse of the Crown under the direction of the younger generation in the form of the Prince of Wales and James's last favourite, Buckingham. The vitality in the visual arts typical of the years 1610 to 1612 returned in a highly significant series of events: Inigo Jones's Whitehall Banqueting House; the commission to Rubens to paint its ceiling; the arrival of Van Somer and Mytens and the first visit of Van Dyck; the establishment of the Mortlake tapestry workshops and the coming of the garden designer and hydraulic engineer, Isaac de Caus. The pattern of Caroline civilization was fast taking shape during the last years of the old King's reign.

Limning is a family tree, father to son, master to pupil. The tree extended its branches upwards well into the new century by means of two sons. In the case of the first, Nicholas Hilliard's son, Laurence, we come to a dead end.[1] Laurence was the miniaturist's fourth son and the only one to inherit a fragment of his father's talent; but fragment is the operative word. He was born in 1582 and entered his father's workshop about 1597 in the same manner as Lockey, by way of apprenticeship via the Goldsmiths' Company. In 1605 he became a freeman and three years later he received the office of 'his Majesty's limner' in reversion, granted in anticipation of him succeeding his father. Far less gifted than Lockey, he must have begun his life assisting his father in producing some of the endless repetitions of portraits of members of the royal family. After Nicholas's death he succeeded him as royal limner and indeed in 1624 was paid for executing four miniatures. In my view the final portrait type of James I, usually assigned to Nicholas, is solely by Laurence. The surviving examples are all of depressing quality and mechanical in feeling – the withering of a tradition in the hands of the talentless. Laurence could never survive the accession of the aesthete Charles I whose patronage was promptly bestowed on Peter Oliver and John Hoskins. There is, however, no lack of miniatures that must be by Laurence in addition to the signed ones. They record a descent in ability, and the clientèle is not of the court but of middle-range gentry and the legal profession. It would be a thankless task even to list them, so feeble a draughtsman was he. A solitary signed portrait of Charles I shows him trying to come to grips with 'curious painting' in the wake of the revolution of Van

Dyck but it is a smudgy failure. Until the time of his death, a year or so before the execution of the King, Laurence was to remain an exponent of 'lively colours'.

In sharp contrast Isaac Oliver's son, Peter, whose life was to run parallel to that of Laurence Hilliard, was to be taken up by the Caroline court and to spend the 1630s producing miniature copies, at the behest of the King, of the glories of the Whitehall collection.[2] He too began his career in the studio of his father, whose stipple technique he inherited; his early work consisted of assisting his father in painting the costume in royal miniatures or in copying. But when we touch on Peter Oliver we are in most senses in contact with a beginning. His shadow stipple style in the 1620s obliterated the linear formalism of the Hilliard tradition. That obliteration was accelerated by another brilliant young artist, John Hoskins.[3] The two families seem to have been connected and although we know nothing certain about Hoskins' training he could have passed a period alongside Peter Oliver in Isaac's studio. Hoskins was the uncle and teacher of both Samuel and Alexander Cooper and with them we are well into the reign of Charles II and the Baroque age.

But the years around 1620 are a turning-point in another sense. Specialization sets in. Although John Hoskins may have begun his life as a painter of oil portraits, once he became a miniaturist he remained one. And this is the great dividing line between the limners of the Tudor and Jacobean era and the miniaturists of the Stuart and Georgian age. In this study of the limners I have tried to remove the distorting glass of later ages which has led us to think of Hilliard or Oliver in much the same way as Cooper or Cosway. We never should. The career of Isaac Oliver offers the first indication that specialization was developing, but that was only because there was no demand for his abilities as a painter in oil of history or as a draughtsman. The arrival of specialization coincides too with something else, the recognition of painting as a liberal as against a mechanical art. This had important sociological repercussions as artists assumed the mantle of learning and gentility. By the 1630s it affected the scope of their work, because for an artist who cherished his status in society, to paint hatchments or colour tombs or produce *imprese* for the tilt would have been regarded as a demeaning activity.

But to the limners of the Tudor and Jacobean periods this distinction in terms of work did not exist. All the limners we have studied still belonged – all perhaps, that is, except Oliver – to that vigorous tradition of the medieval and Renaissance workshop whose members expected to cope with a commission to depict or design anything that came their way. Our failure to come to terms with this has seriously affected our capacity to evaluate the art of sixteenth-century England. The limners have been victims over the succeeding centuries first of antiquarians, then of collectors and connoisseurs, and now, in our own age, of the rigid divisions that hive off those who study title-pages from those who study panel painting, those who study tomb sculpture from those who study jewellery and plate, those who write of court pageantry and spectacle from those who catalogue engravings. What I have tried to do in this book is to reverse that view by attempting to recreate the *whole* work of the limners, however speculative at times this may be. And yet always at the heart of it all remains the limning tradition, that noble tree which was England's supreme contribution in the field of painting to the European Renaissance. As an art

form it was the perfect expression of the Tudor and Jacobean establishment. That it was viewed at the time as something remarkable, Hilliard leaves us in no doubt:

> And yet it excelleth all other painting whatsoever in sundry points, in giving the true lustre to pearl and precious stone, and worketh the metals gold or silver with themselves, which enricheth and ennobleth the work that it seemeth to be the thing itself, even the work of God and not of man: being fittest for the decking of prince's books, or to put in jewels of gold, and for the imitation of the purest flowers and most beautiful creatures in the finest and purest colours which are chargeable; and is for the service of noble persons very meet, in small volumes, in private manner, for them to have the portraits and pictures of themselves, their peers, or any other foreign persons which are of interest to them.[4]

How typical of sixteenth-century England that an art form, one of whose prime purposes had been to adorn the missals and service books of the pre-Reformation Tudor court, should live on to provide the new images that promoted the cult of the post-Reformation monarchy and the triumph of the Protestant ruling classes.

A checklist of miniatures attributed to Lucas Hornebolte

The following miniatures, except nos 15 and 23, have all been subject to technical analysis and examination through intense magnification in the Victoria & Albert Museum's Conservation Department by Mr V. J. Murrell and myself.

1 *Henry VIII* (Fitzwilliam Museum, Cambridge), 1525–6 (ill. 14). First attributed to Hornebolte by T. H. Colding in 1953. It gives the King's age as thirty-five. *Artists of the Tudor Court* (5).

2 *Henry VIII* (HM The Queen, The Royal Collection), 1525–6. A repetition with variant costume of no. 1, first attributed in 1978. Size and inscription suggest that no. 8 could be the pendant.

3 *Henry VIII* (Duke of Buccleuch), 1525–6. A repetition with variant costume of no. 1, also giving the King's age as thirty-five. *Artists of the Tudor Court* (7).

4 *Henry VIII* (HM The Queen, The Royal Collection), 1525–6 (ill. 16). This also gives the King's age as thirty-five but depicts him with a beard, indicating that this miniature is the result of a second sitting.

5 *Katherine of Aragon* (Duke of Buccleuch), *c.* 1525–6 (ill. 15). Undated, but it and the others of Katherine cannot be later than 1529, when she last appeared publicly with the King. They should be the same date, *c.* 1525–6, as those of the King. *Artists of the Tudor Court* (6).

6 *Katherine of Aragon* (Duke of Buccleuch), *c.* 1525–6. See no. 5. A head and shoulders repetition with variant dress of no. 5. Probably a pendant to one of the King.

7 *Katherine of Aragon* (E. Grosvenor Paine Collection), *c.* 1525–6. A repetition virtually identical with no. 6.

8 *Katherine of Aragon* (National Portrait Gallery [4862]), *c.* 1525–6 (ill. 17). Probably a repetition, the inscription presupposes it to be a pendant of one of the King, possibly no. 2. *Artists of the Tudor Court* (8).

9 *Mary I as a Princess* (Private Collection, England), *c.* 1525–9 (ill. 21). The severe restoration of the face makes it difficult to establish whether it is from life. She wears a large jewel with an inscription in English, *Emp[er]our*, referring to Charles V. *Artists of the Tudor Court* (9).

10 *The Emperor Charles V* (Victoria & Albert Museum [P.22–1942]), *c.* 1525–30. A reduced copy of part of a portrait of Charles V in the collection of Henry VIII and still in the Royal Collection. It would be unlikely that this was painted after *c.* 1529, when the Divorce proceedings clouded the relationship of Henry VIII and Charles V. *Artists of the Tudor Court* (11).

11 *?Charles Brandon, Duke of Suffolk* (Louis de Wet Esq.), *c.* 1530 (ill. 20). The condition of this and no. 12 precludes establishing which is the prime version. Formerly called Buckingham, consideration should be given to whether it could be a portrait of Henry VIII's brother-in-law, Charles Brandon, Duke of Suffolk (died 1545) before he grew a beard (Strong, *Tudor and Jacobean Portraits*, 1969, II, pls 604–5). *Artists of the Tudor Court* (10).

12 *?Charles Brandon, Duke of Suffolk* (Private Collection, South Africa), *c.* 1530. See no. 11. First attributed by Reynolds in 1968. This is minus the inscription and was formerly wrongly called the Earl of Essex.

13 *Henry VIII* (Collection V. de S., The Netherlands), *c.* 1530. One of a pair (see no. 14)

depicting the King noticeably older. The fact that the pendant is of Margaret Beaufort, the King's grandmother, could indicate that they were painted between the initiation of the divorce proceedings and 1533, when Anne Boleyn became Queen. *Artists of the Tudor Court* (12).

14 *Margaret Beaufort, Countess of Richmond and Derby* (Collection V. de S., The Netherlands), *c.* 1530. Pendant to no. 13 and derived from the standard portrait of the Countess (Strong, *Tudor and Jacobean Portraits*, 1969, II, pls 34–6). *Artists of the Tudor Court* (13).

15 *?Anne Boleyn* (Royal Ontario Museum, Toronto) *c.* 1532–3 (ill. 22). First attributed by Reynolds. The fact that there are two versions indicates that this should depict a queen and both have been called up until now Jane Seymour. This identity is one that cannot be sustained on the evidence of features and the colour of the eyes, which are brown instead of grey-blue. There is a case for this being a portrait of Jane's predecessor, Anne Boleyn, whose brown eyes and features are otherwise known only through crude workshop versions after a lost portrait of her wearing a French as against a Spanish hood (Strong, *Tudor and Jacobean Portraits*, 1969, II, pls 8–9). The age given is twenty-five, which Anne would have been in 1532–3.

16 *?Anne Boleyn* (Duke of Buccleuch), *c.* 1532–3. No direct comparison with no. 15 has been achieved, but the lively quality of this version would indicate that it has the claim for primacy. *Artists of the Tudor Court* (14).

17 *Henry FitzRoy, Duke of Richmond* (HM The Queen, The Royal Collection), *c.* 1534–5 (ill. 26). First attributed by Reynolds. The date is reached

by the sitter's age of fifteeen. The dress, which is a nightcap and shirt, would indicate that it was painted while the sitter was in bed during one of his frequent illnesses. He in fact died in 1536. *Artists of the Tudor Court* (15).

18 *Henry VIII* (Private Collection), *c.* 1537 (ill. 23). See above, p. 38 for a discussion of this miniature, which shows the heavy influence of Holbein's portrait of the King in the Thyssen Collection. *Artists of the Tudor Court* (16).

19 *Jane Seymour* (Lady Ashcombe, Sudeley Castle), *c.* 1536–7 (ill. 25). The damage to the features make it impossible to conclude whether this is from life. She has the grey-blue eyes and features that appear in the Holbein portraits and there is a contemporary or near-contemporary inscription identifying it as her on the reverse. *Artists of the Tudor Court* (17).

20 *Edward VI as Prince of Wales* (Duke of Buccleuch), *c.* 1541–2 (ill. 27). Formerly circular, this has been trimmed to an oval shape. It certainly seems to be from life and as a portrait of the young Prince falls between Holbein's portrait depicting him at just over two years of age and a drawing, not unanimously accepted as by Holbein, of about 1542 (Strong, *Tudor and Jacobean Portraits*, 1969, I, pp. 91–2). *Artists of the Tudor Court* (18).

21 *?Catherine Parr* (E. Grosvenor Paine Collection), *c.* 1543–4 (ill. 28). The costume is of the 1540s and it is conceivable that this is a portrait of Catherine Parr (cf. Strong, *Tudor and Jacobean Portraits*, 1969, II, pl. 690).

22 *Thomas Seymour, Lord Seymour of Sudeley* (Collection

of HRH Princess Juliana of the Netherlands), *c.* 1540–44. The identity of the sitter is established by oil paintings of the same type (Strong, *Tudor and Jacobean Portraits*, 1969, II, pl. 684). A second version of this miniature, now untraceable, was in the Buccleuch Collection (H. A. Kennedy, *Early English Portrait Miniatures in the Collection of the Duke of Buccleuch*, ed. C. Holmes, The Studio, 1917, pl. VIII).

23 *Hans Holbein* (Wallace Collection), 1543. First attributed by Reynolds (catalogue of the miniatures in the Wallace Collection, London, 1980, pp. 33–9). V. J. Murrell points out that this is a miniature by a right-handed artist copying a portrait of a left-handed artist, as he would have seen himself in a mirror. The date is the year of Holbein's death. *Artists of the Tudor Court* (V).

Notes

Since the original edition of this book the following publications have appeared and should be taken into account:

Bentley-Cranch, D. 'Quelques additions à l'oeuvre de Nicholas Hilliard', *Gazette des Beaux-Arts*, CII, October 1983, pp. 129–33

Cordellier, Dominique 'La mise au tombeau d'Isaac Oliver', *Revue du Louvre et des Musées de France*, XXXIII, 3, 1983, pp. 178–87

Edmond, Mary *Hilliard and Oliver. The lives and works of two great miniaturists*, London, 1983

Finsten, Jill *Isaac Oliver*, Garland Publication, 1981

Murrell, Jim *The Way Howe to Lymne. Tudor Miniatures Observed*, Victoria & Albert Museum, 1983

ABBREVIATIONS

Artists of the Tudor Court Roy Strong, *Artists of the Tudor Court. The Portrait Miniature Re-discovered, 1520–1620*, Victoria & Albert Museum Exhibition Catalogue, 1983.

Auerbach, *Hilliard* Erna Auerbach, *Nicholas Hilliard*, London, 1961.

Auerbach, *Tudor Artists* Erna Auerbach, *Tudor Artists*, University of London, 1954.

Croft-Murray and Hulton, *British Drawings* Edward Croft-Murray and Paul Hulton, *Catalogue of British Drawings*, I, *XVI and XVII Centuries*, British Museum, 1960.

Cult Roy Strong, *The Cult of Elizabeth. Elizabethan Portraiture and Pageantry*, London, 1977.

Edmond, *Limners* Mary Edmond, 'Limners and Picturemakers', *Walpole Society*, XLVII, 1980, pp. 60–242.

Elizabeth Roy Strong, *Portraits of Queen Elizabeth I*, Oxford, 1963.

Goulding, *Welbeck* Richard W. Goulding, 'The Welbeck Miniatures belonging to His Grace the Duke of Portland', *Walpole Society*, IV, 1916.

Hilliard, *Treatise* *A Treatise Concerning the Arte of Limning by Nicholas Hilliard . . .*, ed. R. K. R. Thornton and T. G. S. Cain, Carcanet New Press, 1981.

Hind, *Engraving*, I Arthur M. Hind, *Engraving in England in the Sixteenth and Seventeenth Centuries*, I, *The Tudors*, Cambridge University Press, 1952.

Hind, *Engraving*, II Arthur M. Hind, *Engraving in England in the Sixteenth and Seventeenth Centuries*, II, *The Reign of James I*, Cambridge University Press, 1955.

Icon Roy Strong, *The English Icon. Elizabethan and Jacobean Portraiture*, London, 1969.

McKerrow and Ferguson, *Title-page Borders* R. B. McKerrow and F. S. Ferguson, *Title-page Borders used in England and Scotland 1485–1640*, Bibliographical Society, Oxford University Press, 1932 (for 1931).

Norgate, *Miniatura* Edward Norgate, *Miniatura or the Art of Limning*, ed. Martin Hardie, Oxford, 1918.

Tudor and Jacobean Roy Strong, *Tudor and Jacobean Portraits*, National Portrait Gallery Catalogue, HMSO, 1969.

I The tree of limning

1 *Miniatura*, p. 3. On Norgate see also Mansfield Kirby Talley, *Portrait Painting in England: Studies in the Technical Literature before 1700*, Paul Mellon Centre for Studies in British Art, 1981, pp. 156–70.

2 *Miniatura*, pp. 11, 15, 20, 40.

3 On which see V. J. Murrell, in *The English Miniature*, Yale U.P., 1981, pp. 1–14; the same author in *Artists of the Tudor Court*, introduction, II, 'The Art of Limning'.

4 *Miniatura*, *op.cit.*, p. 39.

5 Patrick J. Noon, *English Portrait Drawings & Miniatures*, Yale Center for British Art, New Haven, 1979 (2).

6 *Artists of the Tudor Court* (II).

7 *Ibid.* (152).

8 Thomas Fuller, *The Worthies of England*, ed. John Freeman, London, 1952, p. 60.

II Science and experience: Lucas Hornebolte

1 See Gordon Kipling, *The Triumph of Honour*.

Burgundian Origins of the Elizabethan Renaissance, Sir Thomas Browne Institute, University of Leiden, 1977.

2 See Pamela Tudor-Craig, *Richard III*, National Portrait Gallery Exhibition Catalogue, 1973, pl. 44 (P.9).

3 Kipling, *Triumph of Honour*, pp. 31–40, 42–8.

4 Otto Pächt, *The Master of Mary of Burgundy*, London, 1948.

5 *Garland of Laurel*, ll. 1156–68.

6 J. B. Trapp and H. S. Herbrüggen, *The King's Good Servant. Sir Thomas More*, National Portrait Gallery

Exhibition Catalogue, 1977–8, p. 35 (38); J. B. Trapp. 'Pieter Meghen 1466/7–1540: scribe and courier', in *Erasmus in English*, University of Toronto Press, II, 1981–2, pp. 28–35.

7 J. M. Fletcher, 'A Group of English Royal Portraits painted soon after 1513. A Dendrochronological Study', *Studies in Conservation*, 21, 1976, pp. 171–6; John Fletcher, 'Tree Ring Dates for Some Panel Paintings in England', *Burlington Magazine*, CXVI, 1974, pp. 250–58; John Fletcher, 'Tree-Ring Dating of Tudor Portraits', *Proc. of the Royal Institution of Great Britain*, 52, 1980, pp. 81–104.

8 *Tudor and Jacobean*, I, pp. 149–50.

9 Kipling, *Triumph of Honour*, p. 59.

10 On Maynard see *ibid.*, pp. 52–66. Kipling provides the vital documentation but his treatment of the actual pictures cannot be accepted.

11 Fletcher, 'A Group of English Royal Portraits . . .', *op.cit.*; same author's 'Tree Ring Dates . . .', p. 256.

12 For the French preoccupation with portraiture subsequent to Francis I's accession see L. Dimier, *French Painting in the Sixteenth Century*, London, 1904, pp. 26 ff.; A. Blunt, *Art and Architecture in France 1500–1700*, London, 1957 edn, pp. 33–5; *Les Clouet et la Cour des Rois de France*, Bibliothèque Nationale, Paris, 1970, pp. 17–20; Peter Mellen, *Jean Clouet*, London, 1971.

13 For example by John Pope-Hennessy, *A Lecture on Nicholas Hilliard*, London, 1949, pp. 12–13; for the most recent assessment see Mellen, *Jean Clouet*, pp. 37–42.

14 G. Lebel, 'British–French Artistic Relations', *Gazette des Beaux-Arts*, I, 1948. pp. 272–3.

15 Mellen, *Jean Clouet*, p. 234 (135)

16 On Brown and Volpe see: Auerbach, *Tudor Artists*, pp. 7–8, 12–13, 149, 190; E. Croft-Murray, *Decorative Painting in England 1537–1830*, London, 1962, I, pp. 156–7, 166; Sydney Anglo, *Spectacle, Pageantry and Early Tudor Policy*, Oxford, 1969, pp. 164–5, 200, 214, 216, 231, 262 for Brown; 212, 214, 216, 231 for Volpe.

17 *Letters and Papers of Henry VIII*, IV, pt ii, 3169.

18 By far the most important

article on the Hornboltes is Hugh Paget, 'Gerard and Lucas Hornebolt in England', *Burlington Magazine*, CI, 1959, pp. 396–402. See also T. H. Colding, *Aspects of Miniature Painting*, Copenhagen, 1953, pp. 58–65; Auerbach, *Tudor Artists*, pp. 41–6, 50–51; Graham Reynolds in *The Connoisseur's Complete Period Guides*, ed. R. Edwards and L. G. G. Ramsay, London, 1968, pp. 190–91; Auerbach, *Hilliard*, pp. 49–51; Roy Strong in *The English Miniature*, Yale University Press, 1981, pp. 29–33.

19 Paget, 'Gerard and Lucas Hornebolt in England', *op.cit.*

20 On the Epistle and Lectionary see E. Auerbach, 'Notes on Flemish Miniaturists in England', *Burlington Magazine*, XCVI, 1954, p. 52; Trapp and Herbrüggen, *Sir Thomas More*, p. 47 (33).

21 On the patents see Auerbach, 'Notes on Flemish Miniatures in England', p. 52; Auerbach, *Tudor Artists*, pp. 42–3.

22 On the Islip Roll see *Vetusta Monumenta*, VII, pt IV; for the attribution by O. Pächt see *Holbein and Other Masters*, Royal Academy, 1950 (625).

23 Paget, 'Gerard and Lucas Hornebolt in England'.

24 Quoted Auerbach, *Tudor Artists*, p. 50.

25 Giorgio Vasari, *Lives of the Most Eminent Painters, Sculptors and Architects*, trans. G. du C. de Vere, London, 1912–15, IX, pp. 268–69.

26 Bodleian MS Tanner 464.IV., f. 58: *scriptiones ornamentorum quae/lucas Regis pictor delineauit./Insignia henrici oct; Regis Angli:/Insignia Joanna Reginae*. Leland's poems were published by Thomas Newton in 1589 and include this one omitting, however, the reference to Lucas: *Principum, Ac illustrium aliquot & eruditorum in Anglia visorum . . . A Joanne Lelando Antiquario conscripta . . .*, London, 1589, p. 103. See also L. Bradner, 'Some unpublished poems by John Leland', *PMLA*, LXXI, 1956, pp. 827–36. I am indebted to Mr Steven Tomlinson for the last two references.

27 Quoted A. B. Chamberlain, *Hans Holbein the Younger*, London, 1913, II, p. 217.

28 See Appendix.

29 On the cabinet miniature see Colding, *Aspects of Miniature Painting*, pp. 55 ff.

30 O. Millar, *Walpole Society*, XXXVII, 1960, pp. 109 (24, 26, 27), 110 (6, 7), 114 (45, 46, 47), 115 (48); *Artists of the Tudor Court* (7).

31 *Artists of the Tudor Court* (8).

32 *Ibid.* (6).

33 *Jan Gossaert genaamd Mabuse*, Catalogue by Pauwet, H. R. Hoetink and S. Herzog, Museum Boymans-van Beuningen and Groeningemuseum, Bruges, 1965, pp. 137–8 (19).

34 *Artists of the Tudor Court* (9).

35 *Ibid.* (14).

36 *Ibid.* (15).

37 *Ibid.* (16).

38 Roy Strong, *Holbein and Henry VIII*, London, 1967, pp. 37–41.

39 *Artists of the Tudor Court* (17).

40 *Ibid.* (18).

41 PRO E 351/340, f.23.

42 *Tudor and Jacobean*, I, p. 20.

43 *Icon*, p. 171 (115).

44 Quoted Auerbach, *Tudor Artists*, p. 69.

45 For illuminations of this type see Auerbach, *Tudor Artists*, pls 17, 23 (a–b).

46 Hind, *Engraving*, I, p. 4; McKerrow and Ferguson, *Title-page Borders*, p. 47 (45).

47 On the Great Seal see A. Wyon, *The Great Seals of England*, London, 1887, pp. 69–71. The payments are all to goldsmiths for making: PRO E 315/251, f.87v: '. . . to the said Morgan [Wolff] for makinge workmanship and gravinge of the greate seale of Englond xldi xs'.

48 E. Auerbach, 'The Black Book of the Garter', *Report of the Society of the Friends of St. George's and Descendants of the Knights of the Garter*, V. no. 4, 1973, pp. 149–53. I am indebted to Dr Pamela Tudor-Craig for this reference.

49 *Letters and Papers of Henry VIII*, pt ii, 1280, f.55b.

50 Tudor-Craig, *Richard III*, pp. 81 (P.5), 87 (P. 22). C. K. Adams was the first to begin to assemble this group.

51 The group from the Cast Shadow Workshop is as follows: Henry VI (*Tudor and Jacobean*, I, p. 146 [2457]); Edward IV (*ibid.*, p. 86 [3542] with a second version); Henry VIII (*ibid.*, p. 159, Type VI with five versions listed; I would now date these to the

early 1530s); Edward VI (*ibid.*, p. 92, Type C with three versions; I would now date these closer to 1540); Henry V (R. Heber-Percy, Faringdon House) and Jane Seymour (Society of Antiquaries, London). *Artists of the Tudor Court* (23).
52 *Ibid.*, I, pp. 272–3 (2607): Tudor-Craig, *Richard III*, p. 81 (P.5); *Artists of the Tudor Court* (24).
53 For documentation see Hugh Paget, 'Gerard and Lucas Hornebolt in England', p. 401, note 11.
54 Auerbach, *Tudor Artists*, p. 67, pl. 22.

III Holbein's manner of limning

1 I cite here only the literature which makes any serious contribution to the study of miniatures by Holbein: Arthur B. Chamberlain, *Hans Holbein the Younger*, London, 1913, II, pp. 217–42; Paul Ganz, *The Paintings of Hans Holbein*, London, 1950, pp. 258–60; Graham Reynolds, *English Portrait Miniatures*, London, 1952, pp. 3–7; T. H. Colding, *Aspects of Miniature Painting*, Copenhagen, 1953, pp. 79–81; Graham Reynolds, *The Connoisseur's Complete Period Guides*, ed. R. Edwards and L. G. G. Ramsay, London, 1968, pp. 191–225; Roy Strong in *The English Miniature*, Yale University Press, 1981, pp. 33–41.
2 Ganz, *Holbein*, p. 258 (137); *Tudor and Jacobean*, I, p. 114.
3 *Artists of the Tudor Court* (25).
4 Ganz, *Holbein*, p. 259 (138).
5 *Artists of the Tudor Court* (28).
6 *Ibid.* (27).
7 *Ibid.* (29).
8 *Ibid.* (31).
9 *Ibid.* (30).
10 *Ibid.* (33).
11 Chamberlain, *Holbein*, II, pp. 193–4; Ganz, *Holbein*, p. 259 (142).
12 Ganz, *Holbein*, p. 260 (147).
13 *Artists of the Tudor Court* (34).
14 *Ibid.* (35).
15 *Ibid.* (36).
16 Peder Mellen, *Jean Clouet*, London, 1971, p. 29.
17 V. J. Murrell points out that all these copies are ones of

a left-handed painter as he would have seen himself in a mirror. Reynolds suggests that the version in the Wallace Collection is by Hornebolte: G. Reynolds, *Catalogue of the Miniatures in the Wallace Collection*, London, 1980, pp. 33–9.
18 Hilliard, *Treatise*, p. 69.

IV Gentlewoman to the Queen: Levina Teerlinc

1 Auerbach, *Tudor Artists*, p. 187.
2 For previous literature on Levina Teerlinc see *ibid.*, pp. 75–7, 91, 103–6, 187–8; Roy Strong in *The English Miniature*, Yale U.P., 1981, pp. 41–5.
3 Paul Durrieu, 'Alexandre Bening et les Peintres du Bréviaire Grimani', *Gazette des Beaux-Arts*, V, Paris, 1891, pp. 353–67; VI, 1891, pp. 55–69.
4 Auerbach, *Tudor Artists*, p. 104.
5 *Ibid.*, pp. 75–6.
6 *Icon*, p. 49.
7 *Tudor Artists*, p. 188.
8 The sources are as follows: 1559: John Lylands Library, Manchester, English MS no. 117; 1562: British Library, Harleian Roll, V.18, printed, John Nichols, *Progresses of Queen Elizabeth*, London, 1824 edn, I, p. 112; 1563: PRO, Chan. Misc. 3/38; 1564: Folger Shakespeare Library, MS Z.d.12; 1565: *ibid.*, Z.d.13; 1567: British Library, Additional MS 9772; 1568: Society of Antiquaries of London MS 538; 1575: Folger Shakespeare Library MS Z.d.14; 1576: British Library, Additional MS 4827.
9 Richard Haydocke, *A Tracte containinge the Artes of curious Paintinge Caruinge & Buildinge*, Oxford, 1598, p. 126.
10 On Shute see: Auerbach, *Tudor Artists*, pp. 185–6; John Summerson, *Architecture in Britain 1530 to 1830*, London, 1953, pp. 17, 22–3.
11 On Bettes see: Auerbach, *Tudor Artists*, pp. 153–4; Edmond, *Limners*, p. 67; *Icon*, pp. 65–8.
12 PRO E 314/22.
13 *Vertue Notebooks*, V, *Walpole Society*, XXVI, 1938, p. 72. It was, according to the *DNB*, in the Bodleian Library, Oxford, but is now untraceable.
14 Information from Mr J. A. Brister.

15 *Artists of the Tudor Court* (42).
16 *Ibid.* (40).
17 V & A (P.21–1954), rep. Auerbach, *Hilliard*, pl. 4.
18 *Artists of the Tudor Court* (37).
19 *Ibid.* (47).
20 Oliver Millar, 'A Collection of Miniatures', *Apollo*, CV, 1977, p. 434.
21 Possible Teerlinc miniatures are (i) Edward VI (Duke of Buccleuch [15/6]), although the face has been entirely repainted; (ii) Catherine Willoughby, Duchess of Suffolk (Earl of Ancaster), which has an added Holbein signature; (iii) Catherine Grey, Countess of Hertford (Duke of Rutland, Belvoir Castle), rep. Auerbach, *Hilliard*, pl. 8; (iv) Elizabeth I (Royal Collection [16]), which has a later inscription added by Hilliard, rep. *The English Miniature, op.cit.*, pl. 59.
23 See Paul Durrieu, 'Alexandre Bening et les Peintres du Bréviaire Grimani', *op.cit.*; F. Winkler, *Die Flamische Buchmalerei des 15 und 16 Jahrhunderts*, Leipzig, 1925.
24 *Certain prayers to be used by the quenes heignes in the consecration of the crampe rynges.* See E. Auerbach, 'Some Tudor Portraits at the Royal Academy', *Burlington Magazine*, XCIX, 1957, p. 13. It was first exhibited in *British Portraits*, Royal Academy, 1956 (598); *Artists of the Tudor Court* (39).
25 E. Croft-Murray, *Decorative Painting in England 1537–1837*, London, 1962, I, p. 165, pls 17–19.
26 Hind, *Engraving*, I, pp. 55–6.
27 E. Auerbach, 'An Elizabethan Indenture', *Burlington Magazine*, CXII, 1951, pp. 319–23.
28 E.g. Auerbach, *Tudor Artists*, pp. 119 ff.; pls 35 (a) (d), 36, 37, 39.
29 A. Wyon, *The Great Seals*, London, 1887, pp. 73–7, pls XX, XXII. Payment for Edward VI's: PRO E 351/2077: 'to the same Henry [Coldwell] for new making the greate seale of England and for mending of others xlvjli xixs xd'; for Mary: PRO E 405/484, f.71v: 'To Dericke Anthony graver of the mynt for the gravinge and making of the great seale of England and for the silver that made the same . . . 83li xvs'.

30 *Ibid.*, pp. 72–3, pl. XX.
31 *Elizabeth*, p. 119 (W.2).
32 *Ibid.*, p. 120 (W.6).
33 *Ibid.*, p. 122 (W.9–12).

V Lively colours: Nicholas Hilliard

1 Apart from the articles which appear in the footnotes the main studies of Hilliard are: Carl Winter, *Elizabethan Miniatures*, London, 1943; Graham Reynolds, *Nicholas Hilliard and Isaac Oliver*, Victoria & Albert Museum Exhibition, 1947, pp. 7–10, 13–15; John Pope-Hennessy, *A Lecture on Nicholas Hilliard*, London, 1949, pp. 14 ff.; Graham Reynolds, *English Portrait Miniatures*, London, 1952, pp. 10–21; Auerbach, *Tudor Artists*, pp. 168–9; Auerbach, *Hilliard* (which contains the best bibliography); Croft-Murray and Hulton, *British Drawings*, pp. 14–18; Graham Reynolds, *The Connoisseur's Complete Period Guides*, ed. R. Edwards and L. G. G. Ramsay, London, 1968, pp. 225–7; Roy Strong, *Nicholas Hilliard*, London, 1975; Hilliard, *Treatise*; Roy Strong in *The English Miniature*, Yale University Press, 1981, pp. 45–59.
2 Hilliard, *Treatise*, p. 69.
3 *Ibid.*, p. 67.
4 *Ibid.*, loc. cit.
5 On Eworth see *Icon*, pp. 8–10, 83–106, 342–5.
6 For this and what follows see *Elizabeth*, pp. 5, 24–5.
7 On Hilliard's early years see Auerbach, *Hilliard*, pp. 1–6; Edmond, *Limners*, p. 67.
8 The version in the Buccleuch Collection is a seventeenth-century copy (rep. Auerbach, *Hilliard*, pl. 11). That in a private collection has a pedigree back to *c*.1720 but is so coarse that it is difficult to use as evidence. The eyes are brown instead of the blue of Hilliard's 1577 self-portrait (ill. 83). See Goulding, *Welbeck*, p. 61 (12).
9 *Artists of the Tudor Court* (51).
10 See below, p. 75.
11 O. Millar, *Walpole Society*, XXXVII, 1960, p. 118 (57).
12 *Four Centuries of Portrait Miniatures. Catalogue of the Heckett Collection*, 1954 (26).
13 Hilliard, *Treatise*, p. 69.
14 *Ibid.*, p. 97.
15 *Ibid.*, p. 101.

16 See V. J. Murrell in *The English Miniature*, Yale U.P., 1981, pp. 5–9.
17 Auerbach, *Hilliard*, pp. 6–10.
18 *Artists of the Tudor Court* (58–9).
19 Auerbach, *Hilliard*, pp. 63, pl. 19; 289 (17).
20 On Gower, see *Icon*, pp. 15–16, 167–84.
21 *Artists of the Tudor Court* (67).
22 *Ibid.* (63).
23 *Ibid.* (55).
24 A. Heal, *The English Writing-Masters*, London, 1931, p. 127. I am much indebted to Miss Irene Whalley for pointing this out to me.
25 Auerbach, *Hilliard*, p. 7.
26 McKerrow and Ferguson, *Title-page Borders*, pp. xxxvi–xxxvii, 116 (133), 127 (148); E. Auerbach, 'More Light on Nicholas Hilliard', *Burlington Magazine*, XCI, 1949, p. 167.
27 On Rutlinger see Hind, *Engraving*, I, pp. 236–8 and bibliography; Auerbach, 'More Light on Nicholas Hilliard', p. 167; E. Auerbach, 'Early English Engravers', *Burlington Magazine*, CXIV, 1952, p. 330.
28 *Icon*, pp. 163–6, 346.
29 *Artists of the Tudor Court* (68).
30 Auerbach, *Hilliard*, p. 228.
31 N. Blakiston, 'Nicholas Hilliard at Court', *Burlington Magazine*, XCIV, 1954, p. 17.
32 For Hilliard in France see: Auerbach, *Hilliard*, pp. 11–16; N. Blakiston, 'Nicholas Hilliard as a Traveller', *Burlington Magazine*, XCI, 1949, p. 169; N. Blakiston, 'Nicholas Hilliard in France', *Gazette des Beaux-Arts*, LI, 1958, pp. 297–300.
33 Auerbach, *Hilliard*, p. 11.
34 *Ibid.*, p. 13, for the 16 June 1578 letter. The earlier reference was missed by Auerbach. It is in a letter from Paulet to Hertford dated 11 March 1577/8: 'I thancke your lordship most humbly for your letters of the xij[th] of the last, and followeing the contentes of the same have delyveryd your letters and boxe to Helyer the painter' (Bodleian Add. VII.c.82, f.43[v]).
35 Jean Adhémar, *Le Dessin Français au XVI^e Siècle*, Lausanne, 1954, pp. xxi–xxiii, 132 (60); *Les Clouet et la Cour des Rois de France*, Bibliothèque Nationale, Paris,

1970, p. 31 (40–41); *Elizabeth*, pp. 25–6.
36 On which see L. Dimier, *French Painting in the Sixteenth Century*, London, 1904; *Les Clouet*, op.cit.
37 *Les Clouet*, p. 11.
38 Adhémar, *Le Dessin Français*, pp. xxi–xxiii; *Elizabeth*, pp. 25–6.
39 *Les Clouet*, pp. 45–8.
40 *Artists of the Tudor Court* (49, 77).
41 See T. H. Colding, *Aspects of Miniature Painting*, Copenhagen, 1953, pp. 82–3; *Princely Magnificence. Court Jewels of the Renaissance*, Victoria & Albert Museum Exhibition, 1980 (23).
42 Auerbach, *Hilliard*, pp. 75, pl. 36; 293 (35).
43 *Artists of the Tudor Court* (74).
44 N. Blakiston, 'Nicholas Hilliard and Bordeaux', *Times Literary Supplement*, 28 July 1950; E. Auerbach, 'English Engraving in the Reign of James I', *Burlington Magazine*, XCIX, 1957, pp. 97–8.
45 Auerbach, 'More Light on Nicholas Hilliard', p. 166.
46 Auerbach, *Hilliard*, p. 11.
47 Dimier, *French Painting*, pp. 253–4.
48 Auerbach, *Hilliard*, pp. 71–2, pl. 22; 293 (32).
49 Roy Strong, 'Nicholas Hilliard's Miniature of Francis Bacon Rediscovered and other Minutiae', *Burlington Magazine*, CVI, 1964, p. 337.
50 *Artists of the Tudor Court* (48).
51 See *Elizabeth*, passim.
52 *Ibid.*, pp. 5–6.
53 Edward Horsey to Don John of Austria, 22 March 1577; Kervyn de Lettenhove, *Relations Politiques des Pays-Bas et de l'Angleterre*, Brussels, 1890, IX, p. 250.
54 On the Pelican and Phoenix Portraits see *Elizabeth*, p. 60 (23–4); *Icon*, pp. 160–61 (106–7); *Tudor and Jacobean*, I, pp. 101–2 (190).
55 *Artists of the Tudor Court* (182).
56 *Elizabeth*, p. 60 (26).
57 On Zuccaro see *Icon*, pp. 163–6, 346.
58 *Elizabeth*, pp. 60–62 (27).
59 Auerbach, *Hilliard*, p. 326 (217).
60 *Ibid.*, loc. cit. (218).
61 *Elizabeth*, p. 60 (25).
62 Auerbach, *Tudor Artists*, pp. 146–7.
63 *Elizabeth*, p. 66 (44).
64 Auerbach, *Tudor Artists*, p. 109; Auerbach, *Hilliard*, p. 20.

65 Quoted Auerbach, *Tudor Artists*, p. 109.
66 *Elizabeth*, pp. 89–92 (4–11). To these we can add (i) a miniature formerly in the Bagot Collection and now in the Royal Collection (see Roy Strong, 'A Portrait Miniature of QEI', *Apollo*, LXXX, 1964, supplement, p. 4); (ii) a second in the Buccleuch Collection (15/7), although it has been very heavily restored; (iii) a third reproduced in *Connoisseur*, XXXIII, 1912, pl. 161 (2).
67 *Artists of the Tudor Court* (187).
68 See note 66 (i).
69 For the Drake Jewel see *Elizabeth*, p. 92 (10); *Princely Magnificence, Court Jewels of the Renaissance*, Victoria & Albert Museum Exhibition, 1980 (40). Since then it has been examined under intense magnification to ascertain the correct date for the miniature, which at present contains a badly restored inscription reading *Ano Dni 1575 Regni 20*. The indentation of the original figures gives a correct reading of *Ano Dni 1586 Regni 28*.
70 *Artists of the Tudor Court* (192).
71 Auerbach, *Hilliard*, pp. 92, pl. 57; 296 (52).
72 Sir John Harington, *Orlando Furioso*, London, 1591, pp. 277–8.
73 *Elizabeth*, p. 102 (9).
74 *Artists of the Tudor Court* (191). For the Mildmay Charter see Auerbach, *Hilliard*, pp. 88–90, 323 (199); A charter for Ashbourne School is virtually a repetition of this: see Janet Arnold, 'The "Coronation Portrait" of Queen Elizabeth I', *Burlington Magazine*, CXX, 1978, p. 734, fig. 20. I have not seen the latter but judging from photographs it is inferior in quality to the Mildmay Charter and, as a less important commission, probably more largely studio work.
75 *Artists of the Tudor Court* (196).
76 *Ibid.*, (189).
77 On Hilliard and the second Great Seal see *ibid.* (193); Auerbach, *Hilliard*, pp. 181–4, 323 (208); *Elizabeth*, p. 148 (12).
78 Quoted Auerbach, *Hilliard*, p. 20.
79 See Frances A. Yates, *The French Academies of the Sixteenth Century*, London, 1947, p. 157.

80 On the Maître de Flore see *L'École de Fontainebleau*, Grand Palais, Paris, 1972–3, pp. 119–25.
81 *Elizabeth*, pp. 136–8 (4–12, 17–18); *Artists of the Tudor Court* (195, 197, 198).
82 Generally on the build-up see E. C. Wilson, *England's Eliza*, F. Cass Reprint, 1966; Frances A. Yates, *Astraea. The Imperial Theme in the Sixteenth Century*, London, 1975, pp. 29–87; *Cult, passim*.
83 See Auerbach, *Hilliard*, pp. 16–23.
84 Auerbach, 'More Light on Nicholas Hilliard', p. 168. Brandon also excluded from his will even the miniaturist's children.
85 Previously dated 1573 the 3 is a mis-restoration for an 8. The oval format, costume and style are all consonant with 1578. See Auerbach, *Hilliard*, pp. 85, pl. 46; 294 (42) where the date is unquestioned.
86 *Artists of the Tudor Court* (87).
87 *Ibid.* (81).
88 *Ibid.* (214).
89 Yates, *Astraea*, pp. 88–111; *Cult*, pp. 129–62.
90 Quoted *Cult*, p. 134.
91 William Camden, *Remaines . . . concerning Britaine*, London, 1870 edn, pp. 366–7.
92 *The Mirrour of Maiestie*, ed. H. Green and J. Croston, Holbein Society, 1870, p. 31.
93 Auerbach, *Hilliard*, pp. 86, pl. 51; 295 (47).
94 *Artists of the Tudor Court* (93).
95 *Ibid.* (83).
96 *Ibid.* (89).
97 Auerbach, *Hilliard*, p. 27.
98 Hilliard, *Treatise*, p. 75.
99 Auerbach, *Hilliard*, p. 325 (216).
100 *Artists of the Tudor Court* (214).
101 On the Shield Gallery see *Cult*, pp. 144, 202, note 43.
102 Camden, *Remaines, op. cit.*, pp. 385–6.
103 Henry Peacham, *Minerva Britanna*, London, 1612, pp. 27, 44, 114.
104 *Cult*, pp. 151–6
105 Recorded as 'the picture of the Earle of Essex and the said Sir Henry (Lee) nowe desceased runninge at Tylte', Auerbach, *Hilliard*, p. 171.
106 McKerrow and Ferguson, *Title-page Borders*, pp. 145–7 (174–87).
107 *Ibid.*, pp. 132 (158–60), 141 (168).
108 On the reign of the Hilliardesque see *Icon*, pp. 13ff.

109 Auerbach, *Hilliard*, pp. 44–8.
110 *Artists of the Tudor Court* (263).
111 *Icon*, pp. 71 (6), 73 (9), 76 (13), 80 (17), 96 (39), 98 (42), 122 (68), 133 (89), 154 (100), 164–5 (108–9), 185.
112 *Artists of the Tudor Court* (216).
113 *Ibid.* (220).
114 *Ibid.* (265).
115 *Ibid.* (264).
116 *Ibid.* (265).
117 The only full-length discussion of this is in *Cult*, pp. 56–83.
118 *Artists of the Tudor Court* (266).
119 *The Life and Minor Works of George Peele*, ed. David H. Horne, Yale U.P., 1952, p. 245.
120 Roy Strong, 'The Elizabethan Malady. Melancholy in Elizabethan and Jacobean Portraiture', *Apollo*, LXXIX, 1964, pp. 164–9.
121 Frances A. Yates, *Giordano Bruno and the Hermetic Tradition in the Renaissance*, University of Chicago Press, 1964, pp. 295 ff.
122 Piero Valeriano, *Hieroglyphica*, Basle, 1567, p. 290.
123 Auerbach, *Hilliard*, pp. 128–32, pl. 99: 305 (99).
124 *Artists of the Tudor Court* (95).
125 *Ibid.* (96).
126 *Ibid.* (98).
127 *Ibid.* (105–8).
128 *Ibid.* (104).
129 *Ibid.* (110).
130 See Auerbach, *Hilliard*, pp. 28–31; N. Blakiston, 'Nicholas Hilliard: Some Unpublished Documents', *Burlington Magazine*, LXXXIX, 1947, pp. 188–9.
131 Leslie Hotson, 'Queen Elizabeth's Master Painter', *Sunday Times Magazine*, 22 March 1970.
132 Auerbach, *Hilliard*, pp. 37–8.
133 Hilliard, *Treatise*, p. 63.
134 O. Millar, *Walpole Society*, XXXVII, 1960, pp. 116 (note 1)–17 (50–53).
135 The documentation is published *in extenso* in N. Blakiston, 'Queen Elizabeth's Third Great Seal', *Burlington Magazine*, XC, 1948, pp. 101–4; Auerbach, *Hilliard*, pp. 31–3.
136 Blakiston, 'Queen Elizabeth's Third Great Seal', p. 103.
137 *Ibid.*, p. 102.
138 Croft-Murray and

Hulton, *British Drawings*, pp. 16–17 (1).

139 *Elizabeth*, p. 40; Auerbach, *Hilliard*, pp. 32–3.

140 Blakiston, 'Queen Elizabeth's Third Great Seal', p. 103.

141 Auerbach, 'More Light on Nicholas Hilliard', p. 168.

142 On the Hardwick Hall Elizabeth see *Artists of the Tudor Court* (206); *Elizabeth*, pp. 83–4 (95); Mark Girouard, *Hardwick Hall*, National Trust, 1976, p. 83 (35), with reference to the transportation of the portrait in 1599, a date which fits the costume exactly. There is no reason why it should date earlier to *c*.1592 as Girouard suggests.

143 *Artists of the Tudor Court* (IV).

144 *Elizabeth*, p. 126 (21); *Artists of the Tudor Court* (207).

145 Hind, *Engraving*, I, pp. 162–3 (13); 272–3 (21).

146 *Cult*, pp. 47–54.

147 *Elizabeth*, pp. 5–6.

148 On Gheeraerts see *Icon*, pp. 22–5, 269–304, 350–51; for the connection of Gheeraerts and Lee see Edmond, *Limners*, p. 138.

149 On the Ditchley Portrait see *Elizabeth*, p. 75 (72); *Tudor and Jacobean*, I, pp. 104–7 (2561); *Cult*, p. 154.

150 *Elizabeth*, pp. 76–8 (73–8).

151 *Artists of the Tudor Court* (199).

152 *Elizabeth*, 94–7 (13–22); 160 (11–12).

153 *Ibid.*, pls XVII, XIX.

154 *Ibid.*, p. 6.

155 *Artists of the Tudor Court* (205).

156 *Ibid.* (208).

157 Auerbach, *Hilliard*, pp. 146, pl. 126; 309 (128).

158 Goulding, *Welbeck*, p. 11 (11).

159 *Artists of the Tudor Court* (211).

160 John Fletcher, 'The Date of the Portrait of Elizabeth I in her Coronation Robes', *Burlington Magazine*, CXX, 1978, p. 75.

161 *Elizabeth*, p. 126 (21).

162 Norgate, *Miniatura*, p. 38.

163 Graham Reynolds, 'Portraits by Nicholas Hilliard and his Assistants of King James I and his Family', *Walpole Society*, XXXIV, 1952–4, pp. 14–26.

164 Blakiston, 'Nicholas Hilliard: Some Unpublished Documents', pp. 188–9.

165 (i) Victoria & Albert Museum (P.3–1937), *Artists of the Tudor Court* (235). (ii) Kunsthistorisches Museum, Vienna. Auerbach, *Hilliard*, pp. 149, pl. 133; 310 (137). (iii) Royal Collection (Vit. I, 43). *Ibid.*, pp. 149, pl. 131; 310 (135). (iv) Ex Cholmondeley Collection. *Ibid.*, pp. 149 (pl. 134; 311 (139). (v) Last recorded Sotheby's 23 October 1979 (lot 40). (vi) Last recorded Sotheby's 29 July 1934 (lot 100). *Ibid.*, p. 318 (177). (vii) Buccleuch Collection (9/2). *Ibid.*, p. 311 (138).

166 (i) Royal Collection (Vit. I, 57), dated 1614. *Artists of the Tudor Court* (240). (ii) Ex Penhurst Collection, dated 1609. Auerbach, *Hilliard*, p. 314 (160). (iii) Victoria & Albert Museum (M. 92–1974). *Artists of the Tudor Court* (238). (iv) Castle Howard Collection, dated 1610. Auerbach, *Hilliard*, p. 315 (161). (v) British Museum. The Lyte Jewel, 1610. *Ibid.*, pp. 166, pl. 165; 318 (179). (vi) Ex Earls of Eglinton. *Ibid.*, pp. 158, pl. 155; 315 (163). (vii) Scottish National Portrait Gallery. *Ibid.*, pp. 159, pl. 156; 315 (164). (viii) Last recorded Sotheby's 29 November 1979 (lot 63). (ix) Royal Collection (Vit. I, 50). (x) Victoria & Albert Museum (P. 25–1975). *The English Miniature*, p. 58, pl. 69. (xi) Ex Pierpont Morgan Collection. G. C. Williamson, *Catalogue of the Miniatures in the Pierpont Morgan Collection*, 1906, I, p. 50 (42).

167 (i) *Artists of the Tudor Court* (241). (ii) Last recorded Sotheby's 20 March 1978 (lot 59). (iii) E. Grosvenor Paine Collection. (iv) Victoria & Albert Museum (P.14–1910). (v) National Trust, Waddesdon Manor.

168 (i) *Artists of the Tudor Court* (243). (ii) *Ibid.* (244). (iii) Ex Cholmondeley Collection. Auerbach, *Hilliard*, pp. 149, pl. 136; 311 (141). (iv) Last recorded Sotheby's 12 December 1966 (lot 47). (v) Last recorded Sotheby's 2 May 1961 (lot 182). *Ibid.*, p. 318 (176). (vi) Victoria & Albert Museum (P.148–1910). (vii) Kunsthistorisches Museum, Vienna. *Ibid.*, pp. 149, pl. 135; 311 (140). (viii) Royal Collection (Vit. I, 45). *Ibid.*, p. 318 (178). (ix) National Museum, Stockholm (NMB 2167). *Artists of the Tudor Court* (242).

169 Bodleian MS Eng. Hist. b.216.c.477, ff.75–6; Hilliard, *Treatise*, p. 28.

170 *Artists of the Tudor Court* (247).

171 *Ibid.* (249).

172 For James I's Great Seal see A. Wyon, *The Great Seals of England*, London, 1887, pp. 79–81. A copy of the warrant dated 9 May 1603 is B. L. Additional MS 5751 A, f.313. It refers only, as one would expect, to Anthony and its concern is solely with the provision of the necessary gold and silver for the making of the matrices.

173 Warrant of 24 December 1604 to pay Nicholas Hilliard £64 10s for twelve 'medallias' of gold including the making and workmanship; Blakiston, 'Nicholas Hilliard: Some Unpublished Documents', p. 188; Auerbach, *Hilliard*, pp. 193–5.

174 Auerbach, *Hilliard*, pp. 40–41.

175 Hind, *Engraving*, II, p. 219 (8); Auerbach, *Hilliard*, p. 197; *Elizabeth*, p. 154 (9).

176 Hind, *Engraving*, II, pp. 321–2 (9); *Artists of the Tudor Court* (259).

177 O. Millar, *Walpole Society*, XXXVII, 1960, p. 153 (23).

178 Hind, *Engraving*, II, pp. 35–6 (1).

179 On Elstracke see *ibid.*, pp. 163–4.

180 *Ibid.*, pp. 167 (8), pl. 89 (c); 168 (10), pl. 90; 174 (21), pl. 94; 175 (22), pl. 96; 176 (25), pl. 95; 178 (33), pl. 97; 181 (37), frontispiece; 190–91 (58), pl. 105.

181 *Artists of the Tudor Court* (252).

182 Auerbach, *Hilliard*, p. 197.

183 Hind, *Engraving*, II, pp. 215–42.

184 *Artists of the Tudor Court* (120).

185 *Ibid.* (121).

186 Auerbach, *Hilliard*, pp. 159–61, pl. 158; 316 (166).

187 *Artists of the Tudor Court* (118).

188 Auerbach, *Hilliard*, pp. 38–42.

189 Blakiston, 'Nicholas Hilliard: Some Unpublished Documents', p. 189.

190 McKerrow and Ferguson, *Title-page Borders*, p. 195 (250).

191 *Ibid.*, p. 201 (266).

192 *Ibid.*, p. 201 (268).

193 Hind, *Engraving*, II, pp. 67–95.

194 Auerbach, *Hilliard*, p. 37.

195 For what follows I am much indebted to the valuable work by Lucy Gent, *Picture and Poetry 1560–1620*, Leamington Spa, 1981.
196 *Ibid.*, p. 20.
197 *Treatise*, p. 87.
198 The main studies of the *Treatise* are John Pope-Hennessy, 'Nicholas Hilliard and Mannerist Art Theory', *Journal of the Warburg and Courtauld Institutes*, VI, 1943, pp. 89–100; Auerbach, *Hilliard*, pp. 198–223; Hilliard, *Treatise*; Mansfield Kirby Talley, *Portrait Painting in England: Studies in the Technical Literature before 1700*, Paul Mellon Centre for Studies in British Art, 1981, pp. 30–45.
199 For Lockey see Auerbach, *Tudor Artists*, p. 175; Otto Kurz, 'Rowland Locky', *Burlington Magazine*, XCIX, 1957, pp. 13–16; Auerbach, *Hilliard*, pp. 254–62; Strong, *Icon*, pp. 255–8; Roy Strong in *The English Miniature*, Yale U.P., 1981, pp. 59–61.
200 Girouard, *Hardwick Hall*, p. 78, with the suggested attribution of nos 3, 13, 19, 22 and 26 to Lockey and no. 14 as specifically the portrait of Lady Frances Maynard paid for in 1612.
201 *Icon*, p. 256 (236); *Tudor and Jacobean*, I, pp. 20–21; Pamela Tudor-Craig, *Richard III*, National Portrait Gallery Exhibition, 1973, p. 82 (P 7).
202 *Artists of the Tudor Court* (267).
203 *Ibid.* (124).
204 Auerbach, *Hilliard*, pp. 24, 254–5; David N. Durant, *Bess of Hardwick. Portrait of an Elizabethan Dynast*, London, 1977, pp. 170–71.
205 *Artists of the Tudor Court* (126–7).
206 *Ibid.* (129)
207 *Ibid.* (125).
208 *Ibid.* (245).
209 McKerrow and Ferguson, *Title-page Borders*, p. 182 (231); Corbett and Lightbown, *The Comely Frontispiece*, pp. 91–7.

VI Curious painting: Isaac Oliver

1 Horace Walpole, *Anecdotes of Painting in England*, ed. J. Dallaway and R. N. Wornum, London, 1849, I, pp. 176–82. The literature on Oliver is surprisingly meagre. The most important studies are: Carl Winter, *Elizabethan Miniatures*, London, 1943; Graham Reynolds, *Nicholas Hilliard and Isaac Oliver*, Victoria & Albert Museum Exhibition, 1947, pp. 11–12, 15–17; Graham Reynolds, *English Portrait Miniatures*, London, 1952, pp. 22–9; Auerbach, *Tudor Artists*, pp. 179–80; Croft-Murray and Hulton, *British Drawings*, pp. 19–24; Auerbach, *Hilliard*, pp. 232–54; Edmond, *Limners*, pp. 72–81; Roy Strong in *The English Miniature*, Yale U.P., 1981, pp. 62–8.
2 Edmond, *Limners*, p. 72.
3 *Ibid.*, loc. cit.
4 Vertue, *Notebooks*, VI, p. 55.
5 Colin Clair, *History of European Printing*, London, 1976, pp. 71–2. One of the books published by Pierre Olivier was Vivaldus's *De Veritate contritionis . . .* , dated 22 May 1514; see *Éditions parisiennes du XVIᵉ siècle . . . d'après les manuscrits de P. Renouard*, Paris, 1977, p. 286.
6 PRO E 179/145/252 19th Elizabeth (1577), f.42, in the Old Bailey Quarter: 'Oliuer Peter, Tyffyn his wife & Isaack Peter [sic] theire soone in Harrysons house in flete lane . . . Poll . . . xijᵈ'. In the same roll in The Minories there are several Olivers listed under 'strangers': Philip, Peter, Joan, Judith, Sara and Samuel. E 179/251/16 24th Elizabeth (1582), f.99, in Fleet Lane in the Old Bailey Quarter of St Sepulchre's: 'Peter Oliuer stranger . . . pol. iiijd'.
7 Auerbach, *Hilliard*, pp. 46/7.
8 The discussion here is confined to the most important certain drawings. A detailed study of Oliver's drawings is a major *desideratum* as so many seem attributed to him on very slender grounds including many listed by Croft-Murray and Hulton, *British Drawings*, pp. 20–26 (1–15).
9 *Artists of the Tudor Court* (136).
10 I am much indebted to Mr David Scrase for this information and for supplying the infra-red and ultra-violet photographs of the inscription.
11 A. P. Oppé, *English Drawings. Stuart and Georgian Periods in the Collection of H.M. The King at Windsor Castle*, London, 1950, p. 79 (459). Signed on an inset: *Isac: Olivier Fec.* First recorded in the collection of James II. *Artists of the Tudor Court* (135).
12 *L'École de Fontainebleau*, Grand Palais, Paris, 1972–3, pp. 6 (1), 7 (3).
13 *Ibid.*, pp. 61 (57), 207 (235), 210 (238).
14 For figures bearing vases in this manner see Sylvie Béguin and others, *La Galerie François Iᵉʳ au Château de Fontainebleau*, special number of *Revue de l'Art*, 1972, p. 91.
15 Edmond, *Limners*, pp. 77–80.
16 PRO E 157/1. Vertue, *Notebooks*, II, p. 62, records in James II's collection: 'two heads in one Frame in limning one Laniere the other Isaac Oliver'.
17 I am much indebted to Mr Ronald Lightbown for suggesting this.
18 R. C. Strong and J. A. van Dorsten, *Leicester's Triumph*, Sir Thomas Browne Institute, Leiden, 1964, p. 49.
19 Croft-Murray and Hulton, *British Drawings*, p. 23 (11).
20 Auerbach, *Hilliard*, p. 235.
21 O. Millar, *Walpole Society*, XXXVII, 1960, pp. 103, 213; see also Norgate, *Miniatura*, p. 55.
22 Croft-Murray and Hulton, *British Drawings*, pp. 22–3 (10).
23 Oppé, *English Drawings*, op. cit., p. 79 (460). Signed: *Ollivier*. First recorded in the collection of James II.
24 Lucy Gent, *Picture and Poetry 1560–1620*, Leamington Spa, 1981, pp. 9–13.
25 F. J. Levy, 'Henry Peacham and the Art of Drawing', *Journal of the Warburg and Courtauld Institutes*, XXXVII, 1974, pp. 174–90.
26 Norgate, *Miniatura*, pp. 83–4.
27 *Artists of the Tudor Court* (275).
28 Vertue, *Notebooks*, II, pp. 73–4.
29 *Artists of the Tudor Court* (137).
30 (i) Fitzwilliam Museum, Cambridge (3883). (ii) HRH Princess Juliana of the Netherlands Collection. *Artists of the Tudor Court* (147). (iii) Royal Collection. *Ibid.* (160).
31 *Artists of the Tudor Court* (140).
32 *Ibid.* (142).
33 *Ibid.* (199).
34 *Ibid.* (150).
35 *Ibid.* (145–6).

36 *Ibid.* (268).
37 *Ibid.* (270).
38 S. Orgel and R. Strong, *Inigo Jones. The Theatre of the Stuart Court*, University of California Press, 1973, I, p. 90, II, pp. 23–4. See also Henry V. S. Ogden and Margaret S. Ogden, *English Taste in Landscape in the Seventeenth Century*, Ann Arbor, 1955, p. 5.
39 On Woutneel see Hind, *Engraving*, I, pp. 284–6; on the Elizabeth engraving *ibid.*, pp. 282–3 (1); *Elizabeth*, p. 152 (4). The drawing at Windsor (*ibid.*, no. 3) was examined in detail and found to be not earlier than the late seventeenth century in date and the result of a tracing from the engraving. It can be discounted henceforth as a work by Oliver.
40 Hind, *Engraving*, I, pp. 265–7 (8); *Elizabeth*, p. 114 (30).
41 Hind, *Engraving*, I, p. 285 (2); *Elizabeth*, p. 113 (23).
42 Hind, *Engraving*, I, pp. 264–5 (7); *Elizabeth*, p. 114 (29).
43 Hind, *Engraving*, I, p. 262 (4), pl. 138.
44 *Artists of the Tudor Court* (152).
45 O. Millar, *Walpole Society*, XXXVII, 1960, p. 123 (1).
46 *Artists of the Tudor Court* (155).
47 *Icon*, p. 297 (300).
48 Gent, *Picture and Poetry 1560–1620*, pp. 22 ff.
49 Richard Haydocke, *A Tracte containinge the Artes of curious Painting Carueinge & Buildinge*, Oxford, 1598, preface.
50 Sir John Harington, *Orlando Furioso*, London, 1591, preface.
51 Orgel and Strong, *Inigo Jones*, I, p. 12.
52 Norgate, *Miniatura*, pp. 5, 60.
53 *Artists of the Tudor Court* (160).
54 *Ibid.* (271).
55 *Ibid.* (156).
56 *Ibid.* (159).
57 *Ibid.* (163).
58 For a variety of these fire emblems see Otto Vaenius, *Amorum Emblemata*, Antwerp, 1608, pp. 134–5, 138–9, 170–71, 184–5, 190–91.
59 Geoffrey Whitney, *A Choice of Emblemes and Other Devises*, Leiden, 1586, p. 183.
60 *Artists of the Tudor Court* (161).
61 O. Millar, *Walpole Society*, XXXVII, 1960, pp. 120; 217.
62 Strong, 'The Elizabethan Malady', *op. cit.*
63 *Artists of the Tudor Court* (272).
64 *Icon*, pp. 96 (39), 102–3 (47).
65 Auerbach, *Hilliard*, pp. 233–4; Edmond, *Limners*, pp. 73 ff.
66 Auerbach, *Tudor Artists*, p. 179; Auerbach, *Hilliard*, p. 233.
67 *Artists of the Tudor Court* (235). On the *Masque of Beauty* see Orgel and Strong, *Inigo Jones*, I, pp. 89–98 and bibliography.
68 *Ibid.* (256).
69 (i) Victoria & Albert Museum (237–1866), *Hilliard & Oliver Exhibition*, Victoria & Albert, 1947 (184). (ii) Ex Pierpont Morgan Collection, Williamson, *Catalogue*, *op. cit.*, I, p. 51 (43). (iii) Ex de la Hey Collection, rep. D. Foskett, *Collecting Miniatures*, London, 1979, fig. 15. (iv) Royal Collection (Vit. I, 54).
70 To be dealt with in my forthcoming study of Henry, Prince of Wales.
71 *Artists of the Tudor Court* (230).
72 On *Oberon* and the *Barriers* see Orgel and Strong, *Inigo Jones*, I, pp. 159–67, 205–28 and bibliography.
73 *Tudor and Jacobean*, I, pp. 144–5; II, pls 281–2.
74 *Artists of the Tudor Court* (257).
75 PRO LC 42/4 (6).
76 Thomas Coryate, *Crudities*, London, 1611, p. 236.
77 *The Letters of John Chamberlain*, ed. N. E. McClure, Philadelphia, 1939, I, p. 312.
78 Auerbach, *Hilliard*, p. 234.
79 *Artists of the Tudor Court* (260).
80 *Ibid.* (261).
81 Auerbach, *Hilliard*, p. 234. Perhaps Oliver had a hand in the formation of Salisbury's collection at Hatfield, as it is difficult otherwise to explain his debt to Oliver of the large sum of £200; see E. Auerbach and C. K. Adams, *Paintings and Sculptures at Hatfield House*, London, 1971, pp. 60–61.
82 Vertue, *Notebooks*, I, pp. 66–7.
83 *Ibid.*, loc. cit.
84 *Ibid.*, p. 40.
85 *Ibid.*, IV, p. 191.
86 *Ibid.*, II, p. 39.
87 *The Autobiography of Edward, Lord Herbert of Cherbury*, ed. W. H. Dircks, London, 1888, pp. 86–7.
88 *Artists of the Tudor Court* (179).
89 This fact is given by Norgate, *Miniatura*, p. 55.
90 *Artists of the Tudor Court* (175).
91 *Ibid.* (174).
92 *Ibid.* (223).
93 *Artists of the Tudor Court* (227).
94 See Orgel and Strong, *Inigo Jones*, *op. cit.*, I, pp. 130–53.
95 *Artists of the Tudor Court* (171).
96 *Icon*, p. 284 (277).
97 *Artists of the Tudor Court* (172).
98 *Artists of the Tudor Court* (173).
99 *Artists of the Tudor Court* (178).
100 *Ibid.* (176–7).
101 *Ibid.* (273).
102 *Icon*, p. 245 (220); 315 (325).
103 *Autobiography*, *op. cit.*, p. 86.
104 G. Wither, *Emblemes*, London, 1635, p. 86.
105 *Artists of the Tudor Court* (276).
106 *Icon*, pp. 321 (336); 323 (341).
107 *Artists of the Tudor Court* (274).
108 Roy Strong, *The Renaissance Garden in England*, London, 1979, pp. 120–22, 139–47.
109 A. G. H. Bachrach, *Sir Constantine Huygens and Britain: 1596–1687*, Sir Thomas Browne Institute, Leiden, 1962, p. 144, note 2.

VII New branches

1 On Laurence Hilliard see Auerbach, *Hilliard*, pp. 224–32; Roy Strong in *The English Miniature*, Yale U.P., 1981, p. 62.
2 John Murdoch in *The English Miniature*, pp. 88–95.
3 *Ibid.*, pp. 95–104.
4 Hilliard, *Treatise*, pp. 63–5.

List of illustrations

1 Isaac Oliver, *Robert Devereux, 2nd Earl of Essex*, *c*.1596 (Yale Center for British Art, New Haven [B.1975.2.75]). Vellum stuck onto card, oval, 5.2 × 4.2, $2\frac{1}{16}$ × $1\frac{11}{16}$. Pattern miniature after one sitting.

2 Nicholas Hilliard, *Unknown Lady*, *c*.1575–80 (Victoria & Albert Museum, London [P.8–1947]). Vellum stuck onto a playing card with three spades showing at the reverse, oval, 3.9 × 3.3, $1\frac{9}{16}$ × $1\frac{9}{32}$. Possibly kept in the studio as a demonstration piece of a miniature after two sittings.

3 Isaac Oliver, *Called Sir Arundell Talbot*, 1596 (Victoria & Albert Museum, London [P.4–1917]). Vellum stuck to a playing card, with an inverted heart verso, rectangular (with clipped corners), 6.9 × 5.4, $2\frac{23}{32}$ × $2\frac{5}{32}$. The inscription on the reverse identifying the sitter is later than Oliver's own inscription recording the date, 15 May 1596, and the place, Venice. The miniature is after two sittings.

4 Anonymous Flemish artist, *Courtiers in a Garden*, *c*.1495 (The British Library, London, [Royal MS 16.F.II, f.1]). Illumination.

5 Anonymous Flemish artist, *Bernard André presents his 'Grace Entière sur le Fait du Gouvernement d'un Prince' to Arthur, Prince of Wales*, *c*.1500 (The British Library, London [Royal MS 16.F.II, f.210v]).

6 Anonymous Flemish artist, with script by Peter Meghen, *Bible for Henry VIII and Katherine of Aragon*, *c*.1509 (By courtesy of The Marquess of Salisbury, Hatfield House, Cecil Papers, MS 234) (Photo Courtauld Institute). Illumination.

7 Michael Sittow, *Henry VII*, 1505 (National Portrait Gallery, London [416]). Oil on panel, 42.5 × 30.5, $16\frac{3}{4}$ × 12.

8 Artist Unknown, *Henry VII*, *c*.1515 (Society of Antiquaries, London). Oil on panel, 3.9 × 24.9, 15 × $9\frac{3}{4}$.

9 Jean Clouet, *Guillaume Gouffier, Seigneur de Bonnivet*, *c*.1516. (Bibliothèque Nationale, Paris). Illumination from *Les Commentaires de la Guerre Gallique*. Gouache on vellum, 5.2, $2\frac{1}{16}$ dia.

10 Jean Clouet, *Guillaume Gouffier, Seigneur de Bonnivet*, *c*.1516 (Musée Condé, Chantilly) (Photo Giraudon). Black and red chalk, 25 × 19.8, $9\frac{3}{4}$ × $7\frac{3}{4}$.

11 Attributed to Jean Clouet, *The Dauphin François*, *c*.1525 (Reproduced by Gracious Permission of Her Majesty the Queen). Vellum, 6.2, $2\frac{7}{16}$ dia.

12 Attributed to Gerard Hornebolte, Patent for Cardinal College, Oxford, 1529 (Public Record Office, London [E 24/20/1]). Illumination.

13 Attributed to Lucas Hornebolte, *Illuminated border with a portrait of Henry VIII on the letters patent granted to Thomas Forster 1524* (Private collection on loan to the Victoria & Albert Museum).

14 Lucas Hornebolte, *Henry VIII*, 1525–6. (The Fitzwilliam Museum, Cambridge [PD19–1949]). Vellum stuck onto plain card, rectangular, 5.5 × 4.8, $2\frac{1}{8}$ × $1\frac{7}{8}$.

15 Lucas Hornebolte, *Katherine of Aragon*, *c*.1525–6 (The Duke of Buccleuch). Vellum stuck onto a plain card, rectangular, 5.45 × 4.8, $2\frac{1}{8}$ × $1\frac{7}{8}$.

16 Lucas Hornebolte, *Henry VIII*, 1525–6 (Reproduced by Gracious Permission of Her Majesty the Queen [C.8]). Vellum stuck onto playing card, circular, 48, $1\frac{7}{8}$ dia. Given to Charles I by Theophilus Howard, 2nd Earl of Suffolk (Millar, *Walpole Society*, XXVII, 1960, p. 114 [46]).

17 Lucas Hornebolte, *Katherine of Aragon*, *c*.1525–6, (National Portrait Gallery, London [4682]). Vellum stuck onto plain card, circular, 3.9, $1\frac{1}{2}$ dia. The inscription presupposes that it is a pendant to one of the King.

18 Jan Gossaert, called Mabuse, *?Jacqueline, daughter of Adolphe de Bourgogne*, *c*.1520–25 (National Gallery, London). Painting. Wood, 38.1 × 28.9, 15 × $11\frac{3}{8}$.

19 Albrecht Dürer, *The Emperor Maximilian*, *c*.1518–19. Woodcut.

20 Lucas Hornebolte, *?Charles Brandon, Duke of Suffolk*, *c*.1530 (Louis de Wet, Esq.). Vellum stuck to plain card, circular, 4, 1 dia. Inscribed with his age, 48.

21 Lucas Hornebolte, *Mary I as a Princess*, *c*.1525–9 (Private Collection). Vellum stuck onto a modern plain card, 4, $1\frac{9}{16}$ dia.

22 Lucas Hornebolte, *?Anne Boleyn*, *c*.1532–3 (Royal Ontario Museum, Toronto). Vellum stuck onto card, circular, 3.8, $1\frac{1}{2}$ dia. The inscription gives the age, 25.

23 Lucas Hornebolte, *Henry VIII*, *c*.1537 (Private Collection). Vellum stuck to plain card, circular, 4.9, $1\frac{15}{16}$ dia.

24 Hans Holbein, *Henry VIII*, *c*.1536–7 (Thyssen-Bornemisza Collection, Lugano). Oil and tempera on panel, 28 × 20, 11 × $7\frac{3}{4}$.

25 Lucas Hornebolte, *Jane Seymour*, *c*.1536–7 (Lady Ashcombe, Sudeley Castle). Vellum stuck to a playing card with three hearts verso, circular, 4.5, $1\frac{25}{32}$. A near-contemporary inscription is on the back identifying the sitter.

26 Lucas Hornebolte, *Henry Fitzroy, Duke of Richmond*, *c*.1533–4 (Reproduced by Gracious Permission of Her Majesty the Queen). Vellum stuck to a playing card with two hearts verso, circular, 4.3, $1\frac{11}{16}$ dia. The inscription gives his age, 15.

27 Lucas Hornebolte, *Edward VI as Prince of Wales*, *c*.1541–2 (The Duke of Buccleuch). Vellum stuck to a playing card with parts of three spades verso, formerly circular, 3.4, $1\frac{3}{8}$ (but since clipped to an oval).

28 Lucas Hornebolte, *?Catherine Parr*, *c*.1543–4 (E. Grosvenor Paine Collection). Vellum stuck onto card, circular, 3.8, $1\frac{1}{2}$. Henry married

Catherine in July 1543.

29 Lucas Hornebolte and assistants, *Henry VIII at Prayer*, *c*.1534 (Reproduced by permission of the Dean of Windsor as Register of the Most Noble Order of the Garter). Illumination.

30 Lucas Hornebolte and assistants, *Henry VIII Enthroned Flanked by Knights of the Garter*, *c*.1534 (detail) (Reproduced by permission of the Dean of Windsor as Register of the Most Noble Order of the Garter). Illumination.

31 Lucas Hornebolte, *Henry VIII Enthroned*, 1535 (Public Record Office, London [E 344/22]). Illumination in the *Valor Ecclesiasticus*.

32 ?Designed by Lucas Hornebolte, Title-page border to the *Great Bible*, 1539. Woodcut.

33 ?Designed by Lucas Hornebolte, Third Great Seal of Henry VIII, 1542. Wax, 125, 5 dia.

34 ?Workshop of Lucas Hornebolte, Henry VIII's writing-desk, *c*.1525-9 (Victoria & Albert Museum, London). Painted wood.

35 Cast Shadow Master/ ?Lucas Hornebolte, *Margaret Pole, Countess of Salisbury*, *c*.1530 (National Portrait Gallery, London [2607]). Oil on panel, 62.8 × 48.9, $24\frac{3}{4}$ × $19\frac{1}{4}$.

36 Cast Shadow Workshop/ ?Hornebolte Workshop, *Henry VI*, 1530s (National Portrait Gallery, London [2457]). Oil on panel, 25.4 × 31.8, 10 × $12\frac{1}{2}$ (including frame).

37 Bernard van Orley, *Margaret of Austria*, *c*.1525 (Musées Royaux des Beaux-Arts, Brussels) (Photo ACL). Wood panel, 37 × 27, $14\frac{1}{2}$ × $10\frac{1}{2}$.

38 Hans Holbein, *Thomas Wriothesley, 1st Earl of South-ampton*, *c*.1535 (Metropolitan Museum of Art, New York [Rogers Fund, 1925]). Vellum stuck onto card, formerly circular now oval, 3 × 4.9, $1\frac{3}{16}$ × $1\frac{15}{16}$.

39 Hans Holbein, *George Neville, Lord Abergavenny*, *c*.1535 (The Duke of Buccleuch [1]). Vellum stuck to a playing card with one heart verso, circular, 4.9, $1\frac{15}{16}$ dia. The inscription is later and by Hilliard.

40 Hans Holbein, *George Neville, 5th Lord Abergavenny*, *c*.1535 (The Earl of Pembroke, Wilton House). Drawing, 27.4 × 24.2, $10\frac{3}{4}$ × $9\frac{1}{2}$.

41 Hans Holbein, *Thomas Cromwell, Earl of Essex*, *c*.1533-4 (Private Collection). Vellum stuck onto card, circular, 47, $1\frac{13}{16}$ dia. The locket includes a second miniature of Cromwell wearing the Garter which he received in 1537, the head of which could be by Holbein although the costume is by an inferior hand.

42 Hans Holbein, *William Roper*, 1536 (Metropolitan Museum of Art, New York [Rogers Fund, 1950]). Vellum stuck to card which has been backed with fabric, circular, 4.6, $1\frac{13}{16}$ dia.

43 Hans Holbein, *Margaret Roper*, 1536 (Metropolitan Museum of Art, New York [Rogers Fund, 1950]). Vellum stuck to card which has been backed with fabric, circular, 4.6, $1\frac{13}{16}$ dia.

44 Hans Holbein, *?Margaret Throckmorton, Mrs Robert Pemberton*, *c*.1536 (Victoria & Albert Museum, London [P.40 -1935]). Vellum stuck to a playing card with five hearts verso, circular, 5.2, $2\frac{1}{16}$, dia.

45 Hans Holbein, *Anne of Cleves*, 1539 (Victoria & Albert Museum, London, [P.153 -1910]). Vellum stuck to a play-ing card with part of a court card verso, circular, 4.5, $1\frac{3}{4}$ dia.

46 Hans Holbein, *Elizabeth Grey, Lady Audley*, probably *c*.1538 (Reproduced by Gracious Permission of Her Majesty the Queen [9.v.1]). Vellum stuck to playing card with part of a heart verso, circular, 5.6, $2\frac{7}{32}$ dia.

47 Hans Holbein, *Elizabeth Grey, Lady Audley*, *c*.1540 (Reproduced by Gracious Permission of Her Majesty the Queen). Black and coloured chalk drawing, 29.2 × 20.7, $11\frac{1}{2}$ × $8\frac{1}{8}$.

48 Hans Holbein, *?Catherine Howard*, *c*.1540-42 (Re-produced by Gracious Per-mission of Her Majesty the Queen [B]). Vellum stuck to a playing card with four diamonds verso, circular, 6.2, $2\frac{15}{32}$, dia.

49 Hans Holbein, *?Catherine Howard*, *c*.1540 (The Duke of Buccleuch). Vellum stuck onto card, circular, 5.1, 2 dia. Slightly reduced by clipping.

50 Hans Holbein, *Henry Brandon, 2nd Duke of Suffolk*, 1540-41 (Reproduced by Gracious Permission of Her Majesty the Queen [18]). Vellum stuck to a playing card with part of a king verso, circular, 5.5, $2\frac{5}{32}$ dia.

51 Hans Holbein, *Charles Brandon, 3rd Duke of Suffolk*,

1541 (Reproduced by Gracious Permission of Her Majesty the Queen). Vellum stuck to a playing card with one club verso, circular, 5.5, $2\frac{5}{32}$, dia.

52 Hans Holbein, *Unknown Youth*, *c*.1540 (Collection of HRH Princess Juliana of the Netherlands). Vellum stuck onto card, circular, 3.5, $1\frac{3}{8}$ dia.

53 Hans Holbein, *Unknown Man*, *c*.1540-43 (Yale Center for British Art, New Haven [B.1974.2.58]). Vellum stuck to plain card, circular, 4.6, $1\frac{13}{16}$ dia.

54 Attributed to Levina Teerlinc, *?Elizabeth I*, *c*.1565 (Reproduced by Gracious Permission of Her Majesty the Queen) [*Rec. Acq. unnumbered*]). Vellum stuck to a playing card with four hearts at the reverse, circular, 4.6, $1\frac{25}{32}$ dia. Once in the collection of Charles I (Millar, *Walpole Society*, XXXVII, 1960, p. 113 [42]).

55 Attributed to Levina Teerlinc, *Katherine Grey, Countess of Hertford*, *c*.1555 (Victoria & Albert Museum, London [P.10-1979]). Vellum stuck to a plain card, circular, 3.5, $1\frac{3}{8}$ dia. The identity is inscribed on the reverse in a late-16th-century hand.

56 Hans Eworth, *Unknown Lady*, 1557 (Tate Gallery, London). Painting. Oil on wood, 58.8 × 48.3, $23\frac{1}{2}$ × 19.

57 Attributed to Levina Teerlinc, *?Elizabeth I as a Princess*, *c*.1550 (Yale Center for British Art, New Haven [B.1974.2.59]). Vellum stuck to plain paper, circular, 4.8, $1\frac{7}{8}$ dia. Inscribed with the age, 18.

58 Attributed to Levina Teerlinc, *Unknown Man*, 1569 (The Countess Beauchamp, Madresfield Court). Vellum stuck onto card, oval, 3.9 × 3.2, $1\frac{9}{16}$ × $1\frac{1}{4}$. The age of the sitter is 27.

59 Attributed to Levina Teerlinc, *Unknown Man*, 1569 (The National Trust, Waddesdon Manor). Vellum stuck onto card, circular, 3.9, $1\frac{9}{16}$ dia.

60 Attributed to Levina Teerlinc, *An Elizabethan Maundy*, *c*.1565 (The Countess Beauchamp, Madresfield Court). Vellum stuck to card, originally square or rectangular but cut into an oval, 6.5 × 5.5, $2\frac{3}{4}$ × $2\frac{1}{4}$.

61 Attributed to Levina Teerlinc, *Mary I Touching for the King's Evil*, *c*.1553-8 (Westminster Cathedral Library, London). Illumination from *Certain prayers to be used by the quenes heignes in the*

consecration of the crampe rynges .

62 ?Designed by Levina Teerlinc, *Queen Elizabeth I at Prayer*, 1569. Woodcut from Richard Day, *Christian Prayers and Meditations in English* (1569).

63 ?Designed by Levina Teerlinc, *Elizabeth I at a Hunt Picnic*, 1575. Woodcut from George Turbervile, *Book of Hunting* (1575).

64 Attributed to Levina Teerlinc, *Elizabeth I Enthroned*, 1559 (Public Record Office, London [E.36/277]). Illumi-nation on the indenture between Elizabeth I and the Dean and Canons of St George's Chapel, Windsor, 30 August 1559.

65 ?Designed by Levina Teerlinc, Letter C with Elizabeth I Enthroned, 1563. Woodcut used in John Foxe, *Actes and Monumentes* (1563).

66 ?Designed by Levina Teerlinc, First Great Seal of Elizabeth I, 1559. Wax, 12.5, 5 dia.

67 Nicholas Hilliard, probably after Levina Teerlinc, *Edward Seymour, Duke of Somerset*, 1560 (The Duke of Buccleuch [DRA 18]) (Photo: V & A). Vellum stuck to plain card, circular, 3.4, $1\frac{11}{32}$ dia.

68 Nicholas Hilliard, *Edward Seymour, 2nd Earl of Hertford*, 1572 (Private Collection) (Photo: V & A). Vellum stuck onto a playing card with four diamonds *verso*, circular, 4.1, $1\frac{5}{8}$ dia

69 Nicholas Hilliard, *Unknown Man*, 1572 (Victoria & Albert Museum, London [P.1-1942]). Vellum stuck to a playing card with three hearts reverse, rectangular, 6 × 4.8, $2\frac{3}{8}$ × $1\frac{7}{8}$.

70 Nicholas Hilliard, *Unknown Lady*, 1572 (The Duke of Buccleuch [7 10]) (Photo: V & A). Vellum stuck to a playing card with four spades visible at the reverse, rectangular, 5.4 × 4.5, $2\frac{1}{8}$ × $1\frac{3}{4}$.

71 Nicholas Hilliard, *Un-known Man*, 1572 (Fitzwilliam Museum, Cambridge [3899]). Vellum stuck to a playing card with three spades showing at the reverse, circular, 4.6, $1\frac{13}{16}$.

72 Hans Eworth, *Thomas Howard, 4th Duke of Norfolk*, 1563 (detail) (Private Collection, UK). Oil on panel, 106.9 × 80.6, 42 × $31\frac{1}{2}$.

73 Nicholas Hilliard, *Unknown Man*, 1571 (Private Collection, UK) (Photo: V & A). Vellum, which has been damaged and stuck to a later card, circular, 4.5, $1\frac{25}{32}$ dia.

74 Nicholas Hilliard, *Robert Dudley, Earl of Leicester*, 1576 (National Portrait Gallery, London [4197]). Vellum stuck to a playing card with part of an unidentified picture card showing at the reverse, painted over with black watercolour, circular, 4.4, $1\frac{3}{4}$.

75 Nicholas Hilliard, *Unknown Lady*, 1576 (Victoria & Albert Museum, London [P.27–1977]). Vellum stuck to a plain card, circular, 3.7, $1\frac{15}{32}$ dia.

76 Nicholas Hilliard, *Jane Coningsby, Mrs Boughton*, 1574 (Private Collection). Vellum stuck to a playing card with part of a 'court' card at the reverse, circular, 4.4, $1\frac{3}{4}$ dia.

77 Master of the Countess of Warwick, *?Helena Snakenborg, Countess of Northampton*, 1569 (The Tate Gallery, London). Oil on panel, 6.3 × 4.8, $2\frac{15}{32}$ × $1\frac{29}{32}$. One of a series of portraits from the late 1560s attributable to this anonymous master possibly identical with Nicholas Lizarde (d.1571), a Frenchman who was Serjeant-Painter.

78 George Gower, *Elizabeth Cornwallis, Lady Kytson*, 1573 (The Tate Gallery, London). Oil on panel, 68.3 × 52.1, $26\frac{13}{16}$ × $20\frac{1}{2}$.

79 Jean de Beauchesne and John Baildon, *A Booke containing divers sortes of handes . . .*, London, 1571. Page of italic script. The book was originally published in 1570 and went through many editions.

80 ?Christopher Tressell after a design attributed to Nicholas Hilliard, Title-border, 1571. Woodcut.

81 ?Christopher Tressell after a design by Nicholas Hilliard, Title-border, 1574. Woodcut.

82 François Clouet, *Henri III*, *c*.1571–2 (Bibliothèque Nationale, Paris, Cabinet des Estampes, Na 21, f.92). Drawing, crayon on paper, 32 × 22, $12\frac{5}{8}$ × $8\frac{11}{16}$.

83 Nicholas Hilliard, *Self-portrait*, 1577 (Victoria & Albert Museum, London [P.155 –1910]). Vellum stuck to card (the back of the original card is not visible, as a thick layer of later card has been glued to it), circular, 4.1, $1\frac{5}{32}$. This miniature, together with one of his father (also in the V & A), descended within the Hilliard family until they are referred to as being, in 1706, in the collection of Simon Fanshawe.

84 Nicholas Hilliard, *Alice Brandon, Mrs Hilliard*, 1578 (Victoria & Albert Museum, London [P.2–1942]). Vellum stuck to card and subsequently stuck to a larger, circular, piece of card upon which the outer band of inscription and decoration has been painted, 5.4 × 5.8, $2\frac{1}{8}$ × $2\frac{1}{4}$. Alice Brandon (b. 1556–d. before 1608), daughter of Robert Brandon, married Hilliard in 1576. The decorative border is a later addition, probably by the artist's own son Lawrence. It records Alice as Hilliard's first wife. He remarried in 1608.

85 French School, *Anne, Duc de Joyeuse*, *c*.1580 (Cabinet des Estampes, Bibliothèque Nationale, Paris) (Photo: Giraudon). Drawing, 33 × 24.4, 13 × $9\frac{1}{2}$.

86 François Clouet, *Elizabeth of Austria*, 1571 (Bibliothèque Nationale, Paris). Drawing.

87 Nicholas Hilliard, *Marguerite de Valois*, 1577 (Private Collection) (Photo: Christie's). Vellum stuck to card, oval, 5.6 × 4.4, $2\frac{7}{32}$ × $1\frac{3}{4}$.

88 François Clouet, *Charles IX*, 1571? (Kunsthistorisches Museum, Vienna). Card, 6.1, $2\frac{1}{2}$ (height of case). One of a pair of miniatures, the other being of the King's mother, Catherine de Medici, by Clouet. Clouet's style is looser than Hilliard's and not graphic. There is no use of gold and silver or any attempt to simulate jewels. The oval shape is likely to have affected Hilliard's adoption of it subsequent to his stay in France. The miniatures are within a contemporary enamelled and jewelled case probably by François Dujardin which may be identical to one commissioned by Catherine in 1571 for the Duke of Savoy. Yvonne Hackenbroch, *Renaissance Jewellery*, Sotheby Parke Bernet, 1979, pp. 95–7; *Princely Magnificence*, V & A, 1980 (23).

89 Nicholas Hilliard, *Louis de Gonzague, Duke of Nevers, and Henriette de Cleves, Duchess of Nevers*, 1578 (Bibliothèque Nationale, Paris, Departement des Imprimés, Vélins, No 999, Lk²71). Woodcuts, oval, 4.8 × 4.5, $1\frac{7}{8}$ × $1\frac{25}{32}$. The oval woodcut portraits alone are by Hilliard.

90 Nicholas Hilliard, *Queen Elizabeth, the 'Pelican Portrait'* *c*.1572–6 (Walker Art Gallery, Liverpool). Oil on panel, 76.8 × 59.8, $30\frac{7}{32}$ × $23\frac{1}{2}$. One of two certain portraits of Elizabeth before Hilliard went to France, it is named after the jewel at her breast. The second is in reverse and has a phoenix jewel (National Portrait Gallery).

91 Nicholas Hilliard, *Elizabeth I*, 1572 (National Portrait Gallery, London [108]). Vellum stuck to a playing card with part of a queen showing at the reverse, oval, 5.2 × 4.7, $2\frac{1}{16}$ × $1\frac{7}{8}$. The face has been repainted. Ultra-violet light reveals a linear approach identical with pl. 90. The flanking, crowned E and R also reflect the Pelican Portrait.

92 Nicholas Hilliard, *Elizabeth I*, *c*.1580 (By permission of the Trustee of the Will of the 8th Earl of Berkeley deceased) (Photo Courtauld Institute). Vellum stuck onto card, oval, 4.8 × 3.9, $1\frac{7}{8}$ × $1\frac{9}{16}$.

93 ?Federigo Zuccaro, *Elizabeth I*, 1575? (National Portrait Gallery, London [2082]). Oil on panel, 113 × 78.8, $44\frac{1}{2}$ × 31. The Darnley Portrait is the most important portrait of Elizabeth from the 1570s. The formalized face-mask was to be a pattern in use in studios until the end of the reign.

94 Nicholas Hilliard, *Elizabeth I*, *c*.1580 (Private Collection). Oil on panel, 86.4 × 61, 34 × 24.

95 George Gower, *Elizabeth I*, 1579 (Private Collection). Oil on panel, 114.3 × 86.4, 45 × 34. The earliest of the portraits of the Queen carrying a sieve, an allegorical reference to her role as the Roman Vestal Virgin, Tuccia.

96 Nicholas Hilliard, *Elizabeth I*, *c*.1580–85 (Reproduced by Gracious Permission of Her Majesty the Queen [Vit.I, 25]). Vellum stuck to thin paper, oval, 3.8 × 3.3, $1\frac{1}{2}$ × $1\frac{9}{32}$. Roy Strong, *Apollo*, LXXX, 1964, Supplement, p. 4.

97 Nicholas Hilliard, *Elizabeth I*, *c*.1580–84 (Location unknown) (Photo British Library). Illuminated prayer-book, 7.6 × 5, 3 × 2 (size of page). Lost since 1892 and known only through a facsimile in the British Library (Fac.218). There is a companion miniature of Francis, Duke of Alençon. Strong, *Portraits of Queen Elizabeth I*, 1963, p. 102 (9).

98 Nicholas Hilliard, *Elizabeth I*, 1586–7 (Private Collection). Vellum stuck onto card, oval, 4.2 × 3.3, $1\frac{1}{2}$ × $1\frac{9}{32}$. The inscription has been mis-restored but the indentations exist making the correct reading: *Ano Dni 15[86]/Regni 2 [8]*. The miniature was given to Sir Francis Drake by the Queen between 17 November 1586 and 31 March 1586/7. The locket, which could have been given also or commissioned by Drake, includes a damaged miniature opposite of the Queen's phoenix emblem. Drake wears this jewel in a portrait dated 1594. Strong, *Portraits of Queen Elizabeth I*, 1963, p. 92 (10); *Princely Magnificence*, 1980 (40).

99 Nicholas Hilliard, *Elizabeth I*, *c*.1585–90 (Victoria & Albert Museum, London [P.23–1975]). Vellum stuck onto plain card, oval, 4.4 × 3.7, $1\frac{3}{4}$ × $1\frac{15}{32}$. A repetition of the type in the Drake Jewel (pl. 98) with a different dress and jewels. The crescent-moon in her hair alludes to the Queen's role as Cynthia.

100 Nicholas Hilliard and assistants, Charter authorising Sir Walter Mildmay to found Emmanuel College, Cambridge, 11 January 1584. (The Master and Fellows of Emmanuel College, Cambridge). Illumination.

101 Dericke Anthony and Nicholas Hilliard, Second Great Seal of Elizabeth I (reverse), 1584–6. Wax, 12, $4\frac{3}{4}$ dia. The Queen's head is encircled by clouds and celestial rays. The background includes the Tudor rose, the fleur-de-lis and the Irish harp.

102 Seal of the Order of the Holy Spirit, 1578. Engraving from A. Favyn, *Théâtre d'humeur et de chevalerie*, Paris, 1620, p. 157.

103 ?Nicholas Hilliard, *Elizabeth I*, *c*.1580 (British Museum, London). Woodcut, 11.7 × 8.9, $4\frac{5}{8}$ × $3\frac{1}{2}$. The woodcut exists in separate impressions as well as added to Giles Godhed's series of kings and queens of England published in 1560–62.

104 ?Nicholas Hilliard, *Elizabeth I*, 1588. Woodcut, 8.25 × 6.7, $3\frac{1}{4}$ × $2\frac{5}{8}$. This woodcut first appears in two publications in 1588 besides in separate impressions.

105 ?After Nicholas Hilliard, Medallion of Elizabeth I, *c*.1585 (The British Museum, London). Bronze, 5 × 4.1, 2 × $1\frac{5}{8}$. The celestial rays re-echo the second Great Seal iconography (pl. 101).

106 Workshop of Nicholas Hilliard, Medallion of Elizabeth, *c*.1588 (British Museum, London). Gold, oval, 5 × 4.5, 2 × $1\frac{3}{4}$.

107 Nicholas Hilliard, *Unknown Lady*, 1578 (Private Collection). Vellum stuck to card, oval, 4.5 × 3.8, $1\frac{23}{32}$ × $1\frac{1}{2}$. The date now reads 1573, the result of early mis-restoration. Style and costume are correct for 1578. The dress is of the citizen

class. Auerbach, *Hilliard*, pp. 85, 294 (42).

108 Nicholas Hilliard, *Unknown Lady*, c.1585–90 (Victoria & Albert Museum, London [P.2–1974]). Vellum stuck onto playing card with a queen showing on the reverse, oval, 4.6 × 3.9, 1$\frac{13}{16}$ × 1$\frac{1}{2}$. See colour pl. III.

109 Nicholas Hilliard, *Unknown Lady*, c.1585–90 (Private Collection). Vellum stuck onto playing card with four diamonds verso, oval, 5.4 × 4.2, 2$\frac{1}{4}$ × 1$\frac{11}{16}$. This miniature is in virtually mint condition; even the silver highlights have only oxidized very slightly.

110 Jean Rabel, *Henri IV as King of Navarre*, c.1580 (British Museum, London). Engraving.

111 Nicholas Hilliard, *Sir Walter Raleigh*, c.1585 (National Portrait Gallery, London [4106]). Vellum stuck onto card, oval, 4.8 × 4.1, 1$\frac{7}{8}$ × 1$\frac{5}{8}$. The correct identity was established only in 1948. Faded and with oxidized highlights.

112 French School, Madame de Liancourt, c.1579 (Bibliothèque Nationale, Paris). Drawing. 34.5 × 24.9, 14 × 9$\frac{3}{4}$.

113 Nicholas Hilliard, *George Clifford, 3rd Earl of Cumberland*, c.1586–7 (Nelson Gallery, Starr Foundation, Kansas City). Vellum stuck onto card, 7.1 × 5.8, 2$\frac{3}{4}$ × 2$\frac{1}{4}$. This is a rare instance where the armour that the sitter wears still survives in the Metropolitan Museum of Art, New York.

114 Nicholas Hilliard, *Unknown Man*, c.1590–93 Victoria & Albert Museum, London (P.3–1974). Vellum stuck to a playing card with six hearts on the verso, oval, 5 × 4.2, 2 × 1$\frac{5}{8}$. The hair is in the style of the early 1590s but painted in Hilliard's free pre-1593 manner.

115 Nicholas Hilliard, *Unknown Man*, 1585 (The Duke of Buccleuch). Vellum stuck to plain card, circular, 4.8, 1$\frac{7}{8}$ dia. The date on the miniature has been mis-restored to 1581 from 1585. It came from the collection of the Earls of Westmorland and was wrongly called Sir George Carey. Auerbach, *Hilliard*, 1961, pp. 86, 295 (47).

116 Nicholas Hilliard, *Man clasping a hand from a cloud*, 1588, perhaps Lord Thomas Howard (Victoria & Albert Museum, London [P.21–1942]). Vellum mounted onto plain brown card, which is probably a later addition, oval, 6 × 5, 2$\frac{3}{4}$ × 1. A second version of this

miniature is in the collection of Dr Leslie Hotson (see his *Shakespeare by Hilliard*, London, 1977). The V & A miniature is faded, with damage to the left cheek.

117 Emblem of fidelity in love from George Wither, *A Collection of Emblemes*, London, 1635, p. 99. Engraving.

118 Emblem of *Concordia* from Alciati, *Emblemata*, Paris, 1534. Woodcut.

119 Device from *The Mirrour of Maiestie*, London, 1618, p. 31. Woodcut.

120 Nicholas Hilliard, *Sir Christopher Hatton*, c.1588–91 Victoria & Albert Museum, London [P.138–1910]). Vellum stuck to a playing card with four clubs showing verso, oval, 5.6 × 4.3, 2$\frac{3}{16}$ × 1$\frac{11}{16}$. Painted after Hatton became KG in 1588 and before his death in 1591. Hilliard records Hatton in his *Treatise* (ed. Thornton and Caine, p. 81). This is the prime version. A replica exists (with a variant background) at Belvoir Castle (V & A, 1947 [51]).

121 Accession Day Tilt *impresa* from Henry Peacham, *Minerva Britanna*, London, 1612, p. 44. Woodcut.

122 Accession Day Tilt *impresa* of Robert Devereux, 2nd Earl of Essex, from Henry Peacham, *Minerva Britanna*, London, 1612, p. 114. Woodcut.

123 Detail of the coat of arms from the Emmanuel College Charter, 1584 (ill. 100).

124 Attributed to Nicholas Hilliard, Title-page border to Thomas Bentley, *The Monument of Matrones*, 1582. Woodcut.

125 Nicholas Hilliard, *Young Man among Roses*, probably Robert Devereux, 2nd Earl of Essex, c.1587. (Victoria & Albert Museum, London [P.163–1910]). Vellum stuck onto card, oval, 13.6 × 7.3, 5$\frac{5}{16}$ × 2$\frac{27}{32}$. For a complete discussion of this see Strong, *Cult of Elizabeth*, 1977, pp. 56–83.

126 Nicholas Hilliard, *Sir Anthony Mildmay*, c.1590 (Cleveland Museum of Art, Ohio). Vellum stuck onto card, 24.5 × 18.5, 9$\frac{3}{4}$ × 7. The dating is very early 1590s and previous suggestions of 1595 or later cannot be sustained from the costume evidence.

127 Nicholas Hilliard, *Robert Devereux, 2nd Earl of Essex*, c.1593–5 (Private Collection). Vellum stuck onto card, 25 × 20.3, 9$\frac{7}{8}$ × 8. See colour pl. IV. The Earl is dressed in fancy dress for the tilt and his *impresa*

is embroidered on the skirts he wears over his armour. For a discussion of this miniature see Strong, *Cult of Elizabeth*, 1977, pp. 64–5.

128 Hendrik Goltzius, *Marcus Curtius*, 1586. Engraving.

129 Hendrik Goltzius, *A Pikebearer*, 1582. Engraving.

130 Nicholas Hilliard, *George Clifford, 3rd Earl of Cumberland*, ?1590 (National Maritime Museum, Greenwich). Vellum stuck to a fruitwood panel, rectangular, 25.8 × 17.6, 10$\frac{1}{8}$ × 6$\frac{31}{32}$. The miniature has been trimmed thus losing part of the *impresa* shield and the motto which should read: *Hasta quan[do]*. The view appears to be across the Thames to a contracted panorama of Westminster and the City. Cumberland is attired as Queen's Champion at the Tilt in the guise of the Knight of Pendragon Castle.

131 Nicholas Hilliard, *Sir Robert Dudley, styled Duke of Northumberland*, c.1591–3 (Nationalmuseum, Stockholm [Bib. 1669]). Vellum stuck onto card, 19 × 11.5, 7$\frac{1}{2}$ × 4$\frac{1}{2}$. Possibly painted to commemorate his first appearance at an Accession Day Tilt in 1592, he wears a jewel as a favour on his left arm. This miniature is painted in parts in an extremely summary manner.

132 Nicholas Hilliard, *Henry Percy, 9th Earl of Northumberland*, c.1590–95 (Rijksmuseum, Amsterdam). Vellum stuck to a later piece of card, rectangular, 25.7 × 17.3, 10$\frac{1}{8}$ × 6$\frac{3}{4}$. The miniature is unusual in having no gold border. For a full discussion see R. Strong, 'Nicholas Hilliard's Portrait of the Wizard Earl', *Bulletin van het Rijksmuseum*, 1983 (forthcoming). There is considerable flaking and restoration.

133 Nicholas Hilliard, *Unknown Lady*, 1593 (Victoria & Albert Museum, London [P.134–1910]). Vellum stuck onto a playing card with five spades showing at the reverse, oval, 5.8 × 4.8, 2$\frac{9}{32}$ × 1$\frac{29}{32}$. There is no basis for the traditional identification as Mrs Holland.

134 Nicholas Hilliard, *Henry Wriothesley, 3rd Earl of Southampton*, 1594 (Fitzwilliam Museum, Cambridge [3856]). Vellum stuck to a playing card with three hearts at the reverse, oval, 4.1 × 3.25, 1$\frac{5}{8}$ × 1$\frac{9}{32}$.

135 Nicholas Hilliard, *Sir Henry Slingsby*, 1595 (Fitz-

william Museum, Cambridge [3850]). Vellum stuck to card with another, gessoed, card stuck to it, oval, 8.4 × 6.3, 3$\frac{5}{16}$ × 2$\frac{1}{2}$. An exceptionally large oval miniature. The hat has an emblematic flower jewel with the motto: SEMPER IDEM.

136 Nicholas Hilliard, *Jane Seymour*, c.1600 (Reproduced by Gracious Permission of Her Majesty the Queen). Vellum stuck to plain card, circular, 3.1, 1$\frac{1}{4}$ dia. One of four miniatures of Tudor monarchs that were within a jewel by Hilliard which was in the collection of Charles I (Millar, *Walpole Society*, XXXVII, 1960, pp. 116–17). The portrait is based on Holbein's portrait now in Vienna.

137 Nicholas Hilliard, *Unknown Lady*, 1602 (Victoria & Albert Museum, London [P.26–1975]). Vellum stuck onto plain card, oval, 5.9 × 4.4, 2 × 1. The dress is that of a citizen's wife.

138 Nicholas Hilliard, *?Edward Seymour, 1st Earl of Hertford and 1st Duke of Somerset*, c.1600, probably after a miniature by Levina Teerlinc, 1550 (Victoria & Albert Museum, London [P.25–1942]). Vellum stuck to plain card, circular, 3.4, 1$\frac{5}{16}$ dia. A fine miniature, although with much flaking. Its importance is emphasized by the use of ultra marine for the background.

139 Nicholas Hilliard, Design for a Great Seal of Ireland, c.1590 (British Museum, London). Pen and black ink, strengthened with wash, over black lead on vellum, 12.9, 5$\frac{1}{8}$ dia. The shields have Irish emblems inscribed on them: a harp and three crowns.

140 ?Studio of Nicholas Hilliard, Elizabeth I, probably 1599 (The National Trust, Hardwick Hall). Oil on canvas 223.5 × 165.1, 88 × 65. A portrait was paid for being brought from London in 1599.

141 Manner of Nicholas Hilliard, Unknown Lady called Queen Elizabeth I, c.1600 (Mrs P. A. Tritton, Parham Park). Oil on canvas, 106.7 × 58.4, 42 × 23. The *trompe l'oeil* curtain at the front is a reference to the normal practice of hanging curtains in front of pictures. The sitter may be Elizabeth, daughter and sole heiress of Edward, 11th Lord Zouche, who married in 1597.

142–4 Jodocus Hondius, possibly after Nicholas Hilliard, Title-page and illustrations to

Hugh Broughton, 'A Concent of Scripture', ?1590. Engravings, normal page size, 17.8 × 11.7, 7 × 4⅝. 142 Title-page. Cf. pl. 81. 143 *The Kingdomes that Overruled the Holy Hebrewes* 144 *The State of Rome for Crucifying our Lorde.*

145 Nicholas Hilliard, *Elizabeth I*, c.1600 (Victoria & Albert Museum, London [4404–1857]). Vellum mounted onto a playing card with one spade showing at the reverse, oval, 6.2 × 4.8, 2⁷⁄₁₆ × 1²⁷⁄₃₂. The miniature is in a contemporary locket.

146 Nicholas Hilliard, The Heneage Jewel, formerly known as the Armada Jewel, c.1600 (Victoria & Albert Museum, London [M.81–1935]). Vellum stuck to card, oval, 3.9 × 3.1, 1¹⁷⁄₃₂ × 1³⁄₁₆. The miniature has been trimmed to fit the locket. It has been heavily restored including a false added date of 1580. The Jewel is of gold enamelled in various colours and set with diamonds and rubies. There is no substance to the tradition that it was given to Sir Thomas Heneage on the defeat of the Spanish Armada.

147 Nicholas Hilliard, *Elizabeth I*, c.1600, possibly after a lost miniature by Levina Teerlinc, c.1559 (Private Collection). Vellum stuck to plain card, rectangular, 9.1 × 5.6, 3⁹⁄₁₆ × 2³⁄₁₆. The dress is that worn by Elizabeth I for her state entry into London and her coronation in January 1559. There is an unusual blue folded curtain background and a real diamond set into the sceptre.

148 Nicholas Hilliard, *Elizabeth I*, c.1595–1600 (Victoria & Albert Museum [Ham House 375]). Vellum which has been relaid onto modern card, oval, 8.6 × 6.6, 3⅜ × 2⅝. The background is unusual in being a blue folded curtain. A crescent moon in her hair alludes to her role as Cynthia. The miniature seems to be the source for Delaram's engraving after Hilliard (pl. 160).

149 After Nicholas Hilliard, *Elizabeth I*, c.1600 (Sutherland Collection, Ashmolean Museum, Oxford). Woodcut, 48.9 × 36.8, 19¼ × 14½.

150 Nicholas Hilliard, *James I*, c.1603–9. (Reproduced by Gracious Permission of Her Majesty the Queen [Vit. I, 43]). Vellum stuck onto card, oval, 4 × 3.8, 1⁹⁄₁₆ × 1³⁄₈. Auerbach, *Hilliard*, 1961, pp. 149, 310 (135).

151 Nicholas Hilliard, *James I*, 1610 (British Museum, London). Vellum stuck onto card, oval, 7.9, 3⅛ (height). The Jewel was presented to Thomas Lyte on 12 July 1610 by James I in gratitude for a genealogy of the King back to Brutus. Auerbach, *Hilliard*, 1961, pp. 166, 318 (179).

152 Rowland Lockey, *James I*, 1614 (Reproduced by Gracious Permission of Her Majesty the Queen [I, 57]). Vellum stuck to a playing card with one diamond showing at the reverse, oval, 4.5 × 3.7, 1²⁵⁄₃₂ × 1⁷⁄₁₆. The date is on the reverse. Auerbach, *Hilliard*, 1961, pp. 165, 317 (174) wrongly as Hilliard.

153 Rowland Lockey, *Anne of Denmark*, c.1605 (National-museum, Stockholm [NMB 2167]). Vellum stuck onto card, 5 × 3.7, 2 × 1½.

154 Nicholas Hilliard, *Elizabeth, Queen of Bohemia*, c.1605 (Victoria & Albert Museum, London [P.4–1937]). Vellum stuck onto a playing card with four diamonds at the reverse, which have been painted black, 5.3 × 4.4, 1²³⁄₃₂ × 2³⁄₃₂. The Princess would have been nine in 1605.

155 Nicholas Hilliard, *Charles I as Prince of Wales*, c.1613 (Victoria & Albert Museum, London [P.150–1910]). Vellum stuck to a playing card with spades at the reverse, oval, 5.1 × 4.1, 2 × 1⅝. The miniature has a decorative border of patterned gold over smalt (blue) typical of Hilliard's work at this period.

156 Nicholas Hilliard and assistants, *James I*, 1603. Illumination in the *Liber Ceruleus* of the Order of the Garter (Reproduced by permission of the Dean of Windsor as Register of the Most Noble Order of the Garter). The portrait is unfortunately very damaged but both it and the canopy are by Hilliard. The border is by a second hand.

157 Nicholas Hilliard and assistants, *James I and Henry, Prince of Wales*, 1610. Letters Patent creating Henry, Prince of Wales, 1610 (The British Library, London [Additional MS 36932]). Hilliard's faces are inserted into figures and a border which have nothing to do with him.

158 Workshop of Nicholas Hilliard, Medal commemorating peace with Spain, 1604 (British Museum, London, Department of Coins and Medals). 3.8, 1½ dia. The face-pattern is of the first type used by Hilliard (pl. 150).

159 Charles Anthony after a design attributed to Nicholas Hilliard, Great Seal of James I, 1603. Wax, 14.9, 5¹⁵⁄₁₆ dia. The coats of arms on the seal emphasize James as the successor to ancient British kings as well as the Saxon kings of England.

160 Francis Delaram after Nicholas Hilliard, *Elizabeth I*, c.1617–19. Engraving, 31.4 × 22.2, 12⅜ × 8¾ (plate), 27.6 × 21.3, 10⅞ × 8⅜ (border). Based on pl. 148. The plate is inscribed: *Nic: Hillyard delin: et excud: cum privilegio Maiest:*

161 Renold Elstracke, probably after Nicholas Hilliard, *Elizabeth, Queen of Bohemia, and Frederick, Elector Palatine and King of Bohemia*, c.1613 (British Museum, London). Engraving, 26 × 20, 10¼ × 7⅞ (plate). Probably issued on the occasion of their marriage in February 1613.

162 William Hole after Isaac Oliver, *Henry, Prince of Wales*, 1612. From Michael Drayton, *Polyolbion*, London, 1612. Engraving, 19.1 × 12.4, 7½ × 4⁷⁄₈ (border). William Hole (d.1624) was chief engraver of the Mint.

163 Nicholas Hilliard, *Elizabeth, Electress Palatine, later Queen of Bohemia, and her son, Frederick Henry*, c.1615 (The British Museum, London). Pen and ink over black lead, on two slips of vellum, the one pasted over the other to enlarge the composition, 12.7 × 8.9, 5 × 3½. Inscribed N.H. bottom left. The child was heir to the British throne until Charles I had children by Henrietta Maria.

164 Nicholas Hilliard, *Unknown Lady*, c.1615 (Private Collection). Vellum stuck to playing card with two clubs verso, oval, 6.3 × 5.2, 2⁵⁄₃₂ × 2³⁄₃₂. At one time wrongly identified as Mary, Queen of Scots, and dated to the 1580s, the sitter is dressed as a widow; the 'jewelled' border is typical of this period of Hilliard's work. Inscribed: VIRTUTIS AMORE.

165 Nicholas Hilliard, *Unknown Man*, 1616 (Private Collection). Vellum stuck to a larger piece of plain card, upon which the border is painted, oval, 6.2 × 5.1, 2⁷⁄₁₆ × 2. In virtually mint condition with a typical late 'jewelled' border. Formerly wrongly identified as Henry Carey, 2nd Earl of Monmouth, the sitter is a lover with the motto: + *Encores vn* [burst of rays] /*Luy pour moy*

150).

159 (Still one star (or sun) shines for me).

166 Nicholas Hilliard, *Lady Elizabeth Stanley*, 1614 (Private Collection). Vellum stuck onto a playing card with three diamonds verso, oval, 6.2 × 5.1, 2⁷⁄₁₆ × 2. Elizabeth Stanley married in 1601 Henry Hastings, 5th Earl of Huntingdon. The miniature is an allegory of constancy in love, expressed by her hand on her heart and two emblems: a pierced heart with a motto on the subject of once pierced, always fixed, and the sun's rays through a cloud with a motto indicating the immutability of love.

167 After a design attributed to Nicholas Hilliard, Title-page border, 1609. Woodcut.

168 After a design attributed to Nicholas Hilliard, Title-page border to John Stow, *Annales*, London, 1615. Woodcut.

169 Jodocus Hondius after a design attributed to Nicholas Hilliard, Title-page border to John Speed, *Theatre of the Empire of Great Britaine*, London, 1611–12. Engraving, 38.1 × 24.4, 15 × 9⅝ (border), 38.7 × 25, 15¼ × 9⅞ (plate).

170 Rowland Lockey, *The Family and Descendants of Sir Thomas More*, c.1593–4. Victoria & Albert Museum, London (P.15–1973). Vellum stuck onto card, rectangular, 24.6 × 29.4, 9¹¹⁄₁₆ × 11⁹⁄₁₆. From left to right the figures are identified by letters: *A.* Sir John More (?1451–1530); *B.* Sir Thomas More (1477/8–1535); *C.* John More (?1509–47); *D.* Anne Cresacre (1511–77); *E.* Thomas More II (1531–1606); *F.* Mary Scrope (1534–1607); *G.* John More (1577–1599?) and Cresacre More (1572–1649); *H.* Cecily Heron (b.1507); Elizabeth Dawncey (b.1506) and Margaret Roper (1505–44). The miniature was commissioned by Thomas More II, who also commissioned two large-scale canvases, one a copy of the Holbein picture (dated 1592, now at Nostell Priory) and one a group close to the miniature (dated 1593, now in the National Portrait Gallery). The panorama is of More's garden at Chelsea.

171 Rowland Lockey, *Margaret Beaufort, Countess of Richmond and Derby*, 1598 (The Master and Fellows of St John's College, Cambridge). Oil on panel, 180.1 × 115.9, 71¼ × 45⅝. The portrait was presented to the College in 1598 and is inscribed on the reverse: *Rolandus Lockey. pinxit Londini.*

172 Rowland Lockey and Christopher Switzer, Title-page border to the Holy Bible (The Bishops' Bible), London, 1602. Woodcut. The title-page is signed in the bottom two corners of the title compartment. The iconography confronts the twelve tribes of Israel (left) with the twelve Apostles (right). Around the central compartment are the four Evangelists and at the top the three Persons of the Trinity.

173 Attributed to Rowland Lockey, *Unknown Lady*, *c*.1600 (E. Grosvenor Paine Collection). Vellum stuck onto card, oval, 4.8 × 4.1, $1\frac{7}{8}$ × $1\frac{5}{8}$.

174 Attributed to Rowland Lockey, *Called Catherine Carey, Countess of Nottingham*, *c*.1605–10 (Nationalmuseum, Stockholm [NMB 1582]). Vellum stuck onto card, oval, 5.7 × 4.7, $2\frac{1}{4}$ × $1\frac{3}{4}$. The miniature is in an unusually good state with a brilliant crimson curtain.

175 Attributed to Rowland Lockey, *Unknown Man*, 1599 (The Duke of Buccleuch [7/8]). Vellum stuck to a playing card with two diamonds, showing at the reverse, oval, 4.6 × 3.9, $1\frac{13}{16}$ × $1\frac{9}{16}$.

176 Attributed to Rowland Lockey, *Charles Howard, Lord Howard of Effingham*, 1605 (National Maritime Museum, Greenwich). Vellum stuck to a card which has been painted black verso, oval, 4.6 × 4, $1\frac{7}{8}$ × $1\frac{5}{16}$. The inscription is identical in style to pl. 175.

177 Nicholas Hilliard, *Unknown Lady*, *c*.1600 (The Duke of Buccleuch [9/37]). Vellum stuck onto plain card, oval, 7.7 × 6, 3 × $2\frac{3}{8}$. An unknown sitter of high social rank depicted in a manner recalling the 'mask of youth' portraits of the Queen.

178 Attributed to Rowland Lockey, *Unknown Lady*, *c*.1600 (Nationalmuseum, Stockholm [NMB 1694]). Vellum stuck onto card, oval, 7.6 × 6.3, 3 × $2\frac{3}{8}$.

179 Isaac Oliver, *Moses striking the Rock*, before 1586 (Reproduced by Gracious Permission of Her Majesty the Queen). Brown and grey wash and white, 21 × 33.3, $8\frac{1}{4}$ × $13\frac{1}{4}$. Signed on inset: *Isac: Oliver Fec.*

180 Niccolò dell'Abate, *The Discovery of Moses*, after 1552 (Musée du Louvre, Paris) (Photo Musées Nationaux). Oil on canvas, 82 × 83, $32\frac{1}{4}$ × $32\frac{21}{32}$.

181 School of Fontainebleau, *Charity*, *c*.1560 (Private Collection, Paris). Oil on canvas, 86 × 985, $33\frac{27}{32}$ × $387\frac{25}{32}$.

182 Isaac Oliver, *The Lamentation over the Dead Christ*, 1586 (Fitzwilliam Museum, Cambridge). Pen and ink, wash, watercolour and ink, 21 × 28, $8\frac{1}{4}$ × 11. Under ultra-violet light a faint and damaged inscription reads: *I.Ollivarus in [venit?]/Tuarnic[um?]/15[8]6* (the third figure is a three or eight and only the latter is possible).

183 Isaac Oliver, *The Entombment*, after 1596, perhaps *c*.1615 (British Museum, London). Black chalk, pen and dark brown ink and wash, heightened with white, 29.5 × 37.7, $31\frac{5}{8}$ × $14\frac{7}{8}$. Inscribed in the lower right hand corner: *Isa: Ollivier.*

184 Isaac Oliver, *The Adoration of the Magi*, after 1596 (British Museum, London). Purplish brown wash, touched with pen and ink, and heightened with white over pencil, 22.9 × 16.8, 9 × $6\frac{5}{8}$. Signed: *Is: Ollivier.*

185 Isaac Oliver, *Nymphs and Satyrs*, *c*.1610–15? (Reproduced by Gracious Permission of Her Majesty the Queen). Black and white on brown paper, 20.5 × 35.7 cm., $8\frac{1}{8}$ × $13\frac{7}{8}$ in. Signed: *Ollivier*: and on an inset: *Isac: Oliver Fec.*

186 Isaac Oliver, *Unknown Lady*, 1587 (The Duke of Buccleuch [169] D.7). Vellum stuck to plain card, oval, 5.4 × 4.4, $2\frac{7}{16}$ × $1\frac{23}{32}$. Signed: *IO*. The dress is that of a citizen's wife.

187 Hendrik Goltzius, *Josina Hamels*, 1580. Engraving.

188 Isaac Oliver, *Unknown Man*, 1588 (Brinsley Ford Collection). Vellum stuck onto card, oval, 5.1 × 4, 2 × $1\frac{5}{8}$ in.

189 Hendrik Goltzius, *A Young Man Aged 22*, 1582. Engraving.

190 Isaac Oliver, *Self-portrait*, *c*.1590 (National Portrait Gallery, London [4852]). Vellum stuck to plain card, oval, 6.2 × 5, $2\frac{7}{16}$ × $1\frac{15}{16}$.

191 Hendrik Goltzius, *Hieronymus Scholiers* 1583. Engraving.

192 Isaac Oliver, *Peregrine Bertie, Lord Willoughby d'Eresby*, *c*.1590 (Victoria & Albert Museum, London [P.5–1947]). Vellum stuck onto card, oval, 3.6 × 2.6, $1\frac{9}{32}$ × 1. Formerly wrongly attributed to Hilliard.

193 Isaac Oliver, *Diderik Sonoy*, 1588 (Collection of HRH Princess Juliana of The Netherlands). Vellum stuck onto card, rectangular, 6.8 × 5.5, $2\frac{5}{8}$ × $2\frac{1}{8}$. Diderik Sonoy, an ardent partisan of the Earl of Leicester,

was in England in 1588. The motto is in Dutch and in translation reads: *To trust without suspicion.*

194 Isaac Oliver, *Unknown Girl*, *c*.1590–95 (The Duke of Buccleuch [9/39]). Vellum stuck to a playing card with one spade showing at the reverse, oval, 4.3 × 3.5, $1\frac{11}{16}$ × $1\frac{3}{8}$. An unfinished miniature although signed.

195 Isaac Oliver, *Unknown Girl*, 1590, (Victoria & Albert Museum, London [P.145 –1910]). Vellum stuck to a playing card with half a red cypher (heart or diamond) showing at the reverse, oval, 5.4 × 4.3, $2\frac{1}{8}$ × $1\frac{11}{16}$. One of a pair of portraits of little girls.

196 Isaac Oliver, *Unknown Melancholy Man*, *c*.1590–95 (Reproduced by Gracious Permission of Her Majesty the Queen). Vellum stuck onto card, rectangular, 11.7 × 8.3, $4\frac{5}{8}$ × $3\frac{1}{4}$. Signed in monogram on the rock left: *IO*.

197 Isaac Oliver, *An Allegorical Scene: Virtue Confronts Vice*, *c*.1590–95 (State Museum of Art, Copenhagen). Vellum stuck onto card, rectangular, 11 × 17, $4\frac{3}{8}$ × $6\frac{3}{4}$. Signed bottom left: *IO* (in monogram) *in [venit].*

198 Isaac Oliver, *Elizabeth I*, *c*.1592 (Victoria & Albert Museum [P.8–1940]). Vellum stuck to a playing card with one club verso. The original rectangular card has been cut to an oval, leaving the original squared edges at top and bottom, oval, 8.2 × 5.2, $2\frac{7}{16}$ × $2\frac{1}{8}$. An *ad vivum* pattern miniature.

199 Crispin van de Passe I, *Elizabeth I*, 1592. Engraving, 14.6 × 12, $5\frac{3}{4}$ × $4\frac{3}{4}$ (border of subject), 18 × 12, $7\frac{1}{8}$ × 5 (near plate with lettering below).

200 Isaac Oliver, *Elizabeth I*, *c*.1592 (Private Collection). Vellum stuck onto plain card, oval, 4.9 × 3.9, $1\frac{15}{16}$ × $1\frac{9}{16}$. Damaged, but a magnificent miniature based on Oliver's pattern portrait of the Queen (pl. 198).

201 William Rogers probably after Isaac Oliver, *Elizabeth I as 'Rosa Electa'*, *c*.1595–1600. Engraving, 23.1 × 17.1, $9\frac{1}{8}$ × $6\frac{3}{4}$ (outer border), 23.5 × 17.8, $9\frac{1}{4}$ × 7 (plate).

202 Crispin van de Passe I after Isaac Oliver, *Elizabeth I*, 1603. Engraving, 31.8 × 22.5, $12\frac{1}{2}$ × $8\frac{7}{8}$ (border), 34.9 × 22.9, $13\frac{3}{4}$ × 9 (plate). The inscription *Mortua anno Miser I CorDIae* indicates that the engraving commemorates the Queen's

death. Oliver's responsibility is recorded in the inscription: *Isaac Olivier effigiebat.*

203 William Rogers after Isaac Oliver, *Elizabeth I*, *c*.1592. Engraving, 38.7 × 26, $15\frac{1}{4}$ × $10\frac{1}{4}$ (plate), 38.1 × 25.4, 15 × 10 (border).

204 Paolo Veronese, *The Mystic Marriage of St Catherine*, 1575 (Galleria dell'Accademia, Venice) (Photo Alinari). Oil on canvas, 337 × 241, $132\frac{11}{16}$ × $94\frac{13}{16}$.

205 Isaac Oliver, *Unknown Man*, *c*.1595–1600 (Private Collection). Vellum stuck to plain card, oval, 5.2 × 4.3, $2\frac{1}{16}$ × $1\frac{11}{16}$. Signed to the left *IO* (in monogram).

206 Isaac Oliver, *Unknown Lady*, *c*.1595–1600 (Reproduced by Gracious Permission of Her Majesty the Queen). Vellum stuck onto card, oval, 7.6 × 5.7, 3 × $2\frac{1}{4}$. The costume is that of a citizen's wife and the expensive pigment ultramarine is used for the background.

207 Isaac Oliver, *Robert Devereux, 2nd Earl of Essex*, *c*.1596 (Private Collection). Vellum stuck onto card, rectangular, 21 × 12.5, $8\frac{1}{4}$ × $4\frac{15}{16}$. This was once in the collection of Charles I (Millar, *Walpole Society*, XXXVII, 1960, p. 108 [23]).

208 Isaac Oliver, *Unknown Lady*, *c*.1595–1600 (Victoria & Albert Museum, London [P.43–1941]). Vellum stuck to a playing card with part of a spade verso, oval, 4.9 × 3.9, $1\frac{15}{16}$ × $1\frac{9}{16}$. A second version with different costume is in the Mauritshuis (Auerbach, *Hilliard*, pp. 242, pl. 305; 329 [240]).

209 Isaac Oliver, *Unknown Lady*, *c*.1595–1600 (Victoria & Albert Museum, London [P.12–1971]). Vellum stuck to plain card, circular, 13, $5\frac{1}{8}$ dia. At one time wrongly identified as Frances Howard, Countess of Somerset. Signed bottom left.

210 Isaac Oliver, *Unknown Melancholy Man*, *c*.1595–1600 (Private Collection). Vellum stuck to plain card, oval, 7.2 × 5.2, $2\frac{13}{16}$ × $2\frac{1}{16}$. Once in the collection of Charles I (Millar, *Walpole Society*, XXXVII, 1960, p. 120).

211 Ship and rock emblem from Henry Peacham, *Minerva Britanna*, London, 1612, p. 158. Woodcut.

212 Paolo Veronese, *Unknown Lady*, *c*.1560 (Musée du Louvre, Paris) (Photo Giraudon). Oil on canvas, 119 × 103, $46\frac{7}{8}$ × $40\frac{1}{2}$.

213 Francesco Melzi, *Flora*,

c.1510 (Hermitage, Leningrad). Tempera and oil on panel transferred to canvas, 76 × 63, $29\frac{15}{16} \times 24\frac{13}{16}$.

214 Giampietrino, *St Mary Magdalene*, c.1525 (Florence, Adele Borsini Bartalini). Oil on panel, 66 × 49, 26 × $19\frac{5}{16}$.

215 Isaac Oliver, *Unknown Man*, c.1595–1600 (Victoria & Albert Museum [P.5–1917]). Vellum stuck to a playing card with one inverted heart at the reverse, oval, 6 × 5.2, $2\frac{19}{32} \times 2\frac{1}{32}$. Formerly wrongly attributed to Hilliard, the stipple technique is pure Oliver.

216 Inverted torch emblem from Geoffrey Whitney, *A Choice of Emblemes*, Leiden, 1586, p. 183. Woodcut.

217 Isaac Oliver, *The Three Brothers Browne*, 1598 (Burghley House Preservation Trust Ltd (Photo Courtauld Institute). Vellum stuck onto card, rectangular, 24 × 26, 9 × 10. The miniature depicts the three grandsons of Anthony Browne, 1st Viscount Montague. From left to right they are: John Browne, Anthony Maria Browne, 2nd Viscount Montague and William Browne. The figure entering right is usually described as a servant but there are no grounds for this. Signed on the pilaster: *IO* (in monogram).

218 Marc Duval, *The Three Coligny Brothers*, 1579. Engraving.

219 Isaac Oliver, *Anne of Denmark*, c.1604 (The National Trust, Waddesdon Manor). Watercolour on vellum set in enamel case decorated with flowers, 5.4 × 4.1, $2\frac{1}{8} \times 1\frac{5}{8}$.

220 Isaac Oliver, *Anne of Denmark*, c.1605 (By permission of the Trustee of the will of the 8th Earl of Berkeley deceased). Vellum stuck onto card, laid down on a later mount, oval, 7.2 × 5.2, $2\frac{7}{8} \times 1\frac{1}{16}$. Probably painted for Elizabeth, daughter of George Carey, 2nd Lord Hunsdon, and wife of Sir Thomas Berkeley.

221 Isaac Oliver with additions probably by Bernard Lens, *Anne of Denmark*, 1609 (Private Collection). Vellum stuck to card, the painting extended on to another, later, card stuck to the back, oval, 5 × 4, $1\frac{31}{32} \times 1\frac{9}{16}$. Originally an unfinished pattern miniature. The face and hair are by Oliver and the outlines of the original costume are still visible through the later overpaint. Vertue noted it was once dated 1609.

222 Isaac Oliver, Anne of

Denmark in a costume for *The Masque of Beauty* (1608) or *Love Freed* (1611) (Reproduced by Gracious Permission of Her Majesty the Queen [42]). Vellum stuck onto plain card, oval, 5.3 × 4.2, $2\frac{1}{16} \times 1\frac{21}{32}$. The most likely identity is for the *Masque of Beauty* in 1608 for which no designs survive and on which Inigo Jones did not work. *Love Freed* is a possibility but if the drawing by Jones identified as for Anne's headdress is correct this is excluded. It is signed to the left *IO* (in monogram).

223 Isaac Oliver, *Henry, Prince of Wales*, c.1612 (Reproduced by Gracious Permission of Her Majesty the Queen). Vellum stuck onto card, rectangular, 13.3 × 10.2, $5\frac{1}{4} \times 4$.

224 Isaac Oliver, *Henry, Prince of Wales*, c.1610–11 (Fitzwilliam Museum, Cambridge [3903]). Vellum stuck onto card, oval, 5 × 4.1, 2 × $1\frac{5}{8}$.

225 Inigo Jones, Headdress for Henry, Prince of Wales, in *Oberon, The Fairy Prince*, 1611 (Devonshire Collection, Chatsworth. Reproduced by permission of the Chatsworth Settlement Trustees). Pen and grey ink, grey wash accentuated in black ink, 25.9 × 17.1, $10\frac{3}{16} \times 6\frac{3}{4}$. Stephen Orgel and Roy Strong, *Inigo Jones. The Theatre of the Stuart Court*, University of California Press, 1973, I, p. 228 (71).

226 Isaac Oliver, *Charles I as Prince of Wales*, c.1615–16 (Private Collection). Vellum stuck onto plain card, oval, 5.1 × 4, 2 × $1\frac{9}{16}$. An unfinished pattern miniature.

227 Isaac Oliver probably assisted by Peter Oliver, *Charles I as Prince of Wales*, c.1615–16 (Nationalmuseum, Stockholm [NMB 1978]). Vellum stuck onto card, oval, 5 × 4.3, 2 × $1\frac{3}{4}$. The head is by Oliver and the rest by an inferior hand, probably his son.

228 Isaac Oliver, *Madonna and Child in Glory*, c.1610–17 (The Beaverbrook Foundation, Beaverbrook Art Gallery, Fredericton, New Brunswick). Vellum laid down on panel, rectangular, 27.6 × 20.3, $10\frac{7}{8} \times 8$. Edward Norgate (*Miniatures*, ed. Martin Hardie, Oxford, 1919, p. 55) records that Oliver spent two years on this miniature.

229 Isaac Oliver, *Diana*, 1615 (Victoria & Albert Museum, London [P.9–1940]). Gouache on sized cambric laid down onto a thin panel of limewood, oval,

8.6 × 6.4, $3\frac{3}{8} \times 2\frac{17}{32}$. Signed and dated to the right: *1615/IO* (in monogram).

230 Peter Paul Rubens, *Madonna della Vallicella*, 1609 (Church of the Oratorians, Rome) (Photo Alinari). Painting.

231 Federigo Barocci, *Madonna of the Clouds*, c.1575. Engraving.

232 Isaac Oliver, *Head of Christ*, probably after c.1610 (Victoria & Albert Museum, London [P.15–1931]). Vellum stuck to a plain card, oval, 5.3 × 4.3, $2\frac{1}{8} \times 1\frac{23}{32}$. Signed in monogram right: *IO*.

233 Isaac Oliver, *Lady in Masque Costume*, c.1605 (Rijksmuseum, Amsterdam, on loan to the Mauritshuis, The Hague [1001]). Vellum stuck onto card, oval, 5.4 × 4.1, $2\frac{1}{8} \times 1\frac{5}{8}$.

234 Isaac Oliver, *?Masquer in Ben Jonson's 'Masque of Queens'*, 1609 (Victoria & Albert Museum [P.3–1942]). Vellum stuck on to plain card, oval, 6.2 × 5.1, $2\frac{7}{16} \times 2$.

235 Isaac Oliver, *Unknown Man*, c.1610 (Victoria & Albert Museum [Ham House 379–1948]). Vellum stuck to card extended by glueing another piece of card to the back, oval, 5.2 × 4.4, $2\frac{1}{16} \times 1\frac{11}{16}$. Unsigned but with the motto: *Alget qui non ardet*.

236 Isaac Oliver, *Unknown Man*, 1614 (Collection of HRH Princess Juliana of the Netherlands). Vellum stuck onto card, oval, 5.4 × 4.1, $2\frac{1}{4} \times 1\frac{5}{8}$. Signed and dated to the right: *1614/30/IO* (in monogram).

237 Marcus Gheeraerts the Younger, *Sir John Kennedy*, 1614 (By kind permission of the Marquess of Tavistock, and the Trustees of the Bedford Estates) (Photo Paul Mellon Centre for Studies in British Art (London) Ltd). Oil on canvas, 197.5 × 115.8, $78\frac{1}{2} \times 45\frac{1}{2}$. Strong, *Icon*, 1969, p. 284 (277).

238 Isaac Oliver, *Elizabeth Harding, Mrs Oliver*, c.1610–15 (Private Collection). Vellum stuck to a playing card with three clubs verso, oval, 5.2 × 4.2, $2\frac{1}{16} \times 1\frac{5}{8}$. The identification as Isaac's third wife depends on the dating of the dress.

239 Isaac Oliver, *John Donne*, 1616 (Reproduced by Gracious Permission of Her Majesty the Queen [21]). Vellum stuck to card, oval, 4.4 × 3.6, $1\frac{3}{4} \times 1\frac{7}{16}$. Signed and dated at either side of the head: *1616/IO* (in monogram).

240 Isaac Oliver, *Unknown Lady*, c.1615 (Victoria & Albert Museum, London [P.39–1941]).

Vellum stuck onto plain card, oval, 5.4 × 4.3, $2\frac{1}{8} \times 1\frac{11}{16}$. Signed to the right: *IO* (in monogram).

241 Isaac Oliver, *Edward Herbert, 1st Baron Herbert of Cherbury*, c.1610–13 (The Earl of Powis, Powis Castle). Vellum stuck onto card, rectangular, 23 × 18, 9 × $7\frac{7}{8}$.

242 Winged heart emblem. George Wither, *Emblemes* (1635).

243 Giulio Campagnolo, *Kronos* river-god type. Engraving.

244 Isaac Oliver, *Richard Sackville, 3rd Earl of Dorset*, 1616 (Victoria & Albert Museum [P.21–1882]). Vellum stuck to plain card, rectangular, 23.9 × 15.7, $9\frac{7}{16} \times 6\frac{3}{16}$. The clothes are recorded in an inventory of 1617 (Peter and Ann MacTaggart, 'The Rich Wearing Apparel of Richard, 3rd Earl of Dorset', *Costume*, XIV, 1980, pp. 41–55). Signed bottom right: *Isaac. Ollivierus.fecit.*; and :1616.

245 William Larkin, *Richard Sackville, 3rd Earl of Dorset*, 1613 (The Suffolk Collection, Rangers House, Blackheath [GLC]). Oil on canvas, 206.4 × 122.3, $81\frac{1}{4} \times 48\frac{1}{8}$. The dress is probably that worn for the marriage of the Princess Elizabeth in 1613.

246 Isaac Oliver, *Lucy Harington, Countess of Bedford*, c.1615 (Fitzwilliam Museum, Cambridge [3902]). Vellum stuck onto card, circular, 7.6, 3 dia. The background is extensively damaged as a result of erroneous 'cleaning'. Although doubts have been cast on the identity the long face and the aquiline nose are in accordance with other authentic portraits of the Countess.

247 Isaac Oliver, Compositional sketch for *Lucy Harington, Countess of Bedford*, c.1615 (Fitzwilliam Museum, Cambridge). Pen and brown ink on paper, 14.9 × 11.1, $5\frac{7}{8} \times 4\frac{3}{8}$.

Index

Figures in italics refer to illustrations